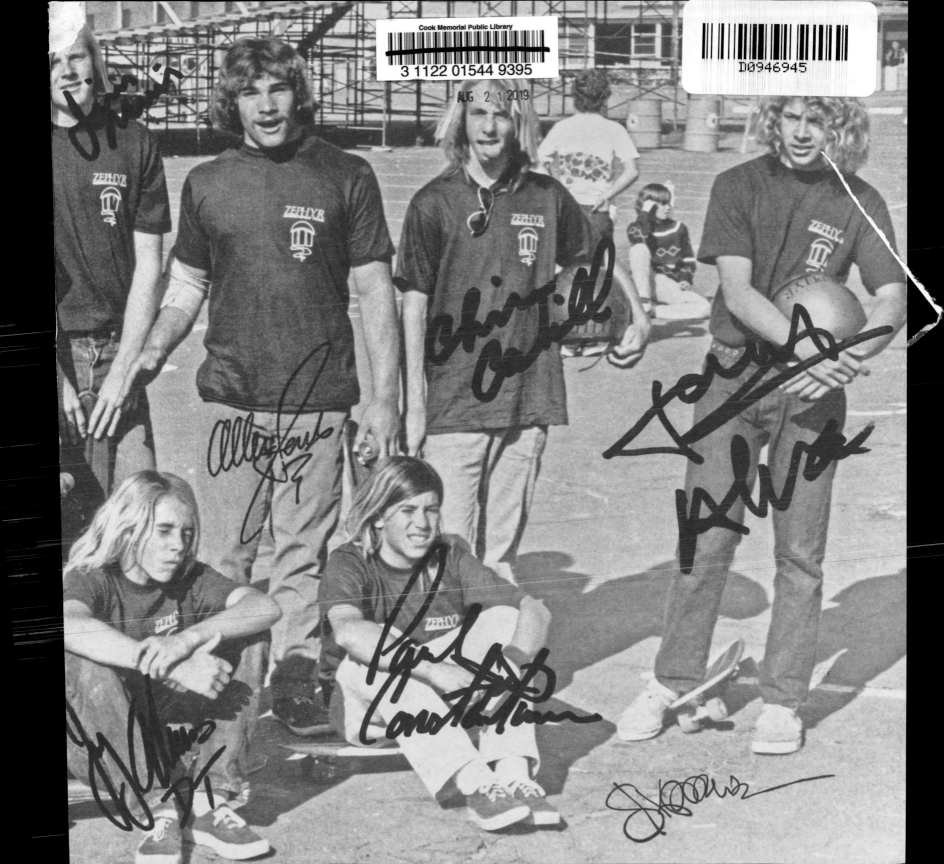

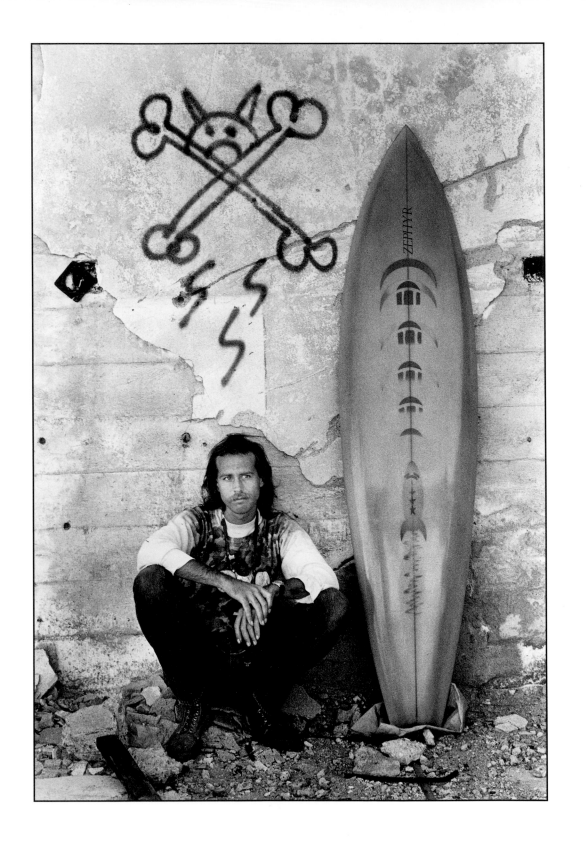

DogTown
THE LEGEND OF THE
Z-Boys

C.R. STECYK III
THE ORIGINAL STORIES AND SELECTED IMAGES

GLEN E. FRIEDMAN
PICTURE ARCHIVE DISCOVERIES

AKASHIC BOOKS
BROOKLYN, NEW YORK, USA
BALLYDEHOB, CO. CORK, IRELAND

DOGTOWN
THE LEGEND OF THE Z-BOYS

SECOND EDITION
PUBLISHED BY AKASHIC BOOKS
COPYRIGHT © 2000, 2019 GLEN E. FRIEDMAN & C.R. STECYK III
ISBN: 978-1-61775-699-3
LIBRARY OF CONGRESS CONTROL NUMBER: 2018960614
FIRST AKASHIC BOOKS EDITION
PRINTED IN CHINA

The original C.R. Stecyk III articles first appeared in *SkateBoarder Magazine* from 1975–1979.

The Zephyr skateboard advertisement reproduced on the last page of this edition is from the premier 1970s issue of *SkateBoarder Magazine*, Vol. 2, No. 1, © Jeff Ho, Zephyr Productions, 1975.

End sheets: Zephyr team members at the Del Mar Nationals, 1975, photos by C.R. Stecyk III.
Left to right: Shogo Kubo, Bob Biniak, Nathan Pratt, Stacy Peralta, Jim Muir, Allen Sarlo, Chris Cahill, Tony Alva, (sitting) Wentzle Ruml, Peggy Oki, Jay Adams, and Paul Constantineau.

The autographs on the end sheets are reproduced from the collection of Nathan Pratt. In 2002, the original Zephyr team members signed eighty copies of the first edition, which were numbered and shared among themselves.

C.R. Stecyk III portrait on previous spread by Anthony Friedkin © 1973.

ZEPHYR logo design on back cover and spine painted by and is a registered trademark of Jeff Ho.

This book was edited and designed by Glen E. Friedman, with Sohrab Habibion (second edition).

Akashic Books, Brooklyn, New York, USA; Ballydehob, Co. Cork, Ireland
Twitter: @AkashicBooks, Facebook: AkashicBooks
info@akashicbooks.com, www.akashicbooks.com

Burning Flags Press
P.O. Box 69, New York City 10003
www.BurningFlags.com

CONTENTS

As far as true folklore is concerned, I can hardly think of any story that is as important or influential to youth in the late twentieth century as that of the DogTown skateboarders.

Their stories and lifestyle were first presented, single-handedly, to the world through one man's writing and pictures. This documentarian/artist's name is C.R. Stecyk III, a.k.a. John Smythe, a.k.a. Carlos Izan. I personally credit this man as the single largest influence on my work. If I could consider anyone a mentor it would be him. Stecyk is a true artist and one of the most creative individuals I have ever encountered. The man is way beyond genius.

Stecyk's contributions to our culture continue to this day, but it was his original documentation of the midseventies DogTown set that would alter the lives of a generation, inspiring confidence and encouraging the rebel instinct to flourish unadulterated. Virtually anyone who grew up during this period and knew *SkateBoarder Magazine* as "the Bible" has been influenced incredibly in his or her outlook and approach toward life and living by Stecyk's articles. Not only myself, but most of the people involved as leaders in the early stages of "hardcore" punk rock with whom I have had a chance to associate, cite these same documentations as most influential in their lives. Stecyk's articles are what became legend most, and it was because of these that you may, even if you never skated, be familiar with the aura that surrounds DogTown.

During the midseventies, when the shape of what would become known as the average "skater's personality" was being formed, many of the industry types were hoping that skateboarding would be portrayed and exposed to new young skaters in much the same way as organized "conformist" team sports (after all, in 1978, *SkateBoarder Magazine* had over one million readers, and if the image was "clean," parents would be more likely to put down the $ to buy more and more new equipment). But once the skate masses were exposed to the exploits of the rowdy/radical DogTown Z-Boys crew, there would be no turning back. And it was through Stecyk's original articles that the standard was set for generations of rebellious individualists to follow, and what is known today as the archetype "skater" was first brought to light.

Stecyk often credits me for uncovering and documenting some of the original radical energies of DogTown's skate heyday. But if it weren't for the instigation and inspiration of his articles, which so vividly told the story of our environment, I doubt that my life's work would have the influence it does.

The first half of this book includes, chronologically from mid-1975 to early 1979, all of Stecyk's original articles with selected photos that first presented the Z-Boys and the DogTown legend to the world.

This is where it all began for me: DogTown and the Zephyr aesthetic. I was skating the schoolyard banks at Kenter, Paul Revere, and Brentwood when I met the members of the original Zephyr crew. I was never as good a skater as any of them, not at all, and I was about a year younger than Jay, the team's youngest. Those days, hanging out at Kenter, were when I first began to comprehend my own identity. It was a tough crowd, and everyone (except the freestylers) was a badass. It wasn't about competition. It was about doing the best you could for yourself and holding your own within the group. There were those who could and those who couldn't. If you rode hard and fast with style, you were down. If not, you were just another one of the kooks. I tried as hard as possible not to be one of the kooks, and I guess I was okay.

I remember that whenever the cops came up Kenter Canyon, I was one of the locals who could show some of my friends from the south side the best places to hide in the neighborhood. That earned me some respect when I was first meeting these guys. One day I dropped into the bowl and slammed head-on into Jim Muir (who was about a foot taller and at least eighty pounds heavier than me at the time). I was knocked flat and he helped me up—I kept skating as soon as I was standing and pushed myself even harder. P.C. and Wentzle were at Kenter often, riding that great asphalt wave with style I would learn from. Peggy was always sweet and one of the very few girls who'd always do more than just sit and watch the guys. While I was skating the upper yard for a change one day, to get away from the crowds down below, this big guy ran up to me and punched me out for my board with valuable new Road Rider wheels, and left me stranded to walk home. We got someone's older brother to drive us to the Zephyr shop to find the bully who I knew stole my board, but to no avail, because Skip was not giving anybody up (it was Biniak!). Stacy befriended me, as well as all the younger skaters, because he was always the nice guy and a pretty good role model; he really felt responsible in some way toward this whole skate thing. Shogo was just the opposite. I think he resented me at first because I lived on the north side of town. Once I started to share my pool finds with Jay, we became friends and would have crazy times doing stupid shit. I don't know how I really got to know Tony. At first, he seemed so intimidating—he had so much confidence in his style and he was so radical—but I think I became better friends with him when I started to sell boards for him at my school (Paul Revere). I was making him some cash off the free equipment that Logan, his new sponsor, would give him, and he started to give me some free stuff—that was cool. Marty Grimes was in the grade above me at Revere (he was bused in), so I became friends with him and his crew easily. I met Stecyk one day while sitting on the bank showing off some of my "photo-mat" shots—he saw them and encouraged me to send them down to *SkateBoarder*. I had no idea it was the Master C.R. speaking to me.

I was taking photography class in seventh grade at Revere with my pocket Instamatic. I started taking shots of the guys since they were friends and skating better than anyone from anywhere, and they were also now becoming famous and a few were getting in the new *SkateBoarder Magazine*. I sent some of my efforts to the manufacturers, and got them returned. I was told I needed to send slides or black-and-white prints. That would never happen easily with the Instamatic. I was still skating and taking photos with that pocket camera. I didn't think there was any reason to get a real camera; they were too big, expensive, and fragile. I got a D in Photography 1. I never followed the assignments, but the classes really helped me understand the basics. That's all I really needed, that and a borrowed 35mm camera when I finally found a cool pool on my own and invited Jay to come skate it. When I told him I was also going to bring a "real" camera, he was into it. I took one roll of color slides and one of b&w. I took my first published photo that day, six months after I received that D!

Hanging out with these guys became a whole new trip—now I could get them in the magazine too! I was just a kid like them, someone whose ass they could kick and badger all day long if they wanted, and all I could do was try to keep up and hold my own like I did when I was skating. These guys toughened me up real good. I was practically forced to get great shots. I knew them pretty well, for better and for worse. It was like a big extended family, as they all used to look out for me, and I always continued to try to do the same for them. It was all about attitude and style with this crew, and I must say this is where the roots of mine came from.

Thanks, fellas. The second half of the book is for y'all and your fans. This is the best of the rest of my DT files that have never been published in my other books (or are now out of print). There are many images that have been permanently lost, but these are some that I found while researching my archives for Stacy's documentary, and have resurfaced since then. I think we got some good ones . . .

—GLEN E. FRIEDMAN

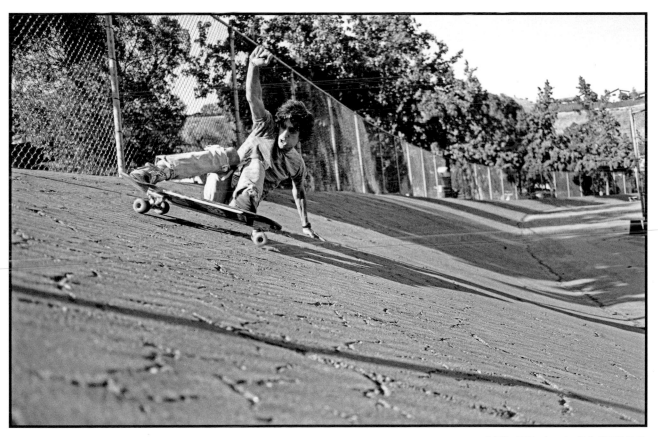

G.E.F., 1981, photo by C.R. STECYK III

Tony Alva speed compressing atop a lateral bank.
(Keep in mind that a bank is an inclined plane. The ultimate outcome of a curvilinear plane is a cylinder.)

ASPECTS OF THE DOWNHILL SLIDE

"Two hundred years of American technology have unwittingly created
a massive cement playground of unlimited potential. But it was the
minds of eleven-year-olds that could see that potential."
—C.R. STECYK III

Somewhere in the Arizona desert lies the estate of Barry Goldwater. In his front yard, amid the rock-and-cactus garden, stands a flagpole topped by a spotlight, an electric fan, and a screaming chrome eagle. The fan blows Barry's flag to keep it erect, while the spot illuminates it twenty-four hours, day in and day out. Tourists make the pilgrimage to this opulent shrine of patriotism in air-conditioned Gray Line tour buses. Two buses arrive every forty-five minutes. A few miles away in one of his department stores, clerks and clerkettes sell skateboards hand over fist. The manager tells that they can't keep enough skateboards in stock; he also confides that Senator Goldwater feels them a public hazard, and consequently is moving to have them outlawed in the Arizona legislature.

We were standing by the frozen food counter at the Lucky Market on the edge of Ocean Park Heights. In the Heights the kids skate with an undeniable aggressive proficiency that prompts outsiders to call the area "SkateTown." (In street gang logistics, SkateTown is located between DogTown, GhostTown, SmogTown, downstream from FrogTown, and south of Kosher Canyon.) The nine- and ten-year-olds in SkateTown traverse hills at 30 mph, the bigger kids go faster. Anyhow, up to the frozen foods strides a local legend and true veteran of the psychedelic wars known only as Spencer. Under Spencer's coiled arm is the latest weapon in his skate arsenal, a forty-five-inch arrow board with appropriate cosmic airbrush designs. Looking guardedly about, the skate jockey whispers that he is going to ride out a well-known back-canyon grade of about twenty-three miles in length. He also divulges some other cosmic and demonic truths that will govern his down-canyon attempt. At this point, it's probably worth noting that this canyon has been the site of numerous automobile mishaps caused by brake failure on the steep curves. The sheriff's mountain rescue squad regularly combs the canyon floor looking for wrecks. Out of Lucky Market, into the black of midnight, Spencer streaked straight to Diamond Back summit. Without a moment's hesitation, he pushed off for fifty yards and hurtled straight down the hill out of sight. That was the last anyone ever saw of him. His friends figure he rode it out and went off in search of steeper flights.

"The thing about skating banks is that if you really fall, you really get hurt."
—TONY ALVA

"There's more energy existing right now in isolated pockets of
skateboarding than there is right now in surfing collectively."
—SKIP ENGBLOM

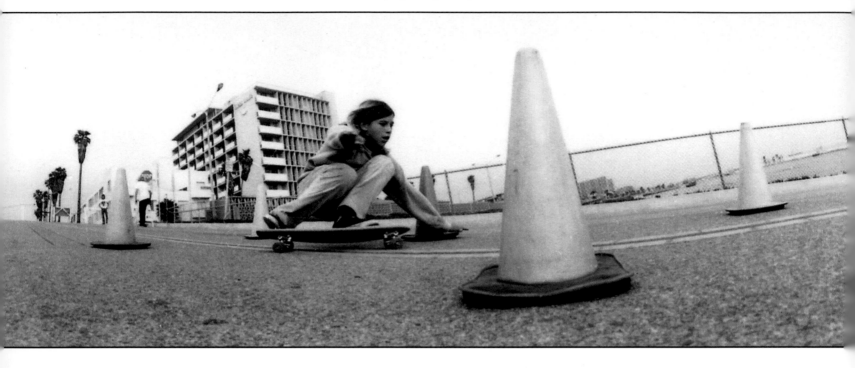

Paul Constantineau keeping his edge through the downhill slide.

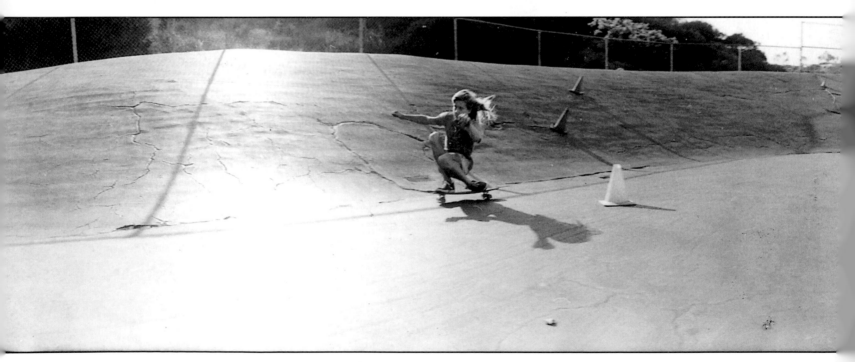

Working the transition of flat vs. bank. Wentzle Ruml amid warped planes.

In a secluded beach community north of Malibu, a scruffy figure guides a skateboard in and out of imaginary slalom gates. The technique is more than adequate and the skater seems vaguely familiar. Another observer, a resident of the area, clarifies the identity question by stating it's Bob Dylan, and adds that "he skates frequently at night, usually alone or occasionally with one of the Dragon brothers." We nod to the living legend and pass down the walkway, leaving him to his solitary slalom. We both flash that if San Fernando Drew (via Laguna Niguel) could see this, he would immediately begin drafting the paramount skate sonnet, a parable disclosing the sociopolitical implications of the skateboard movement as they relate to the lost generation of the sixties.

Downhill somewhere past 45, the fine line fluctuates. It's at a different place and time for each rider, but after 45, it becomes increasingly apparent. An all-encompassing awareness of an impending bad situation. Something you pay no attention to, yet somehow can't ignore. An entity you don't want to look at, yet have the urge to see. Downhill, one inch to either side or one inch past this intangible line and it suddenly becomes a physical presence. By the time you see this line, it's all over anyway; the only thing left to do is reassess your mistakes, get down, and try to find it again. The really interesting thing about the line is that it keeps increasing. A year ago, it was at 40 for most; now it's beyond 50. People keep pushing this line, oblivious to all else; maybe someday soon they will tie it into knots.

"The more illegal they make it, the more attractive it becomes."

Most people probably won't understand some of this, but that really doesn't matter since the intrinsic elements of this discussion are meant for those who really skate (just owning a skateboard or the old "I was into it ten years ago, so I understand it now" doesn't qualify one as a skater). Modern skateboarding is a constantly evolving hybrid very few comprehend. In dealing with the old versus the new, one must take several things into consideration. First, the "high state of the art" premise is a pile of crap. At the present time, there is little being done that is a radical departure from the 1960s. The freestyle area is just coming up to the level of the midsixties. (The big difference here is that there are more people now who are closing in on the advanced levels.) In the downhill and slalom, there are increasing numbers who participate (their confidence being based upon the soft grip of the urethane wheel). All that can be said here is that the validity or lack of it in an objective speed situation is obvious. The composition wheels of the pre-urethane era offered a harder, faster rolling surface, and generally speaking, 40 mph ten years ago was more of an accomplishment than it is today. In fact, many of the older slalom/downhill boys seem to be doing quite well today, perhaps due to having learned on faster-rolling, poorer gripping equipment. In other words, they have got their act down. At this current juncture, one must keep in mind that these days are the infancy of the neo-skate renaissance. The big breakthroughs are yet to come, since the current practitioners really haven't even begun to reach their marks.

As for skate technology, it's just starting to improve; up to this point, the vast majority of products on the market are fast-buck-oriented, ten-year-old trips. The better skaters will create a demand for better equipment, and the better manufacturers will fill it. As a reference point, it would be interesting to see some of these skateboard manufacturers forced into a 40 mph run on their own equipment—this would really separate the men from the boys.

"They (police) chased us off the schoolyards . . . and out into the
streets. Now they want us back in the schoolyards."
—WENTZLE RUML

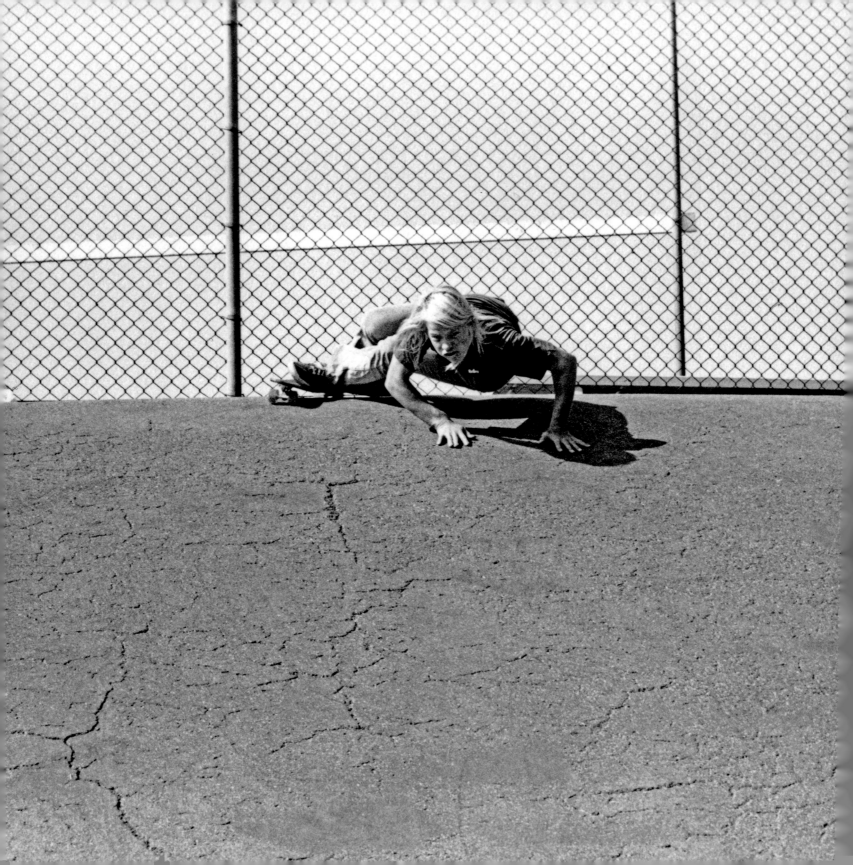

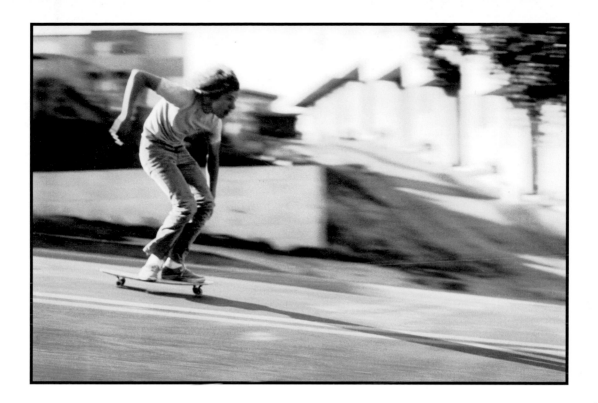

In retrospect, the last time around, the hotter skaters pushed it as far as they could go. To a great extent, they helped bring about the short ski/short surfboard revolution, since their refined technique far surpassed the more stationary orientations of the long ski and long stick trip. Abilities and attitudes honed on a 24"-36" skate could no longer confine themselves to surfing place on a 9'6" (i.e. 114 inches).

It will be enlightening to see what sort of changes the current crop of skaters brings about in related fields in the not-so-distant future.

People have been surf-skating banks for fifteen years. In the sixties, many of these people existed outside of the syndrome of the competition/exhibition team. It was impossible to transport the bank situation to the department stores and shopping centers across America.

Bank riding represents a three-dimensional opportunity—a downhill gradient as modified by the degree of side slope and contours such as bowls, moguls, twists, cracks, and other factors around which you must constantly readjust.

If the present formal competitive structure is to become relevant to the real challenges and esoteric rewards inherent in skateboarding, the movement must become sensitive to the realities by not reducing skateboarding to a conveniently packaged commodity.

"Modern skating brings out a multitude of approaches and attitudes that ten years ago would have been inconceivable. The illuminating aspect today is the degree of acceptance."

(Opposite) Bob Biniak, low cross-rotational movement. (Above) Tony Alva stylistically offers a casual approach to high-speed situations.

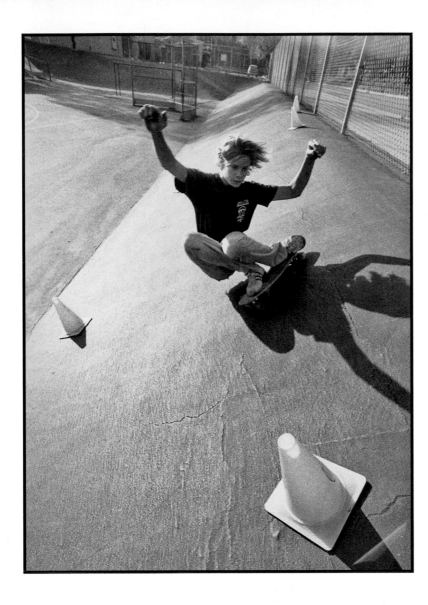

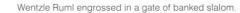
Wentzle Ruml engrossed in a gate of banked slalom.

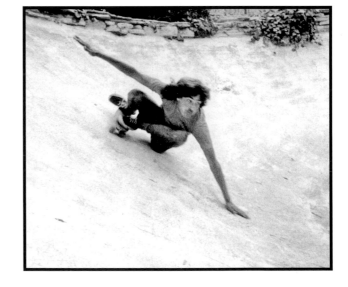

Cutting back through the concrete bowl,
Nathan Pratt, arm functioning as downhill pivot.

(Opposite) Tony Alva.

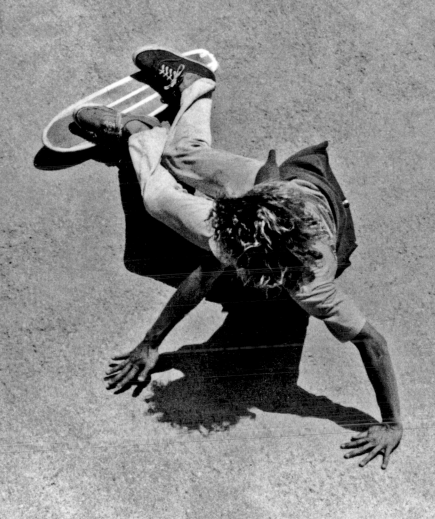

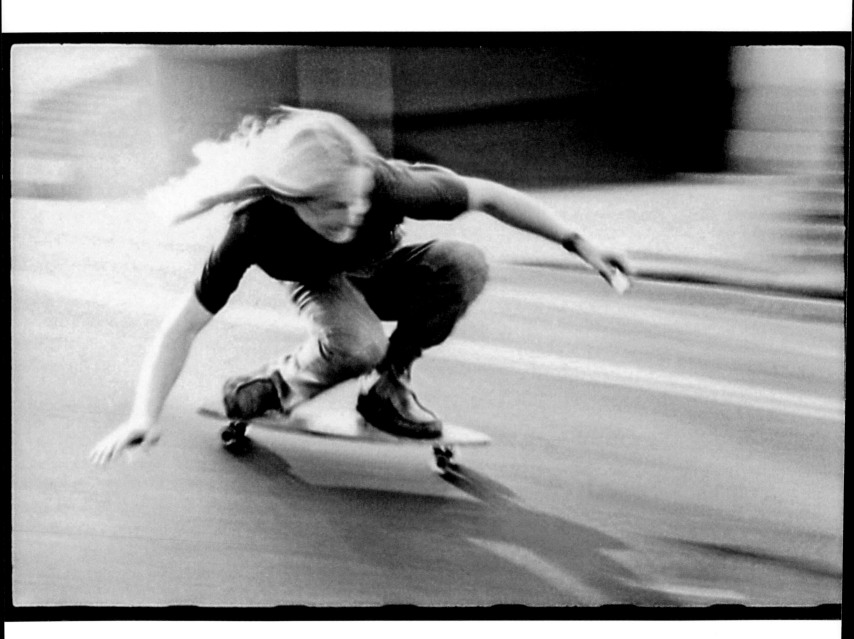

Kids running wild in the street with whiteline fever.

STACY PERALTA

Sixteen years old, rides for Jeff Ho, Zephyr Productions

Stacy Peralta is prototypical of the emerging new style in skateboarding today. At sixteen years, he has been riding skates "off and on" since the age of six (after watching him, one suspects he was mostly on). Stacy describes his early days as mostly "a downhill surf-skate style based around weight shifting."

Recently, along with some friends from the Santa Monica area, he entered the Del Mar Ocean Festival Contest just to see what it would be like . . . and somehow wound up placing sixth or eighth in freestyle. Until this point, Peralta had considered himself a "surf skater as opposed to a trickster." This initial exposure to the varied criteria of freestyle competition caused Stacy to concentrate on learning some of the "conventional maneuvers" under the tutelage of Chris Dawson and Tom Waller. Apparently his endeavors in this direction are beginning to pay off, judging by his recent competitive outings: Santa Barbara, second slalom, third freestyle; Huntington Beach, first slalom, third freestyle; Los Cerritos, third overall; Long Beach, first slalom; Orange County, first freestyle, second overall; Steve's SouthBay, first slalom, second freestyle.

Many seasoned skaters now consider Peralta to be the best all-around competition on the circuit, due to his unequaled proficiency in the banked, flat, downhill, and slalom areas. Stacy credits his surfing and skiing experience with a lot of his success, because the weighting and unweighting actions are so similar to skating.

Stacy enjoys free skating for fun, and really doesn't "dig the formalization of contests." Consequently, he plans to continue in organized meets "only as long as it remains interesting." As a sidelight, Stacy wears out a pair of shoes every two weeks. He says the pants last a little longer.

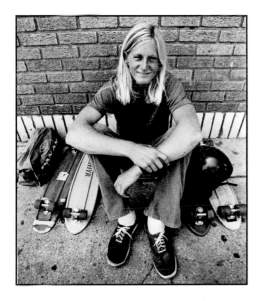

One of DogTown's finest, with his back up against the wall.

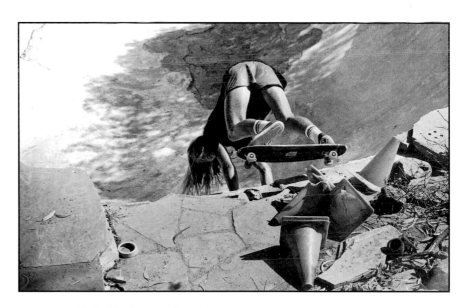

Vertical displacement. Sometimes being in contact, you get out of contact.

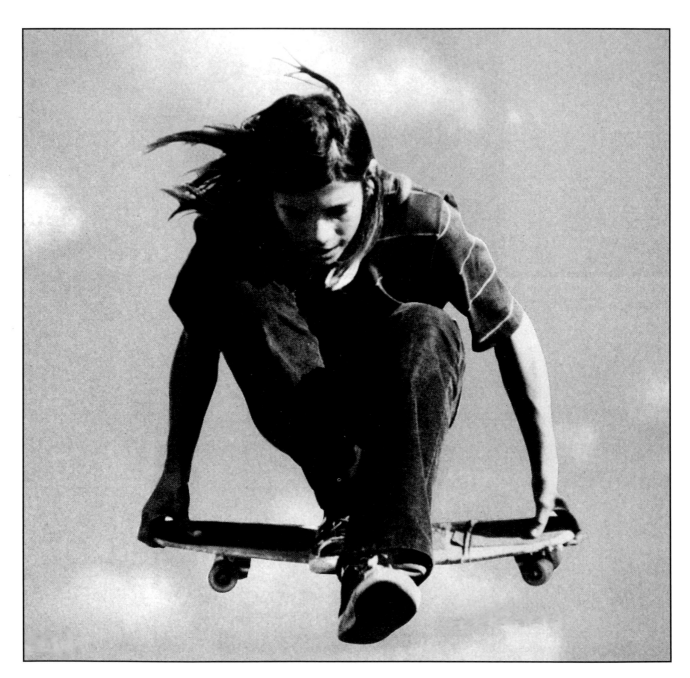

Paul Constantineau.

FEAR OF FLYING

In the final analysis, truth always evolves from the state of total madness. Everyone has their own spatial orientation which is basically a combination of awareness, balance, and experience. A large order of correlated spatial orientations results in a like system called a dimension (hence, two-dimensional, three-dimensional, four-dimensional). For each dimension, there exists objects, persons, and concepts, all with similar spatial orientations. For example, American technology produced a generation of mutants who relate only to the two-dimensional (flat) world, due to prolonged exposure to television. These persons only relate to photographic representations, feeling the medium to be the absolute truth, it being impossible for them to perceive the difficulties and nonstructured events of everyday 3-D life as being more real than the flat, static photograph. Aspects of this phobia are the terms photographic proof, seeing is believing, a picture's worth a thousand words, visual verification, picture perfect, pictorial splendor, etc.

It's been prophesied that the fourth dimension exists at a ninety-degree angle to all known planes and angles simultaneously. Surfing is a three-dimensional experience (especially tube riding). Skateboarding on banks closely parallels surfing, so it must also be 3-D based (after all, the ultimate outcome of a curvilinear plane [a bank] is a cylinder). But what of the 4-D phase?

The fourth-dimensional experience involves weightlessness, relative speed, relative velocity, and time sequences. Since the fourth exists simultaneously to our own third dimension, it is logical that certain 3-D occurrences must be closer to the fourth in nature than others. In other words—here is the other side of there.

SPEED, A STRANGE AND TRAGIC MAGIC

"The high-speed situation creates weightless sensations, somewhere near the top (highest speed point) of a run."
—C.R. STECYK III

Speed is essentially undirected energy, while velocity is speed with direction; i.e. force. At higher speeds, the effect of the gravitrons (the basic cohesive element of gravity) is sufficiently modified structurally to create "high-speed sensations."

"The space helmets were a treat to fly in. I did encounter a few terror-stricken moments in practice runs between 170 and 177 kph. Crosswinds displaced me a few feet to the side when entering the flying part of the KL. The helmets were designed for direct air-speed dynamics, not crosswinds. At 180 kph, you're flying, and you feel your whole body projecting itself through the atmosphere. At this point, the helmet creates a suction that follows the arch of your back—a speed pocket. Entering the speed pocket felt like shifting into sixth gear—eagle power." —Tom Simmons, Universe Ski Team

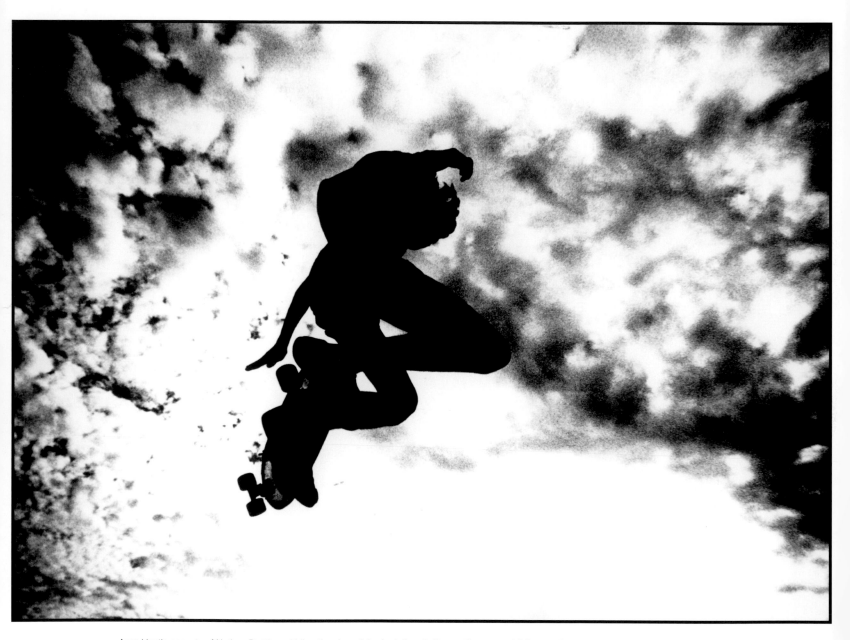

Aero-kinetic aspects of Nathan Pratt's multidirectional spatial orientation. Falling on the verge of flying entails constant weighting and unweighting.

According to Indian legend, the cosmic truths are etched upon the canopy of the eastern sky, where only the "swiftest of the swift" may see them, and once the fleet flyers have glimpsed them, a new destiny will guide their travels.

"While skating the beginning of each run, I'd say to myself, 'This is it,' then down, down, down. Yet higher, higher, higher. Riding the substance of dreams, a magic carpet of air, into which our willpower was sensuously intertwined. It was this air carpet about four to six inches in depth that we found at speeds over 100 mph. We left the snow and actually flew . . ." —Stephen McKinney, Universe Ski Team, World Speed Record Holder

Speed, concentration, and commitment leading to a new horizon of sensory and spiritual awareness.

"By making the runs at night, you depend solely upon your technique, balance, and timing. You are running blind without a sight line or any sort of visual orientation. The whole experience becomes really immediate . . . push-pull, weight-unweight, flex-reflex . . . and you really begin to come onto the speed rush." —C.R. Stecyk III

Pushing the old boundaries establishes the new "limits." In actuality, the only limiting factor is that of your imagination. You can go as far as you want to take it, or perhaps more aptly as far as it takes you. After you leave the realm of traditional preconceptions, you enter the area of endless freedom. There exists no right or wrong, rules are unheard of, and the course is uncharted.

"The new territories are at once aligned and enchanting." **—DANNY BEARER**

"The further you go, the more you know." **—NATHAN PRATT**

Since the new direction has no directions, this is an opportune place to recall that speed is basically undirected energy. New approaches call for new mediums. Concrete topographies severely hamper the spontaneity of a given movement because the ground contours guide the flow. What is needed is a multidirectional framework to improvise upon. Air offers the consummate neutral medium—it's totally unrestricting, has a low frictional coefficient, and is free for the taking. Gravity and centrifugal forces are the new dynamics for aerial attacks.

"Why put your feet on the ground when you can balance against the sky?" **—NATHAN PRATT**

"If man were meant to fly, he'd be born with wings." **—ADAGE OF THE MIDDLE AGES**

Man can fly if he's got the desire. Hang gliding, free diving, surfing, skiing, sailing, ballooning are all aerial oriented. How much you can fly depends upon how much you are willing to cut off that umbilical cord to the ground. The fear of flying resides deep in all our souls; the only way around it is to jump.

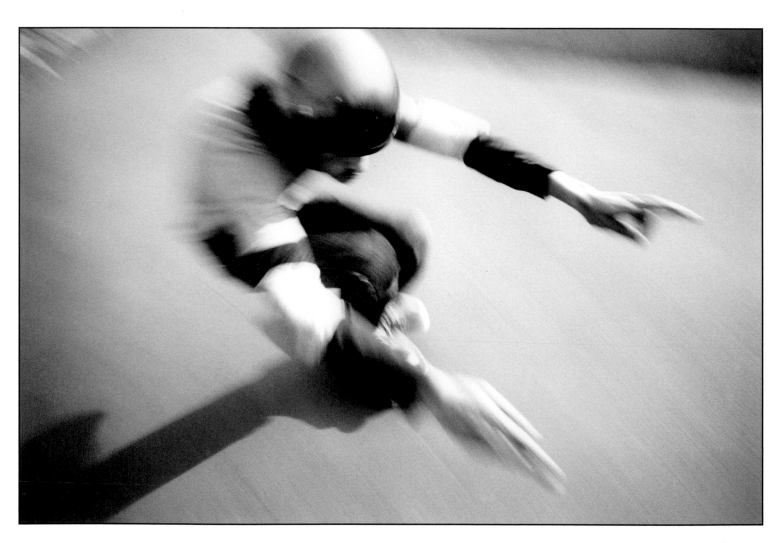

Speed slides on a banked track as executed by Nathan Pratt.

FISH-EYED FREAKS AND LONG DOGS WITH SHORT TALES

A Day in the Black Glass Tower

Universal City is one of those places which really doesn't exist. It's what the developers (civic planners) and real estate promoters call "a dream city for the future." If you set out from LA City Hall and scoured the countryside looking for Universal City, you wouldn't find it. In actuality, Universal City isn't a mile wide, an acre deep, or even a block long; UC is nestled between North Hollywood and Burbank, with its back up against the foothills, and a diligent totaling of the sum of its parts yields only a black glass mini-skyscraper, a black concrete sign with brushed aluminum letters and a movie studio back lot that offers three-dollar tours, featuring synthetic quicksand, the audio-animatronic polyethylene-skinned shark from *Jaws*, who viciously attacks your tram, a simulated runaway train, and your own take-home photo of you with Frankenstein that costs an additional seventy-five cents. Universal City is really just window dressing for the corporate reports of the same company that owns Elton John.

Nathan Pratt knew none of this; he was just a kid from the beach, getting interviewed about doing a skateboard jumping stunt in some movie. Pratt was bored. His manager, Skip Engblom, knew it. The coordinator from the stuntman's association knew it. The fifty-six-year-old mini–movie mogul second-unit director with the flared stretch pants and leather riding crop knew it. Most importantly, the twenty-three-year-old starlet and secretary knew it, for it was her job for the afternoon to keep the seventeen-year-old skate Nazi occupied while the big boys (agents, managers, directors, stunt coordinators, union men, etc.) all took care of business. They figured that the lad could relate better to someone closer to his own age. Only he couldn't relate at all 'cause he'd never been this far inland in his entire life, except for the time he went to the surf contest in Texas, and that was on the other side of the stinking desert, while this was on the other side of the San Fernando Valley. She had already taken him on the studio tour and to the commissary where the movie stars eat lunch. There, over roast beef sandwiches, she introduced him to "somebody like Martin Milner," who plays a cop on TV. "Couldn't I meet Dracula or Gidget instead?" Pratt asked. The girl had even gone so far as to offer him more diversion than he wanted, particularly in light of the fact that glass-off was in about ninety minutes. Consequently, Nathan was standing back in the glass tower looking bored. Manager Skip had already succeeded in drinking the execs at least 93 percent under the table, let out all of his line, and was about to land the fish. "Well, my boy looks a little distraught; I think you guys just better make him a good offer to pick up his interest a bit." So the dickering begins, Nathan continued to look impassive, while Engblom appeared vaguely threatening. Finally, somewhere past three hundred dollars a foot, Skipper muttered, "It will cost you more over fifteen feet and he never jumps less than twelve feet." At this they all shook hands, ventured out onto the lot where Pratt jumps off a roof into the street. Cameras whirred, and everyone looked suitably impressed. On the way home in the studio limo, Pratt and Engblom laughed like hell. Nathan went to the tropics with his score, and Skip went to Hollywood Park.

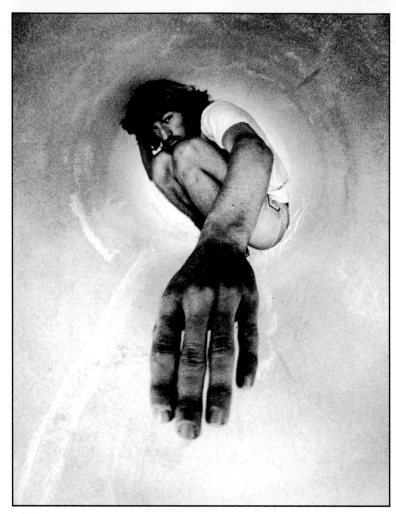

Lost in the concrete spiral:
Nathan Pratt riding.

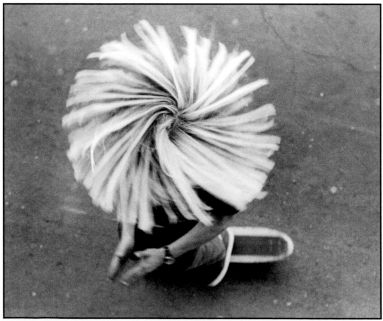

Aspect of Stacy Peralta
as modified by angle of view.

"WHEN MEN WERE MADE OF IRON,
BOARDS WERE MADE OF WOOD,
AND WHEELS WERE MADE OF STEEL"

There is a movement afoot to get skateboarding back to the basics. Its proponents argue that current skateboarding is a no-soul, lackluster, overcommercialized crock of catcrap. The slopes and sidewalks are far too crowded with neophytes to allow any legitimate self-expression. Magazines and films shamelessly exploit individuals and once-virgin spots in the name of corporate greed and individual ego trips.

Camera boys fall over each other, rushing to ruin another skate paradise by exposing it in print. The sensationalism evident in the skate press renders their articles meaningless. Objectively examine one of these publications, and what do you find? Nothing but paper stars and colored dots. Whatever happened to skating just for the pure fun of it?

Or so it goes. What is the answer, if any? Well, some find it in a radical new approach to equipment. The basics involve all-steel trucks, and wheels with a rigid wood top (preferably at least two inches thick). The purpose . . . well, it's said that the best way to find the old knowledge is to use the old doors. The steel-wheeled skate offers a hard, nonbiting, rolling surface which doesn't melt or burn out at extremely high speeds. The technology of these beauties is easily within everyone's grasp. It is said that after a couple of months on steel wheels, you return to the purest essence of the skateboarding experience and begin to encounter control situations previously undreamed of.

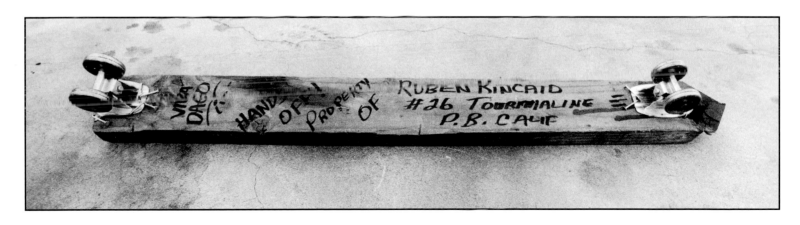

Ruben Kincaid's tourmaline high-speed express.

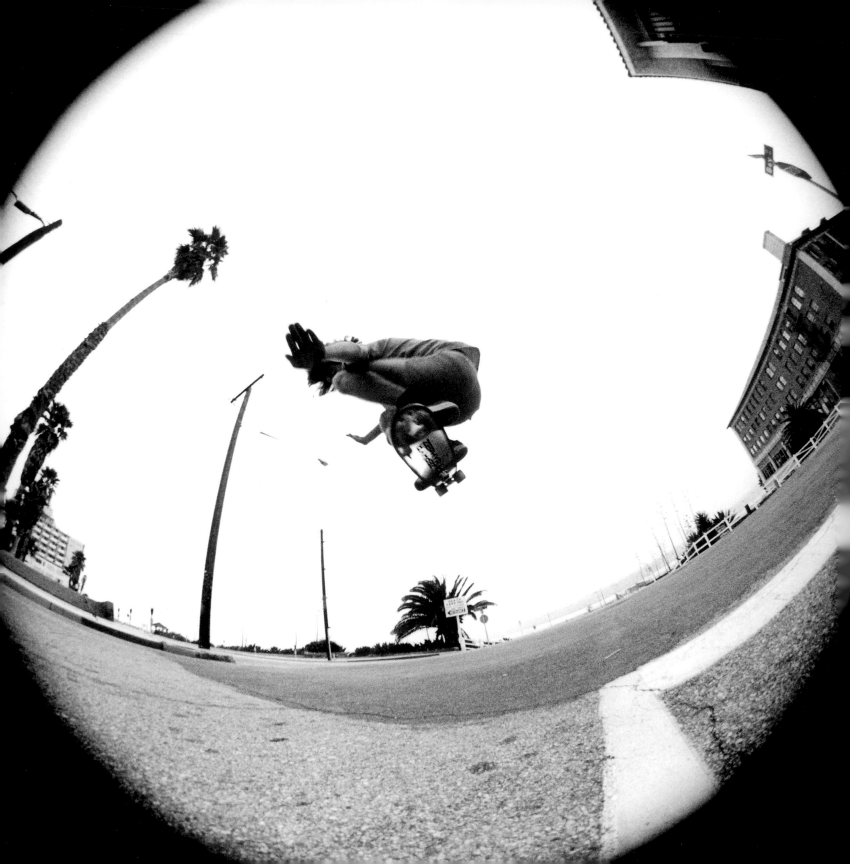

"THE SOUND OF NO HANDS CLAPPING"

Woody Waller is into professionalism. Ten years ago, Woody skateboarded in a Tony the Tiger sugar-frosted flakes TV commercial and netted something like $20,000 for it. Woody is the last of the low-keyed unknowns. Few people recognize him from the commercial. Of course, the fact that he skated in a Tony the Tiger suit and mask probably adds to his obscurity. In the streets of DogTown, everyone has a scam, and that scam is their total essence: their way, manner, time, and place of being are all dependent upon their particular scam. Waller's scam is that of a skate star, and there isn't anyone on Main Street who hasn't witnessed one of Woody's sidewalk serenades. He waits in the shadows for the arrival of the big blue buses. As the old women get off, Woody streaks and pulls off eight to fourteen 360s. He smiles while they drop their shopping bags in astonishment. Woody has been sighted at all hours of the day and night, always in motion. On a recent afternoon, some of DogTown's heaviest scammers were hanging out checking out Woody's action. The crowd included talents like Paul the Nazi, who offers automatic weapons with his cleaning service; Mojo Blue, the King of Silver Satin and Kool-Aid; Willie the Gimp, a trip man who lives off his many insurance settlements; Purcelle the Pimp, who buses his young transvestite honies to the marina in his pink Cadillac pimpmobile; Tall Tex, the second-story man; Wheels the Wino, who takes his wheelchair to the bar so that when he's too drunk to walk, he can wheel home; Bordercross Billy, who baffles the customs agents with his X-ray-proof, lead-lined, polypropylene, zippered stomach bag, which he had surgically implanted in Switzerland to smuggle contraband; Morris the Merchant, the only man to ever have charged $12.75 for a pint of Jack Daniel's No. 7 Tennesse Sour Mash and lived to tell the story; Magnificent Marko, the casualty from the psychedelic wars, who sold his story to Hollywood (it turned out that this little space monkey was an undercover cop); and 3-D Loveall, a bleary-eyed mad genius, who, in between lathering up young lovelies with Reddi-Whip, managed to find fame and fortune by inventing a 3-D television that you have to wear special goggles to see. Anyhow, this convocation of street slicks gave Woody Waller the supreme compliment: after his routine, they began to shower the street with money.

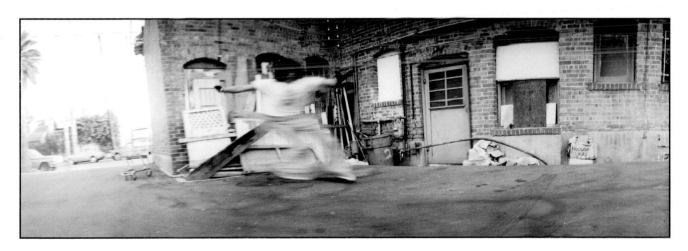

Nose drifting with Paul Hoffman.

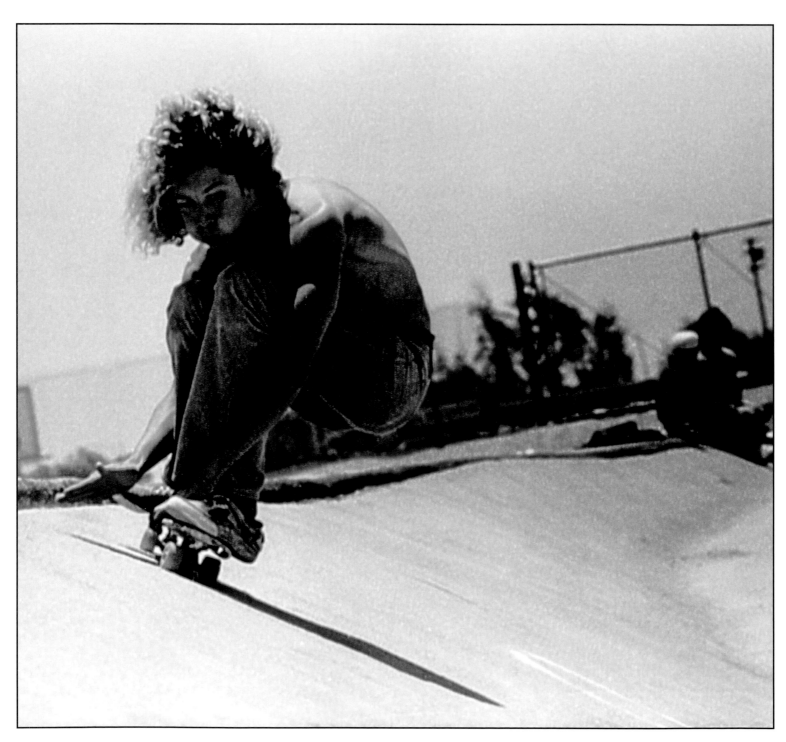

Tony Alva offers a unique stylistic approach to high-speed bank riding.

ALVA

Tony Alva was from the banks and canyons of the Northern Points. He and his friends "didn't go to school" together. Usually they would surf on the low-tide mornings, and ride the banks and canyons during the afternoon winds. He had a reputation for being fast. Tony wasn't sure where this rep came from, and he really didn't care. He just knew he didn't like it. A couple of his friends told him about the contest at the Sports Arena. "Prize money" was the only thing they said that he could remember. His sponsors were up for it, so Alva entered the pro division. "Figured I could have a good time, and maybe pick up a little money. Besides, I needed a new car." So they went to the arena, the pride of Exposition Park. Tony had the fastest time in the slalom prelims, and won the cross country. His friend Bob Biniak got second. Upon receiving his $500 check, Alva stated, "Take the money and run, son!" Tony was spotted in the islands a week later.

PERALTA

Stacy Peralta originally entered his first contest as a lark and eight months later he was the number three freestyler in the World Skateboard Championships in the Los Angeles Sports Arena. All of this meant nothing to him, basically, since he had done it all in the name of fun. He was pretty much tired of the whole scene anyway, then came the final straw. What broke the camel's back this time was the night he was at his grandmother's, and he told her about being number three in the World Contest. His grandmother began looking through a skateboard magazine, and promptly stated, "I don't see you in here anywhere, Stacy." "Yeah, I know," he replied. "Well, Stacy, it seems that if you were number three in the world that you ought to be in this magazine." "Yeah, I guess so, but I'm not really into it." "Then why do you do it?" "For fun, I guess." "Well, are you having fun?" Stacy thought that over and decided to quit entering contests for a while. Might as well quit college too, and go surfing for a while.

The next day, John Arnold called Peralta on the phone from Australia. He told Stacy that Golden Breed Australia would like to bring him "down under," all expenses paid, to show them what he knew about skating. Stacy figured it was a good trip. He was on the next flight out.

On a steep, windswept hill in a long-forgotten canyon, the skaters had assembled. They were nameless, faceless souls, with one goal in common: to hold a professional, no frills, "noncontest" contest. There were seventeen in all, representing the various stratas of the skate experience. The premise of the event was simple: each man would put up $100 cash; it would be a speed contest, with unlimited equipment (no restrictions on wheel size, composition, board length, etc.). It would be decided by the clock, and it would be winner-take-all; the winner pays for the entertainment. (The refreshments, in this case, were considerable.) The advantages of this sort of event are readily apparent. By holding it themselves, they sidestepped the tremendous amount of red tape and financial, legal, organizational, insurance, supervisory, and other hassles inherent to the "official" contest situation. Also, the nonstructured noncontest was totally responsive to the needs of the entrants (after all, the competitors in this case were the organizers). As one of the participants commented, "The whole trip is a lot more up front without all the middlemen." The implications are: if organized contests, per se, don't measure up to your dictates . . . who needs them? Just hold your own. Gather up your friends and equipment, venture up into the hills, put your money down, and get on it.

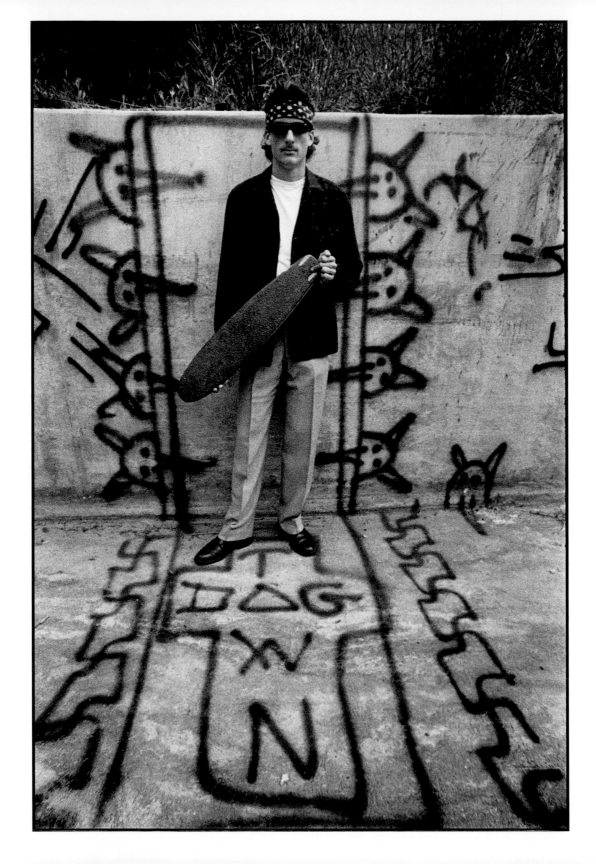

In the East River "El Thumper" is known as one of the hottest homeboys.

THE WESTSIDE STYLE
OR
UNDER THE SKATETOWN INFLUENCE

Traditionally, on the Westside, the varied beach and adjacent communities have been a hotbed of skate action. In the sixties, the Santa Monica Bay area spawned both the original Makaha and Hobie Vita Pak teams. Personalities like Fries, Johnson, Bearer, Woodward, Saens, Blank, Archer, the Hiltons, Trafton, et al., established the freestyle standard for the world. They wowed the masses in innumerable demos at department stores throughout the land, showing city slicks and farm boys alike a glimpse of the Westside style. Even today their exploits are regarded with awe. After all, people still mention "Skater Dater."

There are explanations offered for the area's early emergence as a skate power. The most common is the "origin of the species" proposal. Simply stated, it goes that since skateboarding itself originated in the midfifties as an invention of the Malibu surf crew, the people who lived in the vicinity were naturally more proficient. Other reasons may be found in the region's diverse topographic contours. Canyon runs, storm dams, banked slopes, swimming pools, dams, concrete pipes, and parking lots abound. Consequently, all sorts of skating situations were readily accessible.

Well, the spots are still there, and over the last decade new faces, drawing heavily upon this local heritage, have pioneered some radical new approaches. This style made its public debut at the Del Mar Nationals eighteen months ago in the incarnation of the now-notorious Z-Boys. The boys made quite an impression with their hard-driving, low-slung, pivotal, bank-oriented moves. In the words of the Mellow Cat himself, "There was so much aggression, they were more like a street gang than a skate team," or as the reporter from the *Evening Sentinel* put it, "While everyone else was standing up, these kids were turning all over the ground.

Since the stepping forth of the SkateTown-based Z-Boys and their innovative trips they have been widely imitated, but no one yet seems to have mastered the finer points. "I see guys who have copied one or two moves, but they don't have it . . . they just skate, get down, slide, stand up, and move on to their next trick—the problem is that their approaches are not integrated." —N. Pratt.

On any given day, practitioners of the new Westside style such as Adams, Alva, Biniak, Cullen, Constantineau, Muir, Oldham, Cahill, Oki, Kubo, Peralta, Pratt, Ruml, Hoffman, etc., can be seen on the streets where you live (at least if you dwell in SkateTown), carving out new legends for an even newer era.

"The whole thing has been going on up here for a long time; now the
trip is out of the bag, and the influence is spreading . . ."
—TONY ALVA

Tony Alva offers his Ted Nugent–autographed Earth Ski for closer inspection.

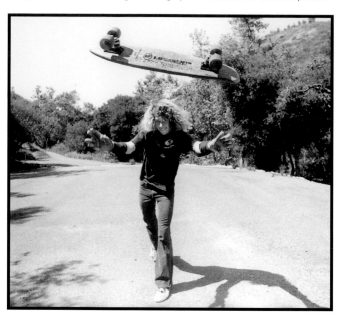

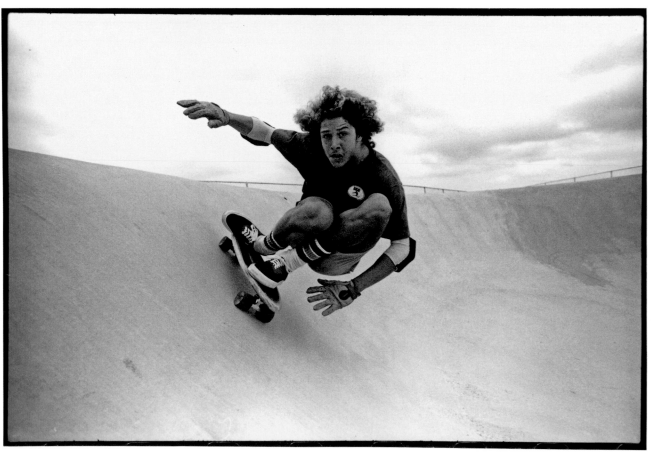

Alva, part of the hard-core nucleus of the SkateTown style, working it at the skate park.

Danny, Payasa, and Chaco from West LA (De Sotel), hanging out, while Jose Gallan executes a series of 360s from the tail.

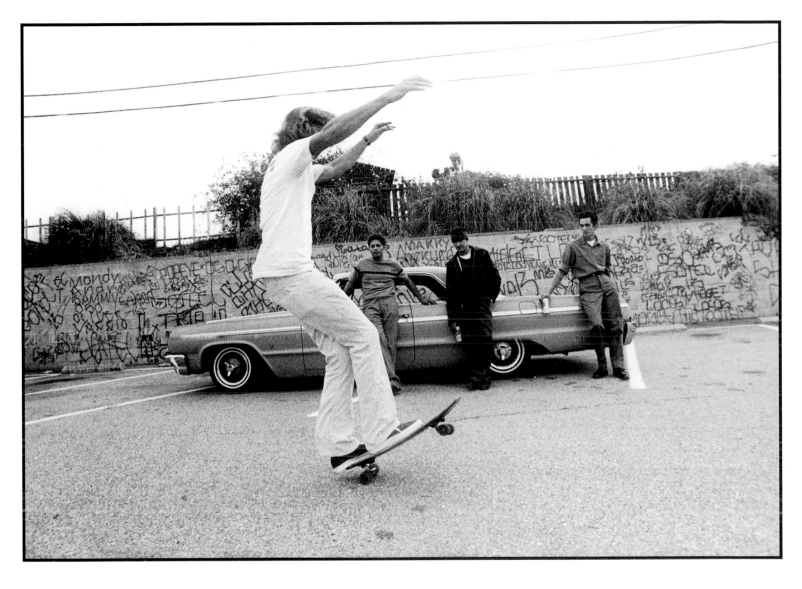

"It will go as fast as you want to take it."
—WENTZEL RUML, 1976

"In any given situation, new approaches invariably precede the new technologies."
—R. BUCKMINSTER FULLER, 1966

"At all times we must keep in sight the limits of realistic possibility."
—R. MILHOUSE NIXON, 1956

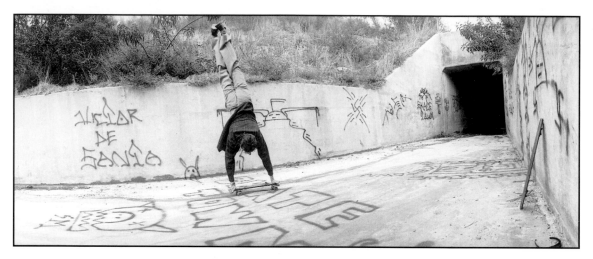

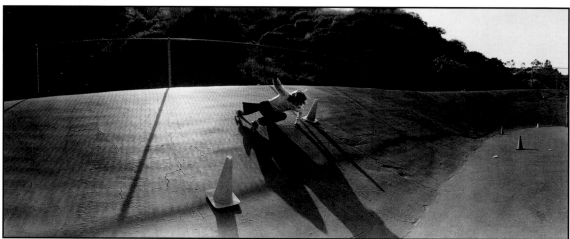

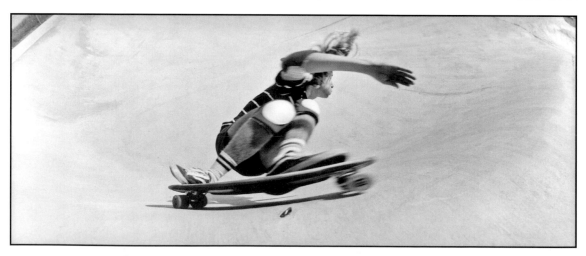

(Top left) El Thumper: reality is where you find it; sometimes you gotta take it there.
(Top right) Paul Hoffman in the local freestyle area behind Moon's Liquor Store.

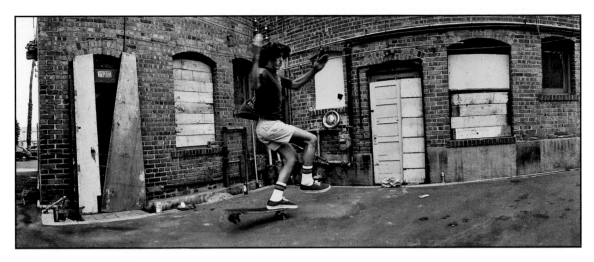

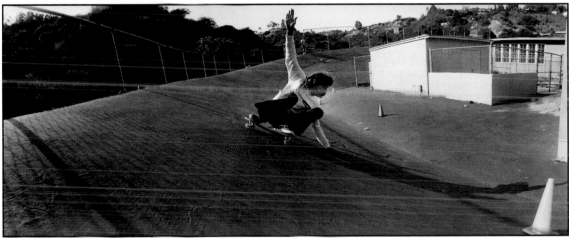

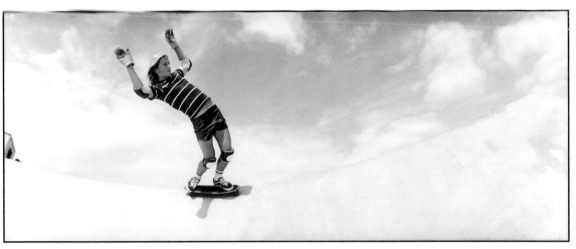

(Middle left and right) N. Pratt at Belagio Elementary, bank-riding mecca for over fifteen years, now closed forever.
(Bottom left and right) Stacy Peralta, carrying the SkateTown style into new terrains.

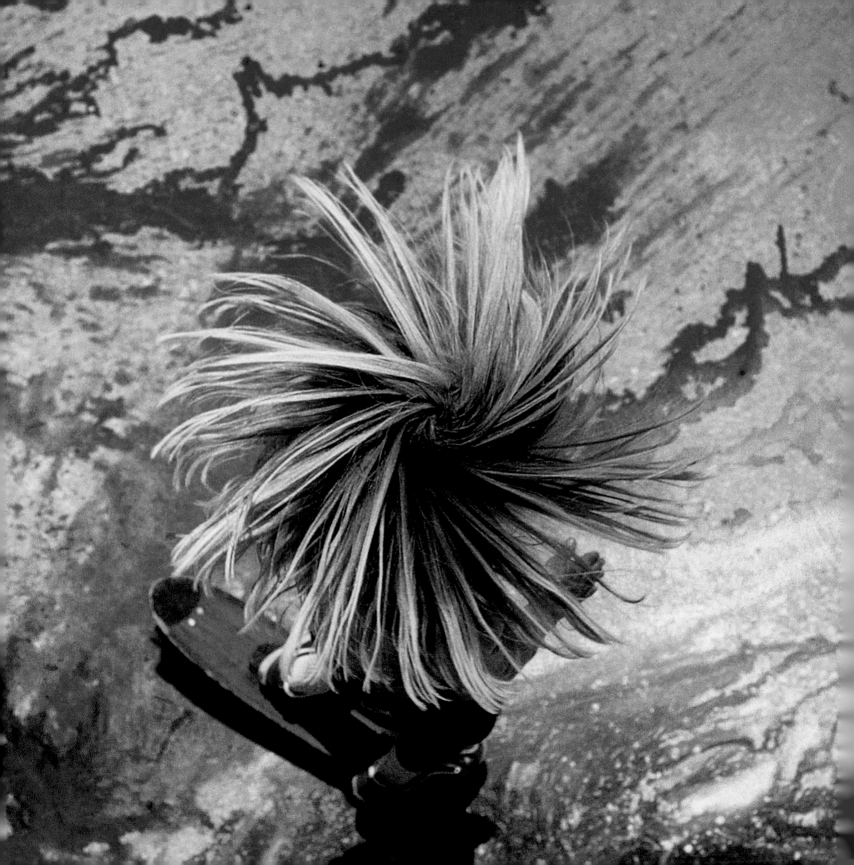

STACY PERALTA

Who is Stacy Peralta? Placed third in the World Pro Freestyle, being the only junior to make the finals, placed fifth in the Northern California Championships Pro Freestyle, being the only person from the pro finals at the World Contest to repeat. Responsible for introducing the modern surf-skate style to Australia. International pro by virtue of commercial activities here and abroad. A star of the 35mm film *Freewheelin'*.

Yet he is virtually unknown by those outside of the skateboard intelligentsia. Reasons—quiet, shy, unassuming, an idealistic perfectionist.

Easy to talk to, but difficult to confine discussion only to skate topics. Typical interview session yields forty-five-minute discussions on contemporary American Southern music, its origins, influences, and directions—footnotes included Bessie Smith, Bob Wills and the Texas Playboys, Robert Johnson, English sea chanteys, the speeches of Lyndon B. Johnson, and the life story of Arnold Ziffell (the pig from *Green Acres* TV show). It seems that Peralta's father is a friend of Ziffell's trainer.

Perhaps the best way to gain insight is through comments of his peers:
"Nice guy and a real good skater." —Ty Page
"The best all-around skater in the world—based on viewing footage of all top skaters in slow motion." —Pat Darrin
"Hot in all areas." —Tony Alva
"Has the most advanced, most adaptable style around. Flawless technique and execution." —N. Pratt

Did you notice any significant changes in the quality of skateboarding here when you returned?
Definitely. Toward the end of my visit, I was feeling stagnant in Australia, because I missed the stimulation of being around hot skating. The most fun I have is when I'm challenged to get better. When I came back here, my friends blew me out heavily . . . I get off the plane and Paul Hoffman is consistently hitting around twelve one-footed nose 360s, while Jose Gallan is doing crossover rolls with a pirouette, while he takes off his hat and passes it behind his back and puts it back on his head again. I figured I would be behind when I got back, but what they were doing was unbelievable. So I skated with them a few days, and I was starting to acclimate when I ran into Jim Muir at Indian Wells Pool. He was doing backside off-the-lips on the coping, and he's calling the pool "dead." So we go up to the Keyhole, where Bob Biniak is running full bore along the tiles and popping frontside off-the-lips wherever he wants to. I flashed again. Next thing, I went to the Carlsbad skate park with Tony Alva, who I haven't seen in eight months because he had been in the islands. We get there, and by the second run, nobody else is skating; they're all just standing around watching. Tony was so fast that with his loose, rubbery style and hair, he looked like a ball of fire. I was stoked . . . Now I knew what I had been missing. My friends showed me the way back home.

Were your friends the primary motivational factor in your development?
Yes, my friends and the area.

The area? How was that?
There are a lot of unknown banked spots in and around the Santa Monica area, and if you live there, you ride them.

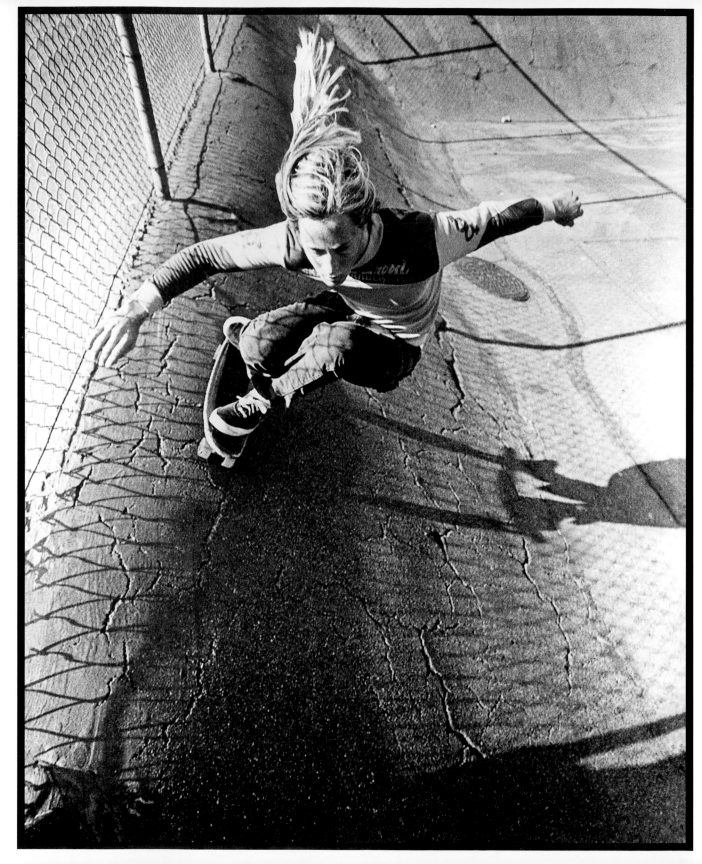

Stroking at the banked track (Revere).

It's sort of hard to explain, but when you're standing on top of the bank at Bellagio looking into the bowl and then on down the line, with a hard wind out of the canyon howling at our back . . . well *(laughing)*, you have just got to do it. If the boys are there, the competitive thing is really intense. I've seen outsiders who are pretty good skaters just walk away from a heavy session without riding; I guess they thought it was too insane. But it goes beyond people pushing you. Everyone around here skates, and people take it seriously. I think maybe the traditions push you as much as anything. Skateboarding itself started at Malibu, and the old Makaha and Hobie teams were from here.

A year and a half ago, we were riding this pool and were carving over the light. Skip Engblom checks it out and tells us, "George Tafton was bluetiling in the very same pool ten years ago on clay wheels." Within a few minutes, there wasn't anyone there who couldn't get tiles. Another time we were all hanging out on the corner, skating next to the Zephyr shop, when this older guy walks up in a Grateful Dead T-shirt, and says he wants to borrow a skate since he used to ride, and he wants to see if he can still do it. He gets on it, space walks, does several 60s, and has a good routine. Pretty far out, we figure. He tells us his name is Tom Waller, and he's got this friend who is really hot. A couple of days later, he shows up with Chris Dawson, who also hasn't ridden in years. Dawson gets out of his car, jumps on his old Hobie Flex model, and holds a perfect nose wheelie for a block. Unreal! It was by far the longest wheelie any of us had ever seen. He changed my idea of freestyle a hundred percent. What they were into was a challenge. They didn't do tricks; they worked out.

Are you aware of a continuity between yourself and the older skaters?
Sure, you pick it up and pass it on. Helping out people is what it's all about. Waller and Dawson showed me the way to freestyle, and I sort of passed it on to Hoffman. Danny Bearer and Torger Johnson helped Tony [Alva], and he gives it to Paul Cullen. What we are doing now isn't anything compared to what the younger guys are going to be doing. Kids like Hoffman and Cullen are the stars; they will learn from us and go us several better.

The people in your area have a different style from those of other areas; in fact, it even differs from the older skaters in your own region. How did the low, pivotal, ground-contact style originate?
It came from riding banks more than anything. How better to ride a wave of cement than to surf-skate it? Besides, the style we have is related to short-board surfing, while I think the older guys have more of a long-board skate style. It's just different attitudes. In the old days you moved on the board, while now you move with the board and the board moves with you. It's much more integrated. Bertleman's surfing was a real influence on it. People came on it individually at first. Nathan Pratt and I were skating Ocean View one night a couple of years ago, and we just starting doing S-turn cutbacks, using our arms as pivots. Down at the beach, Tony and Jay Adams were doing the same things. Different approaches, same conclusions. People all over the area were skating more or less similarly. It really jelled, as far as everyone else was concerned, with the Zephyr team.

How so?
The Zephyr team showed a lot of people what sort of skating we were into up here. At the Del Mar Contest, we blew a lot of minds. The way we skated was really advanced. It was a total surf-skate with no tricks. People, in general, didn't understand it because they had never seen anything like it before. The surfers in the audience got off on it while everyone else was into handstands. We were so far ahead of what was going on in that zone it was amazing. I never realized we were different before that contest; the way we skated was the only way we knew how.

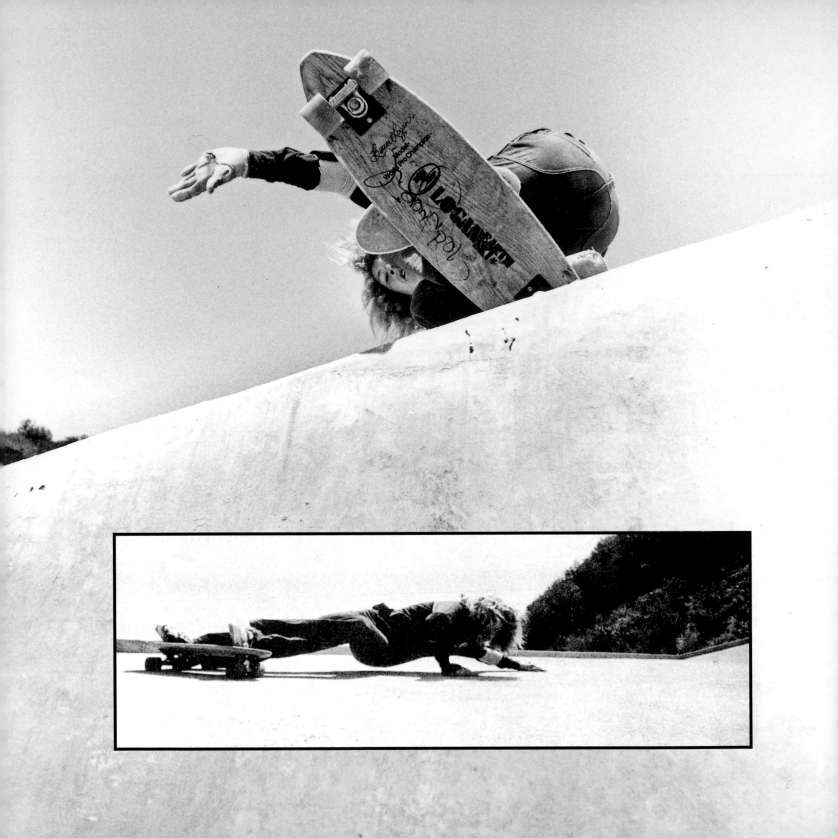

FRONTIER TALES

OR

ANY RESEMBLANCE TO ANY PERSONS LIVING OR DEAD IS PURELY COINCIDENTAL

State of the Art; the Fall of 1976

Much mass-media attention. Publications like *Rolling Stone* and *New West* play up the "outlaw as skater" aspects. *Youth Sport, Boys' Life,* and *International Recreation* emphasize the clean-cut, safe, sane approach, while *Time* and *Sports Illustrated* report on skating as big business. Bill Lancaster, the screenwriter who authored *Bad News Bears,* drafts a wide-screen epic of cement savagery based on assorted interviews and hanging out with the Logans. Each major television network has run a skate special, with the tube's finest moment being Walter Cronkite's explanation of a "skateboarder's fracture" X-ray on prime time.

Even the Beach Boys use a pool-skate session to reinforce their TV special (definitely the high point of the spectacular, which included blondes driving T-birds, numerous sunsets, the entire cheerleading staff of Hawthorne High, assorted seagulls, a birthday party, and climaxed with Brian Wilson being dragged screaming into the surf off Malibu Canyon).

Robin Alaway, Tony Alva, and Stacy Peralta do a demo for their part on the *Tony Orlando and Dawn* show, with Alva pulling off a headstand spinner to wow the fat, cigar-chewing corporate execs. (Alva's comment: "I only did it for the money.") On the same day elsewhere in Tinseltown, Fred Astaire, age seventy seven, broke his wrist falling off his 29" kicktail in the courtyard of his palatial manor. (Fred's comment: "I practice every day.")

Bob Dylan kicks the "kid" and company out of the new pool being constructed at his Point Dume home, but the neighbors say Bob skates it alone at night. (Dylan's comment: "To live outside the law, you must be honest.")

But by far the most symptomatic occurrence of the current phenomenon happens at Universal Studios in North Hollywood. It's the scene of the 1976 Howdy Doody Look-Alike Skateboard Contest—326 young actor-hopefuls with their agents and mothers are tuning up for the tryout under the watchful eyes of Clarabelle the mute clown. (A Universal press release reveals that the original Clarabelle later became Captain Kangaroo.) The clown toots encouragement on his horn box, while the agents pull their young wards, teetering uneasily upon their polypropylene skateboards, along a plywood runway. All 326 kids are dressed alike in red Howdy wigs, checkered flannel shirts, with red engineer scarves around their necks, rolled-up denim pants, and shitkicker boots. Most are wearing makeup. The drama unfolds as kid after kid falls off his skate, hits the ground, loses his Howdy wig, and bursts into tears. Mothers minister reassurance, while the studio nurse dispenses Band-Aids and Bactine. It's time for the finals, as Buffalo Bob (attired in a tan Lycra spandex, double-knit cowboy suit, trimmed with red fringe and a green felt buffalo with rhinestone eyes on the back) exchanges witticisms with Howdy Doody, the Will Rogers of puppetdom: "You won't get cavities if you brush after every meal, right, Howdy?" "Yes indeed, Buffalo Bob," the puppet drawls back.

Tony Alva, a pinpoint pivot on the edge of a sixteen-foot verticle drop. Go for what you know.
(inset) Fully extended at a secret spot "somewhere in the mountains." Considering his directions, it's a sure bet you're never going to find it.

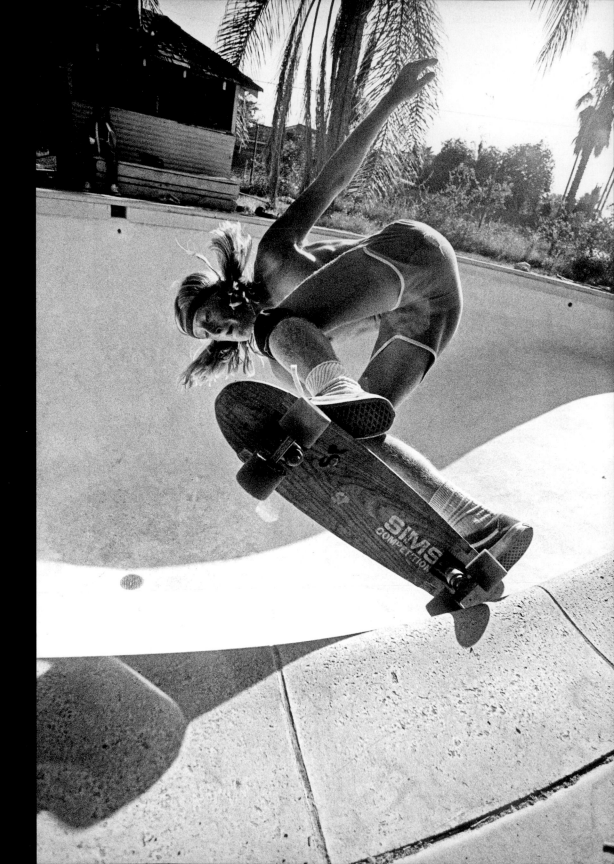

As we leave, the three remaining contestants are a black kid from Pomona, a girl from Sacramento, and some guy who looks just like a thirty-six-year-old midget attempting to pass for age eleven. An onlooker comments that none of the three bears any resemblance to Howdy Doody. Someone suggests, "It's too bad Paul Cullen isn't here"—"But he doesn't look like Howdy Doody either"—"Well . . . at least he can skate."

It is also noteworthy that the *All New Mickey Mouse Club* show is shooting a skate segment. Question—what do Howdy Doody and Mickey Mouse, two forgotten fifties folk heroes, have in common? Answer—they both have big ears and made a lot of money.

So what does it all mean? Probably nothing . . . except that here in the seventies, a lot of outsiders are recognizing skating as a way to commercial profit. Writers are terming it the youth movement of the time, while inside the skate sphere itself, it is a time of flux and indecision. Professionalism is very much in evidence. It seems that there is a team for everyone, and someone for every team. Attacking professionalism is easy, due to its nonpurist orientations. Professionalism tends to breed organized stagnation. On the positive side, professionalism allows the skater to make money to further his other interests. Professionalism also promotes product development. Products at present are of a much higher quality than in the past. Two years ago, a 50 mph run was heavy, now it's commonplace. Why? Primarily due to equipment advancements. Quality equipment is now within everyone's grasp.

Skate parks are frequently touted as the future of skateboarding. While fine for what they are, the parks in general have so far failed to surpass many quality, already extant skate spots.

Have you yet seen a park as radical as the best of pools? People ponder how to get out of the pool. The obvious solution is to create pool-like setups not restricted by the necessity of holding water. Even more radical contours for skating are possible than the ole swimming hole. Inclined runways, beyond vertical walls, kickers, loops, cylinders, spirals, and multiple bowls will bring on the new moves. The more advanced parks will offer the more advanced terrains.

The contest scene is generally lumbering along with the same old format. The presence of skate parks and resultant bank-riding events threatens to shatter the older contest programs in the immediate future. The only drawback here is the danger of the same old people laying down their same old trips in new terrains. A major trend, at present, is the "noncontest" situation. Realizing that competitive events should exist solely for the benefit of the competitors, numerous skaters are putting their money up front, and going for it. The organizers are the competitors and the result is a highly flexible and adaptive form. No trophies, no glitter, no bullshit—the fastest man wins.

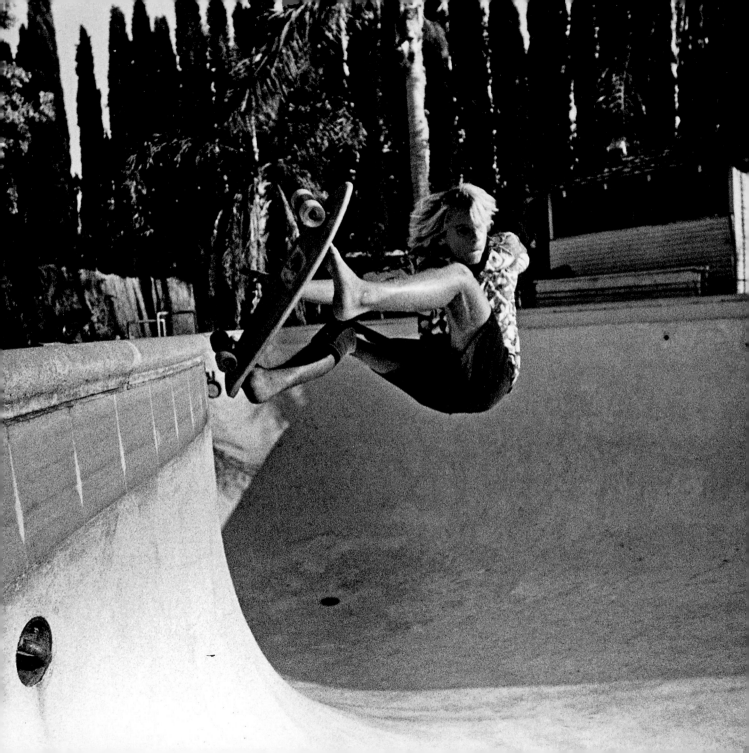

Somewhere beyond the formalized spectrum, street skating reigns supreme. On the banks, drainage ditches, and streets of the land, it's coming down hard and heavy. Flying lines are being drawn down blacktop hills in manners that the civic planners could never conceive of. Street skating does set the standard. While the cops and government are busy closing down spots, the street skaters find new places to ride or new ways to ride the old places, working the Amerikan concrete technology for all it's worth. While the Highway Patrol hides in the bushes of the canyon, looking to catch speeders, the Mad Dog and the Bullet are passing the cars at speed. The patrol takes one glance at the Dog and the Bullet, and knows the situation is totally beyond all control. Guts skating, as always, is the final frontier. It's going to go as far as you are willing to take it, and the only way to know for sure how far you can push it is to lose it. The one certain thing is: when you hit the pavement at 70-plus, it's not gonna matter who you ride for, or what your name is. The future is now; get on it.

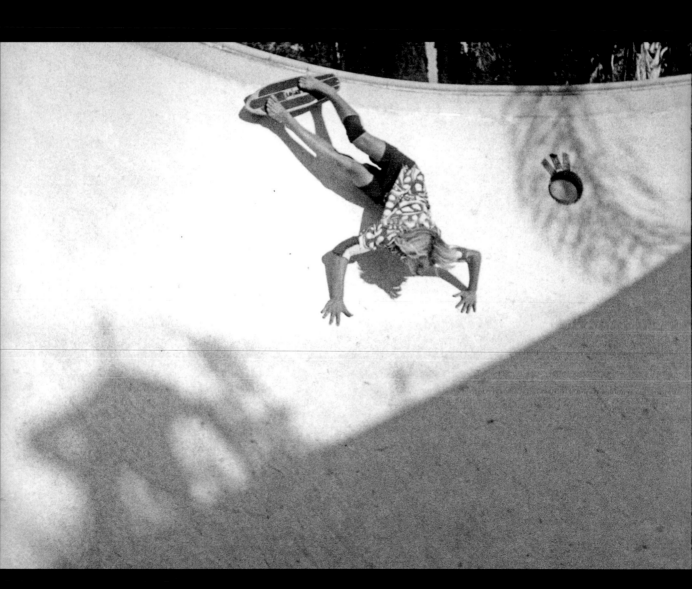

Jay Adams, vertical bert back into the bowl.

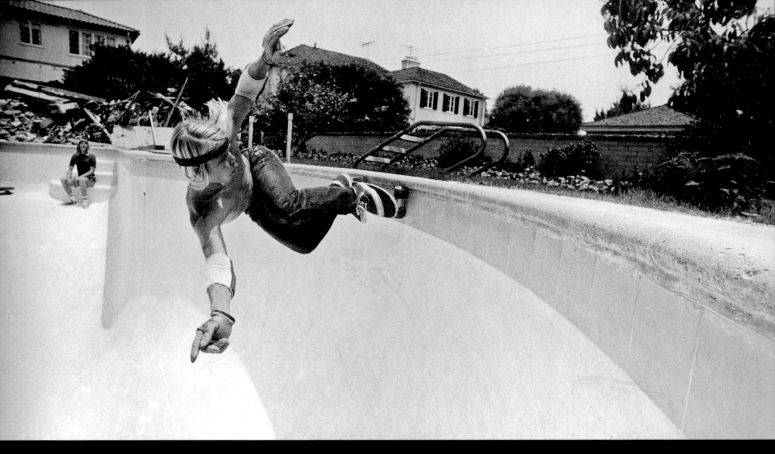
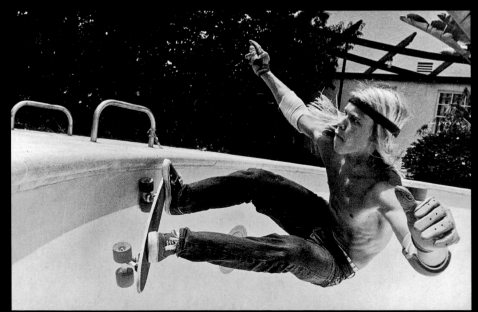

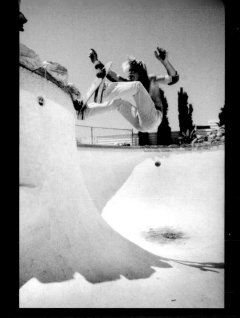

Bob Biniak: (right) rock rolling at the Manhole;
(below) at a spot so new that it didn't even have a name;
(opposite page) off the lip and around the top at Keyhole.

Put your money where the ground is, or in the words of the Bullet:
"Show us some money and we'll show you some speed."

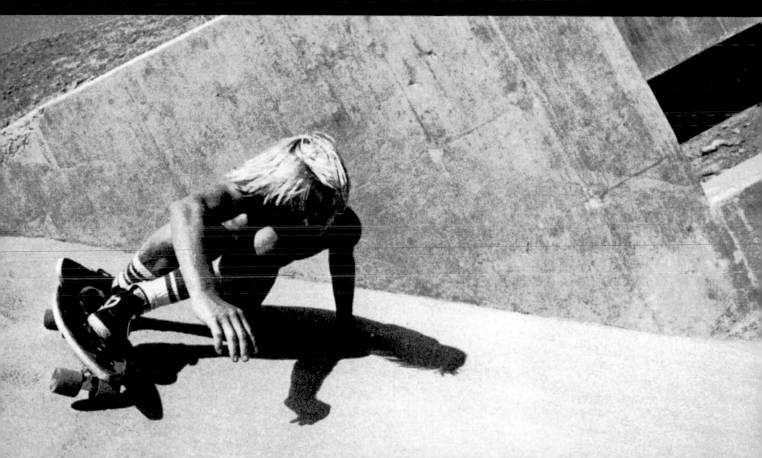

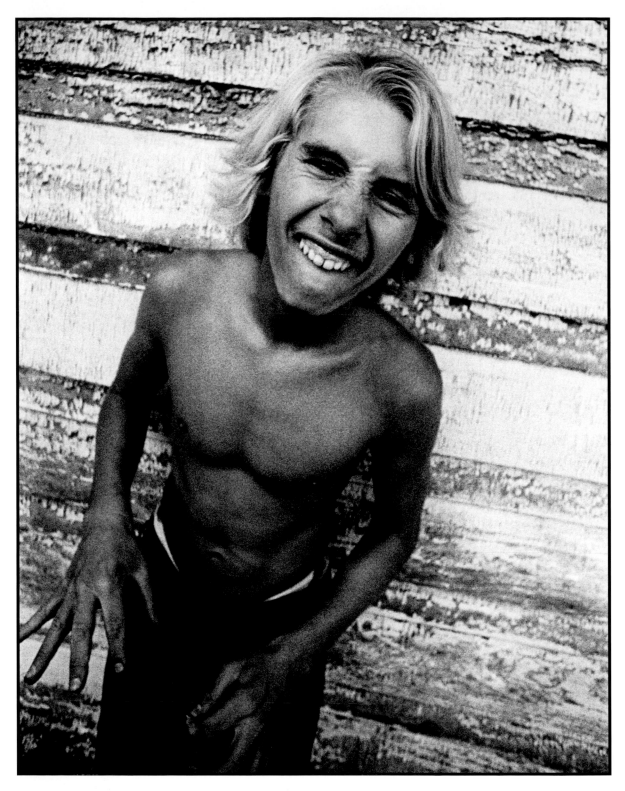

Adams reacts to a question concerning the San Fernando Valley.

JAY ADAMS

Fifteen years old, rides for Logan Earth Ski

What can you say about Jay Adams? Mere words could never come close to accurately describing him. Ask anyone who knows him, they'll tell you. He's one radical mutha. On the streets of his old hometown, Jay's exploits are nearly legendary. Tales of his madness include: the time he got a ticket for skating on the freeway, numerous vicious food fights, when he allegedly skate-snatched the wig off a bald woman's head, his uncanny throwing ability with a dirt clod (total accuracy for up to two city blocks), and how he can be gone for nine months and walk into the Ocean Park Library and still cause the librarian to go into uncontrollable hysteria the instant she recognizes him (this library doesn't have surfing magazines). In regards to these stories, Jay merely smiles and says, "It sounds like somebody else to me; I mean, if I ever stole a bald lady's wig, I'd sure remember THAT!!!"

Aside from the insanity, there remains Adams's undeniable skating ability. People who are known as innovators consider Jay to be an original. Adams and Alva were the prototypical Z-Boys, and their riding did more to turn people on to the new surf-skate style than anything else. Jay did spectacularly well in contests, although now he doesn't remember any of them in particular. When queried further, he states, "After all, contests aren't really important." (Editor's note: Adams won the freestyle and cross-country events in the 1975 Hang Ten World Pro-Am, as well as ten other first-place titles and over twenty other assorted placings.)

Jay began surfing and skating at age five under the encouragement of his father, Kent Sherwood, a longtime surfer. He prefers bank and pool riding to other facets of skateboarding, and credits Tony Alva with "tuning me into the banks." Other favorite skaters include Torger Johnson and Bob Biniak. Adams feels that "it is important to skate well all around—'cause it's dead to be stuck doing just one thing."

These days, the lad spends his winters in the islands and his summers on the mainland taking full advantage of all skating and surfing opportunities.

Jay is very concerned with the quality and type of equipment he uses, feeling "it really makes a difference; it's all that matters." For skating, he is currently breaking in a new Logan 27" kicktail to accompany his old standards, a molded unidirectional fiberglass 27" kicktail for pools (both of which are manufactured by his dad). For surfing, he uses an Urbany 7' x 18" wide round pin, and a 63 x 18 1/4" wide modified sting.

Adams's favorite skate spots are Revere, Belagio, and Highland in California, and Wallos and Stoker Hill in Hawaii. His future visions include "better skate parks, with double-sided vertical walls, like a cross between Wallos and a pool." He adds, "They better come soon, though, because the way it is going, the parks will be the only places left to skate."

For tips, Jay offers that "you should be spontaneous in your skating, and not plan ahead, just do what comes natural." And that "music really helps you to skate better, so just park your car next to the hill and turn up the stereo full blast."

We asked Jay if his mother ever worried about him, and he answered, "Of course not." Then we asked if he ever worried about his mother, and he stated, "No, she's able to take care of herself."

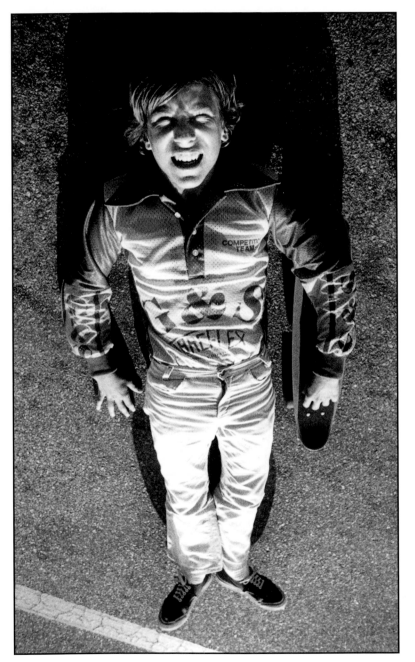

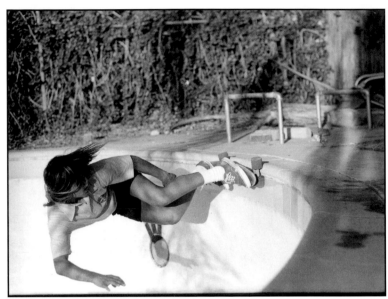

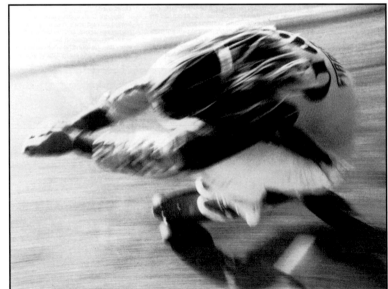

PAUL CONSTANTINEAU

Fifteen years old, rides for Gordon & Smith Fibreflex

Paul Constantineau is a man of few words. It's not that he is uncooperative, though, since Paul will answer any question you ask him in twenty-five words or less (usually less). He exudes an easygoing self-confidence, and is definitely much more into doing it than talking about it. It is this confidence blended with an innate sense of style and a go-for-it attitude that allows Constantineau to show up at a new spot with the boys, rip it apart, blow the locals out, never say a word, get back into the car, and split.

Paul was born in Ontario, Canada, where he lived until six years ago, at which time he moved to Santa Monica, California. Shortly thereafter, Constantineau began the local activities of skating and surfing. He learned the fundamentals from friends like Bob Biniak, Tony Alva, Jay Adams, Stacy Peralta, Wentzle Rumi, etc., and he still considers them to be his favorite skaters. Paul excelled in the action winter sports of his native country, with particular emphasis on ice hockey, skiing, and speed skating. Constantineau is rumored to be an excellent hockey player (position, right wing), who might possibly be bound for a career in the pros. When questioned in this direction, Paul allowed that "I guess I play okay." He feels that the similarities of these winter activities helped him to make the transition to surfing and skating since "they are all similar in balance and motions." Paul "skates just for fun," although he is aware of the commercial possibilities, and is open to them. He has appeared in several films, including *Super Session, Go For It, Five Summer Stories Plus Four, Fluid Drive,* and *Freewheelin',* in which he also performed some action-camera work. Constantineau adds that he is "particularly into the financial rewards" of filmmaking.

Paul is an all-around skater, and prefers "any good bank or pool" for skating terrain. For banks and pools, he uses a 26" Fibreflex kicktail, with Bennett trucks and Sims Pure Juice wheels. For slalom he uses a 28" Fibreflex board with Bennett Pro trucks and Road Rider #4 wheels; and for downhill speed he uses a 28" Fibreflex with Tracker trucks and open-bearing mag-centered wheels.

Constantineau surfs "just about every day" in California, and last winter he went to the islands for the first time. He stayed with the illustrious Adams family, and skated occasionally at Wallos and Kamies Drain, spending most of his time in the water at Laniakea and Gas Chambers. He currently rides a 6'6" stinger swallow shaped by Mike Perry, and is looking to return to the tropics "as soon as possible."

Paul advises that "when skating banks, ride them like a wave, instead of trying to do freestyle tricks on them. Banks are really just cement waves." So if you see an amazingly fluid skater flashing through your local bowl, it just might be Paul Constantineau. If you wonder . . . you'd better ask quick, 'cause he will never tell you on his own.

< P.C., a man of few words. "Copings only count when you hit the trucks."
 Vertical stroke on a borrowed board. Into the reflex phase of a downhill run.

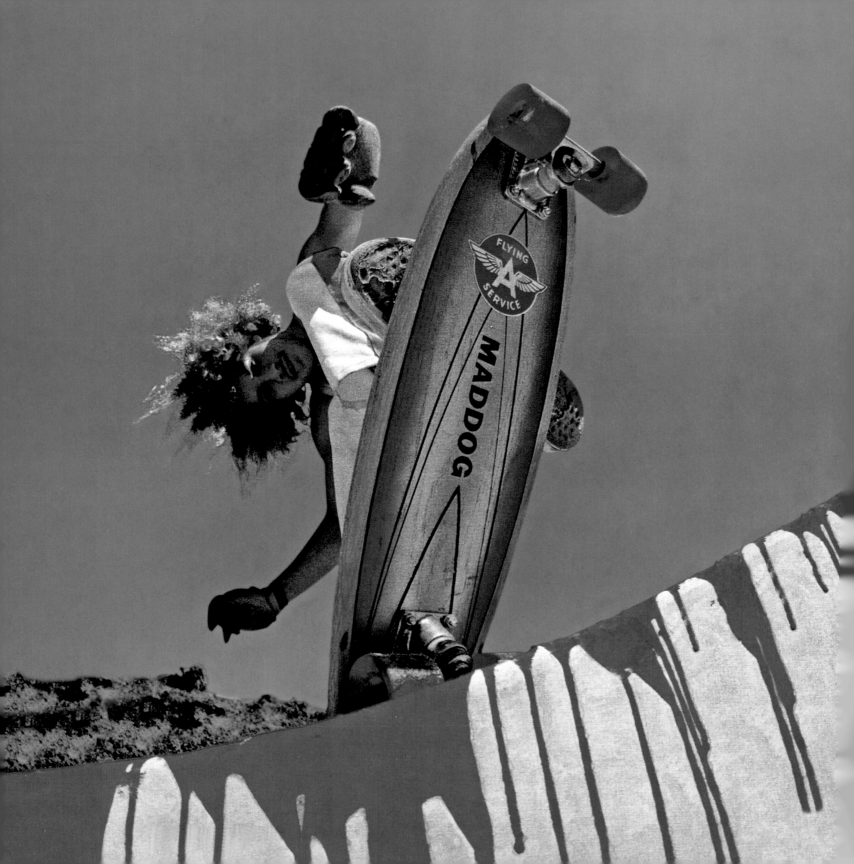

SKATEBOARDER INTERVIEW HIGHLIGHTS:

TONY ALVA

Six years to the day after Jimi Hendrix died, Tony Alva won the World Professional overall title. Two weeks before that, he had set the new world record in the barrel jump. These victories were no surprise to his friends and followers, but still proved a few things to a lot of people. The prototypical Z-Boy, the self-styled skater with the DogTown dreadlocks had commandingly stepped to the forefront of the organized skate scene. It was more than a personal victory; it was the public verification of a variant approach to skating. The Mr. Electric, Mr. Man of the Moment,

Mr. Radical of the Press, known on the streets where he lived as Mad Dog, had brought home the bacon. With his victories, Tony had, in effect, become the man of the MOVEMENT. Alva views this interview as a way to speak his piece. What he has to say will no doubt upset some, but he knows if he doesn't say it, no one else will.

Tony Alva is the one skater today with the across-the-board appeal to surpass the boundaries of the sport/art. He skates with friends like Craig Chaquico of the Jefferson Starship; his boards are autographed by Ted Nugent, and Marley figures the skate rastaman to be a natty dread incarnate. He has been interviewed on ABC-TV's *Wide World of Sports*, sounded by *Rolling Stone*, and featured in the *National Enquirer*. This interview was compiled from ten hours of magnetic tape, completed under the most hazardous of conditions.

Keep in mind that the names have been changed to protect the guilty, as well as the innocent. So he's mad as a dog; what's YOUR story?

Your style differs markedly from these older skaters. When did you develop your current approach?
I was hanging out with Jay Adams, who is like my younger brother. He's always been a radical little rat. When he was eight, he was already into surfing at places like Malibu and Pitas Point. We both had these super-hyperactive personalities, and so we always had to be doing something, and that "something" was usually causing trouble, being rowdy, surfing and skating. Jay was always a good skater, and I passed on what I had learned from the Hobie team to him. Gradually we both evolved into a kind of a mutual style. At that time, we were to such an extreme in our skating that we didn't do any flat freestyle tricks at all. We'd ride the banks, get low and turn over like we were surfing . . . totally into the Bertlemen style. All of the people we hung with were into the same surf-skate approach, and we all surfed Jeff Ho's sticks out of the Zephyr shop. Jeff, Skip Engblom, and Jay's dad, Kent Sherwood, designed a low-center-of-gravity flex board to go along with the new style of skating. The Z-Boys happened through all of that. There wasn't a tryout for the skate team or anything like that; you were only on the team if you belonged. We were all friends, into the same kind of skating, and that was the basis of the whole trip. It just sort of set itself up, and Jeff and Skip backed us. It was a total skate trip . . . no bullshit tricks. People are just now starting to flash on how heavy it all was.

"I just skate and don't talk bullshit."

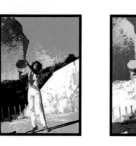
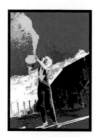
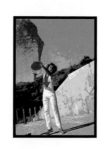
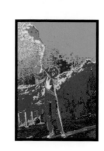
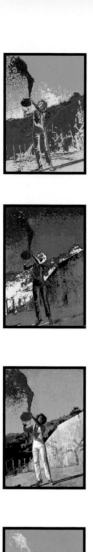

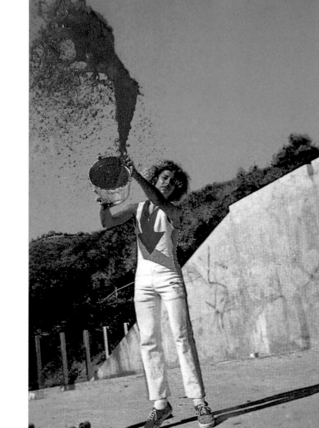
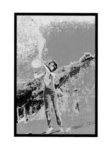
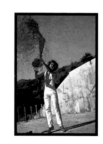
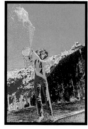

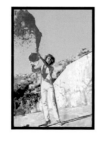
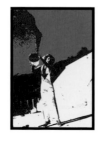
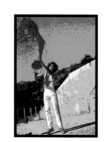
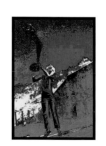

How do you feel that your local style relates to those of other areas?

A couple of years ago, our style was totally different. A lot of people didn't really understand it, but there is much more acceptance now. They were into specialist trips; you know, the slalom boys were from one place, the flatlanders from somewhere else, and on and on, but we had the all-around approach. As others began turning on to banks, they got hip to our trip.

What it comes down to is that in riding banks and pools, we're at least fifteen years ahead of everyone else just because of the area we come from. The people before us put in eight years of bank riding, and we've all personally put in another eight. Experience counts; some other people now do a good imitation of our trip, but that's all it is, an imitation. Followers can never be leaders. Our style is continually advancing. We are different from those who came before, and the younger guys are already different from us. The younger guys are so radical . . . they're continually bringing out the new, new moves. Look at Baby Paul, he's the youngest, and he's as good as anyone.

Do you guys think that you are better than other people?

Sure, in pools and banks, we KNOW it. I can say that outright.

Some observers have characterized you and your friends as being highly aggressive. What do you think about that?

It's true. That's what we've laid on them; it's how we taught them we are. When the boys are together, you could never find a more aggressive, arrogant, rowdy, perhaps ignorant bunch of people than me and my friends. That's just the way we are; that's the way we skateboard; that's the way we talk . . . party . . . surf . . . travel . . . you name it. We don't really get the whole group together too often, though, because we usually end up getting in some kind of trouble.

"When I skate
it's toward the
Nugent, Hendrix,
Zeppelin style."

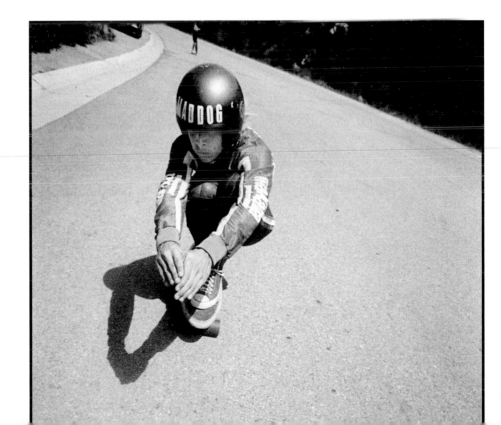

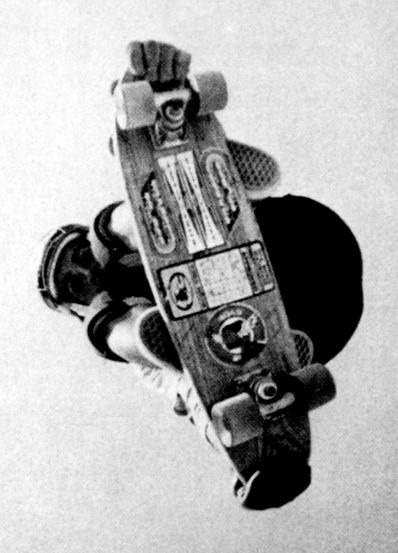

STRANGER THAN FICTION

THE REVOLUTION MAY BE TELEVISED

It's a medium-cool afternoon in Anaheim, and the camera crew for NBC News, with Ray Duncan anchorman, arrives for a film session at the new skate park. On hand at the park are a few skate notables, including Guy Grundy, who is knee-deep in groupies, Stacy Peralta, who's doing 360 banked slides, Foster Dupont, who's changing the oil in his '48 Chevy, and Paul Constantineau, who, in between aerial assaults, is reminiscing over last night's events backstage at the Forum with Charlie Daniels, Eric Clapton, and a few hundred others. (In one of his finer scams, Paul C. with Dexter the Rastaman are skating on the banks of the subterranean artist's entrance to the arena, and catch the eye of Charlie Daniels, the Uneasy Rider. Charlie and his entourage trip so badly on the dog soldiers' actions that they grab ole Slow Hand Clapton, who obliges the boys with backstage passes to the sold-out concert. A splendid time was had by all, especially Constantineau, who is just beginning to come out from under the residuals of last night's madness.) While the NBC crew is committing the frenzy at the cement wave to celluloid, Ray Duncan interviews a wide variety of personages.

In Stacy Peralta's segment, the newscaster comments that he's never seen anything like this, and Peralta replies, "There's never been anything like this." At that point, the interviewer recoils: lost in speculations over this new type of fun—seventies style, that is so far beyond the conceptual shadow of Disney's plastic Matterhorn which exists statically just across the Santa Ana Freeway.

At the other end of the park's concrete and Astroturf expanse, the camera crew is engrossed in a discussion with Paul C. over photographic possibilities in general when the director idly speculates that "it would be sensational to attach the newsreel camera to a skateboard." Constantineau immediately shifts into overdrive, since in the last couple of years he's done action and stunt camera work with a variety of filmmakers such as MacGillivray-Freeman, Dittrich, Darrin, Jepsen, Kalionzas, Murphy, Valentine, and Ketonen. The crew immediately seizes upon the opportunity, attaches the camera to the nose of the warptail, and P.C. begins to put it through the paces. Blazing trails of animal grace and aggression, Constantineau performs continual lippers, vertical berts, slides, bunnyhops, etc., and ends his performance by booking it through the snake run with the thirty pounds of video gear up front, down into the center bowl, and does a high flyaway out of the bowl, lands on his feet, casually catches the camera board, and hands it to the director. The director is totally speechless, having just seen several thousand dollars worth of camera and lens, his job, his sanity, and his life pass before his eyes simultaneously. As they leave, Ray Duncan takes the boys aside and says, "You guys are really heavy." Their reply is, "You ain't seen nothing yet."

< Paul Constantineau passing on the overpass.

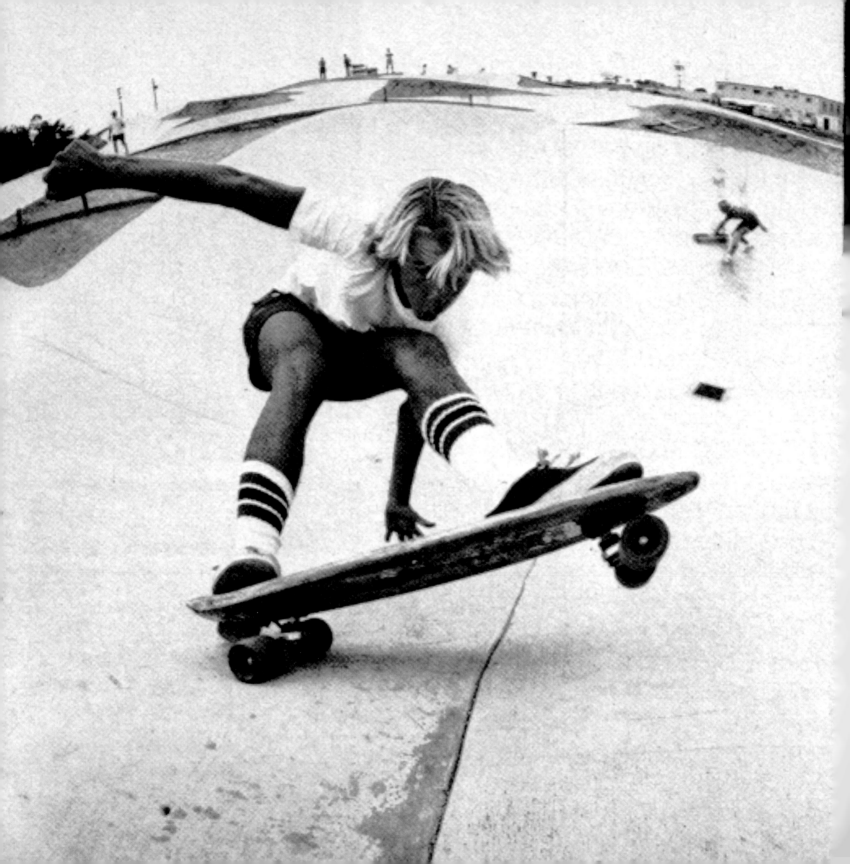

THE MULTIPLE MAD DOG MYSTERY

Stacy Peralta and Bob Biniak were in the third eastbound lane of the Ventura Freeway, heading for a pool located vaguely north of Hollywood Boulevard, when a bulletin came over the radio. The news flash concerned a woman who was sunbathing in Miami Beach, using one of those mirror-like metalized mylar reflective devices, which in the advertisements are guaranteed to double your tan. The sun worshipper, it seemed, had oiled herself up, stepped into her reflective solar pit, suffered a heat stroke, passed out, and was found by her husband seven hours later literally roasted to death. Biniak, a master of the classic understatement, wryly commented, "That's a hard way to get a tan." The news item was immediately followed by the announcement that consumer advocate Ralph Nader was launching an investigation of dangerous tanning products.

The story served as fantasy fuel, feeding numerous bizarre speculations as they traveled the misbegotten avenues of Hollywood searching for the pool. Having finally pinpointed the basin, all energies were directed to the usuals of parking, gathering entry, possible escape routes, and posting a good lookout. Halfway through the skate session, several local kids showed up to check out the action, and began conversing. "Hey, that guy looks just like Stacy Peralta," one of the lads directs toward Biniak, who flatly replies, "Yeah, he kind of does." Biniak, who figures he has diplomatically handled the situation, is amazed at the kid's next statement: "Tony Alva was here this morning. We skated with him for four hours, and he took us to lunch; my brother got his autograph." Now Biniak, who took the tale of the woman in the foil cooking pouch completely in stride, is more than a little skeptical over this revelation (particularly since he spoke with Tony on the phone that morning, at which point Alva was in Hawaii where he'd just returned from riding Pipeline with Rory Russell and Bunker Spreckels). The youths, seeing that Biniak is not suitably impressed, ask him, "You have heard of Tony Alva, haven't you?" Biniak thinks it over for a while, and begins his cross-examination: "You guys saw Tony Alva? . . . Right here? . . . This morning? . . . And he gave you his autograph? . . . Well, then, let's see it." The youngsters produce the autograph in question, and it does vaguely resemble that of his old friend from DogTown. After thoroughly scrutinizing the signature, Biniak shakes his head and states, "The only Tony Alva I've ever heard of is living in Hawaii; in fact, I talked to him today." Peralta looks at Biniak and shrugs, while the street urchins tell them both: "We are talking about Tony 'Mad Dog' Alva, not the one you guys know." Being pretty well-skated-out anyhow, the Z-Boys decide to journey elsewhere, totally perplexed over the riddle of the multiple Mad Dogs. The pair begin laughing uncontrollably over the knowledge that somewhere in the wilds of North Hollywood there is somebody dressed up in a Tony Alva racing suit, wearing a dreadlock wig, and carrying a bogus Mad Dog model, giving out autographs. One thing is certain: he may look like Tony Alva, but he definitely won't skate like him.

< Jay Adams, whose friends describe him as a "radical little rat."

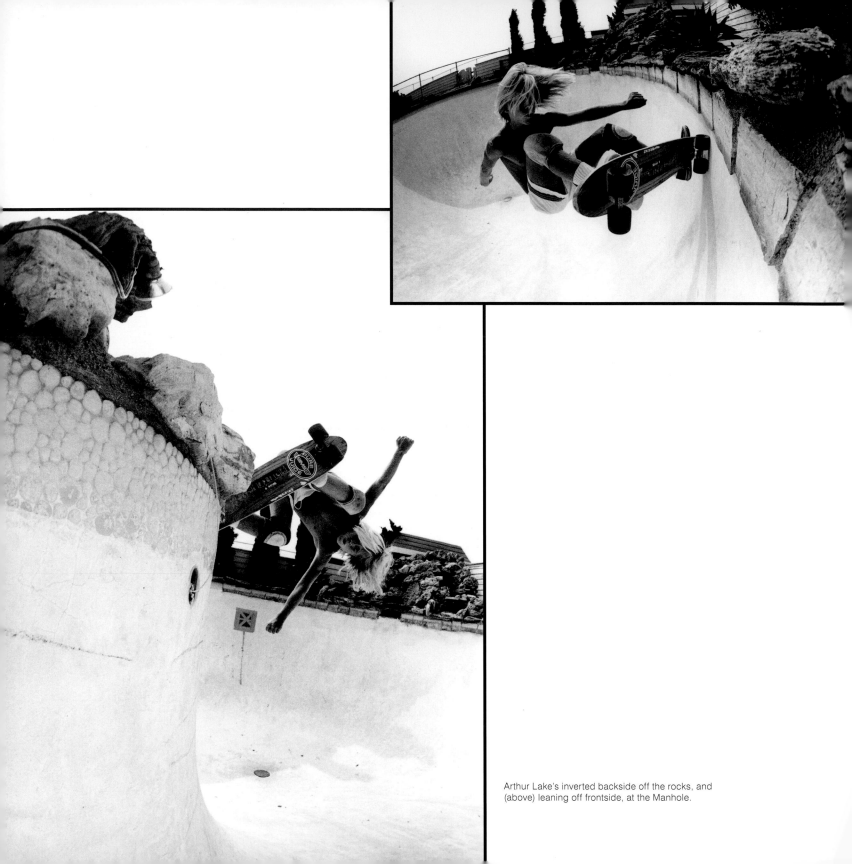

Arthur Lake's inverted backside off the rocks, and (above) leaning off frontside, at the Manhole.

CRIME & PUNISHMENT

Spencer the Space Monkey, back from Burleigh Heads, comes to town for that DogTown debutant debut, the Annual Pass Around Pack Christmas Party and Luau. Spencer, one-time guerrilla fighter in the psychedelic wars, is now on the road to prosperity with his new Balinese-Congolese import-export business. A pack of Rit dye, a Balinese peasant outfit, a Paasche A/B airbrush, pinking shears, and thirty minutes are all the Space Monkey needs to turn a fifty-cent foreign smock into the latest sixty-four-dollar trendset New York status fashion ensemble. His export business is based on selling Levi's blue jeans in Eastern European countries at a substantial markup.

Spencer's abilities with an airbrush are legendary. His latest exploits include airbrushed special effects for Dino De Laurentis's King Kong and the multi-hued, metal-flaked jumpsuit he is wearing attests to his facile mind and hand. Anyhow, the Space Monkey is hanging out in the Lunar Liquors parking lot, chatting with the uptown high-heeled sneakers gang as they all powder their noses in preparation for the upcoming melee. Everyone is dressed up to the max in DogTown finery . . . true Salvation Army chic. As the group begins to dance, Spencer appears as a glittered eel in the eerie cast luminescence of the streetlight. His ever-present, five-foot downhill skate beastie is color coordinated to match his outfit. When the two redded-out yokels in the '65 Buick Electra with Jersey City Garden plates drove into the Lunar lot, nobody pays much attention. Their hasty departure, however, causes quite a stir, for as the two pile into the Buick and lay down a sixty-foot positraction trail, Bennie the Book, liquor store clerk and night manager, is screaming after them in red-hot foot pursuit. Bennie runs down the story: "Dese two jorks on da nod come in and stick me up—now dis one guy's got his finger in his pocket and jives me it's a gun. Shit . . . I only got thirty bucks in da register, an I figure maybe it is a gun . . . so why chance it?" The Book may be a fool, but he's sure not stupid. Bennie knows two things the crooks aren't aware of: 1) Ocean Park is a very small town, and 2) Lunar Liquors is the official caterer to the Pack's Christmas Party. At this point, the store clerk offers the boys an intriguing proposition . . . cases of Heineken Dark to anyone and everyone who helps apprehend these criminals. The gang is off in a flash over to the Third Street cutoff where Spencer grabs a skate tow off the rear of the crook's car. While the Space Monkey, unbeknownst to the speeding desperados, is enjoying a free ride, his cohorts inform the police. The rest was simple . . . I mean, just how many madmen in neon rainbow metallic suits are going to be towed down Main Street by a car with out-of-state plates?

For Spencer's heroics, he was awarded $100 cash by the local merchants association, and is being named the Optimists' Bay Area Boy of the Year. This cooperative citizenship is also a very positive step in raising the prestige of the sport in the eye of the public. The newspaper headlines referred to the episode as follows: "Skateboarder Spoils Armed Robbery Attempt in High-Speed Pursuit." The only question now is what sort of outfit the Space Monkey will wear to the highly formal Optimists' awards banquet. Whatever it is, it's sure gonna blow them out.

Tony Alva, setting up the angles to shatter further limits.

Peralta's rim shot.

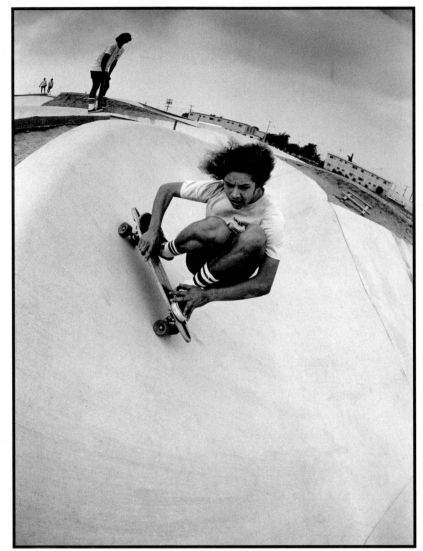

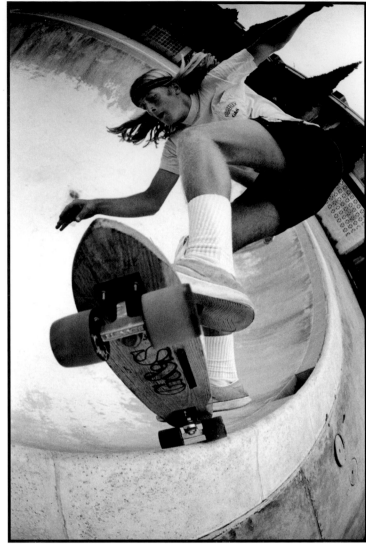

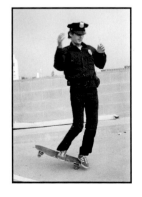

It's nice to have a good car to go skating in.

The skating policeman puts a little flow into his patrol.

When you see a guy's patch, you know what team he's on.

PLUGGING IT IN THE SANDWICH ISLES

Tony Alva was relaxing by the pool at the Kuilima on Oahu, talking things over with his close friend and confidant Wentzle Ruml. The course of the discussion covered Alva's more recent activities such as his unique screen test for the Argentine film genius Adolpho Antonio Brasura. For the final sequence of the test, Brasura, a master of a vicious brand of cinema verite, rented an entire plush resort on the Kauai coast, and had Tony toss a 24" Zenith color television off the roof twenty stories into the pool below. The TV was plugged in via a 250-foot extension cord, and its impact produced a 100-foot-high brilliant flash of pure prismatic color. The Zenith people were so taken with the quality of this work they are negotiating for the rights to a Brasura-Alva commercial. Imagine Alva skate jumping off a pile of color TVs, grabbing one, dropping it into a swimming hole far below, and the resultant crash landing at which point an underwater camera reveals that the set is still working perfectly. It would definitely sell a few million sets.

The conversation revealed other interesting facets of the upcoming Brasura epic. Robin Alaway will play female lead (an apt choice considering her stunning performance with Russ Howell in the hilariously satirical segment of *Freewheelin'*). Arthur Jennings Brewer will handle the in-the-pool water photography, Ted Nugent will record and engineer the soundtrack, Señor Brasura will play himself in a cameo role, and Roy Rogers's horse Trigger will be the hero's mount.

By far the most interesting thing to emerge that afternoon was Tony's plan for a bowl-riding invitational. The sponsors and entrants would all put their money into a collective pot, up front, with the winner taking it all. Alva envisions it as either a one-on-one or a team competition. When queried as to how it would be judged, he laughingly replied: "Well, just have everyone go skate it out . . . and the last man to emerge from the bowl wins!"

THE SKATING POLICEMAN

A group of young rowdies are sitting in the alley down by the Central Towers when the patrol car arrives. The two policemen inside get out, saunter over, and politely ask the kids what they're up to, and this smart-ass punk sardonically replies, "What the hell is it to you, anyway?" Now the elder cop of the duo is about to blow his cool, but the younger one intercedes. "Let me handle this. Is that your skateboard, son?" he inquires. "Yeah, bet you can't ride it, pig!"

The young centurion silently grabs the skate, takes off his gun, and borrows a pair of tennis shoes from one of the other kids, all of whom are quite upset with their loudmouth friend for getting them into trouble. With the borrowed Adidas three-stripers on his feet, the lawman executes a highly technical freestyle routing, and ends it with a stylish crossover dismount. The troublemaker, now thoroughly humbled, apologizes profusely, and the skating policeman advises the youth to tighten his mounts as well as his act. The two officers reenter the black-and-white and motor on, leaving the mischievous lad a bit wiser in the ways of the world.

BOB BINIAK

Eighteen years old, rides for Logan Earth Ski

The assignment for this Who's Hot! came down some eight months ago, and it has taken that long to corner Bob Biniak and get him to answer these few scant questions. (Bob is definitely unconcerned over publicity and such matters.) Recently he was contacted by a major manufacturer that was interested in marketing a Biniak signature model, and he turned them down flat: "I didn't dig their trip, or their product." Biniak is an uncompromising person, and a perfectionist. He gives and accepts no substitutes. This attitude is readily apparent in his skating, and has earned him a heavy-duty reputation. His well-known affinity toward high-speed situations led his peers to label him with the street name of Bullet.

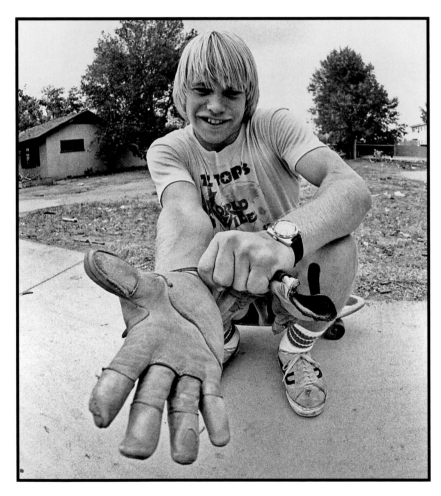

Bob Biniak—show your hand.

It's perhaps noteworthy that during this interview Biniak was upping the rpm's on his moped, "Ought to be hitting 45 when I'm done." (Editor's note: the California State limit is 30 mph.)

The best insight into his skating abilities is through the words of his friends:
"Biniak's totally rad. Hard to beat in a pool, heavy on the vertical action." —J. Adams
"He's definitely got the speed and power moves down . . . always skates with strength and style." —Stacy Peralta
"Bob's definitely the fastest skater I know; he's a good dude and a hard rider." —Tony Alva

Biniak started "skating seriously" three years ago in Ocean Park with the Z-Boys, and his approach clearly shows these origins. In reference to the DT style, he offers, "Our attitude has always been different, definitely more go-for-it." He lists being on the original Zephyr team as the "high point" of his career, and feels that the current Logan regime "runs a good second, particularly in the area of parties; we always have a good time."

Bob prefers pool and bank riding "by far," and his favorite spots are the Keyhole, Pipeline, and Revere.

Although having been in the money at several pro meets, Biniak classifies himself as "positively not into contests in their present format . . . Show me some banks." Having posted the fastest standup time at Signal Hill in 1976, he is looking forward to next year's event since "they should have the bugs worked out, and will have established separate classes for standing, kneeling, and prone positions."

Bob offers that "an open-canyon speed contest would be a much better test in terms of speed and control; fifteen to twenty miles of steep, winding mountain roads would tear up a few people's trips for sure!"

Biniak lists his favorite activities as "skiing, golfing, skating, surfing, and chasing women—not necessarily in that order."

Feeling that quality equipment is the key to success in any endeavor, Biniak's lineup attests to his current concerns.

For the cement: a 27" Logan kicktail—"good for pools, banks, and freestyle." A 30" Logan cutaway—"for racing." A 30" Torger kicktail—"for backup." For wheels, he uses cut-down Road Rider 6s. He also has a full set of leathers for racing—"You need them after 60."

For the slopes: 195cm Lange downhill skis—"Your basic speed demons, skiing's much faster than skating."

For the fairways: lefthanded Wilson Staff golf clubs—Biniak golfs in the seventies and can "foresee the possibility of turning pro in a couple years." He gives a terse "no comment" on the persistent rumors that he's picking up more than a little spending money out on the links.

For the water: a 6'11" Bill Urbany rounded pintail—"It's very light and loose, good off the lip and in the tube."

And for general advice: "You tear that stuff up twice as bad when you're off the walls."

SEQUENTIAL OVERDRIVE

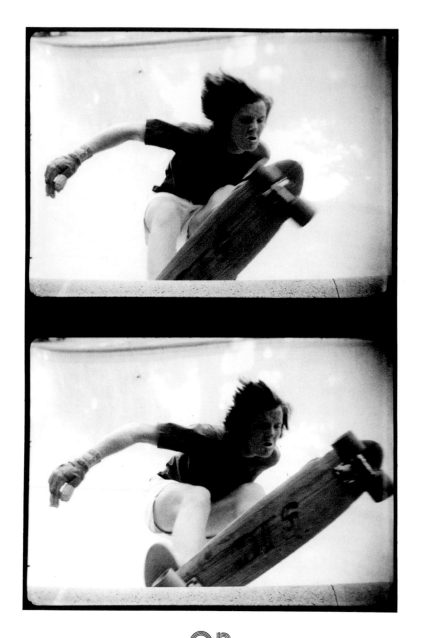

James Muir, an aggressive
DogTown homeboy, lays down
a sequential challenge
to all comers.

OR
DOG'S-EYE VIEW

DIALING FOR DOLLARS

It was 11:45 on a hot Tuesday night. I sat in my office, hunched over my typewriter, chain-smoking and sipping stale coffee. Suddenly the phone rang. I answered. "Hello, Mr. Smythe, my name is Marilyn Nicholsberg, and I'm writing an article on skateboarding for a women's skin magazine." The crackling voice on the other end of the phone went on to explain that Adams, Mad Dog, and Constantineau had given her my number. It all seemed so innocent. The writer asked all of the typical questions, said all of the usual things: "Why do they call it DogTown?" . . . "You know, they really seem to be outlaw types," etc., etc. She casually mentioned that Alva had recommended Bad H. and Fats as possible models. I concurred, "They'd make great beefcake; I think they're just what your magazine needs." Finally she goes, "Let me level with you . . . It's about this 'skate-nazi' thing. How serious is it? . . . I mean they all do have blond hair and blue eyes. They are all so Germanic." I thought it over and realized that she'd really got a wrong number. I hung up. A baby's crying shattered the stillness of the night. Somewhere a dog circled a fire hydrant.

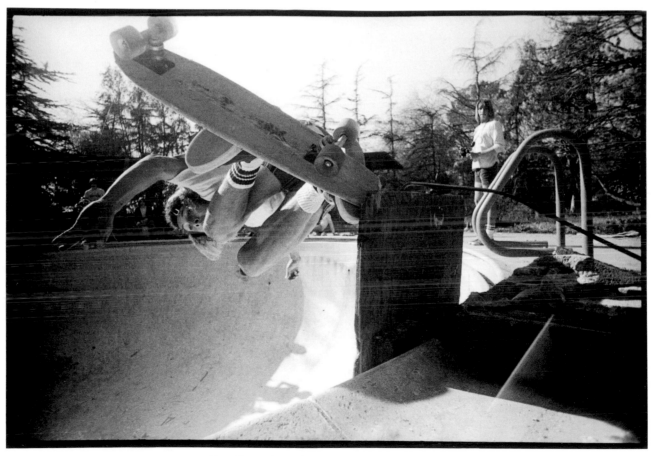

Tony Alva, total commitment beyond all previous tracks.

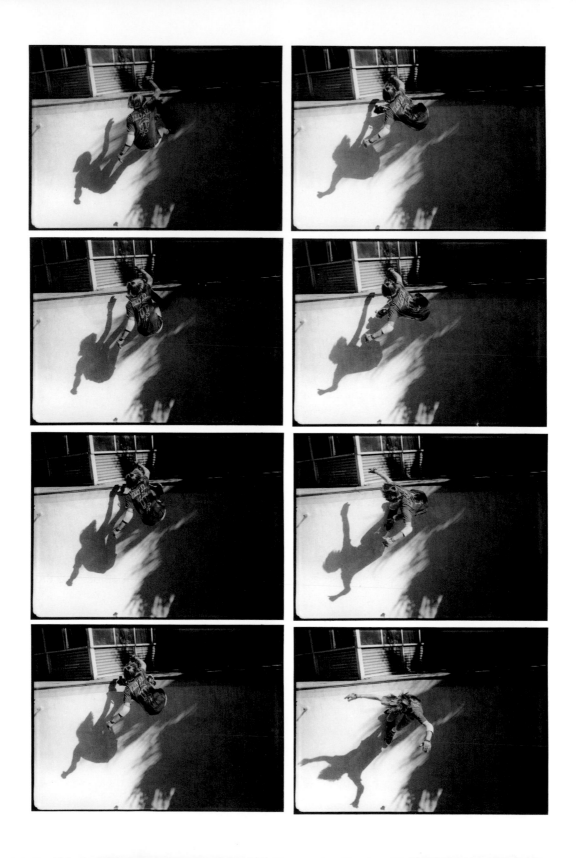

"Dead weight is lost energy." —James Muir, sequential overdrive.

SHOOTING THE RAPIDS

Pool riding's parameters are ever-expanding, and pool sessions are starting to draw interesting cross sections of the nonskating public. A recent afternoon at the Dog Bowl drew a varied crowd, including: Tom Waits, whose 1955 Cadillac was parked at the curb. Doug Moench, artist extraordinaire from the Marvel group, who was making action sketches for the Concrete Crusader. (The Crusader promises to be the first skating superhero in comicland.) A three-hundred-pound gentleman with the handle "Big Daddy," who picked up on the melee listening to his Hy-Gain CB radio. A group of forty-five interested neighbors. Two LAPD squad cars. One of the uniformed occupants stated, "We're just watching—it's always a good show." The leggy blond chaufeurette, who had driven Mad Dog from the movie set in her tan Mercedes. A Channel 4 news mini-cam unit with assorted personnel. Foster Dupont, bay millionaire, who has encased his headphones, listening to Furry Lewis on a portable cassette. And an anonymous looking photographer who was filming the festivities at somewhere past 500 shots per second, with an extremely odd-looking camera.

The skaters included everyone who was anyone in DogTown, and a few who were not. The talk centered around looking for Brucie. Everyone's waitin' on him to come up and lay down some lines so that they can settle it like men.

The equipment employed offered radical departures from the mass-production line technologies. Jay Adams has his well-advertised fiberglass chassis approach. James Muir and Wes Humpston are riding their hand-honed hardwood rise tails, with sophisticated rocker-edge contours fully transitional volume. Tony Alva features a multiple-laminate design with a layered wood core that has a drilled-out center, and is surfaced with fiberglass skins. The entire unit is heat-and-pressure bonded. Among the boys, three-quarter-pound blanks are the new rule.

"Dead weight is lost energy." —**James Muir**
"The lighter, the livelier." —**Paul Constantineau**
"Keep your heights heavy and your skates light." —**Wentzle Ruml**

To realize what it all means to performance, weight your current blank.

The skating is reality therapy, with each move surpassing all previous ones. Biniak head-checks a newsreel cameraman, and Palfreyman asks if he got the shot. Tropical madness overcomes all. It's total dementia in the deep end, ranging from complete upside-down aerial assaults to four-walled off-the-lips. The crowd is going through the changes as they strain their necks trying to follow the action. The skate troopers continually put the heads of the watchers in new places. Most of the beholders wear the look of someone trying to understand something they've never seen before.

On the vertical lip, Alva and Muir are hitting airborne frontsides, and making them while their anonymous-looking camera accomplice records the act at 500-plus frames. The newscaster comes up and attempts to talk to the photographer, who remains silent behind the high-pitched shrill whine of this mechanized camera. The work done, Alva comes up, and the news guy begins to interview him. Eventually he gestures to the mute high-speed man, and tentatively utters, "Tony, I don't think I caught your friend's name." Alva replies, "That's probably because he didn't give it." The news gatherer again approaches the photographer and inquires, "That is a very interesting device there; just what exactly are you doing?" The speed cameraman wearily replies, "We have divided the peak of action plane into twelve cubic sectors, and are using this machine to analyze each of these

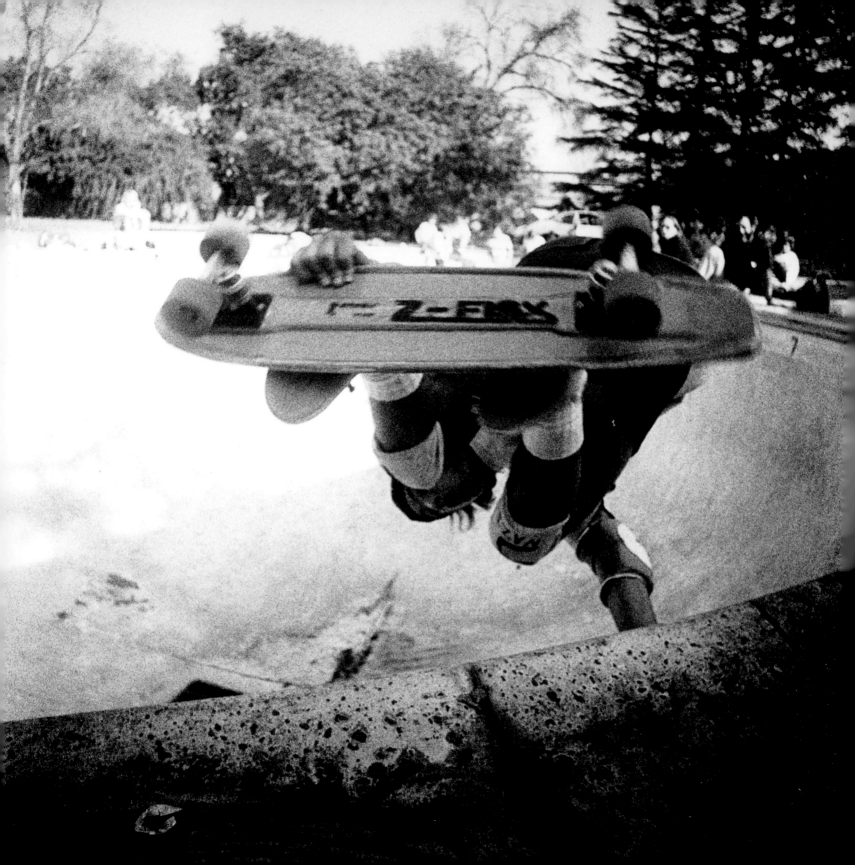

in terms of speed, velocity, depth, and distance traveled." The photographer stalks off, leaving the commentator, who blankly gazes at Alva. Tony now offers in clarification, "That camera is 100 times faster than a typical motor drive . . . it's the only one fast enough." Alva departs, leaving the newscaster standing alone with the look of someone trying to understand *something that he cannot see on his face.*

The boys were dealing with things too rapid to be observed, the kind that are so quick that they are felt rather than seen. The documentation must be done in sequential overdrive . . . faster than the speed of life, it's the dog's-eye view. "You should have been here yesterday" has become "You ought to be here tomorrow."

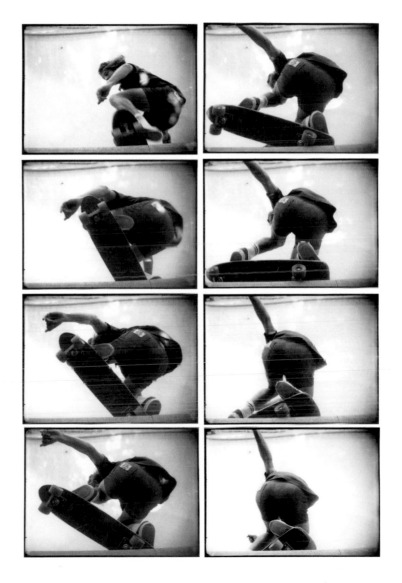

Tony Alva, viewed 100 times faster than the speed of sight (you've never seen pictures like these before, because there's never been any).

< Jay Adams,
 total dementia in the deep end.

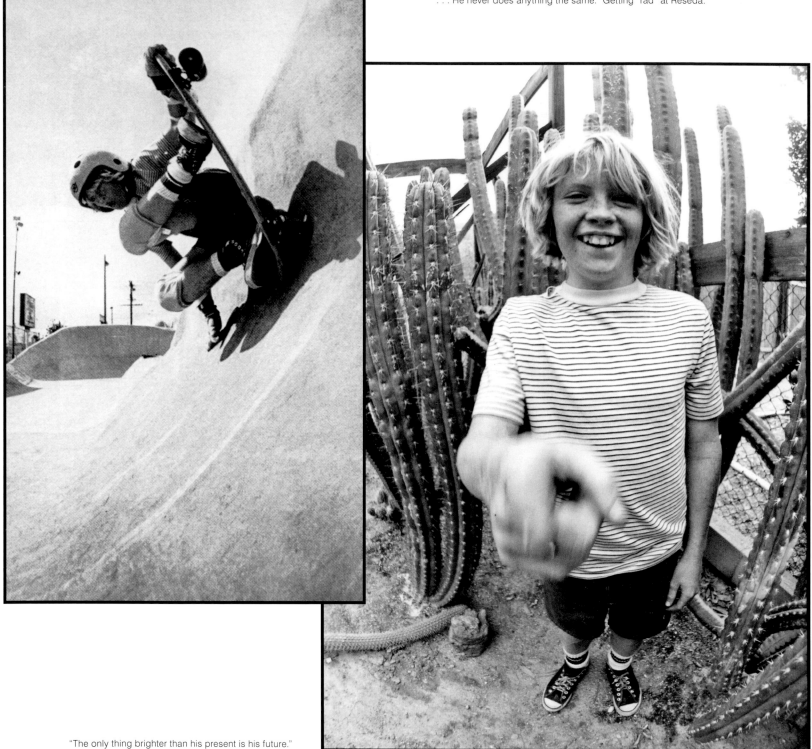

". . . He never does anything the same." Getting "rad" at Reseda.

"The only thing brighter than his present is his future."

PAUL CULLEN

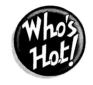

Fourteen years old, rides for Z-Flex

Paul Cullen has been described as a "present and future terrorist," which pretty well sums it up. His skate activities constantly blow out the unprepared and the unaware.

"Paul skates as well as anyone in DogTown." —**Tony Alva**

In any given situation, Cullen comes through with one of the most radical, vanguard, and spontaneous approaches around. You can never figure what he's going to do next, 'cause he never does anything the same. He is continually expanding his limits, and becoming more attuned. Paul emanates a poise and confidence that clearly shows his nine years of skating experience (and a longtime association with many of the finest skaters around). Cullen's past team affiliations read like a Who's Who of contemporary skating: Zephyr, E Z, Makaha, Logan, and Z-Flex. He feels that "good equipment and hot riders" are what make up a quality team.

Paul credits Tony Alva with showing him "how to ride pools and banks," Stacy Peralta with "turning him on to freestyle," and Jay Adams with teaching him how to "just get radical."

The young skater is currently riding the standard 27" Z-Flex, and the 30" Adam design, both with Bennett Pros and Road Rider 6 wheels. For maneuvers, he's into "trying to get past vertical and pull it off," and being able to do anything frontside that he can do backside. Pools, bowls, and vertical banks are Paul's favorite skating terrains, in general, with Keyhole, Manhole, and Kenter "just for Sunday material" being his specific preferences.

Cullen "likes competing a lot," and feels that competition is a means of advancement. He's done well at skate meets in the past (first La Costa, second 1975 Hang Ten Pro-Am, second Ventura, third 1976 Northern California Pro-Am), and regrets the scarcity of them at present. "I'm waiting and ready for them." (Paul admits that he's been practicing, and has a few new tricks ready, but refuses to elaborate.)

Arthur Lake, Don Oldham, and Shawn Sullivan are the young skaters whom Paul feels are "doing the best things." Cullen considers himself a professional and he already has several notable film and commercial credits, including Pepsi, Heinz Ketchup, and *Go For It*.

These days, Paul divides his time between skating, surfing, fishing, going to school, and "just getting crazy." In the coming time, he'd like to "travel and see some different places." (Considering that he's already lived in Canada, Australia, and Hawaii, he's got a head start.)

Paul thinks that there just might be some good opportunities ahead for him in skating, and he's "just gonna wait and see what happens." There are few persons who would disagree with him; the only thing brighter than his present is his future.

Aerial attacking. Showing a definite commitment toward the hard-core realities of landing on concrete.

SKATEBOARDER INTERVIEW HIGHLIGHTS:
NATHAN PRATT

Keeping the low profile in his speed profile, Nathan Pratt remains unknown by choice rather than chance. In dealing with this individual, the visibility factor cannot be ignored. For instance, Pratt shows up at the opening day of a new skate park. He is here to investigate rather than ride. Out of a crowd of 300 very star-conscious people, no one recognizes him. Nathan likes it that way. During an early interview session at a posh Ocean Park, California, eatery, a young woman, who appeared to be on rather intimate terms with Pratt (she was sitting on his lap), exclaimed incredulously, "Nathan, I never knew you rode a skateboard!" The interesting thing about him is that while he's virtually invisible within the sport, he's highly visible outside of it. Pratt frequently demonstrates his stunt-skating expertise in assorted television and motion picture productions. His prominence in this area is such that he was recently the subject of a German public television broadcast. (Characteristically, Nathan conducted his entire TV dialogue from within the confines of one of his speed shells, never once revealing his face to the camera.) Through his appearances, Pratt presents skateboarding to millions who would otherwise have no contact with it.

Nathan possesses an inquisitive mind, and he continually offers unconventional solutions to conventional situations. In skating, he was the first to engage in jumping substantial heights. Pratt's sophisticated equipment and stylish jumping endeavors offered a dramatic counterpoint to the apish gripping of the low-"flying" aerial BF gang. He was also the first to build wind-foil fairing devices, an approach that has generated numerous imitations.

Pratt doesn't fit the mold of the skate star, because he doesn't recognize such boundaries. His perspective is always unusual. Perhaps this interview is best defined as the view of someone looking from the outside in . . . or is it someone looking from the inside out?

How long have you been skating?
Off and on for about ten years.

How did you get started?
Back in the midsixties, I had a Chicago Bun Buster, and just rode around with a bunch of my friends. We really didn't know anyone else that did it. The big thing was riding around the block, doing turns in driveways. Got into surfing about 1970, and started skating with the surf guys. Every night, fifteen or twenty of us would skate and hang out. We were into skating banks and hills . . . mostly at Mar Vista and Revere. For equipment, we had wood boards and clay wheels. We would go through two or three boards a night. You'd be riding, crack a board, split home, take out the saber saw, and whack out another one. There were many cannibalized pieces of furniture in various garages in those days. A lot of parents flipped out.

What sort of style did you ride in then?
A surf style, kind of similar to now—low turns, off-the-lips, cutbacks, etc.

"A definite advocate of the quiver theory."

Payday at Paramount,
or skating for fun and money.

How did you enter into the contemporary era?

About '73, I started using urethane wheels. Had them on a flat oak 30" board. Rode that a lot, always on banks. We were all on the Zephyr surf team (Jay Adams, Tony Alva, Peralta, etc.). One day we decided to get a skate team together. We started skating with Tony and Jay a lot. Hit Bellagio the most; it had high banks with lots of speed. Tony was the best performance guy; Biniak was the fastest. You could tell when he was coming long before you could see him by the sound of his wheels; they always had this high-pitched whine.

What was the Zephyr team like?

Radical, really radical! In the beginning, there were ten or twelve of us, all of the best skateboarders from Santa Monica. All the boys were on it. Jeff Ho and Skip Engblom managed us. They designed a board to fit the style that was totally unlike anything else on the market at that time. A couple of months after we organized the team, we heard about the Del Mar National. Immediately we went into a heavy practice program. First we'd ride banks for a couple of hours, then we'd ride slalom. Never really practiced freestyle, though. Our concept of freestyle was entirely different; nobody did handstands or wheelies or any of that kind of junk: we skated low, hit Bert's and slides . . . it was a performance style, not a trick style. When we finally got to the contest, it was completely different than any of us thought it would be.

How did you guys think you were going to do?

We knew we were going to win; we had the best guys around.

What is the heaviest speed situation you've ever encountered?

The heaviest speed racing incident I've seen occurred a couple of years ago on the marine run in Ocean Park. We were all taking turns going down. Tony Alva pushed off, and was midway through the run, in the steepest part, when this car pulled out in front of him from a side street. Tony passes the car on the double line in the center of the street, doing 40 or 45, maybe a little faster. While he is passing that car, a line of cars starts going up the hill. Alva was boxed in between the cars with just inches of running room on either side. That ride showed me a lot in terms of speed and control. A wrong move either way, and it would have been all over. Instead of freezing or psyching, he shot himself straight ahead through the gap, and outran the car. It was one of the most intense situations I've seen anyone put themselves into.

You seem to excel in some rather exotic phases of skateboarding. How do you think you relate to the mainstream?

I don't.

Then how do you view what you do?

I see myself as being more into personal achievement and satisfaction than trying to gain peer acceptance. What other people think doesn't affect me as far as influencing what I do.

Most of those people are from DogTown. Why do you think the Santa Monica area is such a hotbed of skating activity?

The DogTown skate style is a phenomenon of the DT lifestyle. It's a very tough and physical place, and it's only natural for people who skate there to be radical and aggressive. The skate style follows the lifestyle. When you're dealing with the bikers, Vatos, and Bloods every day, you've got to have your shit together. The kids just end up being a little tougher and a lot more go-for-it. It's life on the streets.

VICIOUS LIES

AND MORE INTERPLANETARY COMMUNICATIONS

DOG STAR

The incredible powers of the Dog Star (Sirius), brother to the dark star, are a well-known and much-documented phenomenon. Accounts of this celestial body's effects are common to the recorded histories of all cultures. For instance, on August 25, 1943, *LIFE Magazine* answered that, "It was a time when the Dog Star rises in the heavens, when the heat of the midday sun can supposedly make dogs go mad, and hair hangs heavy on a woman's nape." The Dog luminary's most recent ascendancy, which was coupled with a total lunar eclipse, yielded a series of typically bizarre occurrences.

HOSPITAL RAGA

Euell, Sidehack, and the Pirate were all checked into Santa Monica Hospital for assorted repairs. The boys, who refused to accept the limits of their incapacitations, terrorized the ward in general, and the young nurses in particular. They were last spotted in the lobby doing off-the-lips in their wheelchairs.

THE MISSING MYSTERY MUMMY MYSTERY

Sometime after the dinner hour, malicious miscreants broke into the prestigious "Living Desert Museum," and absconded with the Mystery Mummy exhibit. The loss of this valuable artifact and popular tourist attraction caused widespread concern in scientific circles. The mummy, which was the dehydrated remains of an unknown personage found resting on a chaise lounge in the middle of the desert, was considered irreplaceable. The missing mummy was located five days later comfortably reclining amid the plastic plants next to the empty swimming pool (drained for the drought) atop the old Pasadena Hilton Hotel.

LOST HORIZONS

At 9:45 p.m. on a desolate curve near the summit of Diamond Back peak, the skater stood. He was not alone, for two men from the Highway Patrol were explaining to him the dangers of high-speed skating at night. Having been clocked at around 55, the rider remained silent, having no appreciable defense. Upon the scene drove Skip Engblom in his '49 Gray Ghost Cadillac. Recognizing a friend in distress, Engblom loaned his considerable diplomatic skill to the situation. The law agents, learning that the speeder was former champion of the world, were duly impressed, and agreed to pass on it "till next time." Witnesses insist the skater's identity to be one Dan Bearer, a true legend in his own time. Furthermore, his alleged equipment was vintage Team Hobie with clay composition wheels. Both Bearer and Engblom refuse to comment on, or clarify, any details concerning the event.

Muir—Red Dog frontside axle slide.

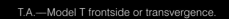

T.A.—Model T frontside or transvergence.

Jay—flyaway, episodic discontrol.

THE VISITATION

Paul Consantineau and Dexter Green moved swiftly across the canyon floor down to the riverbed. The setting could have been hundreds of years ago—Chico-y-Inyos hunting in the moonlight among the reeds and cattails. However, our latter-day explorers had a different sort of game in mind. The lunar lamp illuminated the spray-paint-festooned walls of the massive concrete arena, as they climbed down into it. The adventurers were fully equipped, having brought a complete skate arsenal, 150 feet of rope, climbing equipment, a couple of breeders for entertainment, and a camera to record the lunar eclipse with. They partied and skated the flood control until the hungover hours of early morning when they stopped to view the zenith of the eclipse. At this point, just exactly what happened next is obscured by the variety of the observers' personal narratives. A summary is as follows:

At approximately 2:09 a.m., a large spherical, metallic form appeared overhead directly across the canyon. The craft hovered for several minutes while emitting rhythmic servomechanical sounds and exotically colored, high-intensity light beams. The only onlookers were basically mesmerized, except for Paul, who had the presence of mind to snap a photograph. Eventually the ship banked sharply to port and accelerated out of sight in six seconds. After its departure, all present agreed to a code of silence, since they reasoned that no one would believe it anyway. The *Los Angeles Times* the next day related sightings of an unidentified flying object traveling at extremely high speeds. Reports were filed by such varied beings as: Spaceship Ruthie, who was contacted by the aliens on her mountaintop thirty-five miles east of San Diego, where she had erected large billboards saying, *Welcome Space Brothers,* the Orange County Sheriff's Air Patrol, the LAPD's air watch, several residents at the Camarillo State Hospital, and the United States Air Force. Several days later, Paul and Dexter retrieved their now-developed film from the local Fotomat. To everyone's amazement, a non-metal-organic glowing object was clearly visible in one of the pictures. This incident proves that in dealing with energy, the thing is not to go find it, but to let it find you.

ADIOS AMIGO OR EL DESTRUCTO

The sky was merging from the blackish-purple opacity of night into the bluish-purple opalescence of the predawn hours. James Muir, West Humpston, and John Palfreyman were engrossed in a vicious and frantic session in the old canyon pool, once a lovely oasis on a corner of citizen-statesman Leo Carillo's estancia, which was going to fall under the wrecker's ball. Carillo's Santa Monica Canyon estate was one of the last remaining pieces of the original Spanish land grant, which gave birth to the area. It was an eerie scene as the sun rose, highlighting the thirty-five-foot cacti surrounding the pool, and the massive yellow Caterpillar destruction equipment poised nearby. The workers were quite congenial, even allowing the skaters a few additional rides for old times' sake. Then they wheeled in the hydraulic arm, which unceremoniously shattered the pristine bowl with its 5,200 pounds per square inch of pressure. The entire proceedings took only a couple of hours from the first crack until they hauled away the last scrap of coping. The amazing thing is that the canyon pool had managed to last so long. For over three years it pulsated as a hotbed of skate radicalism. The cops and neighbors had established a truce with the skaters, who in turn self-policed the area, keeping out all undesirables. A steadfast rule of no commercial photography helped keep things quiet. (This dictate was only broken once by someone who never came back again.) The intelligent control demonstrated at the canyon pool offers a direct contrast to the recent tragic busting of Bisquit Flats by individuals bent on greed and self-promotion, rather than the good of skating as a whole. It's just like White Boy discovered: you can burn your money, but you can't burn your friends. Keep it cool, and all concerned will benefit. Otherwise, it only takes one jerk, and it's gone for keeps.

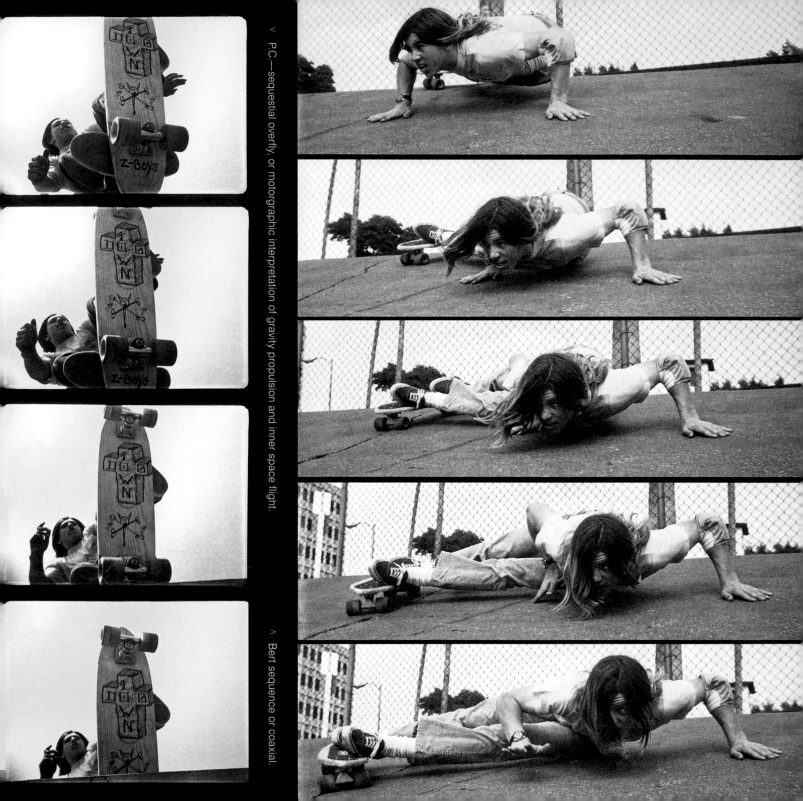

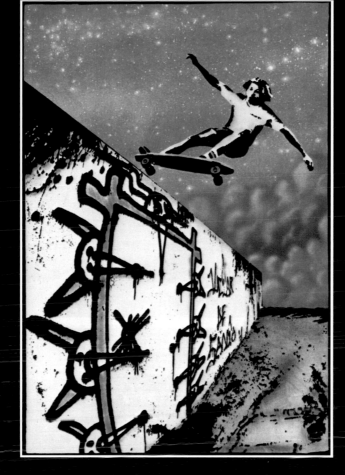

THE WRITINGS ON THE WALLS

Conflicts, being what they are, come and go. It seems that in these recent days, certain negative utterings and slurs have been directed toward the DogTown province by persons whose credibilities remain unknown and unproven. The canine community remains largely silent, since the time of reckoning is soon at hand. Perhaps during these troubled times, the cryptic truths are best revealed, as in the Bible, by looking at the writings on the wall. A recent survey of assorted walls in Santa Monica, California, provides these pearls of wisdom.

Live clean, skate clean, crossed out and replaced with, *Get down and dirty.* —General Telephone building
Southern Comfort puts you to sleep. —Back of Star Liquors
Flush Twice, it's a long way to El Cajon. —Interior Municipal Pier restroom
Repent—your time's gonna come. —Main Street Mercy Mission
You may think that you are, but we know that we are. —East River pumphouse
. . . and, *For a good time call 399-9911.* —Alley behind Gold's Gym

Truth is wherever you find it. Look around, the only question is . . . once you find it, how are you going to use it?

Gazing through smashed barriers: Paul Constantineau.

TRUTH OR CONSEQUENCES
OR LET'S NOT AND SAY WE DID

THE CLEANING UP OF A SKATE GUERRILLA

Home of the unsung heroes, it's the other side of pool riding, the unadmitted and unspoken one. Where do all these swimming holes come from? How do you find them? How do you gain access? How do you escape when the going gets tough? Such are the realities of the oval-obsessed skate guerrilla. A vanishing breed, perhaps, but a resourceful and persevering one nevertheless. They are the frontiersmen of the sport/art, always pioneering new ways to skate even newer places.

The infamous Red Dog and Bull Dog are typical of the kind. Otherwise known as the Dog Brothers, these gents are among the elite vanguard of the pool-riding movement. Members of an elaborate communications network which stretches from border to border and coast to coast, the pair are continually exchanging information and locations with their numerous cohorts in bowl detection. The Brothers, over the years, have gone to incredible lengths to locate the paramount skate-riding environments. They made numerous trips to the Hall of Records and to the Department of Building and Safety to obtain much-needed blueprints and diagrams. Another time, Bull Dog and an unnamed female accomplice posed as a house-hunting married couple, and were taken on a tour of pool-riding mecca by a Palm Springs real estate agent. The salesman thought Bull Dog a bit eccentric to insist on testing all of the pools for stress by using a 27" board with wheels on it, but he realized that a gentleman with such exacting standards was the ideal customer.

Then there were the three days Red Dog spent aerial charting and photographing all of the basins (in conceivable traveling distance) from an Aero-Rents helicopter. (Red Dog had worked out a rather exotic trade with the copter's pilot.) Of course, for sheer bravado, who could forget their memorable exploits at a high-security federal government pipeline project. In this episode, the Dog Brothers, armed with only dime-store variety tin sheriff's badges, obtained access to the site on the pretense that they were "undercover agents" on patrol to keep out the skaters who had been assaulting the project's cylindrical surfaces. The Brothers, not being the sorts to let a good thing die, managed to keep up the charade for fourteen days. Red Dog, feeling exceptionally pleased and confident, felt no threat as the fellow wearing the Ban-Lon sports shirt with button-down collar and wingtipped shoes approached, carrying a walkie-talkie. Probably another surveyor, he reckoned. Unfortunately, he reasoned incorrectly, for the person in question turned out to be the real undercover agent assigned to skate patrol. Red Dog and Bull Dog, being very personable types, managed to talk their way out of certain confinement, but they still had to turn in their badges.

Some time after this encounter, Bull Dog mentioned to his partner that perhaps they should both find a new line of work. Brushes with the law had been commonplace; it was just that now the law knew who they were. The jig was up; the Dog Brothers figured that they had pushed it further than they should. While the last time had been cool, the next time definitely wouldn't be.

Taking inventory, Red Dog wondered what they would do with their completely restored war-surplus German command car. The unit was equipped with police-band, citizens-band, and short-wave radios, quadraflex tape player, auxiliary night lights, power generator, complete wardrobe changes, and their most prized possession—a high-capacity silent-running portable water pump. Bull Dog commented that considering their vast experience at emptying out pools, and since they already owned the uniforms emblazoned with the Pinnacle Pool Maintenance insignia, that perhaps they should go street legal.

Currently, the Dog Brothers can be found conscientiously working the pools on their appointed rounds. Being experts in their field, they frequently advise their clients to let the now-drained pool dry out a few days longer before replastering. Red Dog says that he misses the old days, since now they must work so hard. "Some days we have to ride three or four pools." Bull Dog advises that "the money ain't bad."

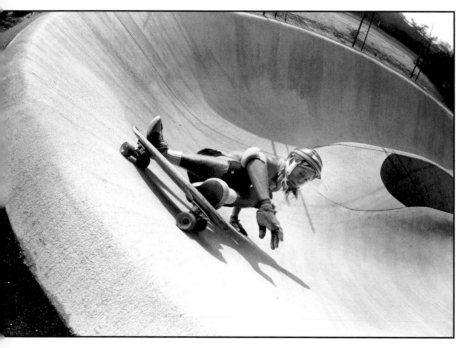

Stacy Peralta redirecting off the wall at "Concrete Wave."

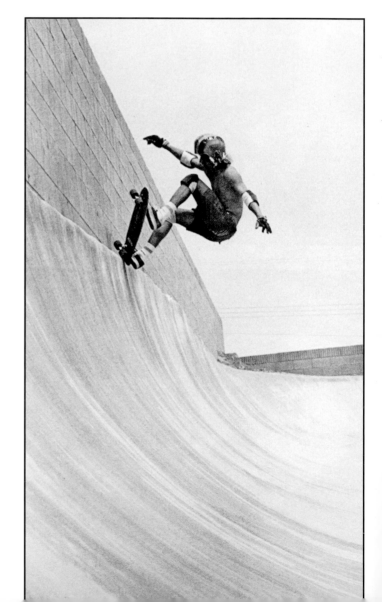

Tony Alva hovers at the top on his first ride at a new park.
Alva's comment: "You can buy a thrill."

THE FUTURE IS NOW

While the Dog Brothers and others like them indulge in the laissez-faire style of skating, others labor to "clean up the sport." Now everyone digs a truly clean scene, but there exists much confusion as to exactly who is doing what, and for what reasons. The future being now, maybe everyone ought to wake up and get on it. We've all got a stake in skating, and the better the sport/art as a whole does, the better everyone does. Whether you skate for pay or play, it's all interrelated and interdependent. At present, in certain quarters of the skate phenomenon confusion, greed and dishonesty threaten to displace the essential essence of skating itself: enjoyment.

ASSOCIATIONAL DISASSOCIATION

The proliferation of conflicting and competing governing organizations seems to be strangling the skating community in their struggle for power. How many organizations do you really need? How many do you really want? While some undoubtedly strive to improve the lot of the skate, others' motives are open to question. With similar names and similar claims, yet with different intentions, it is at this time impossible to figure out. It's becoming a question of which side you are on, yet the unwilling player/participant is unable to discern the nature of the games.

If people desire to form an association, that's fine; the problem is that many of these outfits drag the skater into needless unwanted political head trips. A typical way is by forcing the rider into dealing (joining) with them in order to skate competitively. In the contest sphere, there are so many differing and often opposing governing bodies, each with its own rules, sanctions, approvals, judging "systems," awards, rankings, classifications, professional and amateur distinctions, equipment guidelines, protocol mandates, etc., ad nauseum, that the individual skater finds himself alienated and excluded from the very same factions which are presumably acting for him. People have got to start asking who some of these rule makers are, and whom they answer to.

STRANGE GOINGS-ON IN ORGANIZATION LAND

Promoters who desire to get in on some quick action initiate their own supervisory group, which in turn sanctions its originators' various scams. Contests, magazines, television package deals, motion picture enterprises, and commercial endorsements are their most common areas of involvement. In their not-so-subliminal seduction, the promoter often wines, dines, and shines the skater. One continues to wonder if each successive enterprise will turn out to be another "evil" soggy-rocket snake shot.

The antics of these shuck-and-jive masters are quite humorous (if you ignore their more sinister implications). Consider the case of the promotional czar who, in public, adamantly advocates the use of protective gear (a good move, for sure), yet in private eats it at 35-plus, without helmet or pads. Another interesting fellow, who was backed by an impressive array of establishment approvals, claimed to be an emissary from the Magic Kingdom. He recruited an assortment of big-name skaters to appear in his feature-length film, a TV show, and special appearances. This gent rapidly became the darling of many until someone had the foresight to question his credentials. Everyone at Disneyland was queried, and no one from the head mouse to Tinkerbell had ever heard of the guy.

Paul Cullen, at age fourteen, effectively works out on the coping, proving that knowledge isn't necessarily related to age.

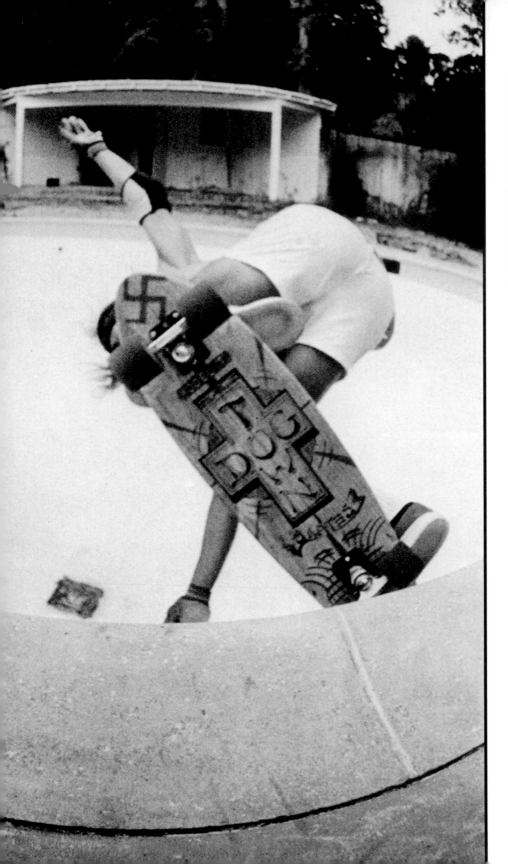

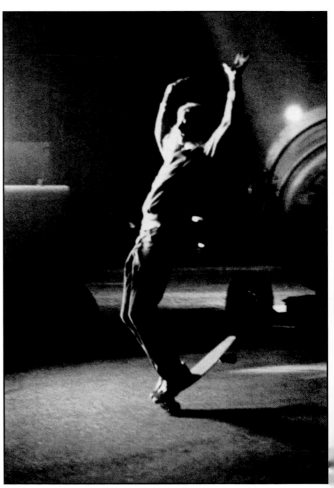

Peralta cruising in the highlights off Hollywood Boulevard.

< Alva's vertical stroke at a pool known simply as Adolph's.

While we're at it, let's not forget the man with the applause meter in one hand and the sixteen-page contracts in the other. Or how about the boy from the Big Apple with his big talks and his low pay (less than union scale)? Each of them tells you that their truth will set you free, but the only constant truth is, fifteen will get you twenty. Can this be the law of the excluded middle, or is it only the sound of no hands clapping?

The dealers have given us so many current "world, international, inter-planetary, national, multicontinental champions" that rational thought precludes the possibility that they all are residents of this earth. Things have gotten so shockingly bizarre that, as rumor has it, a certain governing group is going to stage the qualifications for its heavy-duty championships at a remote location thousands of miles from any major continental US population center. If that isn't strange enough, no one seems to know how to qualify for these qualifications.

MEDIA BLITZ

The continual media barrage of skateboarding material remains astounding. An abundance of diverse quality pieces frequently appear in both print and film. On occasion, the perpetrators of these works seem concerned only with getting the job done as swiftly and cheaply as possible. In print, the objectivity level can be particularly low. Sensationalism appears to be many tabloids' rule, but if you want to really read about skateboarding, you go to a skating periodical, not to some chickenhawk journal or women's skin rag.

The greatest potential public exposure of the sport/art undoubtedly lies in television. The medium of the present, it offers widespread, easily accessible, instant communication. TV coverage, at present, leans toward flat-bland freestyle contests that visually are little changed from the sixties documentations of the Anaheim Championships. Besides the occasional skate stuntmen who are "bonged" on *The Gong Show*, there have been little diversions on the old cathode-ray tube. Bank, pool, cylinder action is reportedly in the works, and should completely restructure the thinking process of the general video public.

Properly directed, television has the inherent capabilities to revolutionize competition as we know it today. Record the meet's action with multiple cameras on video tape and then replay it. The participants could also become the judges by reviewing the tape. Collective judging and video analysis would lead to fewer disputes and a greater common understanding. A commercial TV production of such a process (i.e. skating, filming, and reviewing) could have wide-based public appeal. The public's awareness of skateboarding's finer points would be vastly improved by such an undertaking.

The future offers a kaleidoscope of opportunities. The possibilities of quality equipment and combinations of same are nearly limitless, and things will only get better. The progressive skate park operators have begun to approximate more advanced riding terrains. Banks, pools, pipes, and such will shortly be widely available. The further the skaters push it, the further the enterprising park operator must go as a matter of economics. More radical moves require more radical parks. The great thing about skating is that you can do it anytime and anywhere. So take it wherever you find it, and work the hell out of it. Second best isn't fun at all. If you can't be bad, be good. Your galactic tomorrows are on the line now, so do it up right.

Wentzle Ruml . . . original (and radical) stylist.

WENTZLE RUML

Eighteen years old, rides for Town & Country/Z-Flex

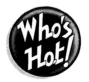

Wentzle Ruml is a man of few words with a heavy rep. Stacy Peralta credits Wentzle with pioneering the 360 slide. Tony Alva says Ruml was the first to execute the elusive 180 lip slide into a 360 roundhouse and back into a 180. The following interview was conducted in the kitchen of Wentzle's North Shore home while he cooked Swanson beef pot pies and listened to Hank Williams, the crying country crooner, on the stereo. It appears in the unadulterated question-and-answer format because Ruml insisted on no embellishments—"just give 'em the facts."

Hometown—"DogTown."

Skating experience—"Six years."

Favorite type—"Pools, bowls, banks."

Equipment—"For pools, 30" slightly kicked 1/2" ash (very light) with Bennett's and 4s; for freestyle, 28 1/2" ash square tail with moderate kick and full plan shape, mounted with Bennetts and 4s; for banks, original Z-Flex with Bennett Pros and 6s with open bearings."

Style and goals—"A smooth but radical style flow. Always try to go further, always try to make it harder than before, to keep pushing it beyond the extreme limits."

Favorite skaters— "My friends . . . you know who they are."

Up-and-coming skaters—"Jay Schien—he drives his VW to all the local spots and rips."

Favorite spots—"Mainland, Skatopia, Bellagio, Kenter, Canyon Pool, B-pool, Manhole, Highland, La Costa, Islands, Wallos, Kammies Drain, Master Blaster, Uluwatu, and Spreckles Ditch."

Favorite musicians—"Lynyrd Skynrd, Allman Bros., Gabby Pahinui—see 'em as often as possible."

Contest experience—"Placed second in freestyle at 1975 Hang Ten World Pro-Am."

Comments on contest—"Getting there wasn't half the fun . . . it was the only fun. Definitely not into organization; am waiting for money in pool and bowl action."

Brushes with the law—"Six citations for various skating infractions."

Safety equipment—"Possess all pads."

Injuries incurred—"Lost three teeth, received sixteen stitches in lip, dislocated elbow—had equipment on, but it didn't prevent these . . . it could have been worse."

Surfing equipment—"Kneeboards: 5'3" x 19" square tail winger, and a thin 5'6" x 18" winger swallow. Both are Dean Edwards shapes with airbrush by Chris Cahill."

The future of skateboarding—"What is that question . . . tomorrow is the future of skateboarding."

Advice—"Break out the stick and giveee-um."

High point of career—"Being discovered by Skip Engblom doing Berts under the Ocean Park bus at the Third Street stop." Engblom's comment: "He always missed the rear wheels, so I picked him up for the team. I had the feeling that we had to get him off the street if he was gonna last much longer."

Future plans—"None of the above."

Alva: Getting down at Upland.

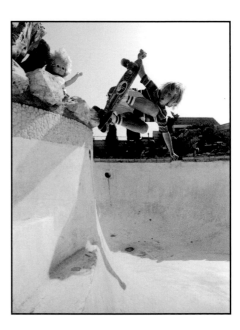

A typical picture of Arthur Lake
rocking out at the old Manhole.

Opening Day At The Park

BUENA PARK

Actually, it wasn't really opening day, because the management had allowed the skate cognoscenti to cruise the contours in the interest of design feedback. It was the official opening day, and there were plenty of officials there.

On tap for the occasion were the mayor, various councilmen and assemblypersons, Miss Buena Park, the chief, the police, insurance agents, the black pimp from Baretta, lovely little Laura Thornhill, the Good Humor man, assorted groupies, television, radio, and other media personalities. There were some of the best; there were some of the worst. You could have been blinded by the magnitude of the straight. The paramedics were on standby while a couple of hundred eager kids awaited their turn to sample the new topographies. All in all, it was a cosmetically clean deal.

The skateboarders had spared no expense, and even the most minute details were scrupulously attended to. The pink champagne in the long-stemmed glasses, the super graphics on the walls, the housing-development-style festival flags, and the hand-dyed green grass all added to the professional presentation.

SIDELIGHTS

The Price is Right

A manufacturer, who shall here remain unnamed, reportedly handed out forty "team" jerseys to riders he had never laid his eyes on before. Now we all know you can buy a name skater for a day's photo session with your product, but who would have ever dared dream of getting forty at once? They must be cheaper by the dozen.

It Was a Long Way from San Bernadino

Two Hell's Angels from the San Berdoo chapter lounged on their chrome-laden Harley Hogs in front of the Pro Shop. With them, wearing mirrored sunglasses, white Italian shoes, black satin shirt, and bloodred corduroy pants with a Gucci belt, was Paul Hoffman. While claiming to be an incognito skate star, Paul discussed the virtues of suicide shifts on Sportsters, and made comments to the passing females. A typical passage was, "Hey, sweetheart, turn around; I think I am in love." When the girl would look around hesitantly, Hoffman would deadpan, "Sorry, baby, I can tell I made a mistake." After a while, the Angels, who themselves looked slightly out of place, were thinking out loud that this licentious youth was totally out of sync with the surroundings. To counter the bikers' suspicions, Paul grabbed a skate that he had stashed in the bushes, and promptly cranked fourteen one-footed nose 360s. The two Angels, obviously more dazed than confused, kicked their starters over and split.

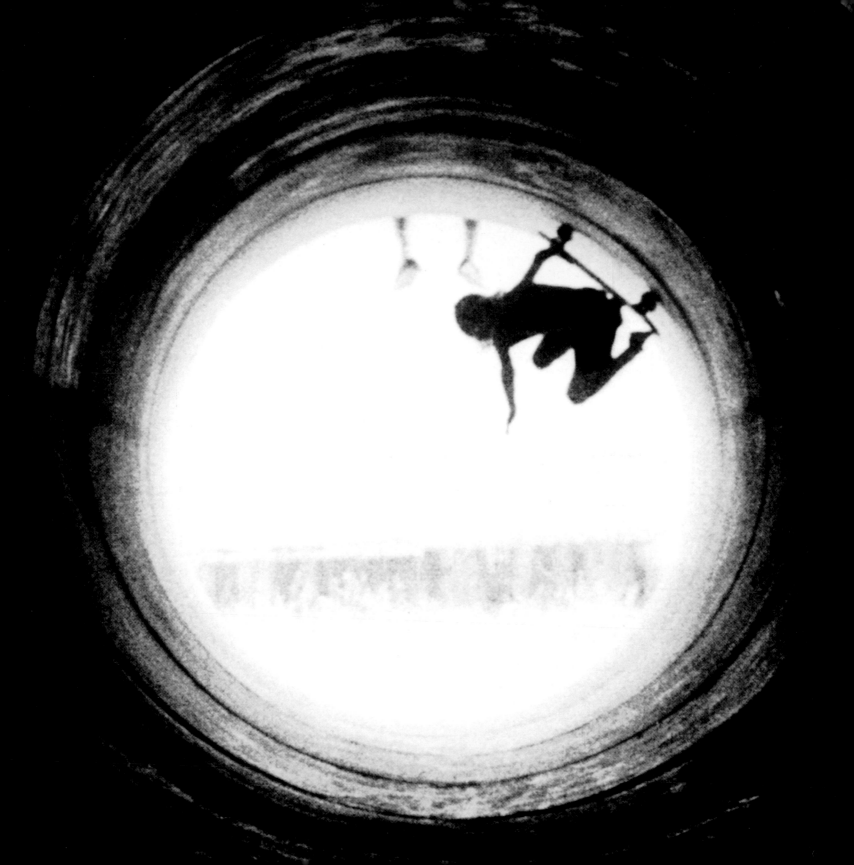

THE GREAT PRETENDERS

The people at the registration desk were continually confronted by media pretenders, all desiring access to the event. Depending upon their act, they usually claimed to be from either *SkateBoarder, Rolling Stone,* or *Sports Illustrated.* With the Beast, Giggles, Seymour Snow, Ray Woody Allen, the Dull Brothers, Tall Dog, Tarzan, Junior, Sam Fernando, James Cassimus, Tom Robbins, and all the rest of the "real" media men present, it was a hard body to crash.

THE CHALLENGE

The Pepsi-Cola Skateboard Team was hovering on center stage. Stacy Peralta's sly, slick, and subtle humor on the microphone had the audience in stitches. The members of the Pepsi unit displayed a variety of freestyle forms that surely changed some minds. The surprise of the show came from the ever-amazing Waldo, who gave the assembled multitudes an eloquent safety-first speech. The new Autry is such a credit to the sport, one wonders how his old sponsors at Becks Brewery ever allowed him to bolt the fold and take up the Pepsi Challenge. After the demo, Greg Ayres categorically stated to this reporter that he's never heard of anyone named "Queaver" or of a maneuver called a "boinker."

FAR FROM THE MADDENING CROWD

Ignoring the celebrating convocation, Lonnie Toft, north countryman, was undergoing some strange transformations atop his eight-wheeled, wide-bodied skate vehicle. Several gathered around the back pool in astonishment as Toft rolled continual one-wheelers (seven wheels out). It was a form of riding not many have witnessed before, since there are few practitioners. The word *outrageous* routed out on the bottom of Lonnie's board best describes his actions. The configuration of his wheels, the inherent flex ratios, and the ample plan shape of the board all make the unique weight-leverage characteristics. Those who have ridden Toft's crafts have commented that the sensations are quite close to the surfing experience. Critics have called the eight-wheeler unfunctional. Lonnie just calls it fun.

THE GAZE OF THE GLASS EYE

Packs of photo documentarians stalked the environs seeking activities to scrutinize with their glass eyes. Throngs of starstruck hopefuls gravitated around the more notable shooters in the same manner that planets orbit the sun. In short duration, the lens boys had almost unanimously decided to confer their attentions on Tom Inouye. (It was a logical choice, since "Wally" is one of the few individuals around whom people had heard about long before they ever even knew his name. Succinctly stated, his reputation was not built upon media hype. No matter what anyone tells you, it's what the boys say on the street that counts.) Unfortunately for the photographers, Inouye seemed either unaware or uncaring about their activities, and he repeatedly alternated runs, and in general avoided the scene. It was quite humorous as those dedicated disciples of the great yellow father, George Eastman, set up to shoot the skater only to discover that their target was in another vicinity. They would swiftly relocate only to find that the elusive lad had escaped from their sight once again. When they momentarily encountered him, it seemed as if his super-quick moves far exceeded the technical proficiency and lag time of many of the photographers. Wally would do a stylish front-side roll four or five blocks up the wall, and depart while the cameramen were still fumbling for their shutter buttons. You have got to be quick to catch lightning in a jar, and you have got to be high to see it before it falls. It was just another day in Buena Park. It was all done in fun.

Tony Alva: high lines in the Upland blow hole, where it's always 110 degrees in the shade.

GETTING DOWN IN UPLAND

Sessioneering, somewhat akin to imagineering, is that unpredictable aspect of the skateboard experience that occurs whenever the varied personages who comprise the contemporary vanguard assemble together. The action is always faster, always more furious, and the limits are always pushed further than ever before. The sight of these high-octane situations continually floats. Since paths invariably will cross, the sole determining factors are the skaters present. If you get the right combination of terrorists, it's going to happen no matter what. You can't prevent it, you can't control it, and you can't avoid it. The only thing left to do is sit down and dig it. The sight might be in the wilds at a spot known only to the inner circle, or may be in a more public forum. On a day close to the 4th of July, in 1977, it all came down at the Pipeline Skatepark in Upland, California.

Foster DuPont, heir to paint and chemical fortune, man about town, and a skater of incredible dimension, had the word, and was on his way. He had gotten the basic drift that morning at a freeway fakie session on a curvilinear banked support under the overpass on Interstate 105. It was while piloting his pearlescent-blue-flamed '48 Chevy lowrider through Pomona that a garbage truck tried to pull the old two-lanes-into-one squeeze play. Foster put the accelerator to the floor, and cleared the intruding truck by inches, and gave the other driver an appropriate gesture. Instantly the red light of the Highway Patrol summoned both refuse carrier and the lowrider to the side of the road. The garbage man received a ticket for his trouble, while the cop only wanted to check out DuPont's mobile.

The officer, having expressed surprise at the rider's sudden burst of speed, was treated to a viewing of Foster's 427-cubic-inch, fuel-injected Corvette engine and five-speed box. Fully stoked, the patrolman remarked it was the first fast-action lowrider he'd ever seen. The law agent was particularly enthralled with another of the modifications to the car. Never wanting to be thirsty during his travels, the millionaire mechanic had converted his trunk into a refrigeration unit. The cooler was stocked with favorite elixirs, including cases of Pilsner Urquell, Löwenbräu Zürich, Anchor Steam, and Heineken Dark. Foster offered the lawman his pick, but the latter declined since he was still on duty. In consideration of DuPont's lack of familiarity with the region, the cop gave him a one-motorcycle escort to his destination.

The gang in the Pipeline parking lot were aghast as the lowrider slunk in with its legal guardian's siren blasting. Foster glided from the auto, waved goodbye to his nowfound friend, and surveyed the situation. At that particular moment, the activity was halted, since the unrestrainable Jay Adams had put out fluorescent lights on top of the twenty-two-foot cylinder. While the attendants swept up the remaining glass, the park's owner drew plans for a protective shield to guard against any future shattering occurrences. The crew was clustered at the mouth of the tubular playground, trading lines and attacks. Alva and Biniak were making extremely high frontside drops. Waldo pushed his backside to the hilt. Ayres dwarfed the concrete closure with authority. The local Crazyman projected some acute climbs. Thai Creenst showed his usual force. Peralta was doing 360s past the vert. Wally was launching free flights off the lip. On one memorable ride, James Muir, skating with a broken arm, transversed high into the fourth quadrant, and free-fell the full measure, landing on his cast, which caused one female onlooker to faint dead away. (He continued to skate after comforting the lady in distress.)

It went on like that for hours, and since such intense feats take their toll, we finally had to adjourn. We fled with DuPont in the Chevrolet Deluxe, and headed for the darkness of LA at night. As we departed, Dan Devine pulled in with Paul Constantineau and Shogo Kubo in tow. Reports circulated that the Beast was bringing more famous faces. Yes, the heat was on . . . and it was only going to get hotter.

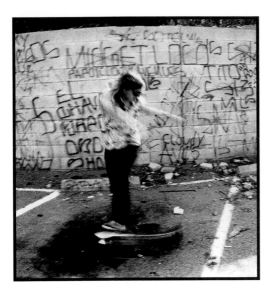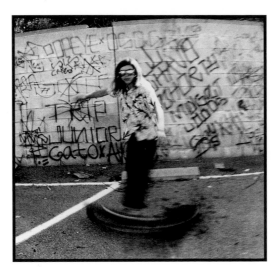

Paul Constantineau proves style doesn't come free.

PHOTOS OF GHOSTS, OR TUBE SHOOTING

The phantom-like projections of a projectile in flight. The potentiality that compromises the great part of actuality. These were the things the young skater realized intuitively, but had never bothered to dwell upon. All of the above, and more, were about to become physically apparent to Arthur Lake.

As he neared the end of the five-mile hike to the rumored location of a downhill pipe, the fragrant scent of the surrounding lemon groves wafted over the mountain ridge. Lake's superbly trained pigeon, Maxfield, was aloft in the point position. Anticipations were very evident, since Arthur and his companions had driven 150 miles from the coast to check out the reported cylindrical concourse. They realized that the pipe might turn out to be nonexistent, but had decided to take a chance . . . After all, it's not where you go, but how you get there that counts.

Reaching the summit, they looked down into the valley and saw the concrete cage bore into the mountainside. It was a pipeline all right . . . but there was one major drawback. The pipe measured only eight feet in diameter. Lake's companions, older in age and experienced in the ways of pipes, dejectedly informed him that the pipe's diameter was about eight feet less than the amount necessary. Sixteen feet would be acceptable, but this could never do it. Because it was Arthur's first pipe venture, he refused to take no for an answer. Promptly, he ventured into the "too small to ride" pipe, and began to perform acts that astounded his taller compatriots. Using a borrowed skate, quick reflexes, and sure determination, Lake was powering for the vertical loop. His friend, who had made statements regarding the "impossible," now looked on in amazement. Maybe he would pull it off. All the experts had been saying that you needed the correct incline and a properly intersecting pipe to do it, yet here was this kid cranking near-upside-down backsides, and calling for more.

Arthur is clearly more into doing than listening about what cannot be done. As of this writing, he hasn't made full circle yet, but he's going for it. It could only be a matter of time. Right now, no one's betting against it.

IN THE FRENCH FASHION

Chris Cahill and Paul Constantineau were hanging in the parking lot overlooking the beach where the old P.O.P. pier used to be. When the surf was blown out, there wasn't much else to do. They were approached by an ultra-stylish foreign man in odd (for the beach) attire. In later discussions, they referred to him as "the swish in the gray velvet suit." The guy related that he was an art director from the fabulous French fashion magazine *Paris Vogue*. Having noticed their skateboards, he made overtures to them about doing some "tricks" in the background of a layout he was shooting. Constantineau told him that they didn't do tricks, while Cahill just laughed. The art director, not getting the gist of the conversation, persevered. "We don't do freestyle," Cahill interjected. "My frens, zat is toooo bad, since I will pay very goood," the Frenchman said.

With that, the foreigner had their interest, and further mention of six French fashion models didn't hurt his cause any. "How much?" Paul inquired. The answer being one hundred dollars, the boys stated that although they didn't do freestyle, as professional skaters, they would fake it. The man from *Paris Vogue* drove them to the shooting session in his immaculate cream-colored Bentley. His well-groomed black Labrador retriever with the rhinestone collar rode shotgun. "Must be this year's 'in' dog," Chris mused.

After skating for one-half hour, they received their checks. The fragile French fellow, feeling pleased with the enterprise, praised them extravagantly, "Oooh, my frens, see you can dooo zee freestyle." P.C. just looked at him and said, "Naw, buddy, you got it all wrong, that was zee hundred-dollar style." These days, style doesn't come free.

ARTHUR LAKE IV

Fourteen years old, unattached

Arthur Lake figures he started skating two years ago when his father decided to drain the pool conveniently located in his backyard. "It was just sitting there empty, so I decided to try it. I had to try it." Actually, Lake had ridden "occasionally" since age six when he began to negotiate the road at Malibu's Corral Beach on his clay composition-wheeled Black Knight skateboard. The only things Arthur recalls from that period are "rocky roads and skinned knees."

From the beginning, Lake felt the correlation between skating and surfing. (His father had introduced him to surfing a year before the skater's initial Black Knight adventures.) Currently, this association is underscored by the fact that Arthur's home, in addition to having the aforementioned pool, is located on the beach. If you take years of surfing and skating exposure, add a good pool in the backyard, and toss in constant jamming with all of the best skaters in DogTown, what results undoubtedly is a stylish, aggressive, and technically proficient rider. Arthur Lake fits the bill, and then some.

Tony Alva, Stacy Peralta, Bob Biniak, and Jay Adams all rate him as being in the contemporary pool-riding vanguard. In view of his abundant abilities, some may find it strange that he doesn't yet have any commercial affiliations. Lake has received offers from several manufacturers, but has not found an organization he feels comfortable with. "Teams are doing too much stuff . . . they expect you to ride their products, but a lot of time their equipment isn't very good." Reservations like these caused him to recently turn down membership on a highly prominent team. "Their boards just wouldn't work for me; I could never get them to happen." Arthur obviously takes his choice of equipment very seriously. His present lineup consists of:

For pools: a 27 3/4" DogTown skate. "It's my main board . . . very light in weight." Dimensions—8" wide at outline's fullest point, 5 1/4" wide tail with 1 1/8" rise, rear truck mounted 4 1/2" up from the tail, a 5 1/2" nose with the forward truck positioned four inches back from the tip. The thickness is a 7/16 of an inch.

For running gear: Half Tracks with Tunnel Rock wheels and Keinholtz precision bearings with open faces ("Must be blown clean after each session").

For parks: the 28" standard Adams Z-Flex mounted with Bennett trucks and Road Rider 5 wheels, with Keinholtz bearings (open-faced). Axle ride mug shot.

For downhill: a 36" Muir-Humpston design set up with the Tracker trucks (wide) and Road Rider 6 and Keinholtz bearings (open-faced).

He uses Minnesota Mining and Manufacturing Diamond Gut Adhesive (3M-1J604) on the decks of all his boards.

Bob Biniak, Paul Cullen, Tony Alva, and James Muir are Arthur's favorite skaters, and he adds that he's been particularly influenced by Biniak. "I'd just watch him and try to do what he was doing." He says that young DT local Bella is the most up-and-coming skater he's seen. "He's four feet tall, and rips pools and banks." At five feet in height himself, Lake thinks that the shorter skaters have definite advantages over their taller counterparts. "Being smaller, you can expand your skateboarding a lot further . . . you can fit into a tighter space, and you also can do some things a lot longer."

On the topic of skating environs his favorite are: Bel Air (for backyard pools), Canyon Pool, Daly City Pool, Los Gatos Pool, San Francisco City College, Pipeline Park, Reseda Park, and the San Jacinto Tunnel.

Talent-wise, Arthur rates the Santa Monica region as "the hottest . . . we've got the number one riders," and adds that "DT rules the pools." The "up north" locals hold the best future prospects, in his estimation. "Marin's the new hot spot; they've got a great drought going, and all the pools are drained."

For general advice, Arthur offers, "Go all the way when you ride pools, and don't think about falling. If you're scared, then you are going to fall and hurt yourself."

Lake's usual activities revolve around skating and surfing, "up north in the winter, down south in the summer," and, of course, school, where he is eyeing an art career. Immediate future plans include getting a new Stinger swallow, and obtaining a Screen Actors Guild "A" card. This card will allow Arthur to work at the major studios doing "background and possibly stunt work." Considering his wealth of theatrical background (his great-grandfather was a circus performer, his grandfather and grandmother were both well-known actors whose parts included the title roles in the Dagwood and Blondie films, his great-aunt Marion Davies was a famous leading lady, his godfather Johnny Weissmuller is a former Olympic champion swimmer, and was the screen's most distinguished Tarzan, and finally, Arthur's dad is a stuntman). It might not be long until we will be hearing of the skater's cinema exploits.

Like we were saying, the kid is going places.

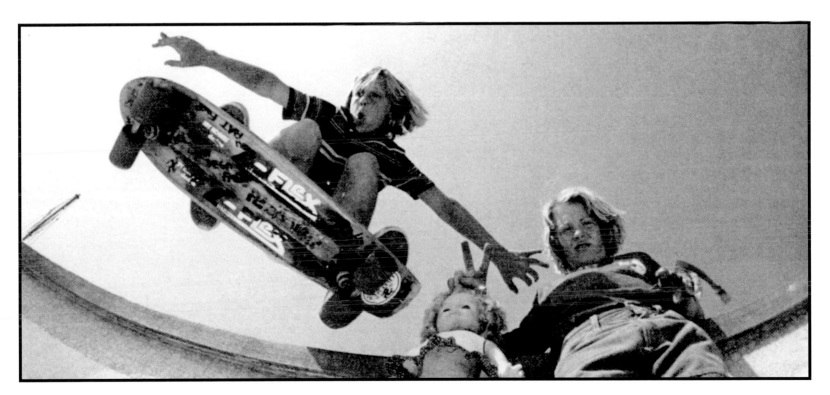

A snake shot of Lake with a borrowed skate; Cullen with a borrowed doll; and Chatty Cathy with borrowed time.

SKATEBOARDER INTERVIEW HIGHLIGHTS:

Bob Biniak

A member in good standing of the no b.s. school of skating.

Somebody once said something about walking softly and carrying a big stick, a statement which aptly describes Bob Biniak's position in the pantheon of skate notables. His reputation in the sport/art centers around his unparalleled aggression and continually unique moves on and in radical terrains. Coming from what is generally regarded as a hard-core area (DogTown), Biniak has always been recognized as one of the prime exponents of the region's uncompromising style. However, aside from his skating, Bob remains an enigma to the general public. He doesn't speak often and he doesn't say a lot; but when he does, people listen 'cause he's known to back up what he says to the hilt. This interview was conducted in between his morning round of golf at the Rivera Country Club, a luncheon pool shoot at the Dog Bowl, and *Hustler's* opening at Gazzari's on the Sunset Strip. Read on, 'cause this constitutes a rare insight into the thoughts of one of the leaders of skating's avant garde.

What do you think about interviews?
I really don't think about 'em, so that's why I don't know how this is gonna turn out.

I've heard a lot about your DogTown training program. Would you care to go into that?
Sure. A lot of people seem to think that DT boys are just partying radicals, but actually we're professional athletes with a full training program. See, we get up every morning at six o'clock, and jog on down to Gold's Gym, pump iron for about an hour and a half, then after that we go for a run to the top of Topanga Canyon and back. It's really good for your stamina, and it really builds up your endurance on the high-altitude climb up Topanga. The beach part of the run builds up those calves and ankles. And then it's off to three or four hours of skating. After that, it's off to the health club for a swim, steam bath, and good rubdown. Then we have the evening meal. We always set a full training table. I think proper training and conditioning is what separates the men from the boys. Why do you think Bruce Logan's been on top for so long? It's entirely due to his strenuous workout schedule.

What are your future plans?
In the next couple of months, I'll be going on a world tour, and I'd like to break the world speed record on a standup skateboard. And for right now, I think I'll go to the Chart House for a lobster dinner and a few mai tais with the boys.

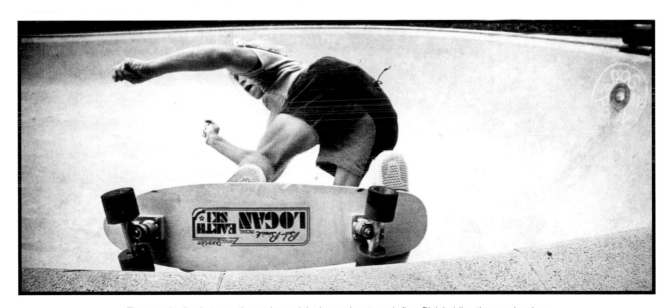

They say the line between the genius and the insane is extremely fine. Biniak riding the razor's edge.

The "Death of DogTown" . . . even the concept of such a thing made me shudder; surely it had to be a wrong number. I played the machine answer phone tape again and it was there, all the key elements . . . "a story, DT, death, call associate editor Mary Horowitz at *SkateBoarder Mag*," and that ever-enticing phrase, "will pay top dollar on completion of assignment." But perhaps I should backtrack a bit . . . I'd just come home from three months of fishing off the Baja coast and the catch had been less than anticipated. I walked through the door and pressed the playback button on the phone answering device to discover exactly what "important" messages I'd missed during my sojourn. Most of the calls were from lawyers seeking to contact me concerning the three borrowed cars I'd been unfortunate enough to total during a bad month last year. (It was enlightening to note the changes in the barristers' tones and attitudes as the tape went on. The first month they were friendly and cajoling, the second found them matter-of-fact and to-the-point, and by the end of the third they had become absolutely annoying.) Enough of such psychological pursuits. The basis of the matter proved to be that they all knew I was good for it; the question was when was I going to pay? The answer being, "As soon as I can." I turned over my fishing revenues and eased the Belchfire I recently rescued from oblivion on Warner Bros.' back lot onto Highway 101 and floored it. I knew the answers to all my problems lay in that curious burg to the south known as Santa Monica to the masses and as DogTown to the initiated.

As I motorized past Malibu Point, a six-foot swell was running—but not even such physical phenomena could erase the nagging phrase from my mind. The "Death of DT." It sounded like a press agent's nightmare and a journalist's dream. Perhaps it was only alarmism . . . but no, Mary was usually up on things. After all, she was the first to tell me that Linda Rondstadt was going to get styled hair, start wearing red, white, and blue satin, and generally go Middle American in order to make herself a suitable First Lady for presidential hopeful California Governor Jerry Brown. Since that turned out to be true, I'd believe anything now.

Consequently, I turned left onto the municipal pier (which is about as close as you can get to the heart of DogTown). As I looked about I began to comprehend what the editors meant.

In some misguided gesture of civic pride, they had bulldozed a massive portion of the architecturally classic downtown district and were erecting one of those concrete, chrome-and-smoked-plexiglass-mansard-roofed-mission-style-disco-beat shopping centers. On the pier, Universal was shooting a lowriding epic (starring blue-eyed Robbie Benson) called *Gang*. At the movie set's perimeter, the local 18th Street Vatos Locos were vibing their Venice and CC counterparts. Seeing all of those "Los Chingaderos de Controlla" types together at once and in a movie to boot proved something really rare was afoot. Coincidentally, further investigation revealed it to be opening day at Marina del Rey Skatepark.

My arrival there confirmed my suspicions: SM wasn't dead; it had just mutated into some new evolutionary form. It looked like Donnie and Marie in DT. Running the park were Ray Allen and Dennis Ogden. Imagine a gent who once won a Woody Allen look-alike contest now in a supervisory position. Think of all the tourists who'll consider him to be just another comic and not realize what an important person he is! Present and accounted for were many of the sport's finest aficionados as well as most of the legendary Zephyr team. Yes, for the first time in years, the true Z-Boys were united and the proximity of a park to their home stomping grounds proved an apt catalyst. The sessioneering was as intense as you'd find anywhere, although the SM style remains unique in its esoteric iconoclasm. The Santa Monica approach has always been regarded with disdain. The guiding dictate undoubtedly is that simplicity is the ultimate complexity. Basically phrased: it's not what you do, it's how you do it. True progression results not only from where you go, but from how you get there. A gram of push is always worth a ton of holding back.

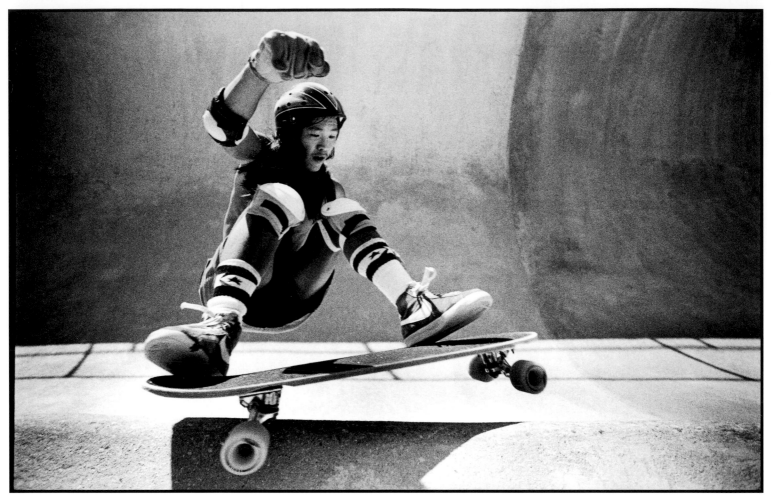

Shogo Kubo, Lakewood.

Desert Pipes.

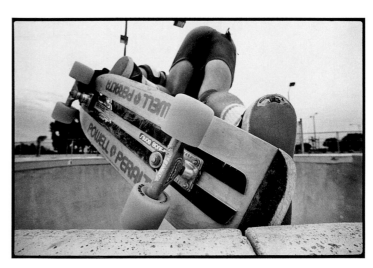

Stacy Peralta, Lakewood.

Money Shot for Greed.

An opening-day countdown found the original Zephyr boys to be engaged in typically interesting pursuits. Jay Adams skates with his customary abandon and innovation. Tony Alva continues to refine and expand upon his patented approach. Jim Muir is into exploring the wide board approach, Bob Biniak is as good as he wants to be, Shogo Kubo rides with an authority and aggression that generally blows minds, Stacy Peralta continues to be the highly polished consummate technician, Paul Constantineau is stylish in his attacks, Wentzle Ruml is back on the track after food poisoning (induced by some bad cheddar cheese), Nathan Pratt creates skate and surf crafts under his Horizons West label, Paul Cullen anxiously awaits the freedom of his eighteenth birthday, Chris Cahill is into surf vehicles shaping and airbrush applications, and Allen Sarlo stops by to work some 'crete on his way to the pro surfing contest circuit in Hawaii.

Can people involved with such a variety of activities be considered dead? Energy equaling life, I think not. What has happened is that DogTown as we knew it has given way to the next phase. For instance, the name DogTown is now "trademarked." The skaters, instead of walking, now drive imported cars. Some now carve for currency. Once unknown names are now famous ones. DogTown has gone uptown; or more precisely, Uptown had gone DogTown.

The region spawned the sport itself as an outgrowth of the Malibu surfing culture. Subsequent generations, like the original teams Makaha, Hobie, and Zephyr, laid down the basis for banked and vertical riding as we know it today. In the midseventies the underground DT movement went public—that began the change. At the '74 Del Mar Nationals, the approach of the Z-Boys was like nothing in sight. Five years later, most of these once underground riders are now considered among the sport's vanguard. The one time variant style has been adopted by the masses. The SM boys have turned a lot of people on to an abundance of things over the years, and logic dictates that they will again do so. Also, masses of new-area talent are beginning to make their marks. If anything has changed, it is that the media circus has moved on, looking for new clowns. The important question is not, "Who's dead?"; it's, "Who's liver than you'll ever be?" Good skating is the name of the game and quality is wherever you find it. If you're into it, you can take it and do whatever you want with it.

"Anybody who thinks DT is dead never understood what it was all about in the first place." —Tony Alva

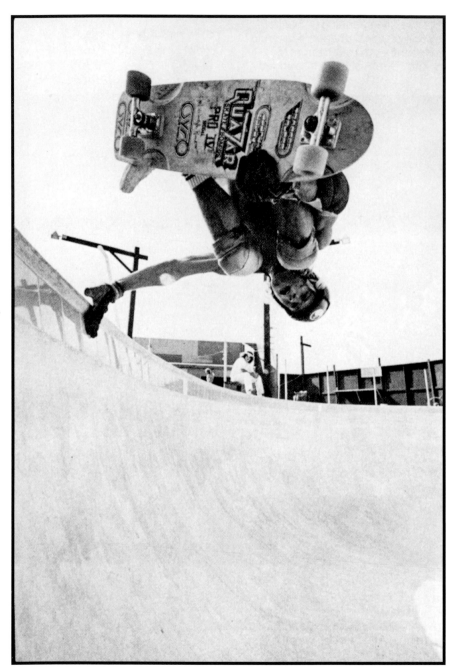

Wentzle Ruml, Marina.

Paul Constantineau, Marina.

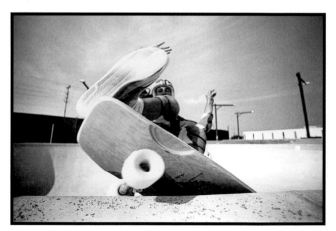

FOR A FEW DOLLARS MORE or THE FUTURE OF THE SPORT

The need for greed has put a lot of people in a bad place. What was once fun for all has become dreary for more than a few. It seems that their total embracement of commercial consumerism has obscured the very reasons they became involved with skating in the first place (n.b. to hang out, get loose, and have a good time). The doomsayers are calling it curtains for the sport because sales are down and a recession is coming.

Some fanatics are endeavoring to make the act of riding a skateboard illegal. Pro skaters are finding themselves in a shrinking market as the once "free rides" of the glory days suddenly dry up. Overnight sensations become today's tragedies. A few manufacturers have been forced to economically swallow products that would best have not been made at all. Many who sought the easy buck are out of luck. People are finding out that there are few free lunches in life; and when you get one, you generally have to eat it by yourself. While some shouldn't have taken more than they gave, others shouldn't have given more than they got.

But don't despair; live and learn, the thrill isn't gone forever, it was just sold up the river for a while. The sport isn't gonna die because of momentary economic setbacks. Sure, a few of the fly-by-nighters may bite the bullet, but manufacturers who offer decent products which the public desires will survive and prosper. The basic factor that will keep everything going is the need to skate. Individuals who have got to ride are going to continue to do so, no matter what. That's the very nature of the hard core. Those who figure they can legislate out of existence a clean, creative, and fun personal transportation source are in for a few surprises.

Skating itself was born out of the power structure's inadvertent creation of abundant concrete playgrounds that offered youth recreational potentials too obvious to be ignored. To get rid of skating you'd have to do away with concrete—in all its various forms. Even then, beings hooked on the skating thrill will find some way to harness the new surfaces. Additionally, in unity there is strength, and there are a lot of skaters around who think alike. So, get down and have fun; the best may be yet to come.

CYLINDRICAL CONFUSION

At an isolated spot in the middle of the desertscape, the pit vipers were sharpening their plastic fangs on offerings of cylindrical pipe. Their names are unimportant; it is their quest that is significant. Traveling hundreds of miles, sneaking about in appropriate camouflage, employing hand-drawn maps, eluding security guards, and spending countless dollars and hours perfecting their art, the practitioners exude a fanatical dedication that eclipses the common definitions of total insanity. They are members of an elite group whose only membership requirement is that you attend the meetings It remains a select organization, nevertheless, since you must discover the secret and ever-changing locations in order to join. Their craving for true vertical loops, perfect surfaces, proper radii, and correct downhill angles remains insatiable. The actions of the group are living proof that you can't get enough of a good thing. People who've been there can think of nothing else. The only thing that's certain is that no matter where you are or what the time is, someone's out there going for it.

"DogTown has become a myth, part of history; but the skating is better than it ever was." —Jim Muir

Jay Adams, Marina.

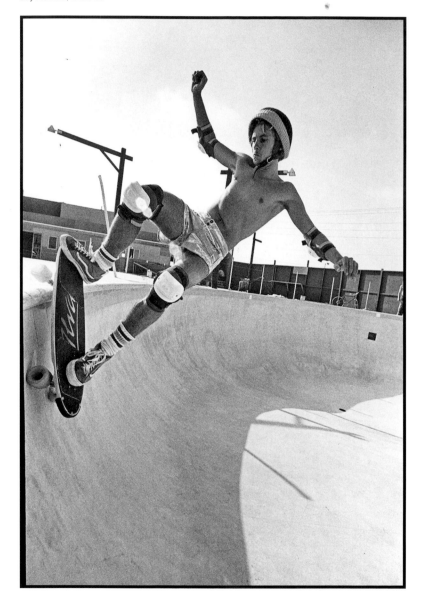

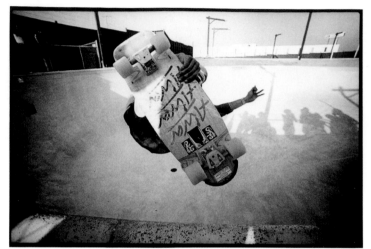

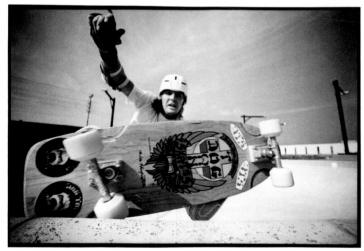

Jim Muir, Marina.

LIMOUSINE LIBERALS

Everyone knows the saga of the hardworking skating professional, right? You know: doing demos in every town, constructing schedules, jet lag to the max, motorway food, exhausting photo sessions and interviews, energy-draining groupies, and, worst of all, the backbreaking ordeal of carrying all those dollars to the bank. Can this be true in this day and age? Why, just moments ago some fool was telling us tales of anticommercial woe. If you doubt it, consider the plight of these three dedicated pros.

It was a sun-drenched dawn as Danny "Mini Shred" Smith, Gregg Ayres, and Stacy Peralta were sitting in front of the TV awaiting the arrival of their ride. According to the men, an important film mogul (whose name escapes me at the moment) had contacted them to perform assorted skate exploits in a production. In order to assure the skaters' safe and prompt arrival, the movieman dispatched a chauffeur-driven Lincoln Continental, complete with wet bar, color TV, stereo, and telephone. Ayres termed these, "Your basic auto accessories," and proceeded to examine the Detroit iron's power plant. Peralta was his usual low-key self, indicating that he either A) travels this way often, or B) was on a late-night date with Johnny Carson. Now, Smith, on the other hand, was incredulous and began interrogating the driver. "You're supposed to drive us?" he inquired. "Anywhere you want," was the reply. This was a good enough offer to tempt even the likes of Gregg, who claims to have "tried everything at least once." The trio entered the limo and began their tour, guiding the wheelman through some of the strangest environs he'd ever met up with. Imagine his amazement at being taught the art of climbing and dropping along the paved banks of the LA River! The skatemen report that their driver really got off on lippers and four-wheel drifts. A long time later they landed the limo at Malibu Point, where there was a six-foot swell running. We'll leave it to the readers to decide if our skate subjects ever made it to their appointment on time. Interestingly enough, they arrived at the same time as our author (see beginning of story) was motoring into town.

We'll end it all here, since the ending so closely parallels the beginning. Remember, it was just a day like any other and it all happened just like we said . . . and was done in the best of spirits. Put it to the roof.

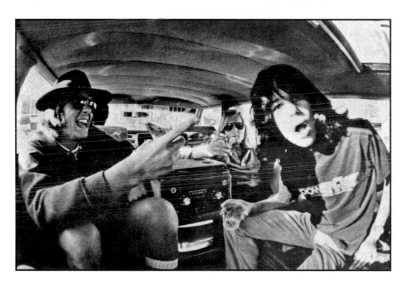

Airport limo service: Ayers, Peralta, Mini Shred.

SKATEBOARDER INTERVIEW HIGHLIGHTS:
JAY ADAMS

The first time I can ever remember talking to Jay was back in '66 at the Ocean Park Pier. His stepfather Kent ran the surfboard rental concession there and Adams naturally was in the vortex of the beach scene energy conduit. Now it's thirteen years later and Jay at eighteen is truly one of the sport's seasoned veterans. Having known Adams over the years I really can't say he's changed much. He remains one of the most spontaneous, unpredictable persons I've ever encountered. Jay's always been capable of short-circuiting any situation. The man's the stuff legends are made of and everything you've ever heard about him is probably true, or should be anyway.

As a skater he certainly is the "Player's Choice." Adams has won a load of contests, world titles, and such, most of which he can't even remember. This lack of concern over past achievements is probably the most striking thing about Jay. He truly doesn't care that much about the tokenism of cheap ego trips or about cashing in on his abilities at the box office. (For instance, he passed on doing this interview for over four years.) Jay continues to defy the odds and skate in his brilliant, consistently innovative manner. If you doubt any of this, just check him out sometime.

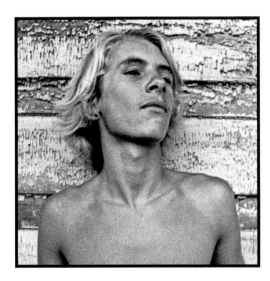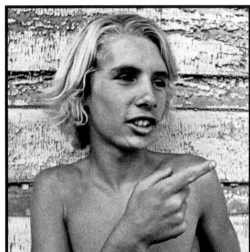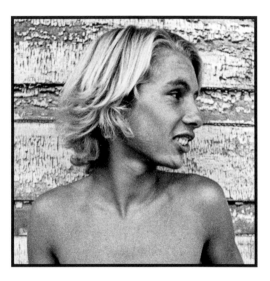

What's the most radical thing you've ever seen done?
Maybe Alva going down Marine Hill . . . remember that one? Passing one car, when another one was going up. But then I remember he fell that day, and he cried and said that he'd quit skateboarding forever. Remember that? Shogo ate it that day too. I think I kinda mellowed out that day. Skating seemed a lot different back then. I was almost always on a skateboard. I'd wake up, probably go surfing, then I'd come home, ride my skateboard back from the beach, all over town, then take the bus somewhere to go skating, then I'd ride home from there. Seems like you always had your skateboard with you, were always on it. That was your main way of getting around—either the bus or a skateboard. Plus we did a lot of different things: we did slaloms, we did speed runs, bank riding. And now it's mostly into pool-riding skateboarding.

What's your lifestyle like now?

My basic day . . . wake up, take a shower, either go to the beach or ride skateboards.

What kinds of things are important to you in life?

I don't have too many important things. I like to surf a lot. I guess important things are getting fed every day . . . just surviving.

How long have you lived on your own?

About a year. It's different, you know. Living with my mom was kind of like living on my own . . . I paid her money and stuff, I cooked all my own food, washed my own stuff. We were just kind of like roommates. It was like that for a while, though I didn't have to pay her money till I was about seventeen. We were living in Hawaii, we had welfare sent to us . . . we've always been pretty poor.

Do you think this was a disadvantage?

Not really. It's a disadvantage in ways. In other ways it's an advantage too. I've got some friends that don't even know what's happening . . . they don't even know how to take care of themselves if they had to. If I got thrown out of my house, I could survive easy. I know some people that couldn't.

About the Nazi thing—in the past you and other people have been known to adorn your bodies, equipment, as well as private and public property with swastikas. At one time this blew a lot of people out . . .

I know my mom didn't like it . . . Z-Flex didn't like it. I think they look pretty neat. It doesn't really mean Nazi. We meant it as more of a skating trip. Kind of like punk rock, but not the weird kind of music.

Didn't you guys used to call yourselves "Skate Nazis"?

Yeah, I used to call myself a "Skate Nazi" plenty of times.

So there was no political motivation behind the use of the swastika?

None. I see kids in pictures from Texas with Nazi signs all over the place. They're all into it. I don't think they mean the Nazi sign as having anything to do with being against Jews; it's more or less just "go for it" skating and not caring about anybody else, except for your friends.

What's the best contest you've ever been in?

Probably the '75 World Championships. The one I got two firsts in. That's the one I had the most fun in.

Has your attitude changed through the course of your career? No, not much at all.

Over the years you've exhibited a highly spontaneous approach to skating, and I think social situations too. Are you trying to be spontaneous . . . are you aware of it?

I don't know, I just try to skate, and the rest of it, the financial stuff, I'd rather have somebody else take care of. Some other jerk tell me what to do and stuff. I'd rather just go out and do the skating part.

But when you're skating, what are you going after? How do you try to do it? Are you conscious about what you're doing when you skate?

Yeah! I just try to have fun and try different things, you know. I don't like to . . . I get bored when I do the same thing over and over.

Have there been times in your career when you were interested in business or did you just not deal with it when you could have? Yeah, I guess. Like with this interview . . . I just kept kind of putting it off. How long's it been?

It's only been four years. *[Laughter]*

You feel like you've been exploited in any way? What's that, exploited?

Used . . . used by others possibly for their commercial gain.
Maybe a little bit, but not really though. No more than I use them. What the heck, most of them are trying to rip everybody off.

Have you made money out of skateboarding?
Not too much. Enough to survive . . . barely. A lot of people think they can make a lot of money, but you can't.

What do you spend your money on? Food and rent . . . and partying.

After that there's nothing left? Not really.

You got a bank account? Yeah, now I do *[laughs]*. I just opened one, about three days ago, with five hundred bucks.

Why? 'Cause I got some money finally and I wanted to save it instead of just spending it.

Who are your favorite skaters to watch?
I like Marty Grimes, Chris Strople, Steve Alba. That whole crowd's unreal. And from around here I like Polar Bear, 'cause he's radical. A lot of skaters around here are unreal. It's hard to name them.

Who's the most overrated person in skateboarding today? I'd say Alva.

Underrated?
There's too many underrated to just say one. Marty Grimes, Pineapple, all those guys. They've ripped for a long time, and they never got much credit.

How long does your average skateboard deck last you?
About four days, depends on if I skate hard all day, if it's a normal board that's light, laminated.

Do you think you're hard on boards? Yeah, I'd say so.

Do you think of yourself as a star? No.

Do people come on to you that way?
Sometimes. I think most of 'em just kid around when they do. To some kids in some other states, we might seem like stars, I'm not really sure. I used to get letters at Z-Flex, these little fan letters and stuff. That kind of used to trip me off. So you know something must be going on.

Did you read them? Yeah. When they came.

Answer them? No. I guess I'm mean *[ha ha]*. Not one of them cool guys.

Do you think stardom's ruined any of your friends? A couple.

Think it's hurt you?
Someone else might think, *That guy's a jerk, he's big-headed or something*. I, myself, don't think it has. I still feel the same way about all my friends as I ever did. I don't put myself above anybody or anything, unless they're some kook, jerk, or kind of egoed-out a little.

**Spontaneity as a way of life—and especially skating . . .
Jay's influence on skating has been one of attitude more so than maneuver.**

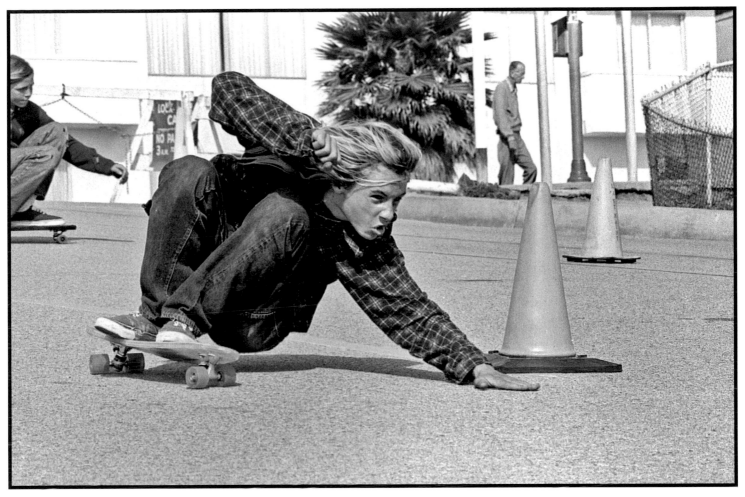

Jamming the cones by a Ray Street parking lot (Bicknell Hill), Santa Monica, 1975.

Do you ever think about finishing school?
Maybe later, when I need to. A couple of years ago I was making a lot of money so I didn't really need to go to school. Plus I was skating almost every day. School just kind of got in my way.

Have you always lived around the beach?
Yeah. I'd say right now is the farthest I've ever lived from the beach. It's about a mile away.

Do you think about the future? I mostly live from day to day.

What do you think about gas shortage?
I don't have a car so it doesn't bother me at all. Now, when the food shortage comes along, then I'll be bummed out. That'll happen pretty soon.

POSTSCRIPT

At the turn of the millennium while we were working on the *DogTown and Z-Boys* documentary, G.E.F. coaxed me into allowing him to republish versions of my original DTZ stories and photographs in book form. I agreed contingent to Glen's participating with some of his own views. He acquiesced immediately, coming up with a hundred-plus never-before-seen works.

Subsequently he requested words regarding what happened to the DTZ crew and aesthetic in the years since the last article created for the original *SkateBoarder Magazine* in 1979.

At the time I told him via the phone, "I never thought about it then, I never think about it now, I never thought about it in between. So, let me think about it for a while and I'll get back to you." He printed that verbatim.

Fifteen years, multiple book pressings and movies later, he hit me up again for this new edition of the book.

Okay. Here goes…

In the commodification of private rituals, fact rapidly subsumed into fiction. In the aforementioned process, once personal moments mutate and are subsumed into public misunderstanding. This reinterpretation may either lead to acclaim or infamy.

Change and random chance are the only things you can count on. I still have the first skateboard I ever cobbled together and that same ratty pawn shop Pentax camera. Why do some artifacts endure when the harbingers of obsoleteness conspire against them? How do various slices of time still exist while other thousandths-of-a-second exposures are long forgotten?

It is a trifle strange to me that a photograph that I took of Jay Adams ended up on Spider-Man's bedroom wall in a Hollywood film. I find it equally quizzical that a shot of Glen's wound up in Marvel's *Black Panther*.

The ethos of the DogTown skate era demanded that we document it as it occurred. The Zephyr competition team was only together in its original manifestation for a little over six months. It had to break apart due to the overload of energy.

In true nuclear-explosion fashion, its particles and side effects can still be found throughout our universe.

—C.R. STECYK III (2019)

C.R. Stecyk III riding the embankment at Brentwood Elementary School, circa 1967.
Photographer unknown, from the Stecyk personal archive.

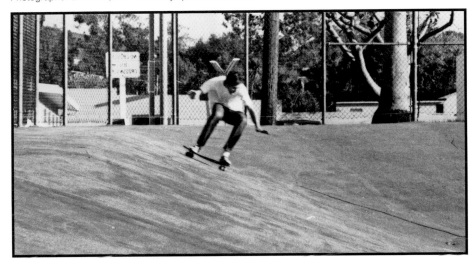

C.R. Stecyk III as dinosaur, at the La Brea Tar Pits, 2018,
during his interview for *The Fuck You Heroes* by Glen E. Friedman.

GLEN E. FRIEDMAN

PICTURE ARCHIVE DISCOVERIES—RARE DOGTOWN IMAGES 1975-1985+

ACCIDENTAL, END OF ROLL, FIRST-EVER SELF-PORTRAIT, SIXTEEN YEARS OLD—MARINA DEL REY SKATEPARK ARCADE—1978

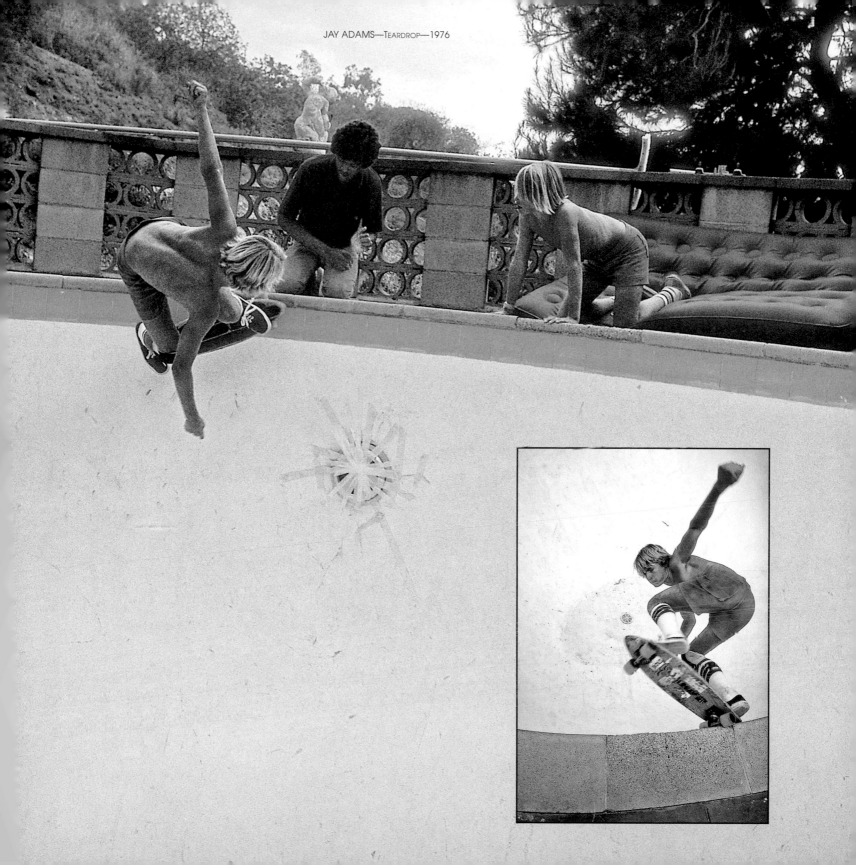

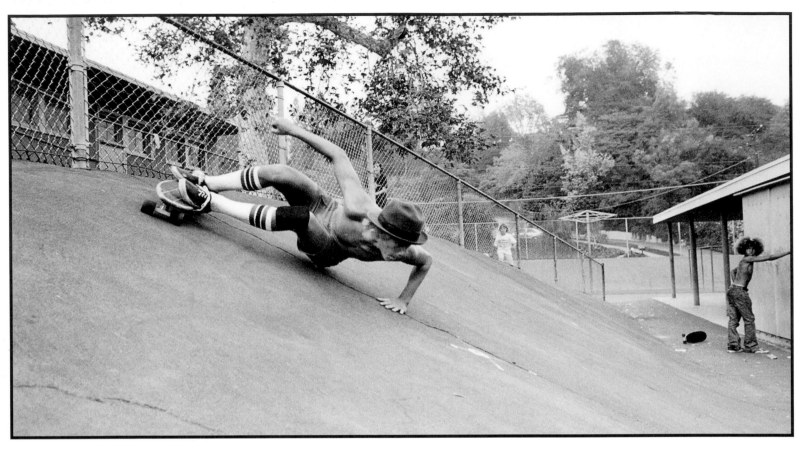

JAY ADAMS—Kenter Canyon Elementary School—1976

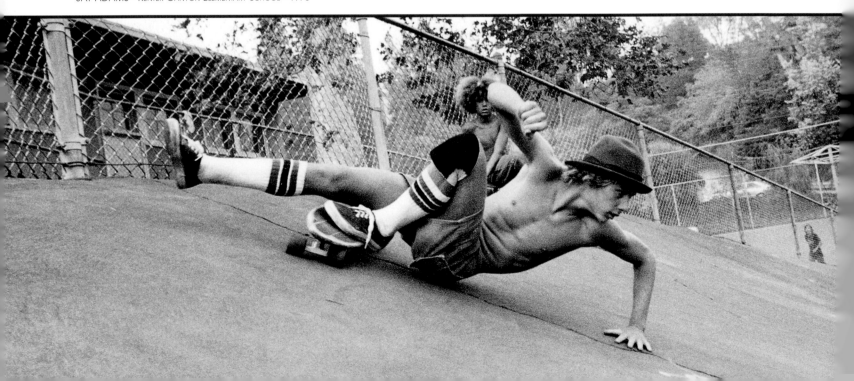

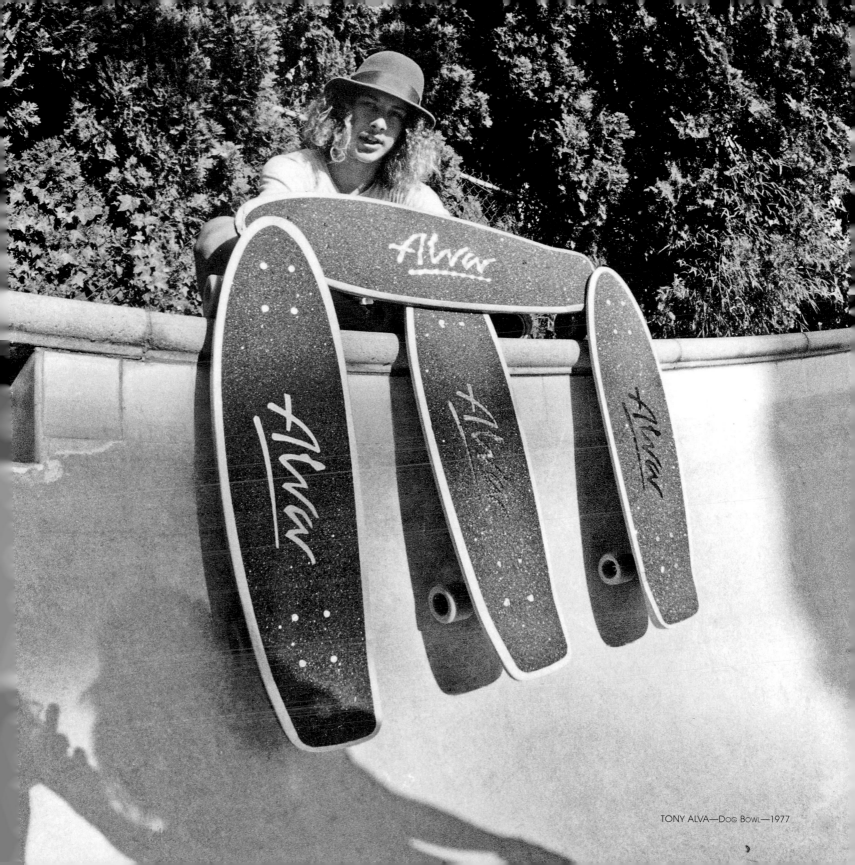

TONY ALVA—Dog Bowl—1977

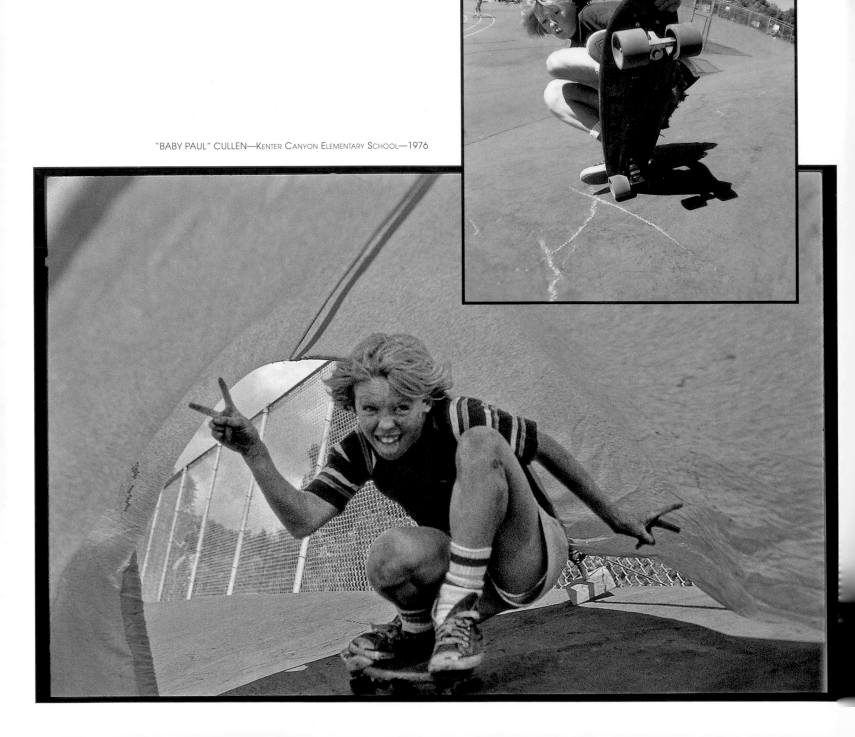

"BABY PAUL" CULLEN—Kenter Canyon Elementary School—1976

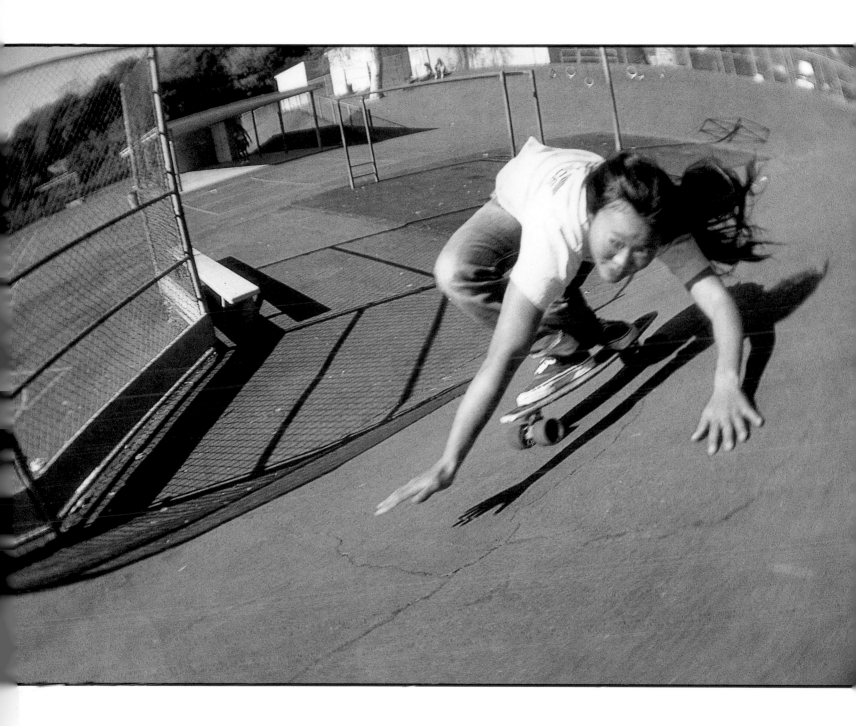

PEGGY OKI—Kenter Canyon Elementary School—1976

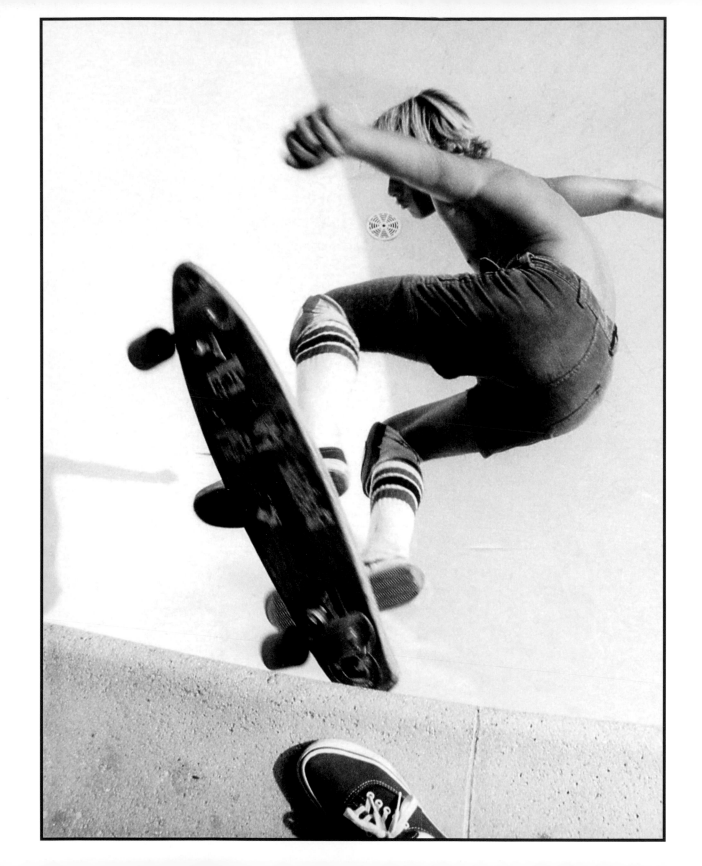

JAY ADAMS
Teardrop
1976

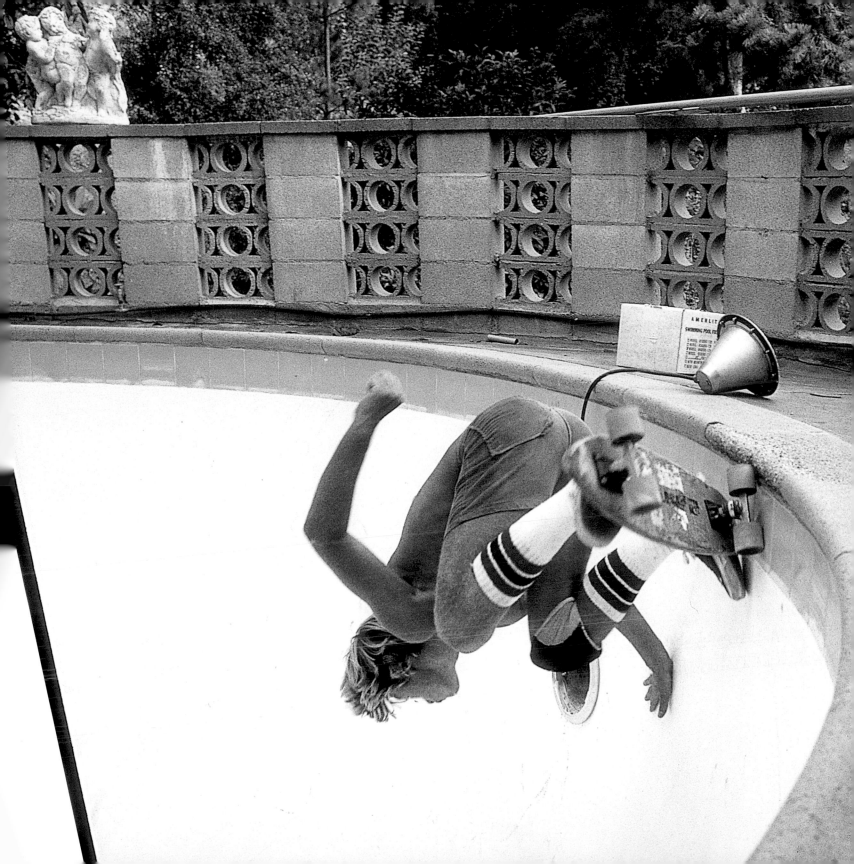

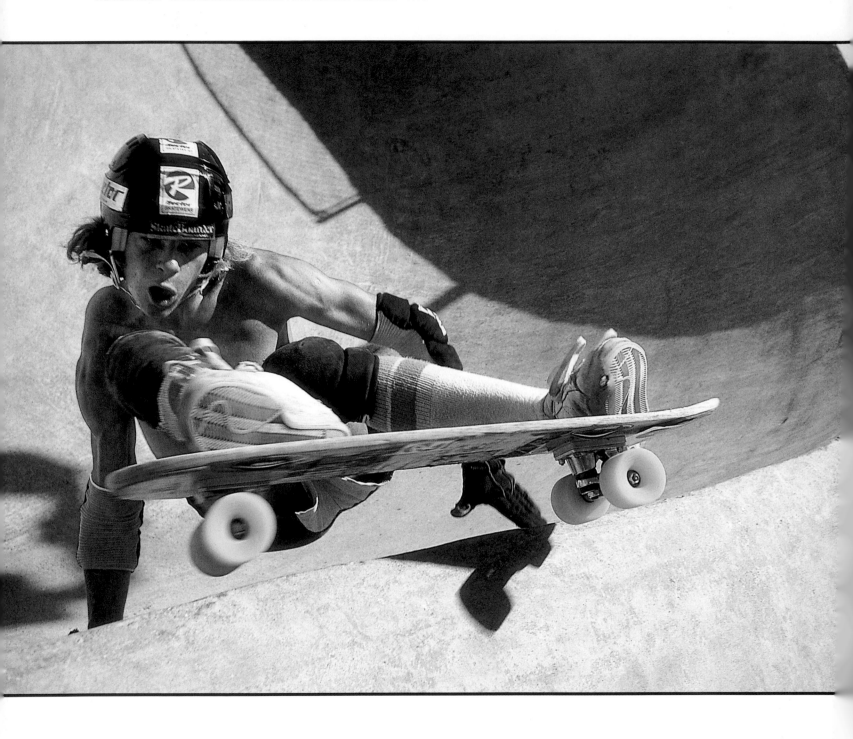

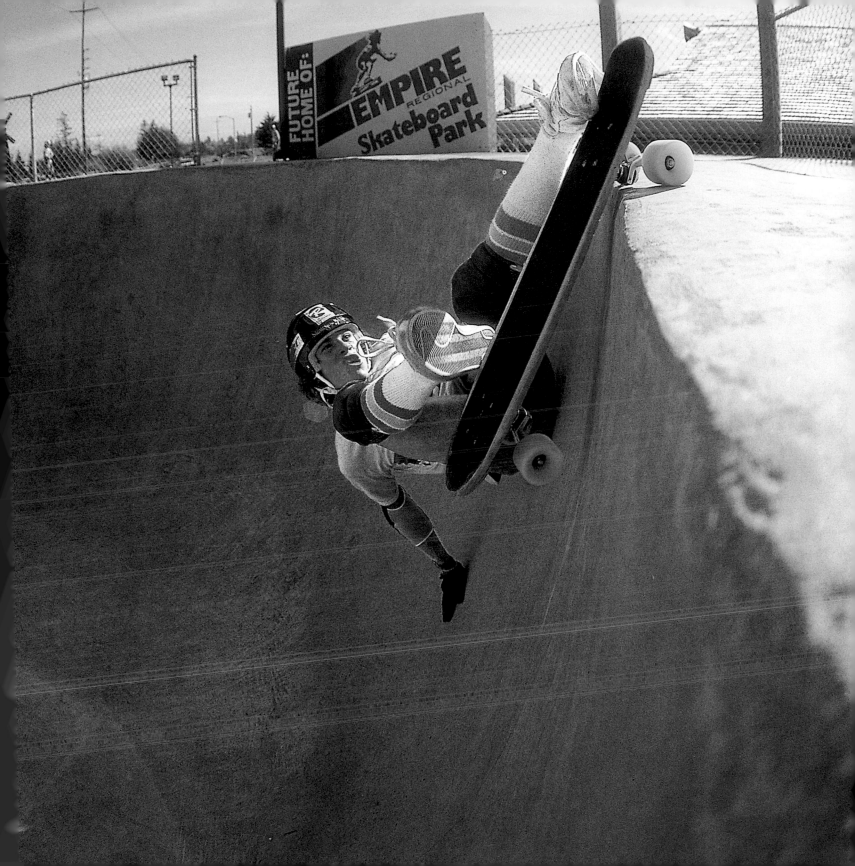

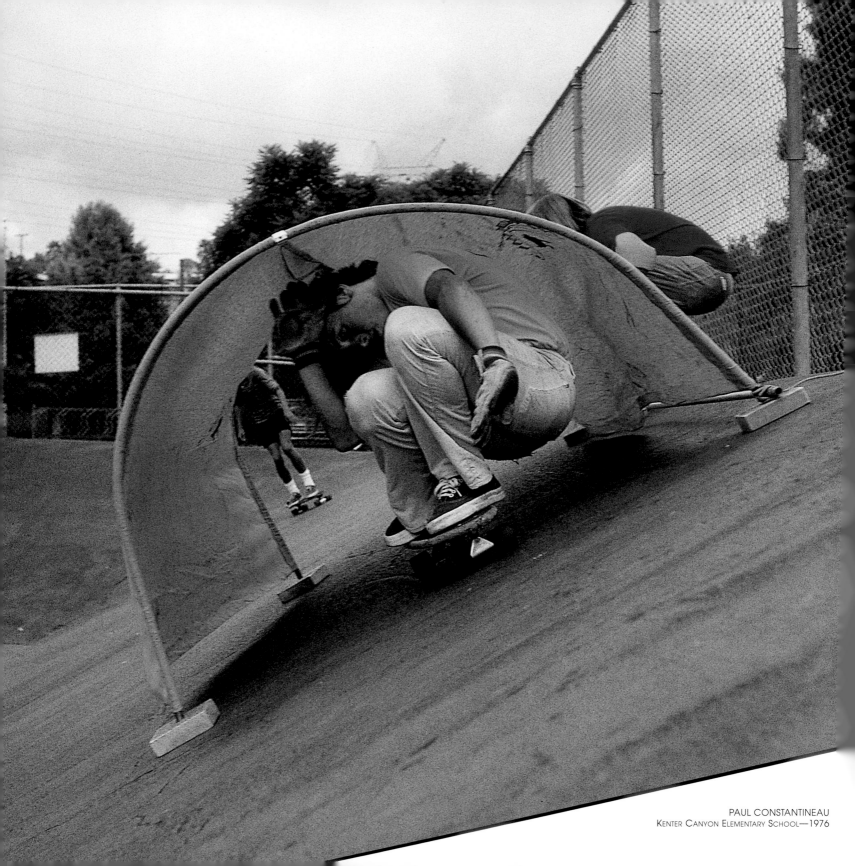

PAUL CONSTANTINEAU
KENTER CANYON ELEMENTARY SCHOOL—1976

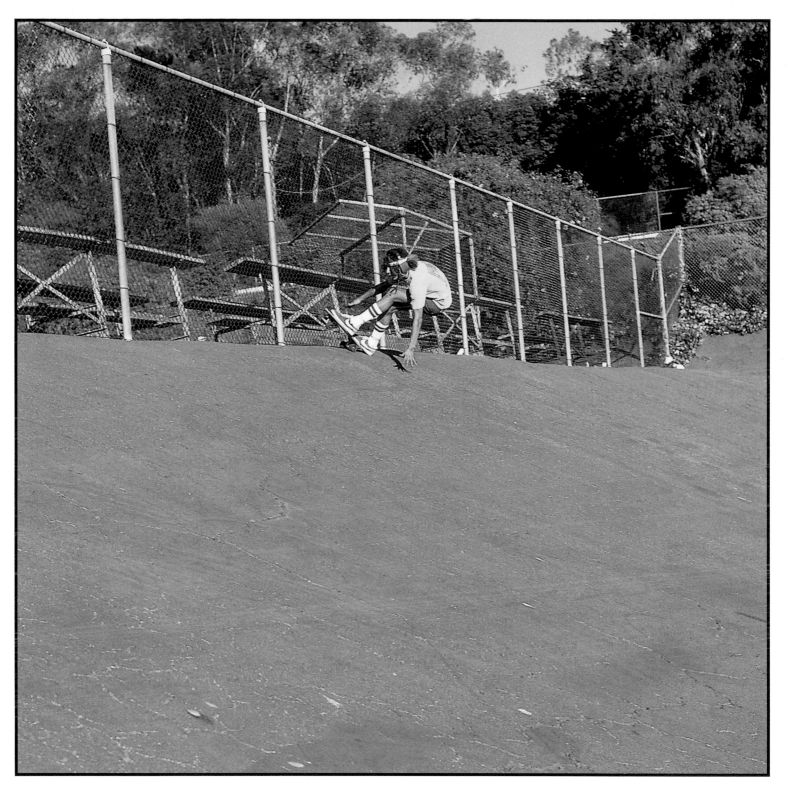

TONY ALVA—Paul Revere Junior High School—1977

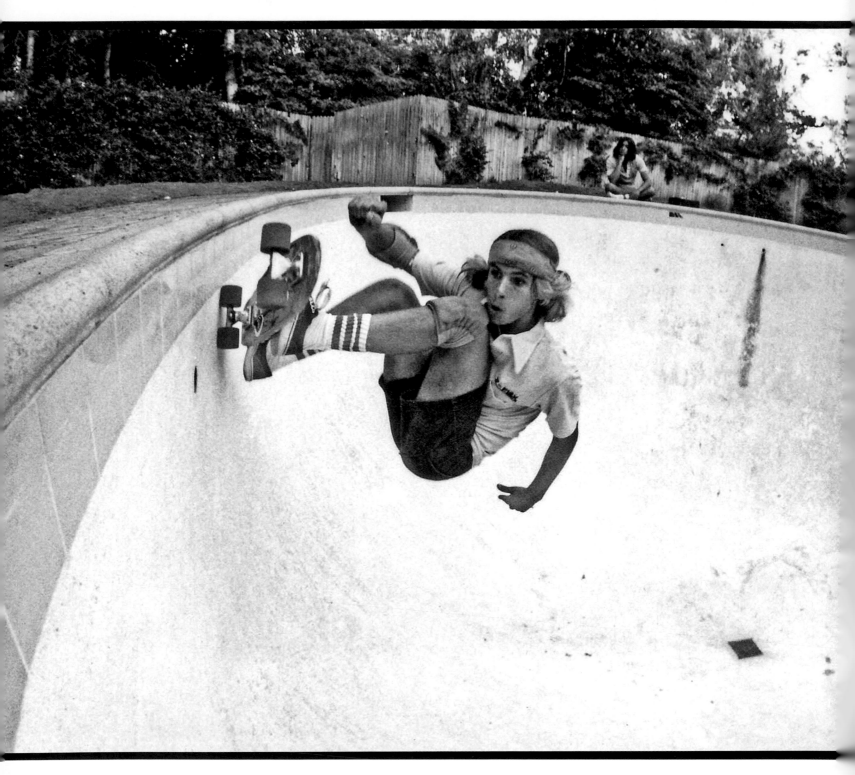

JAY ADAMS—Adolph's pool—1977

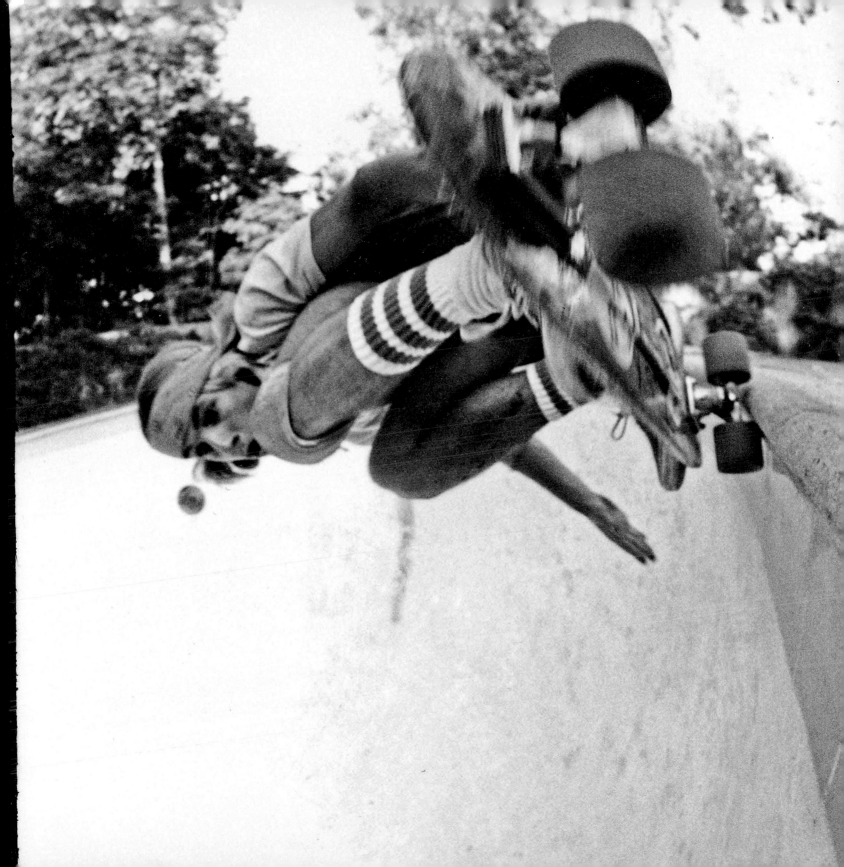

SANTA MONICA BEACH—1978

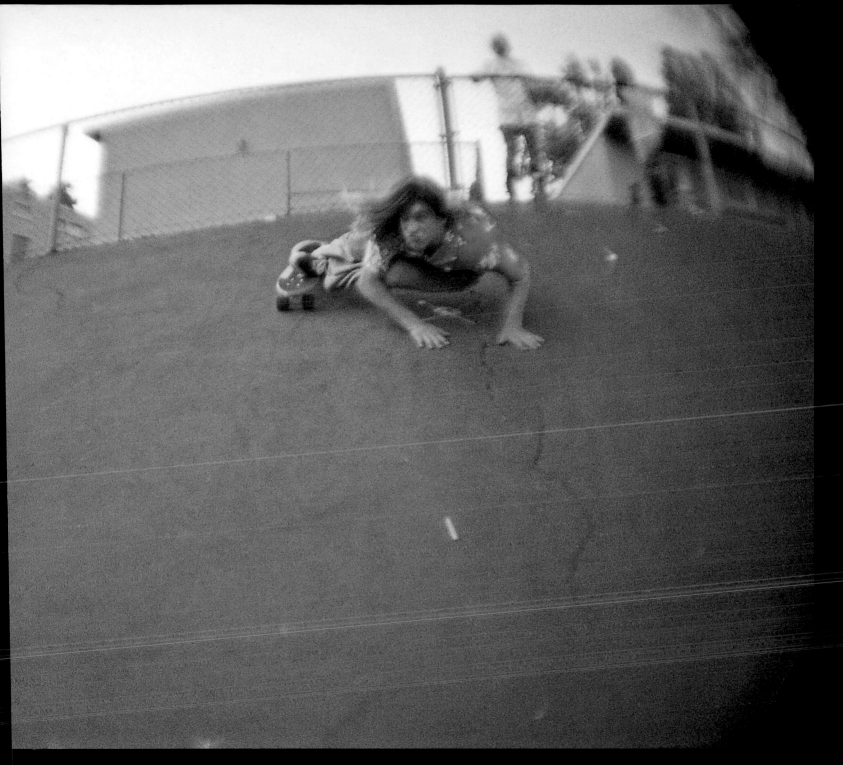

PAUL CONSTANTINEAU—Kenter Canyon Elementary School—1976

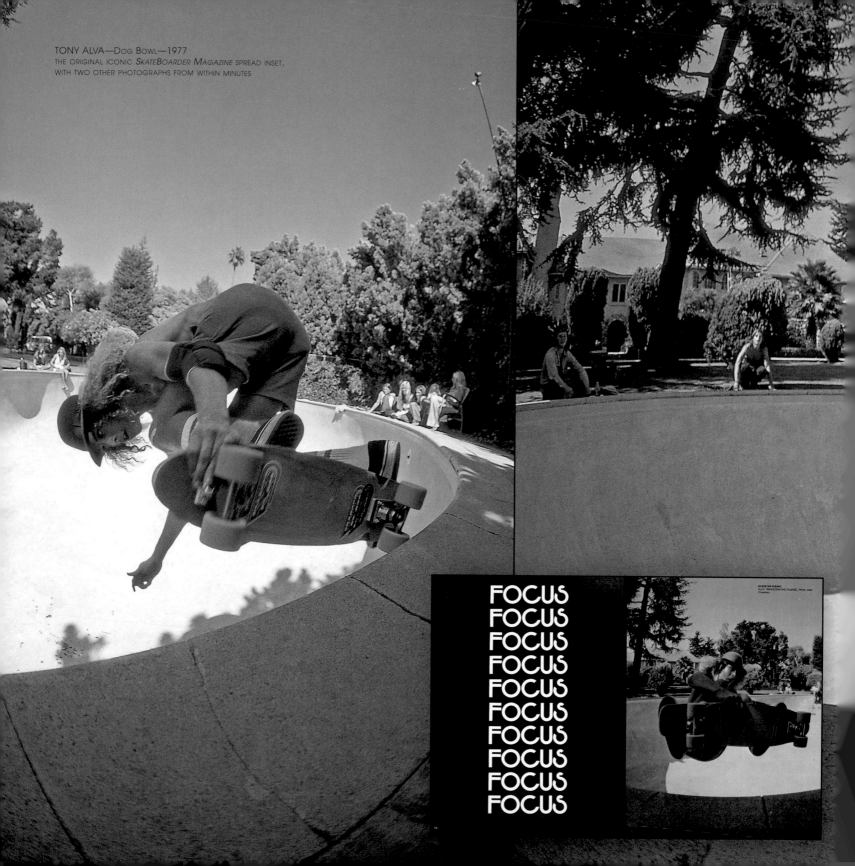

TONY ALVA—Dog Bowl—1977
THE ORIGINAL ICONIC *SkateBoarder Magazine* SPREAD INSET,
WITH TWO OTHER PHOTOGRAPHS FROM WITHIN MINUTES

FOCUS
FOCUS
FOCUS
FOCUS
FOCUS
FOCUS
FOCUS
FOCUS
FOCUS
FOCUS

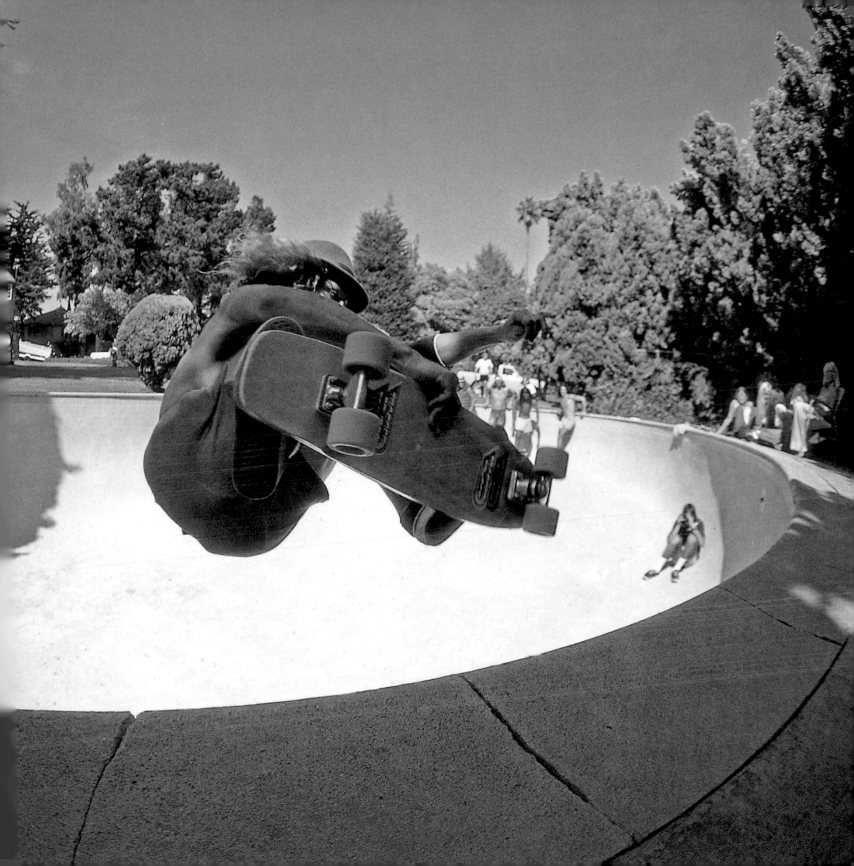

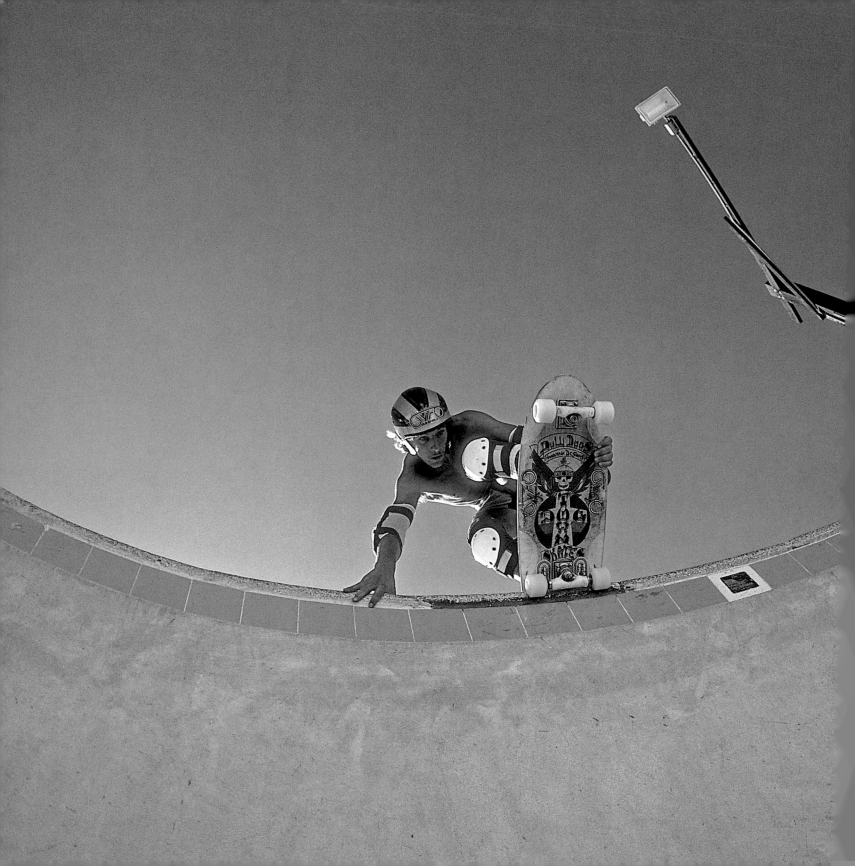

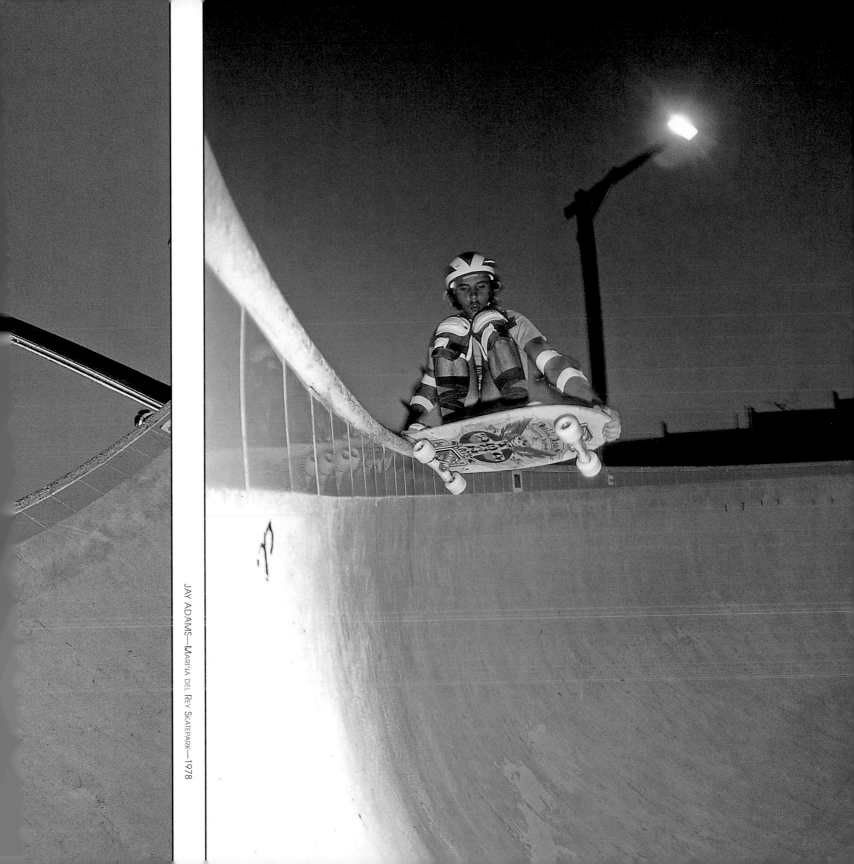

JAY ADAMS—MARINA DEL REY SKATEPARK—1978

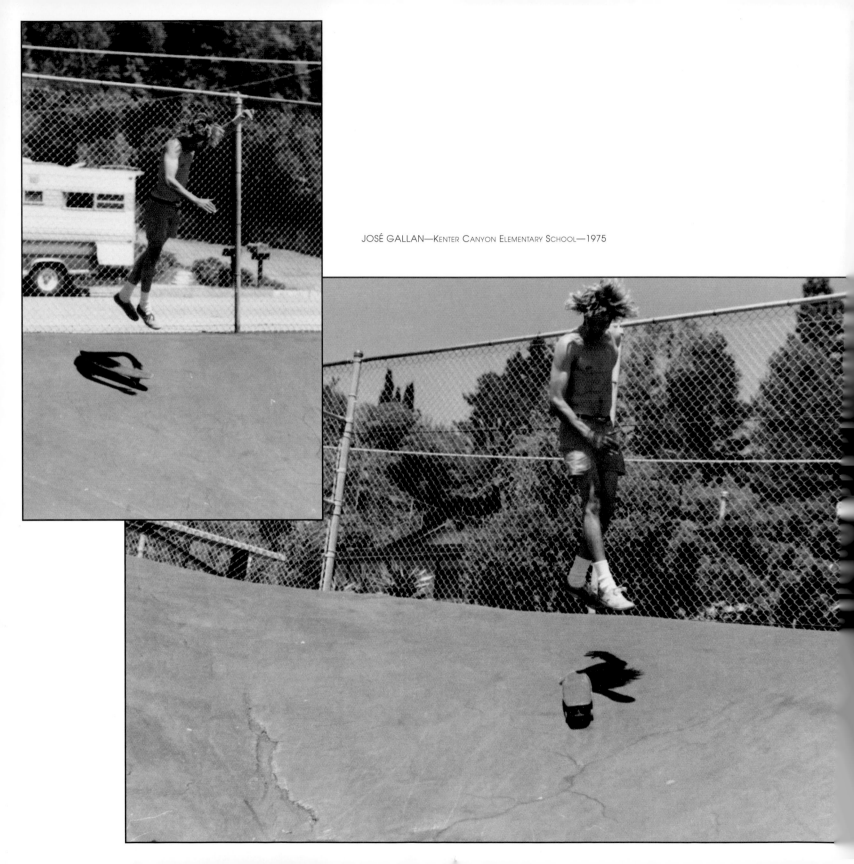

JOSÉ GALLAN—Kenter Canyon Elementary School—1975

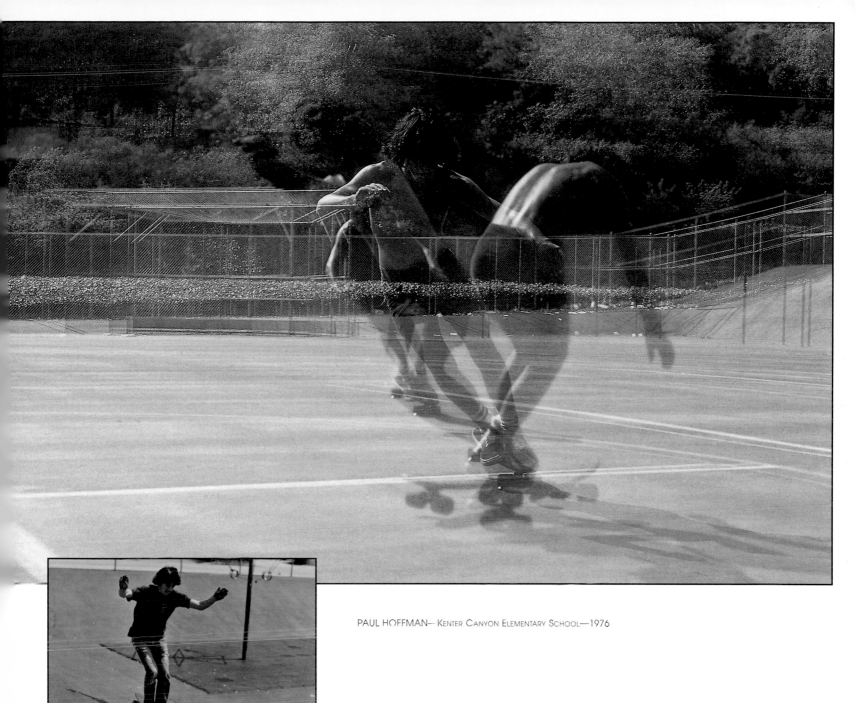

PAUL HOFFMAN— KENTER CANYON ELEMENTARY SCHOOL—1976

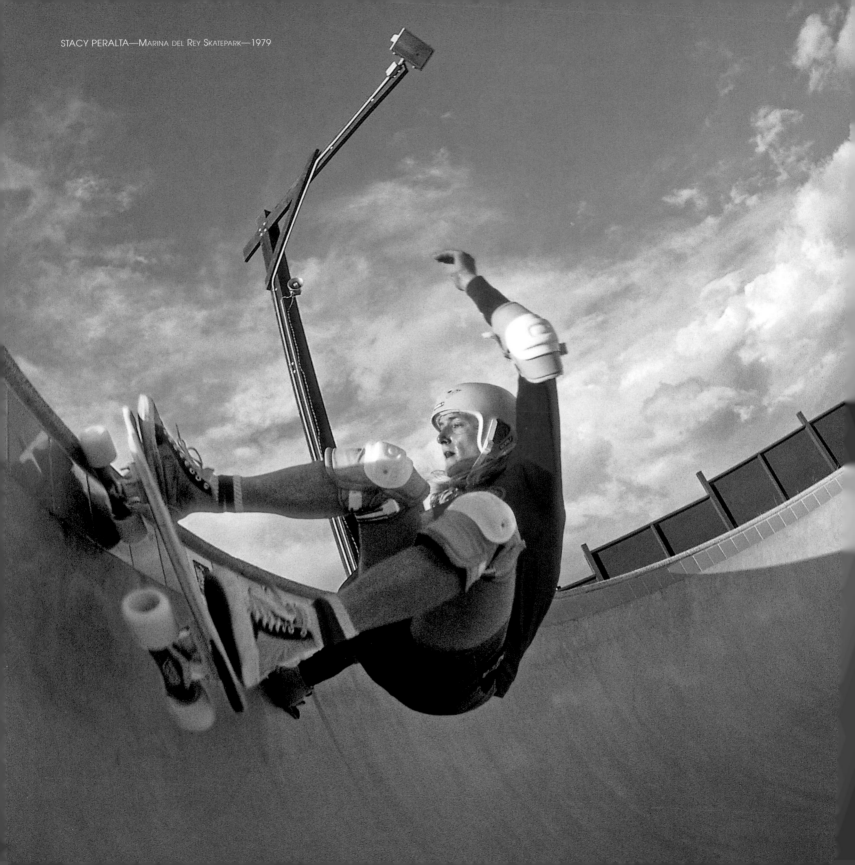

STACY PERALTA—Marina del Rey Skatepark—1979

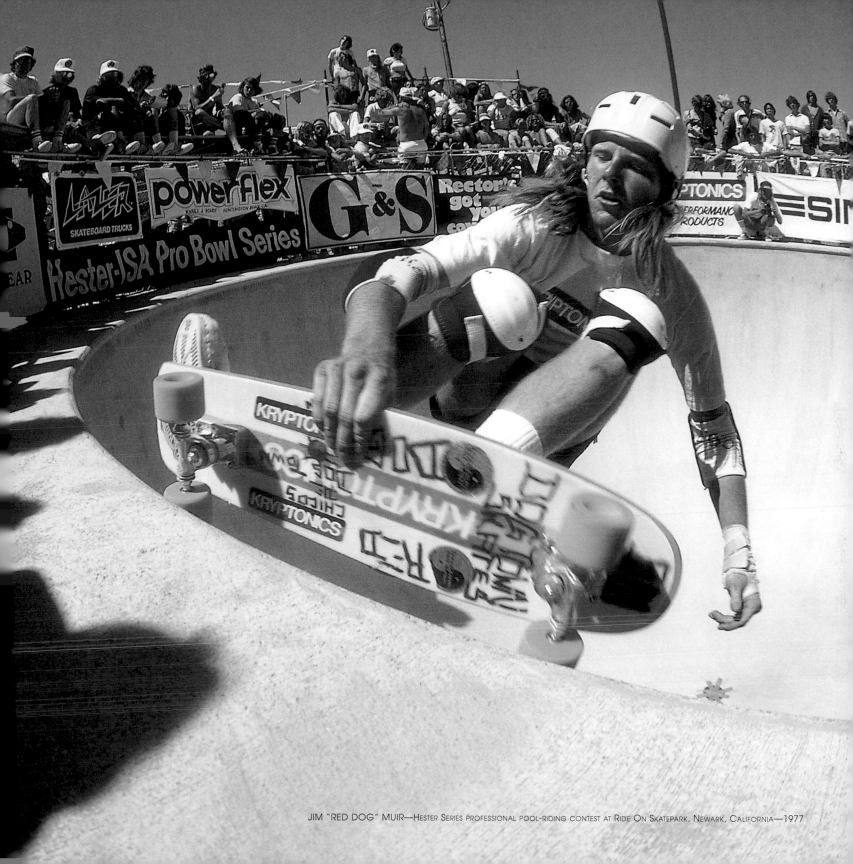

JIM "RED DOG" MUIR—Hester Series professional pool-riding contest at Ride On Skatepark, Newark, California—1977

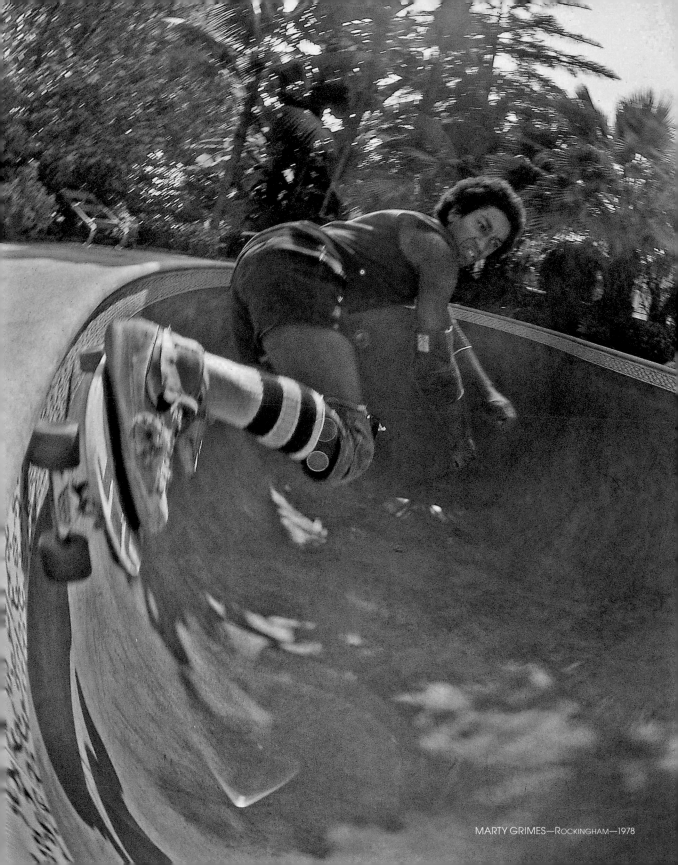

MARTY GRIMES—Rockingham—1978

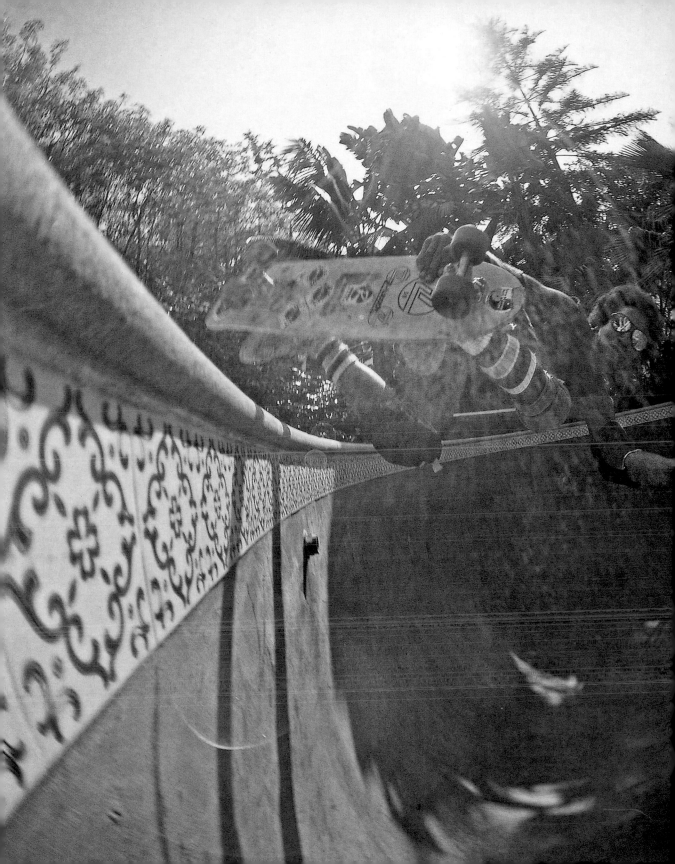

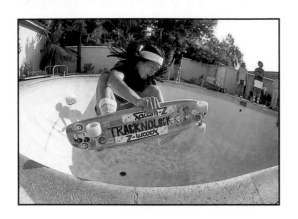

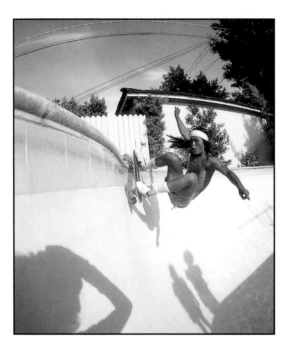

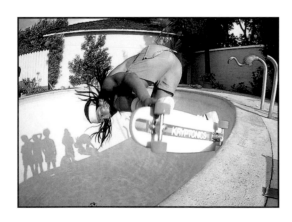

SHOGO KUBO—Krypto bowl—1978

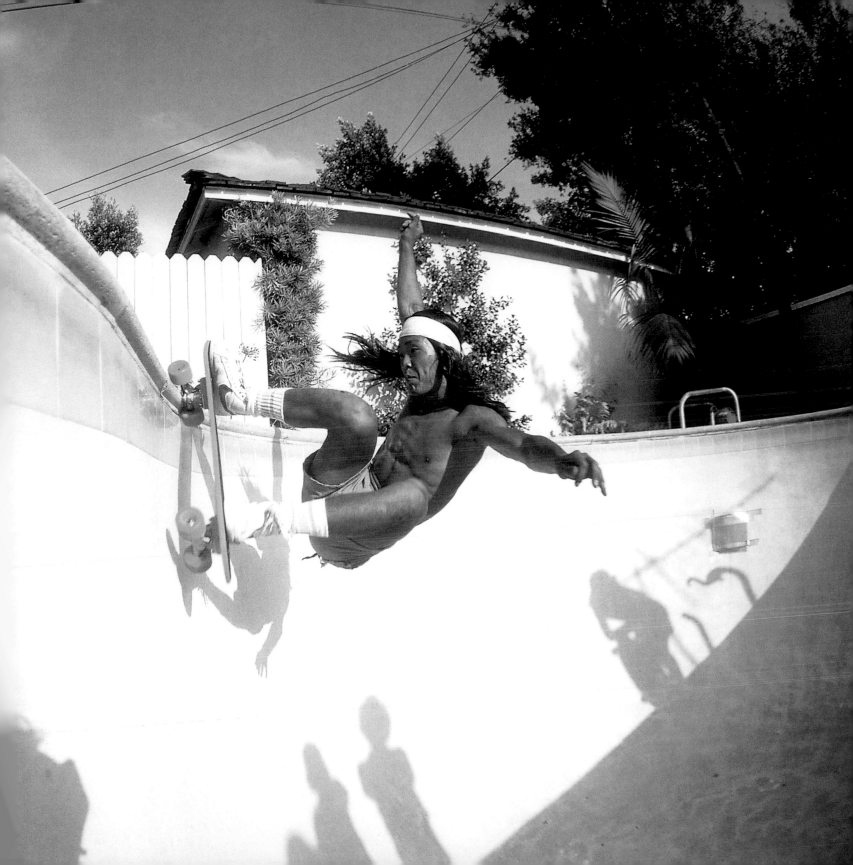

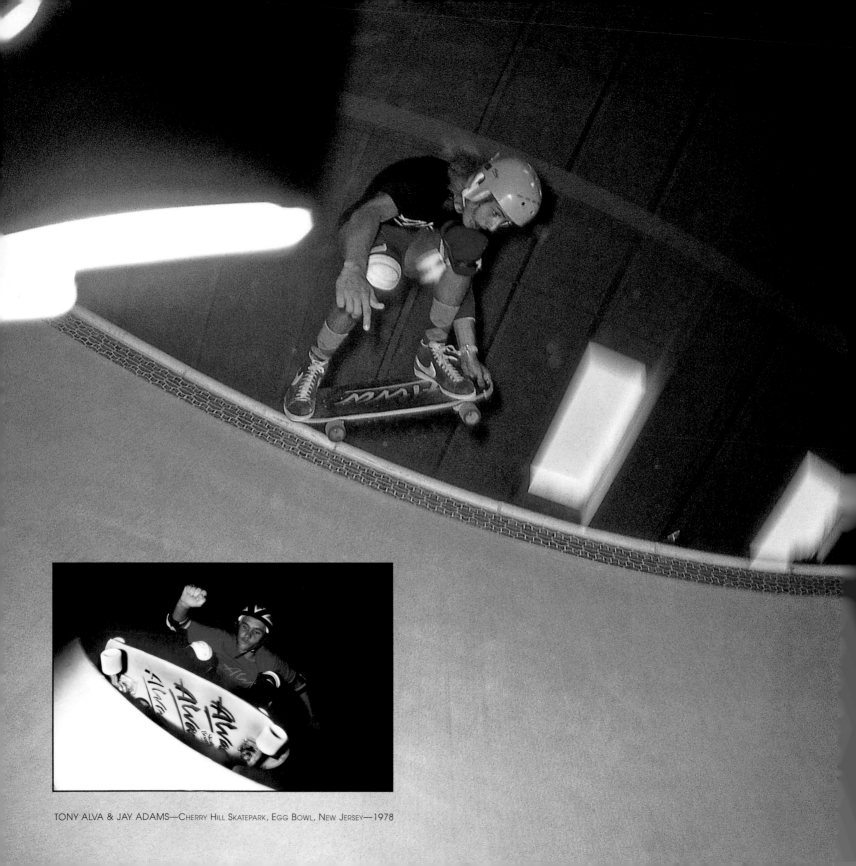

TONY ALVA & JAY ADAMS—Cherry Hill Skatepark, Egg Bowl, New Jersey—1978

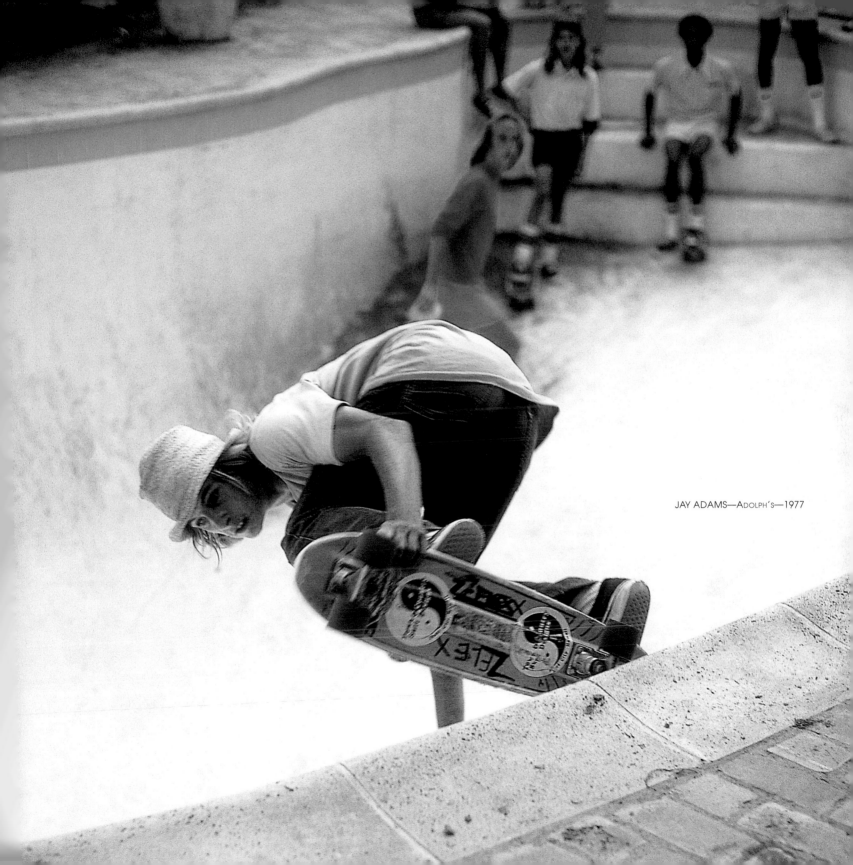

JAY ADAMS—Adolph's—1977

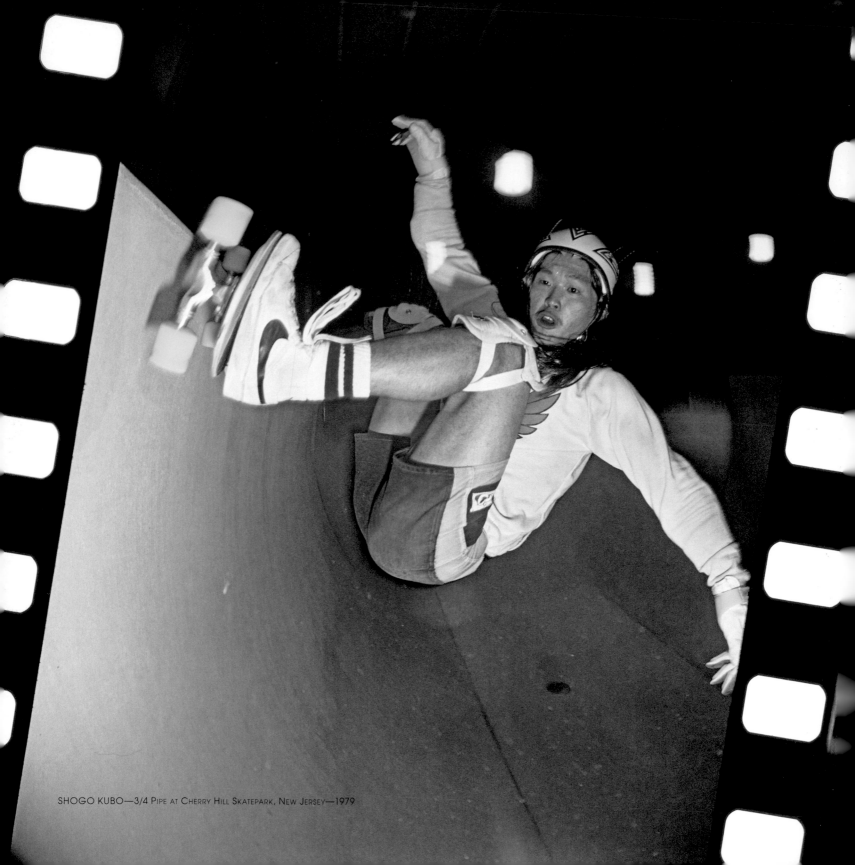

SHOGO KUBO—3/4 PIPE AT CHERRY HILL SKATEPARK, NEW JERSEY—1979

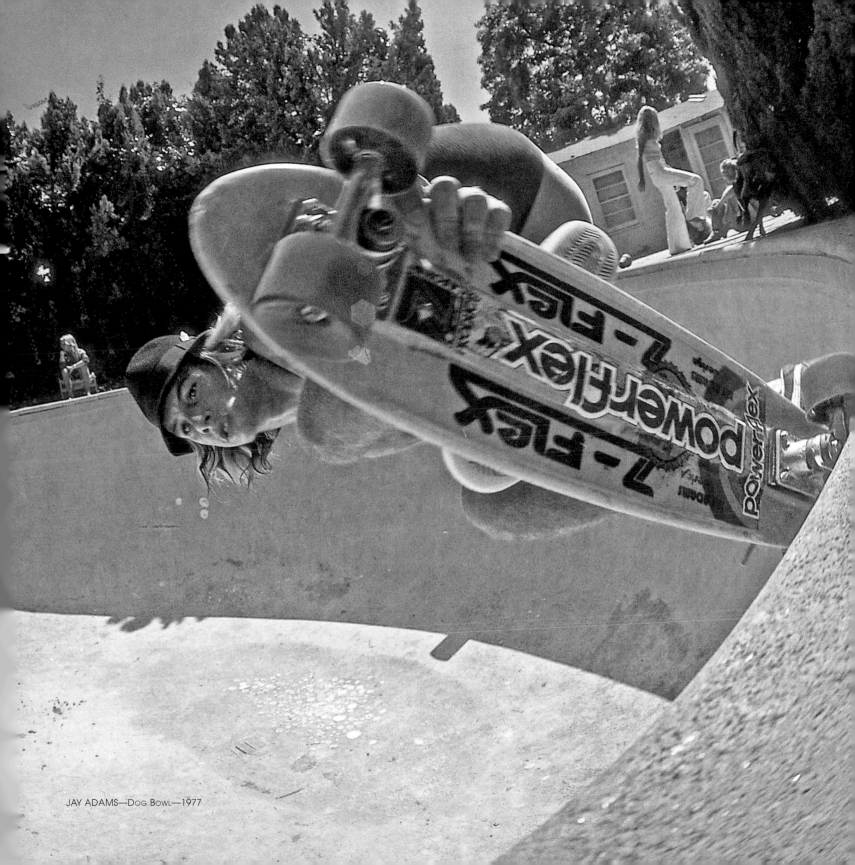

JAY ADAMS—Dog Bowl—1977

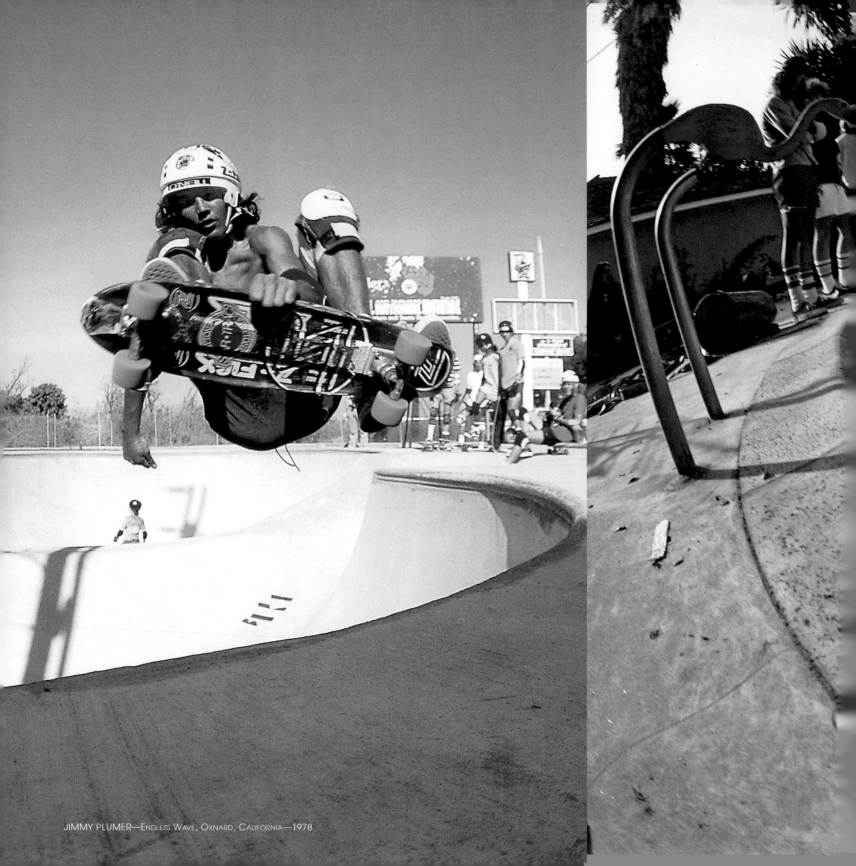

JIMMY PLUMER—Endless Wave, Oxnard, California—1978

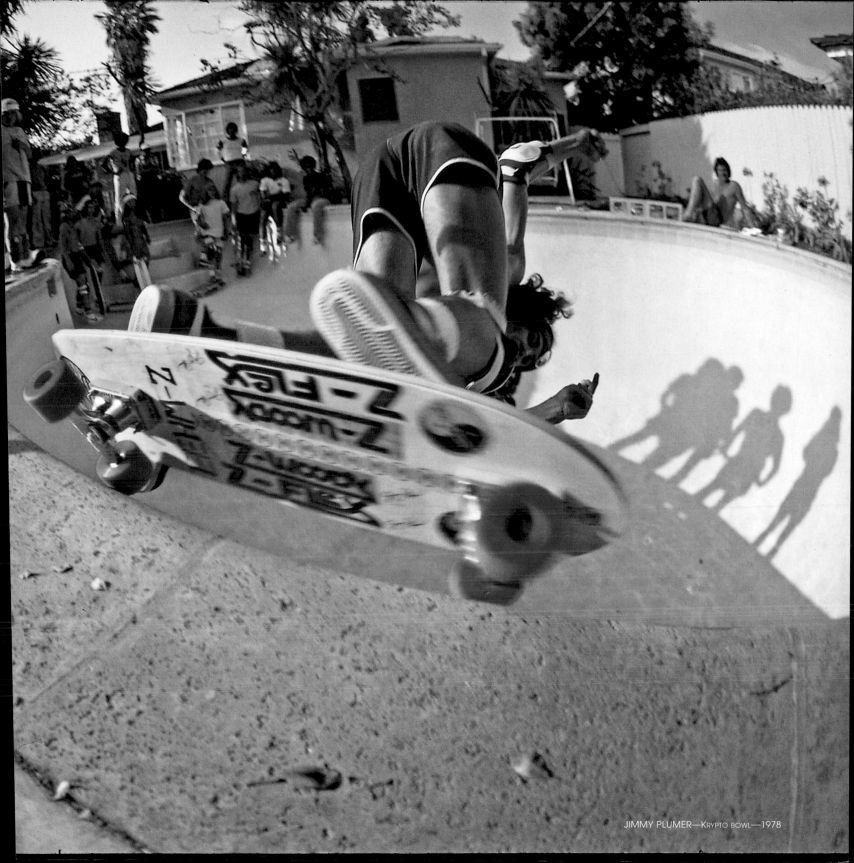

JIMMY PLUMER—Krypto bowl—1978

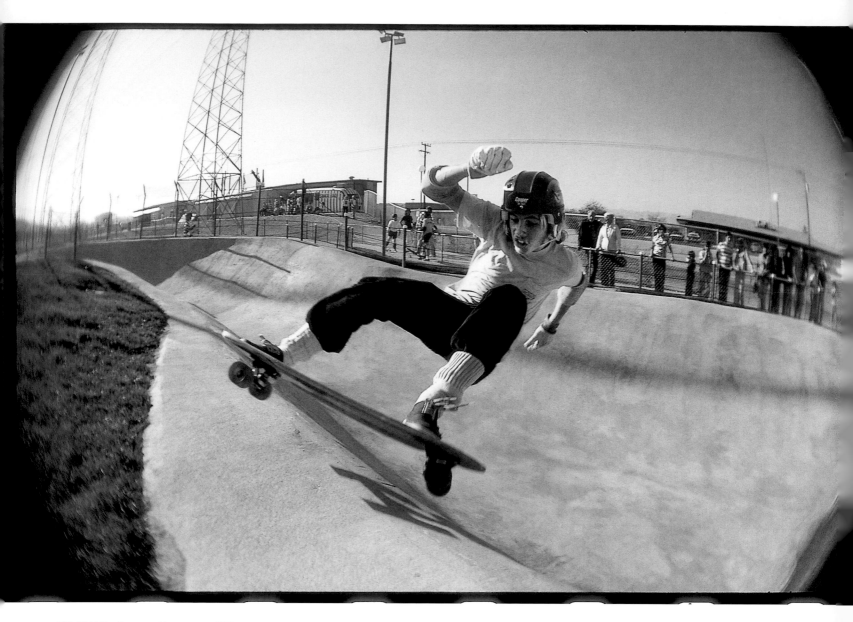

JAY ADAMS—Skatepark Montebello—1977

"BABY PAUL" CULLEN—Skatepark Montebello—1977 >

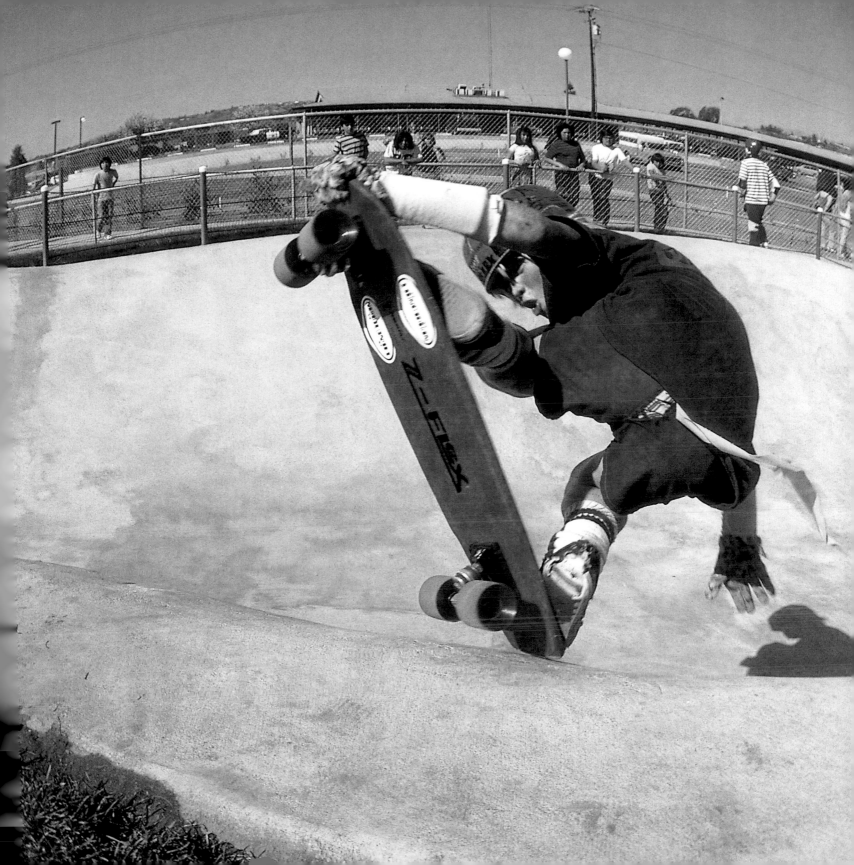

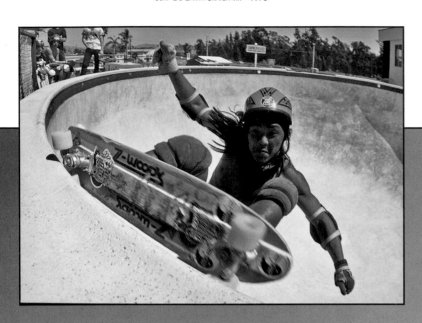

SHOGO KUBO & TONY ALVA
Surf De Earth Skatepark—1978

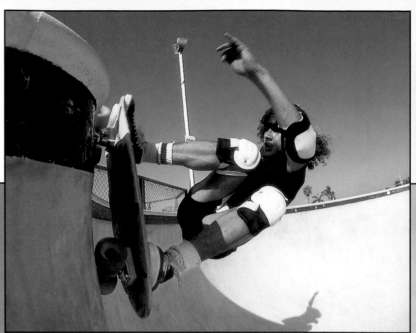

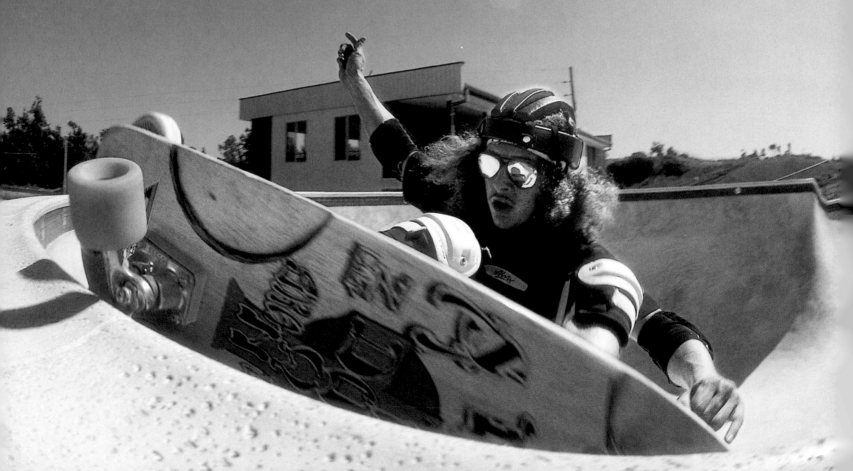

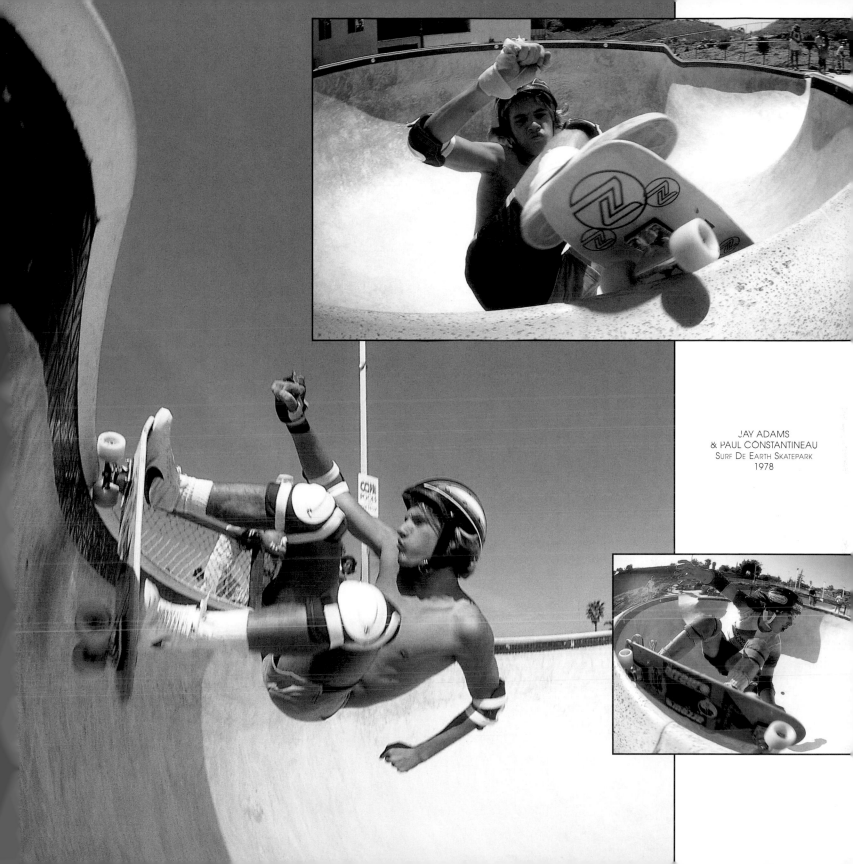

JAY ADAMS
& PAUL CONSTANTINEAU
SURF DE EARTH SKATEPARK
1978

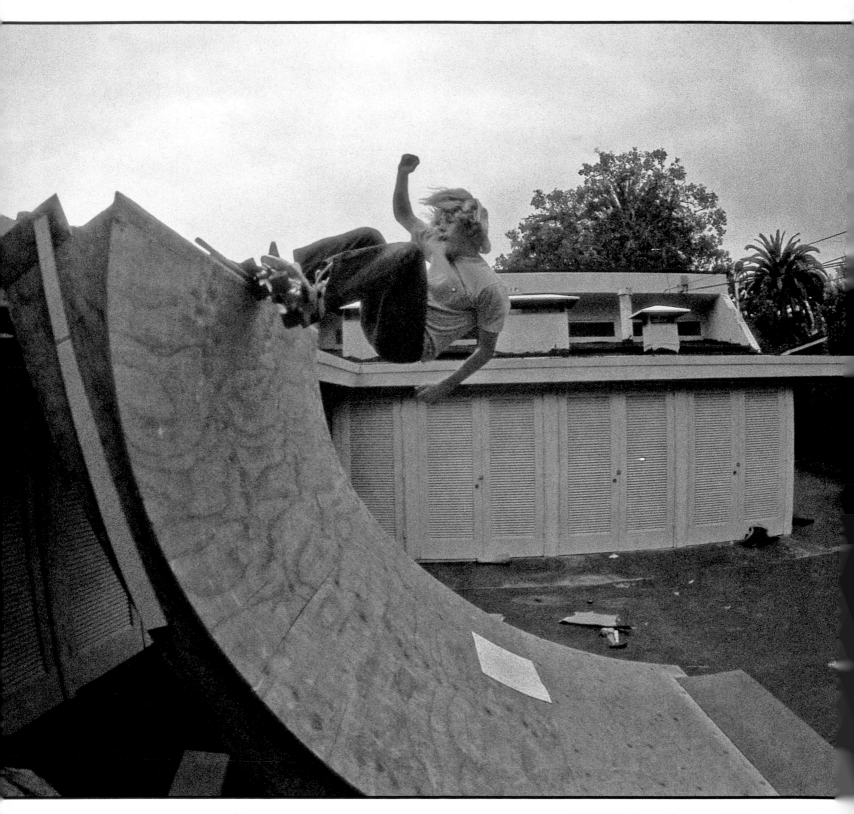

JAY ADAMS—Oakmont Drive ramp—1977

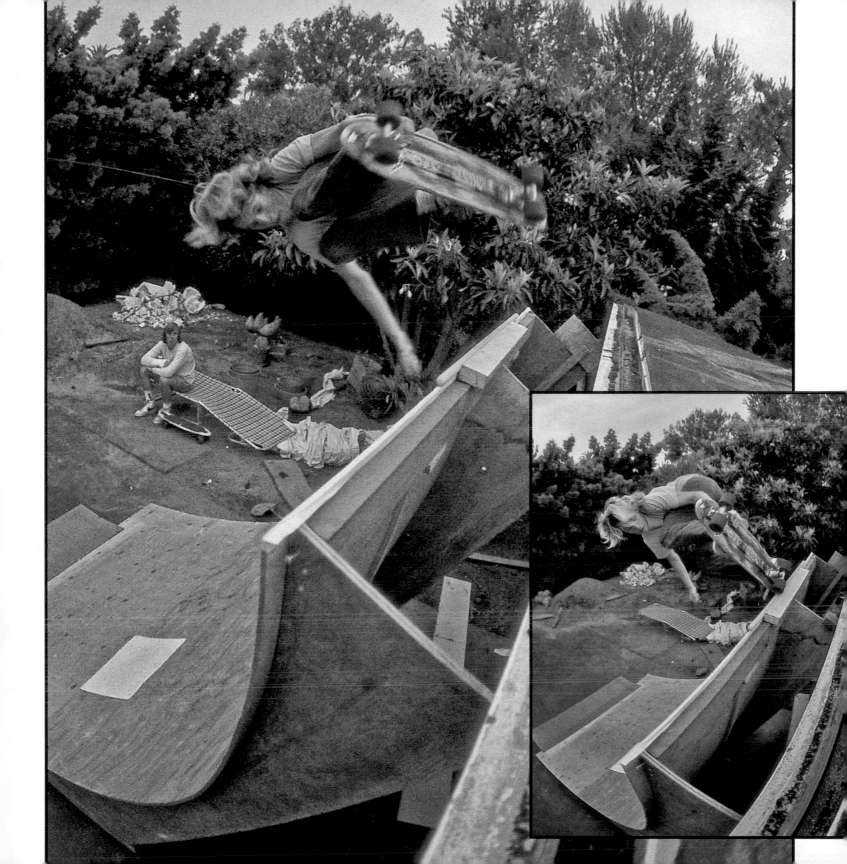

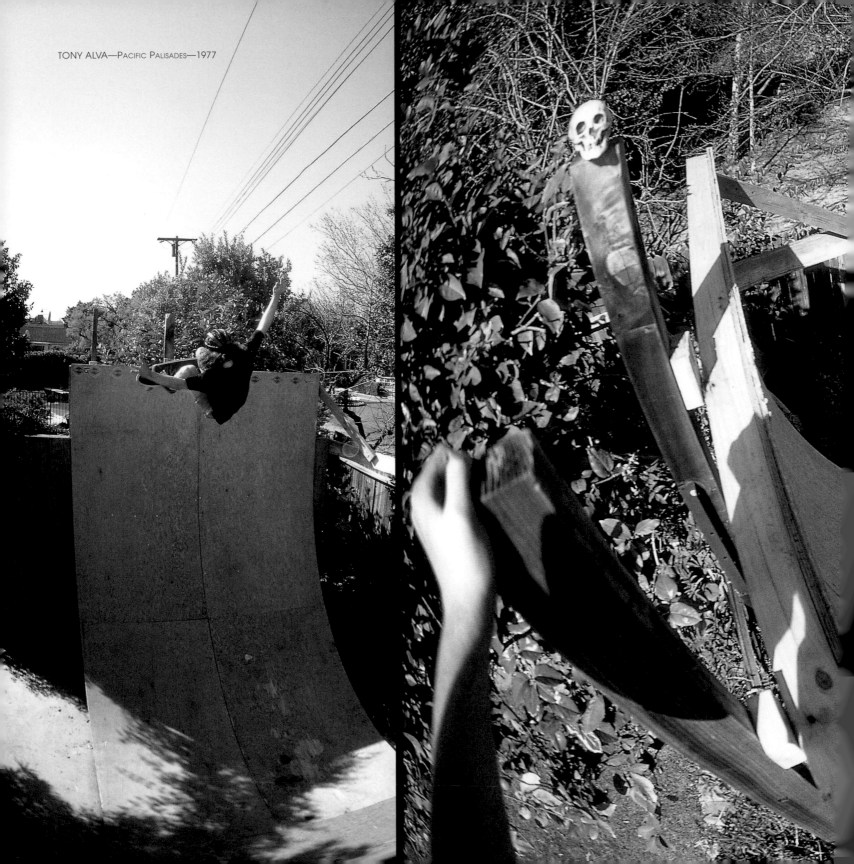

TONY ALVA—PACIFIC PALISADES—1977

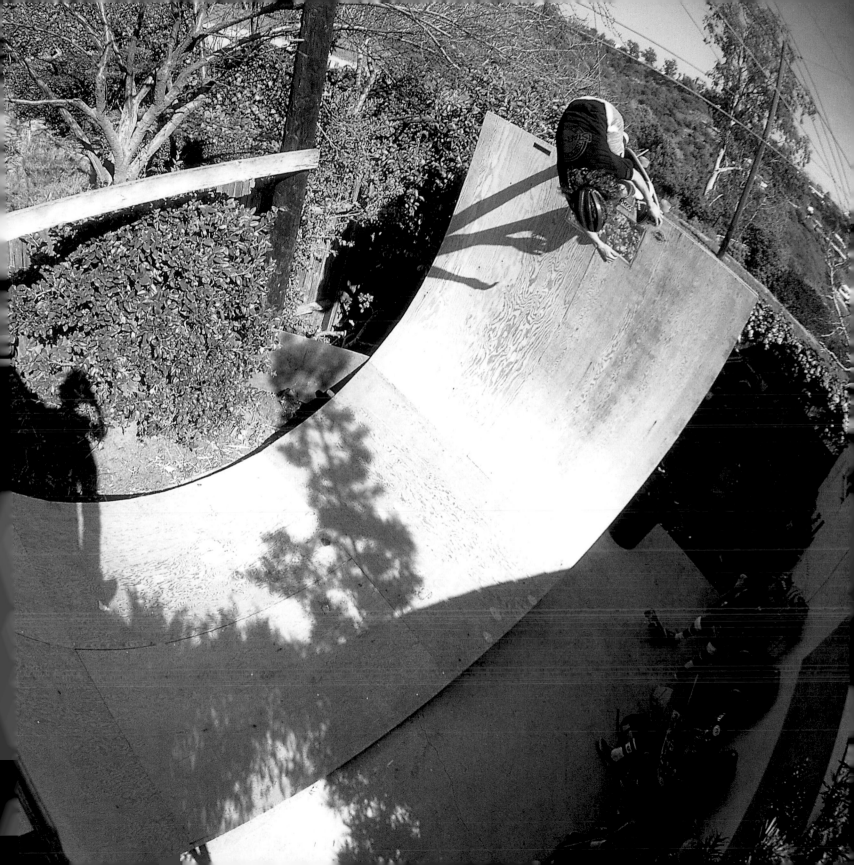

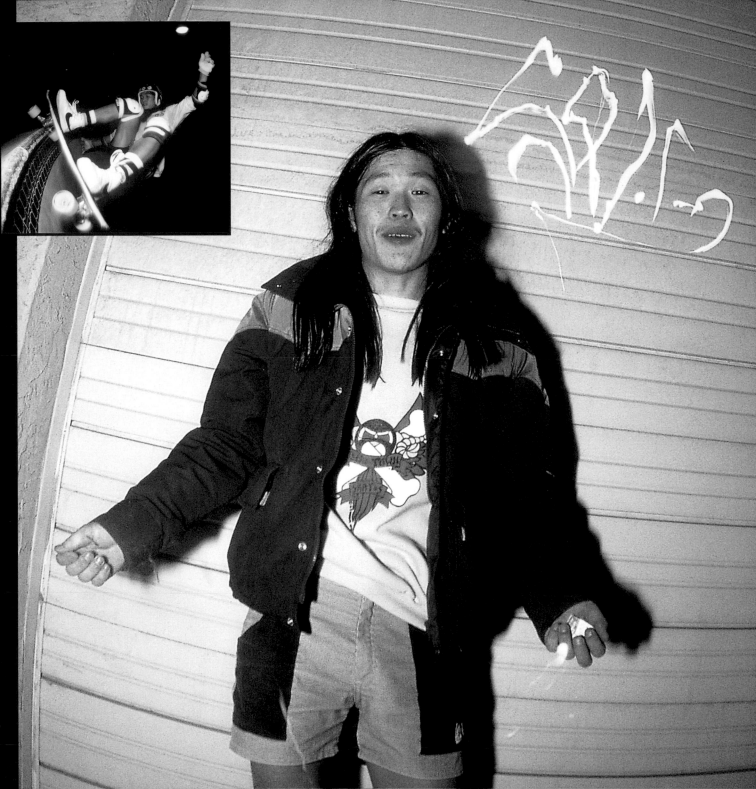

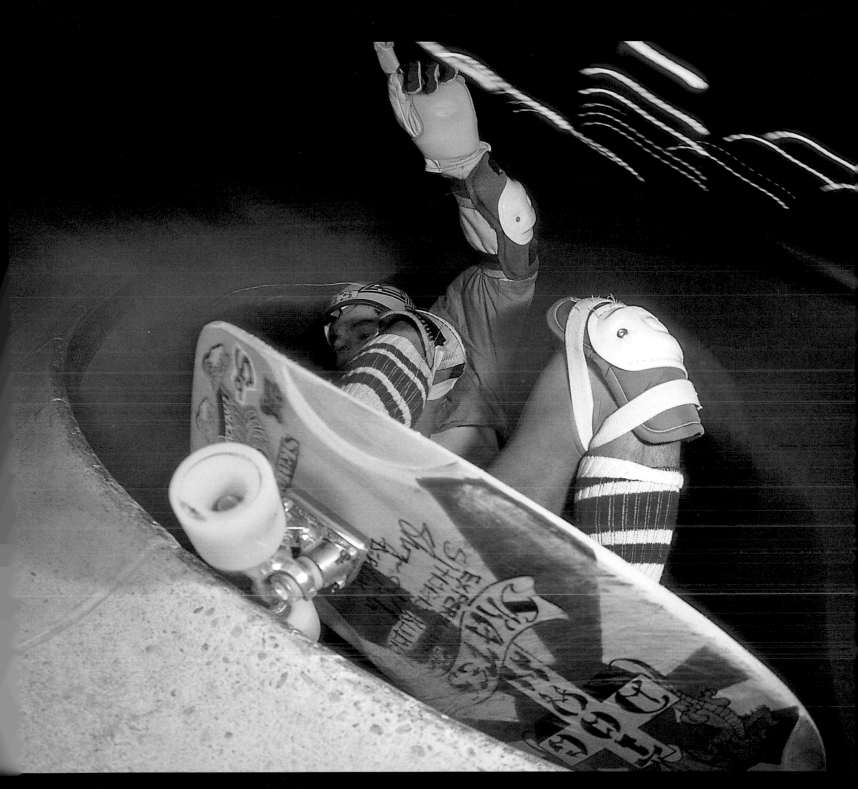

SHOGO KUBO—CHERRY HILL SKATEPARK, NEW JERSEY—1979

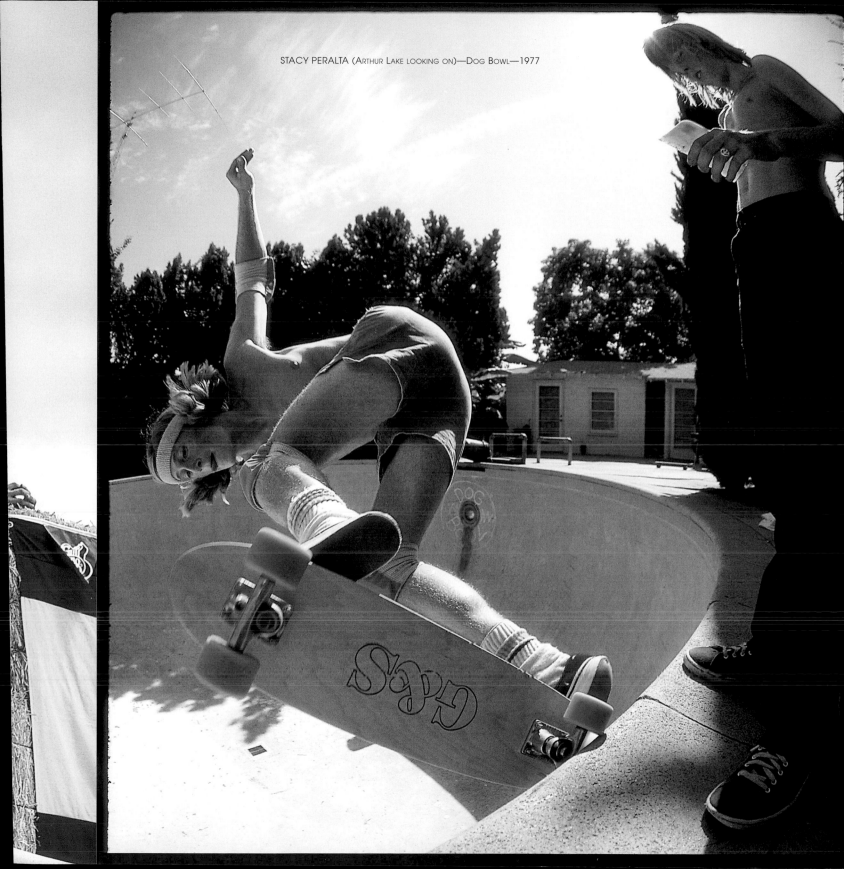

STACY PERALTA (Arthur Lake looking on)—Dog Bowl—1977

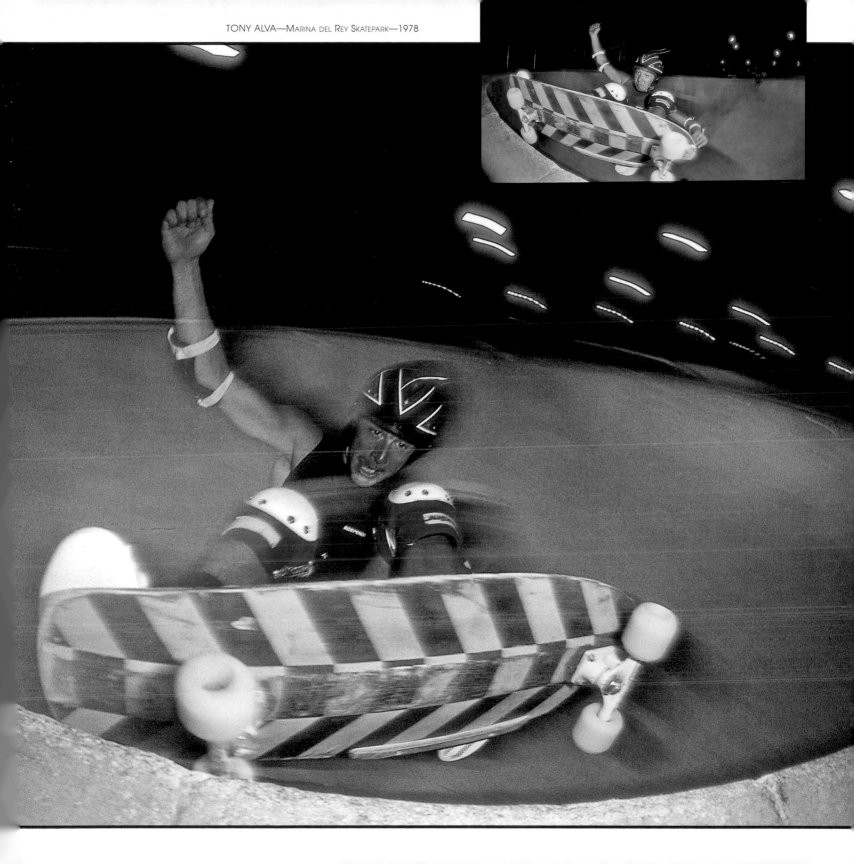

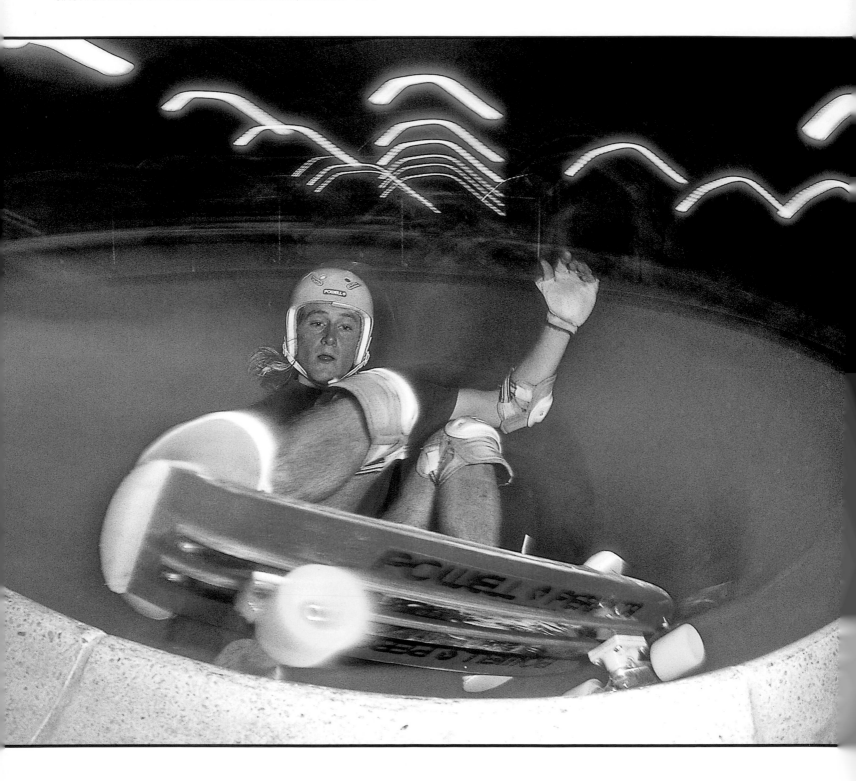

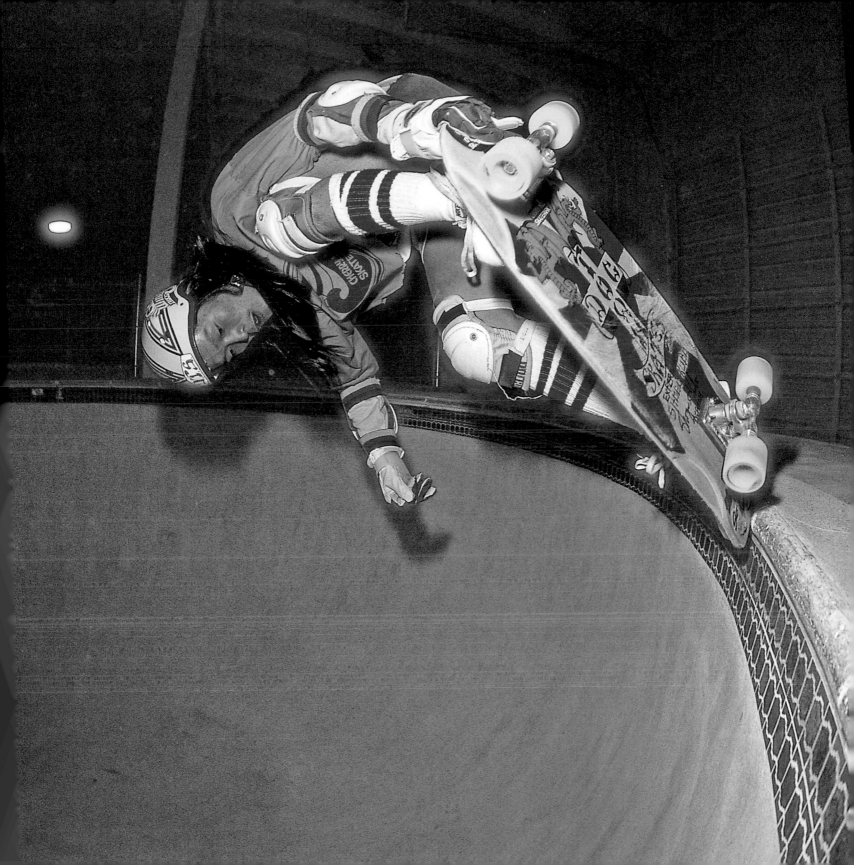

TONY ALVA—BARREL-JUMPING WINNER
WORLD PROFESSIONAL SKATEBOARD CHAMPIONSHIPS
LONG BEACH ARENA—1977

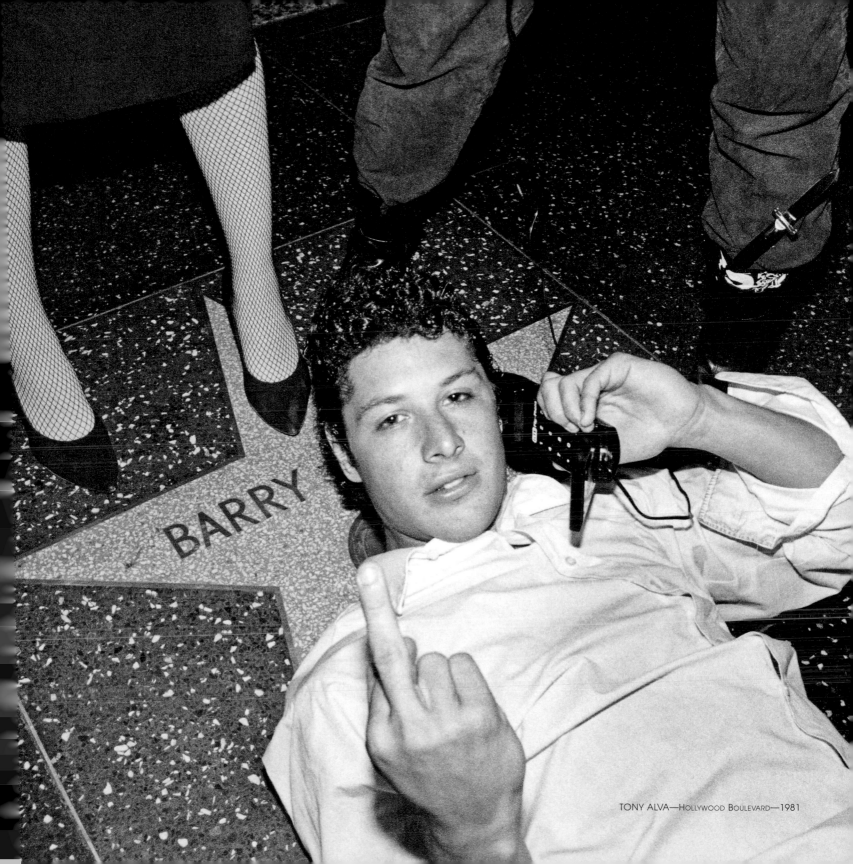

TONY ALVA—HOLLYWOOD BOULEVARD—1981

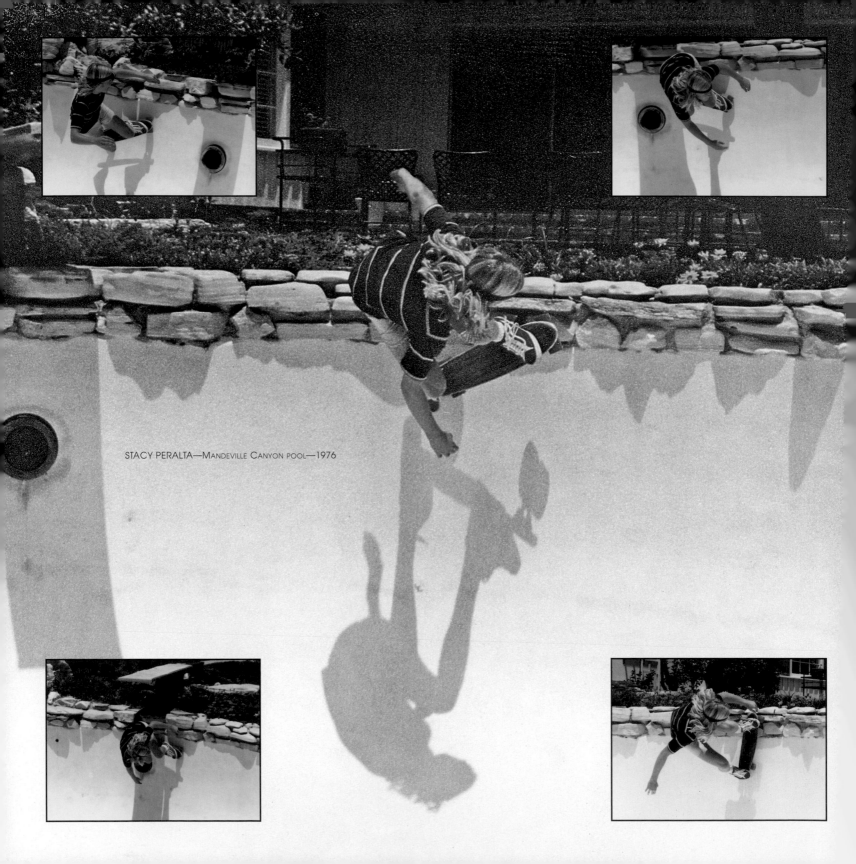

STACY PERALTA—Mandeville Canyon pool—1976

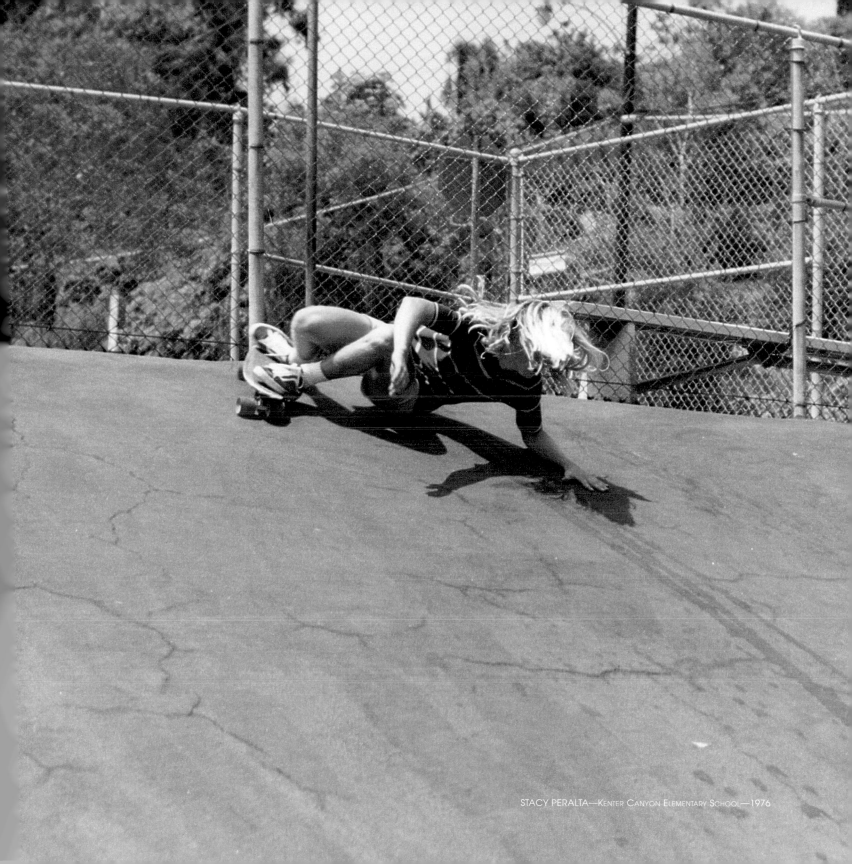

STACY PERALTA—Kenter Canyon Elementary School—1976

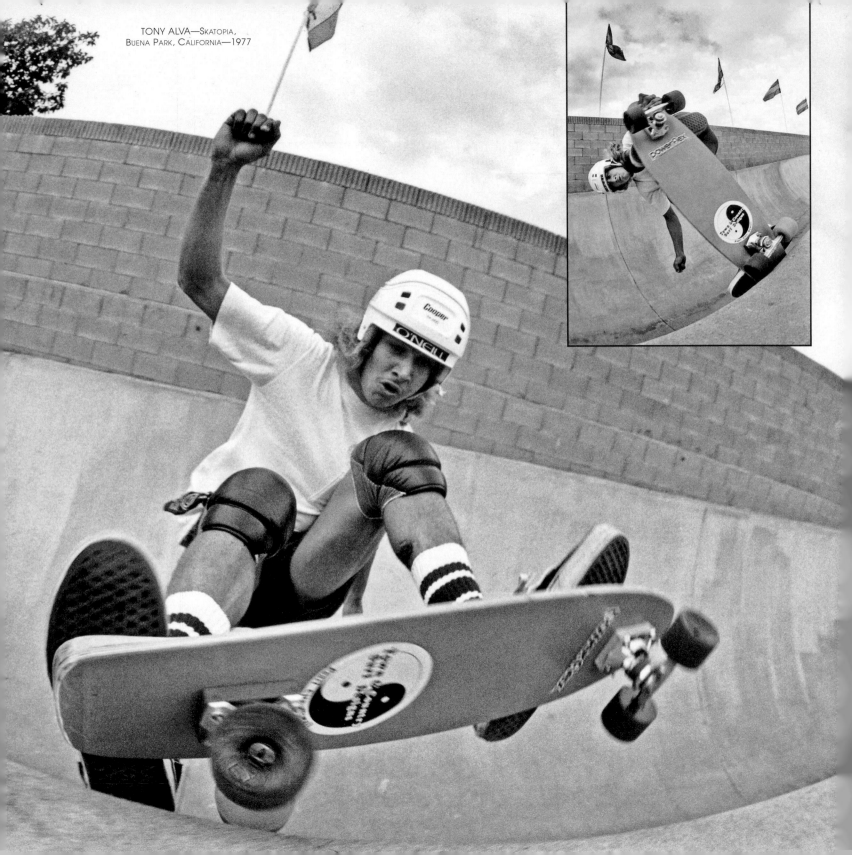

TONY ALVA—Skatopia,
Buena Park, California—1977

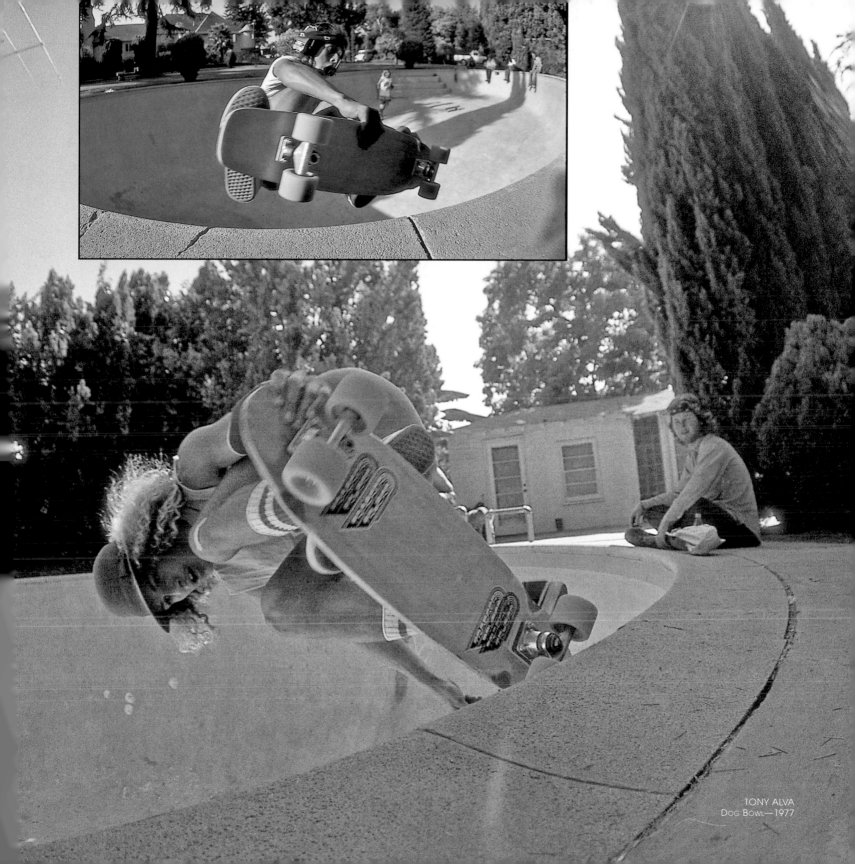

TONY ALVA
Dog Bowl—1977

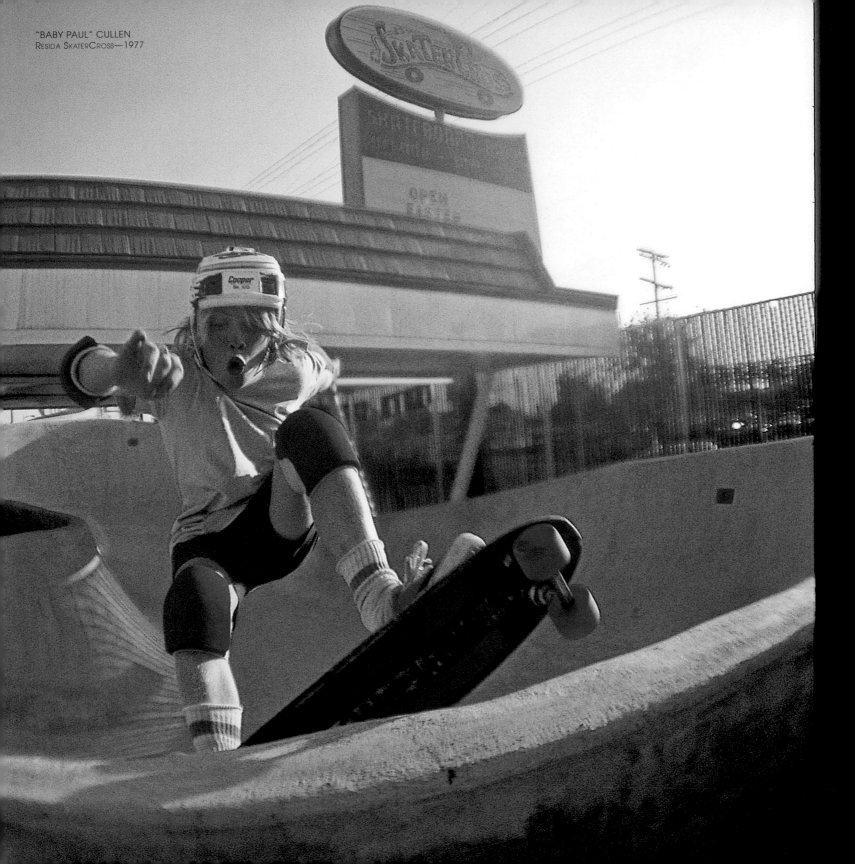

"BABY PAUL" CULLEN
Resida SkaterCross—1977

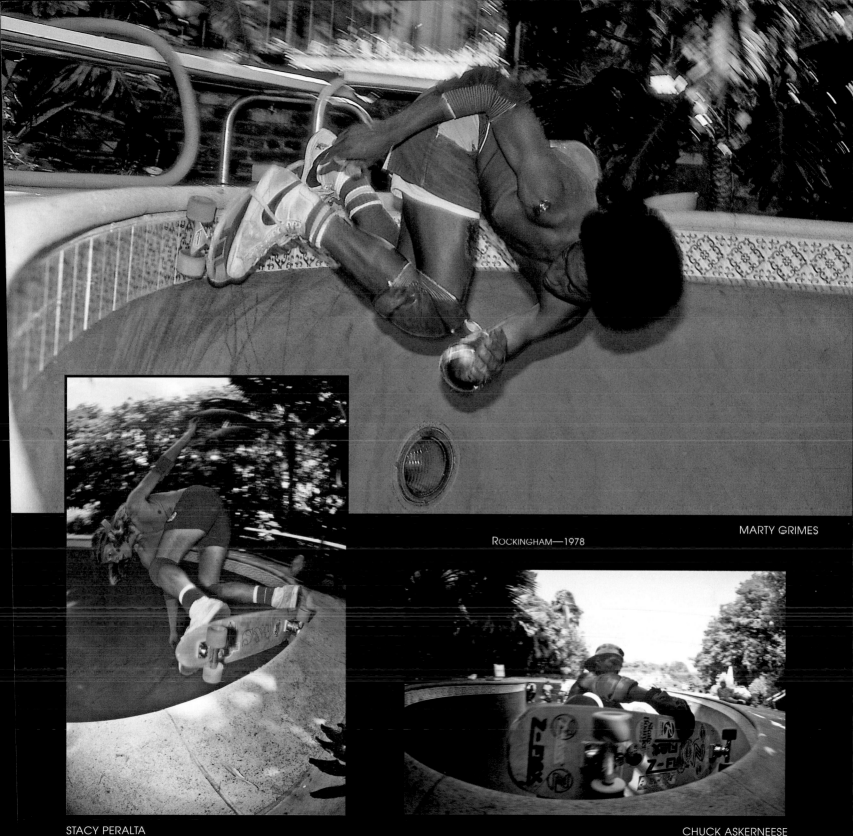

ROCKINGHAM—1978

MARTY GRIMES

STACY PERALTA

CHUCK ASKERNEESE

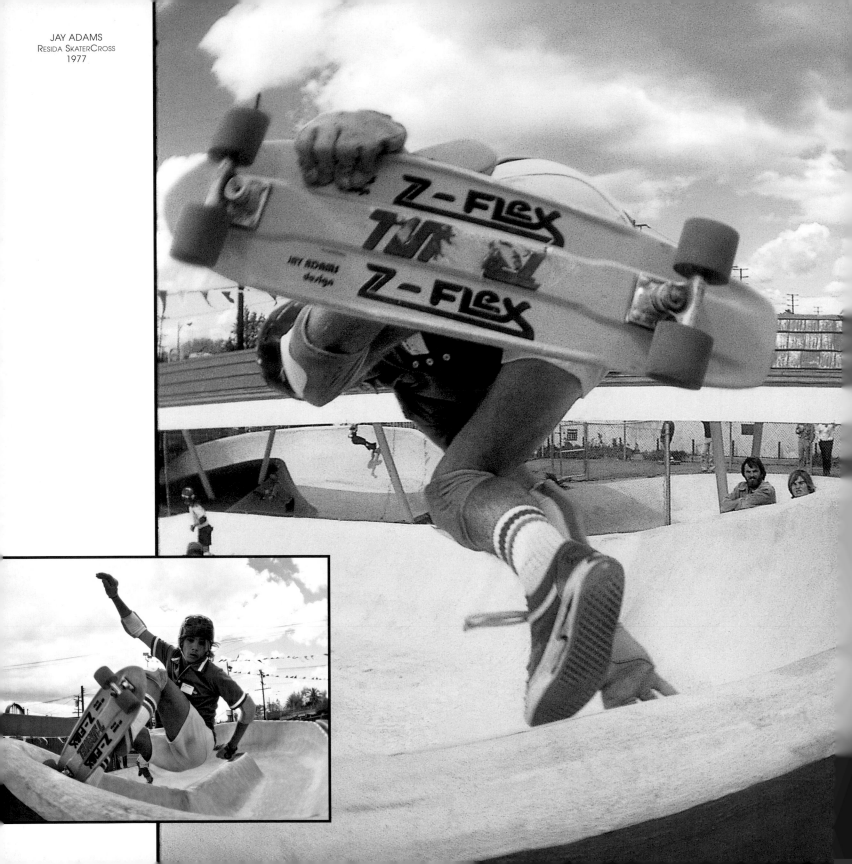

JAY ADAMS
Resida SkaterCross
1977

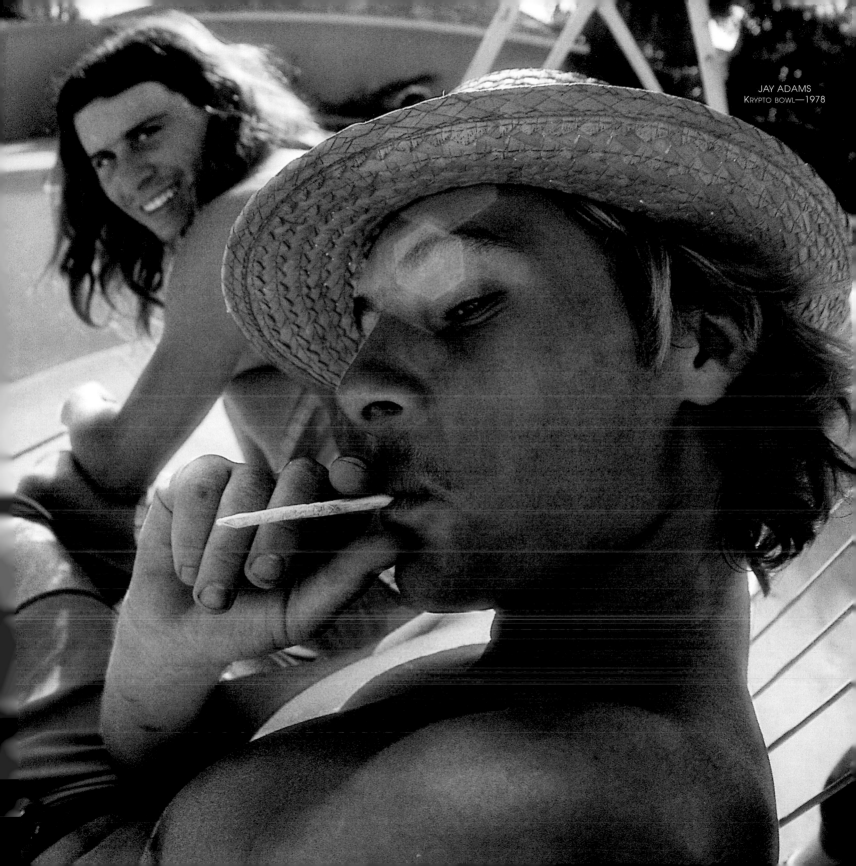

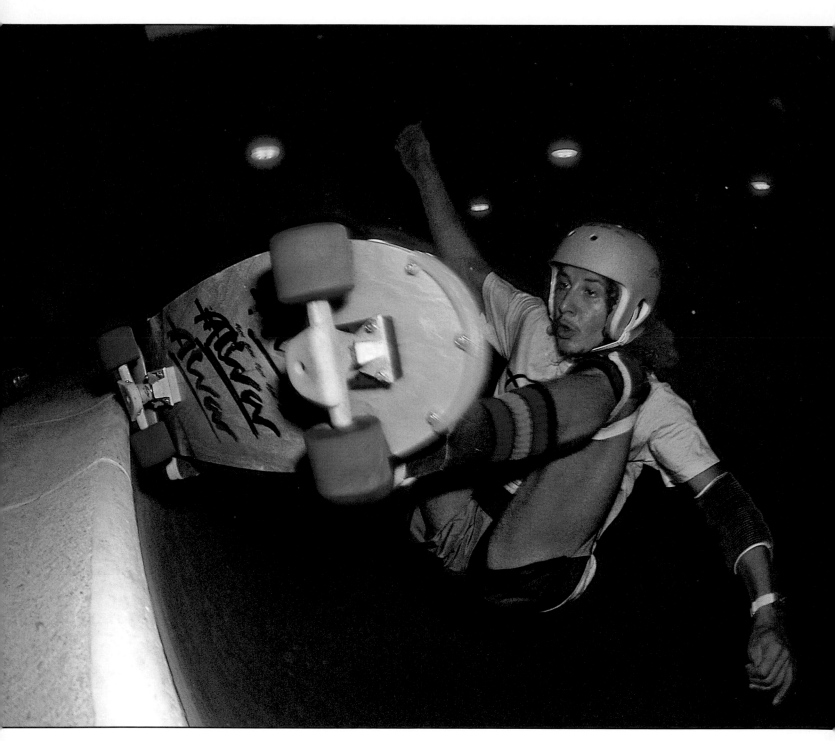

TONY ALVA—Cherry Hill Skatepark, New Jersey—1979

JAY ADAMS—Endless Wave, Oxnard, California—1978 >

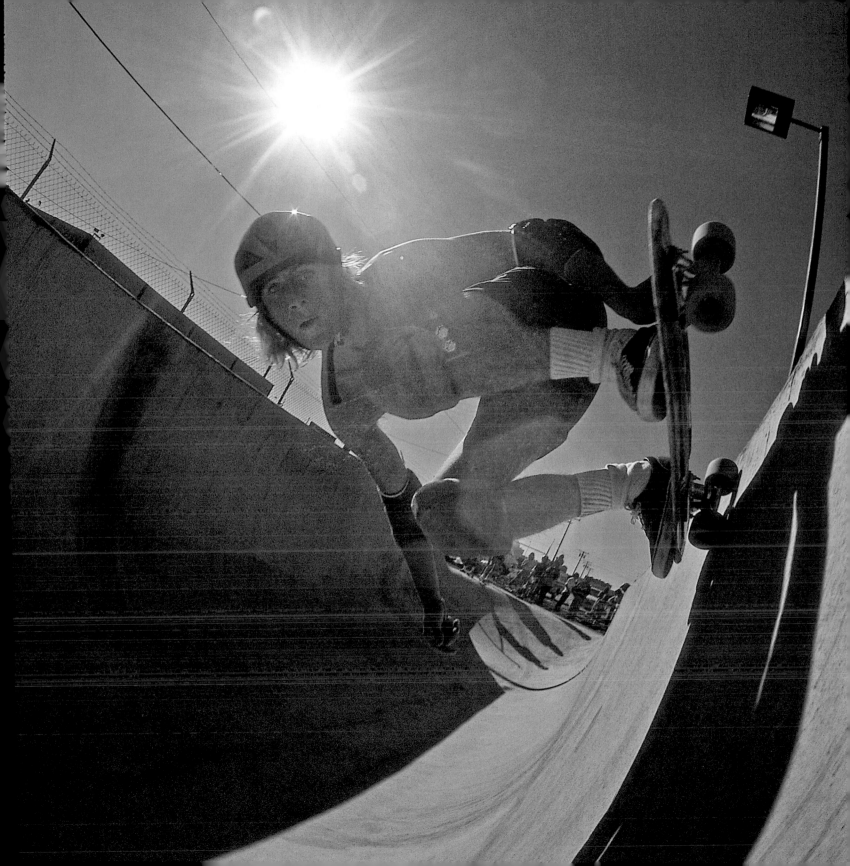

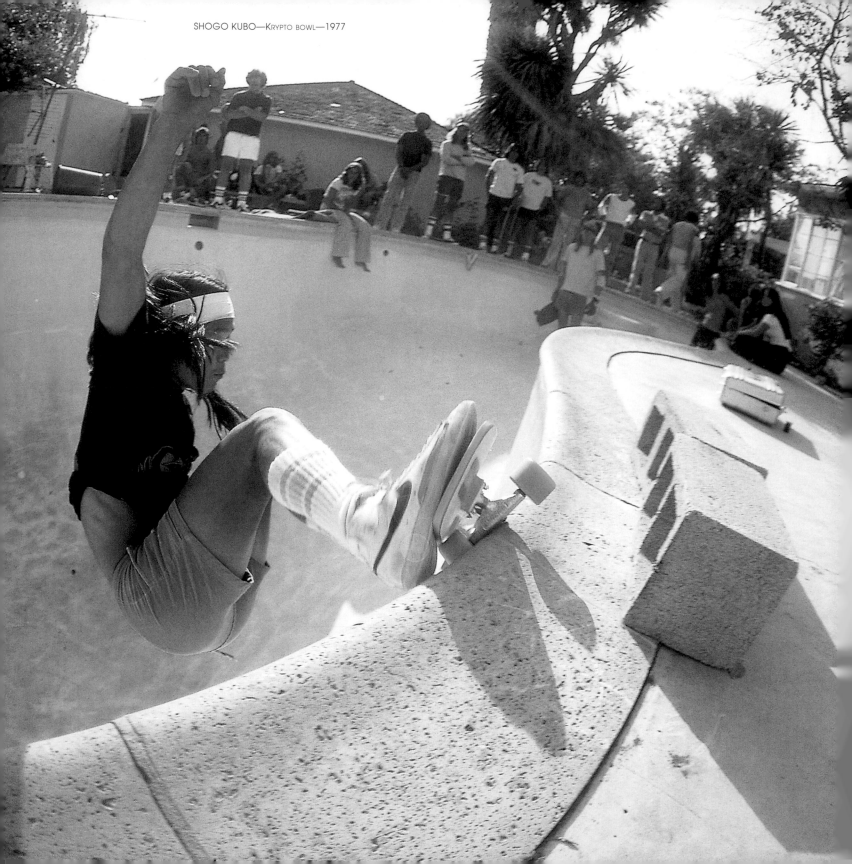

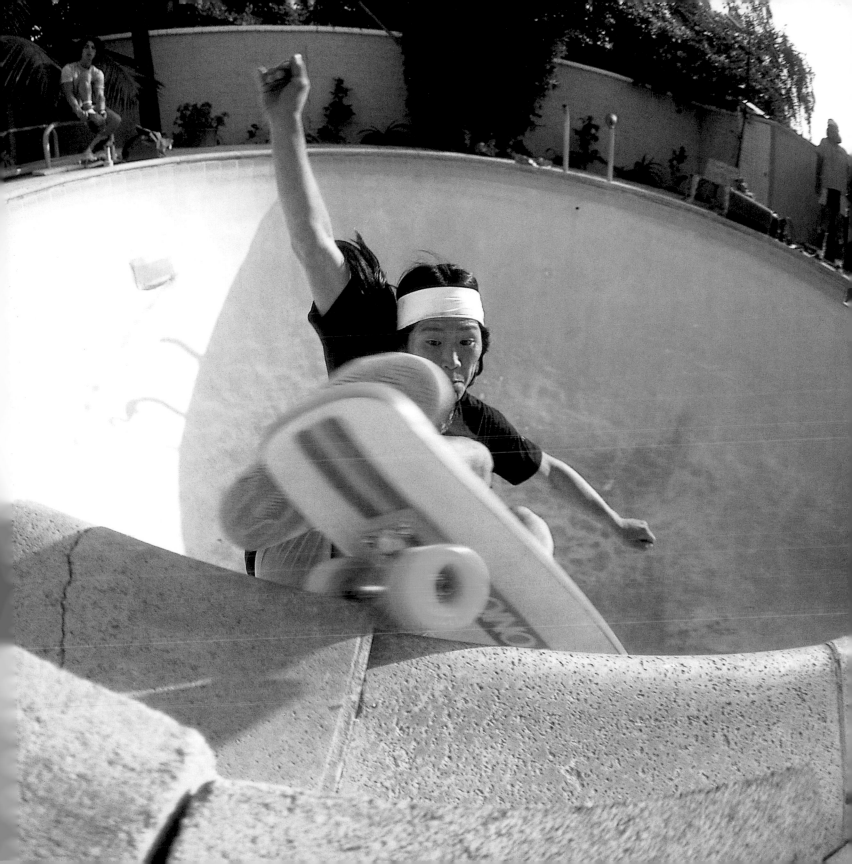

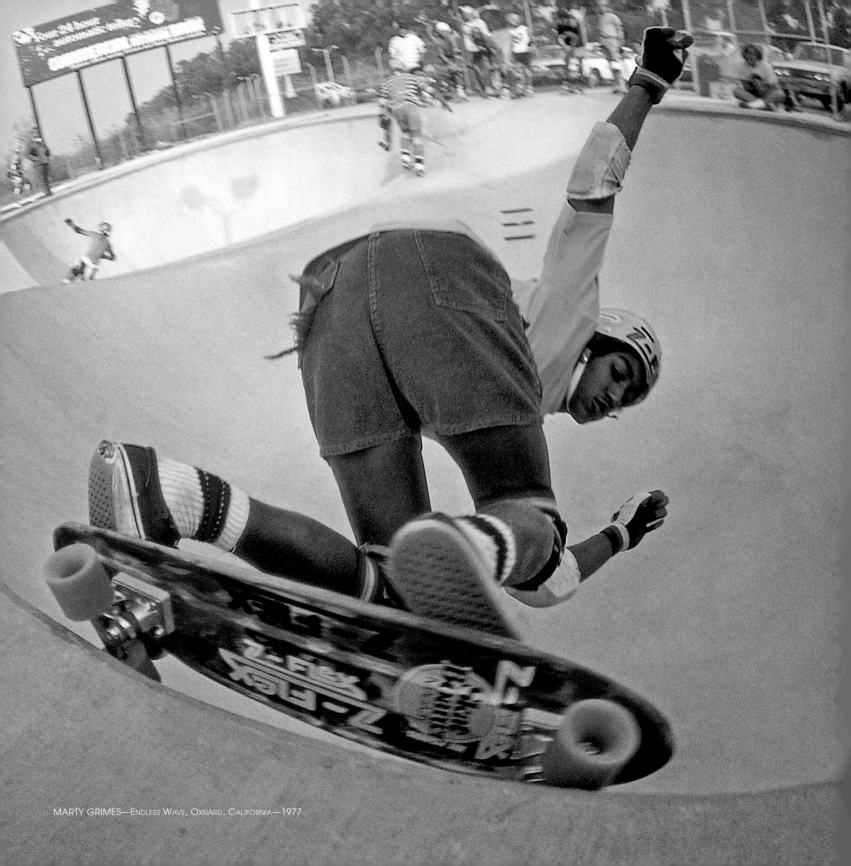

MARTY GRIMES—Endless Wave, Oxnard, California—1977

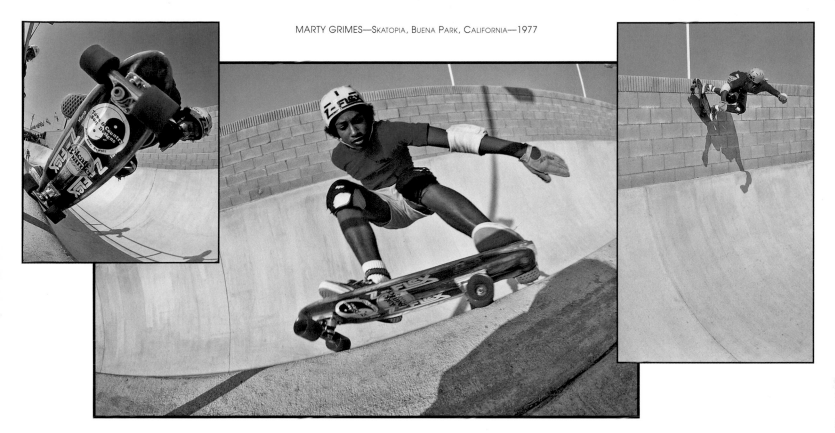

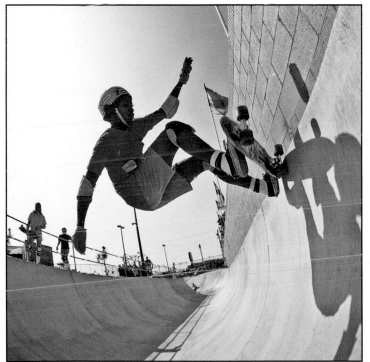

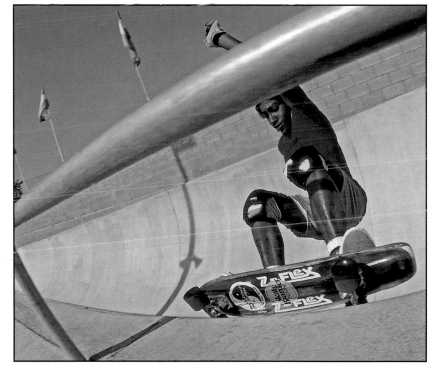

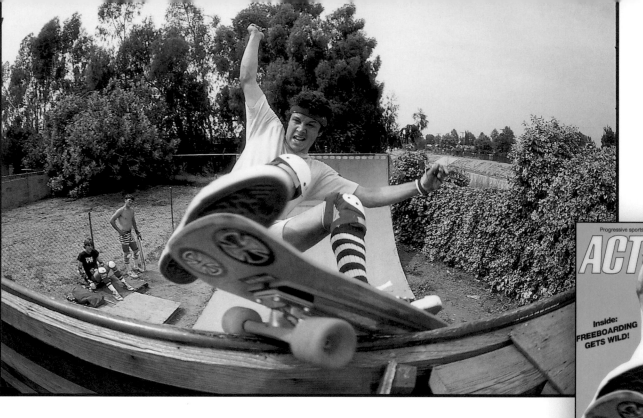

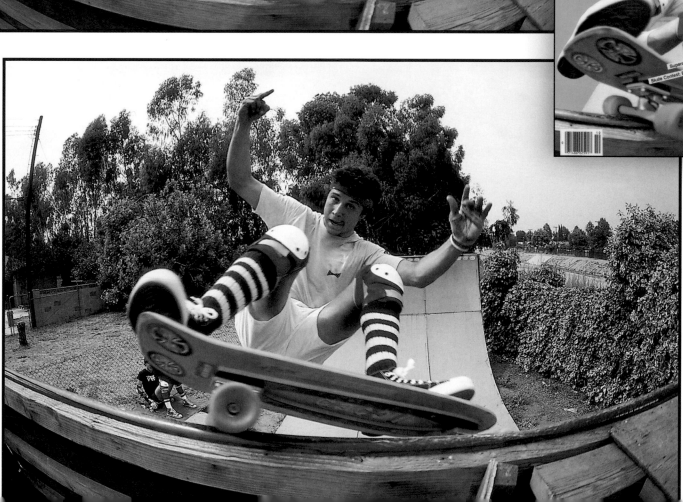

Progressive sports, people, music and way more

ACTION NOW $2.00 OCTOBER 1981 VOL. 6, NO. 3

SkateBoarding:

Inside: FREEBOARDING GETS WILD!

WHAT HAPPENED?
WHO'S TO BLAME??
CAN IT SURVIVE???

Fashion: THE CHIC "G.Q." LOOK

Supercross: BARNETT TAKES L.A. AND THE SERIES

Skate Contest: EAST MEETS WEST AT FLORIDA'S KONA PRO

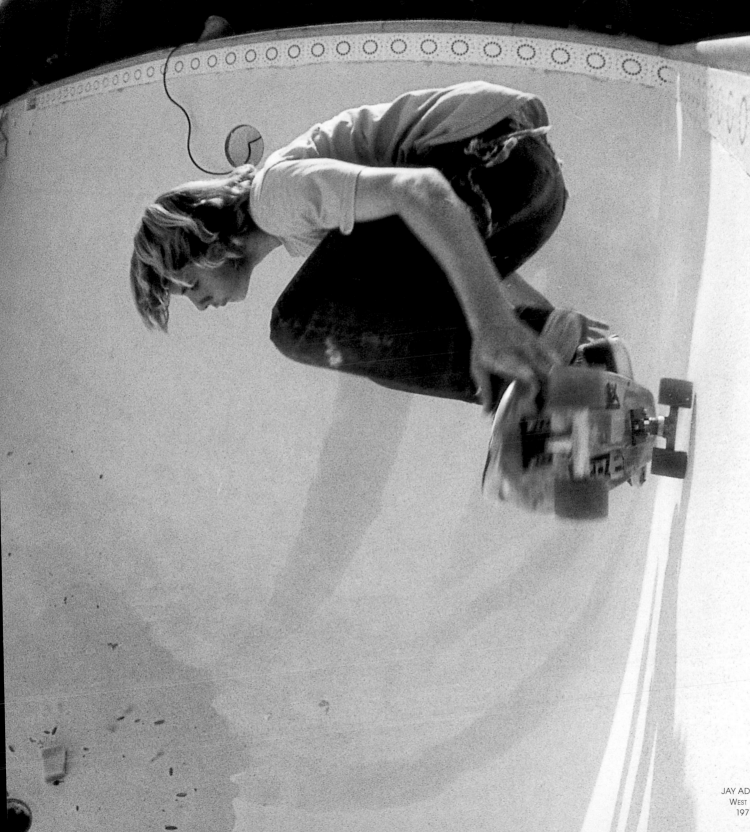

JAY ADAMS
WEST LA
1977

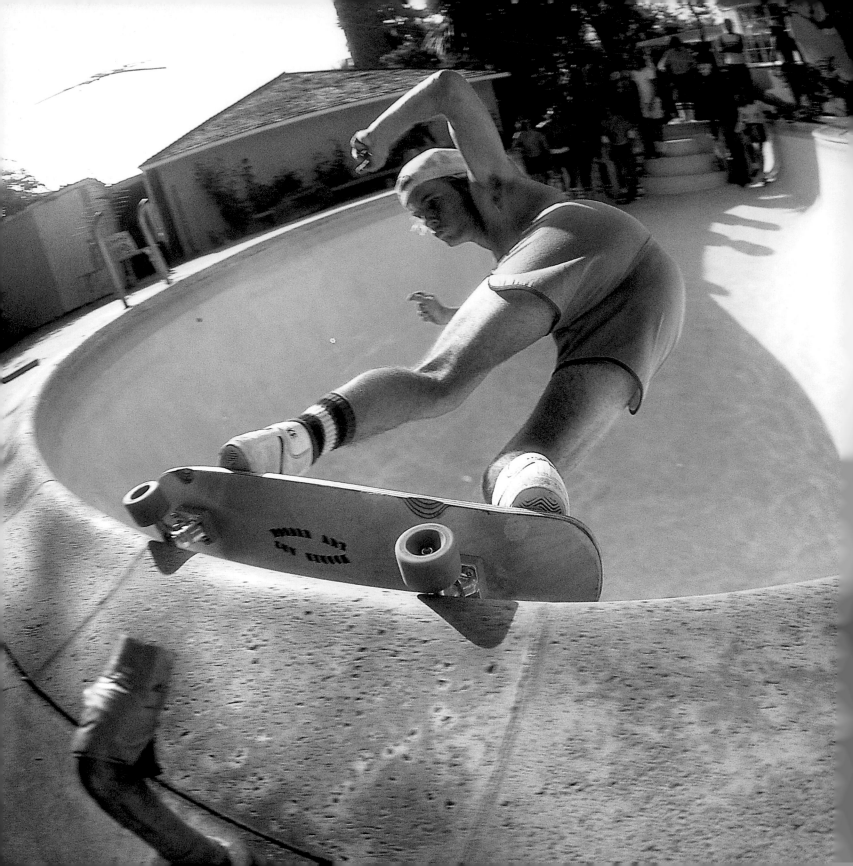

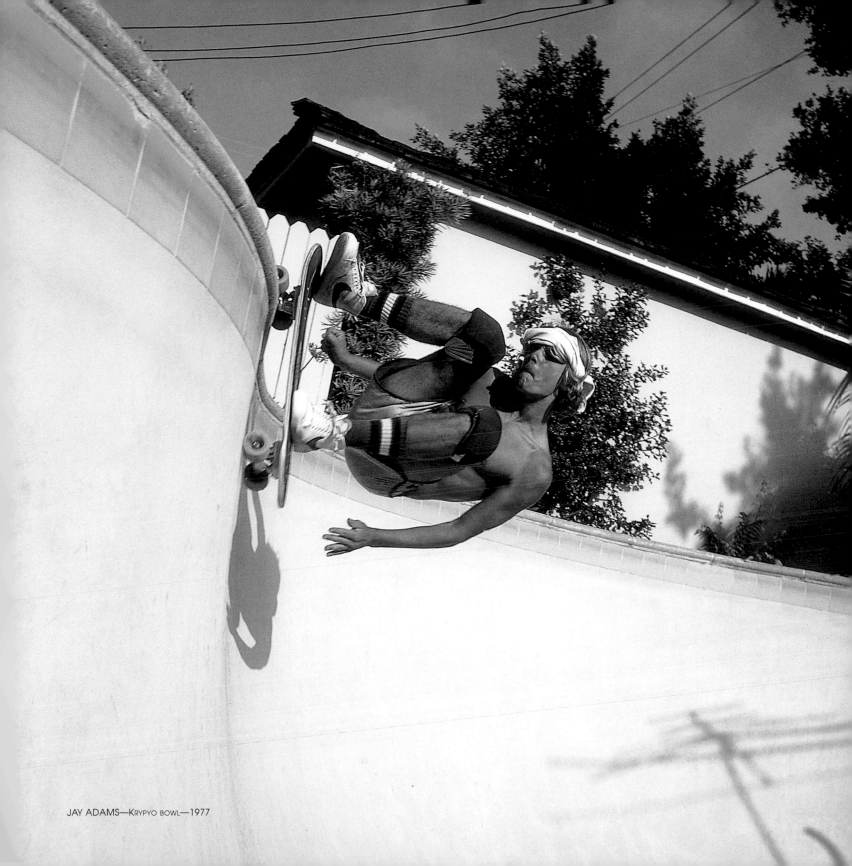

JAY ADAMS—Krypyo bowl—1977

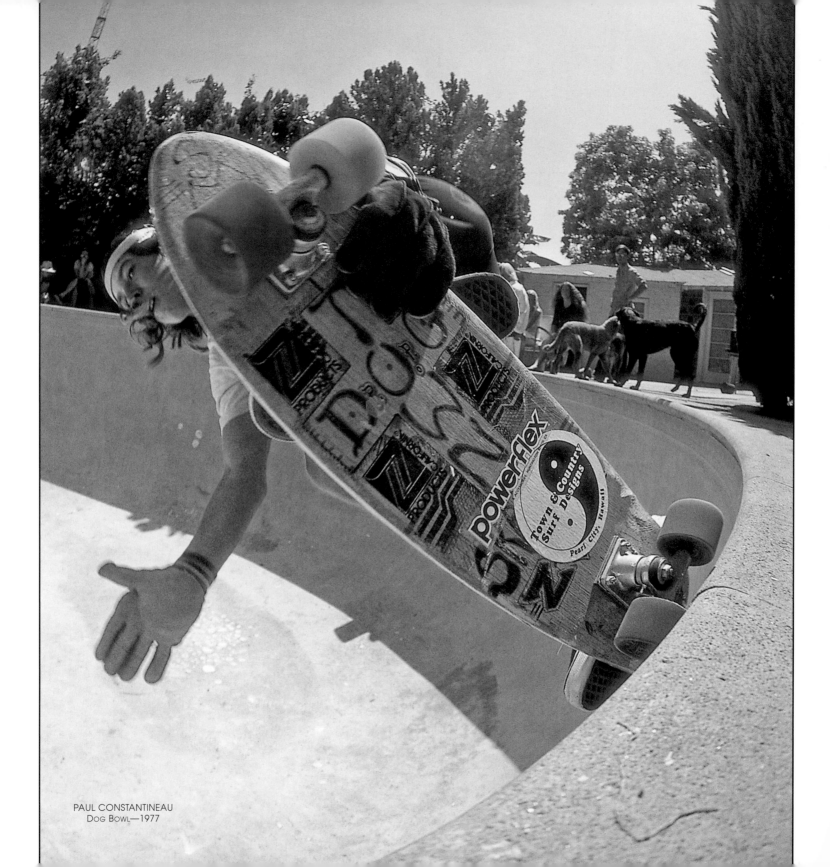

PAUL CONSTANTINEAU
Dog Bowl—1977

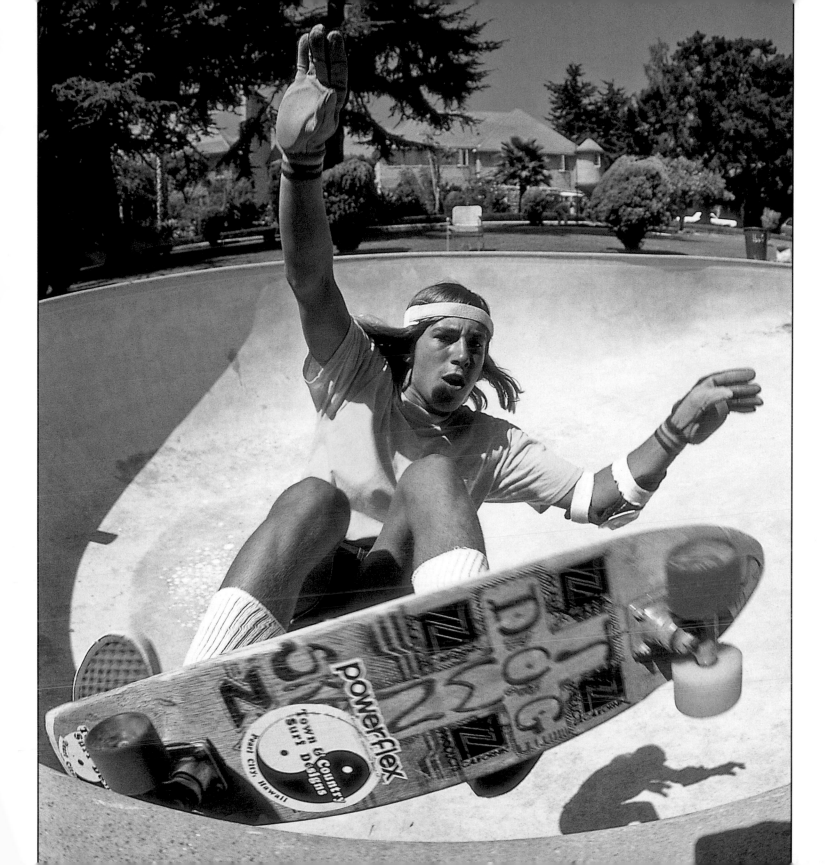

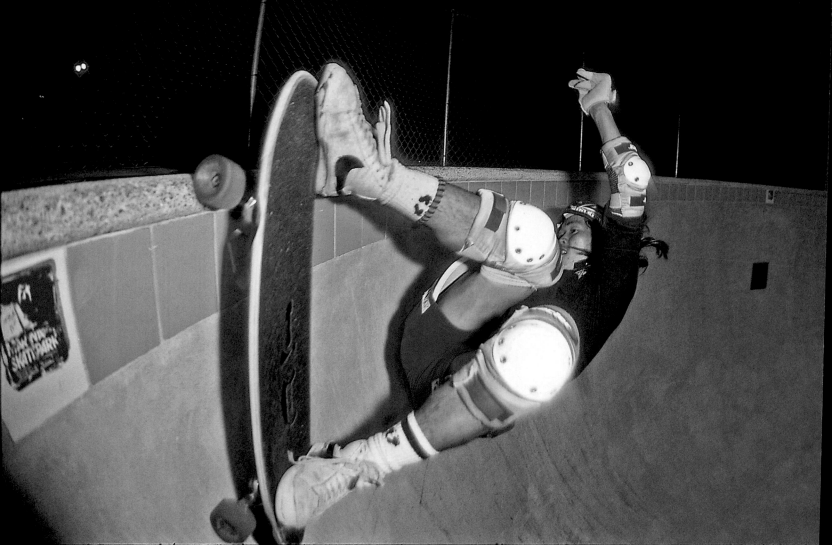

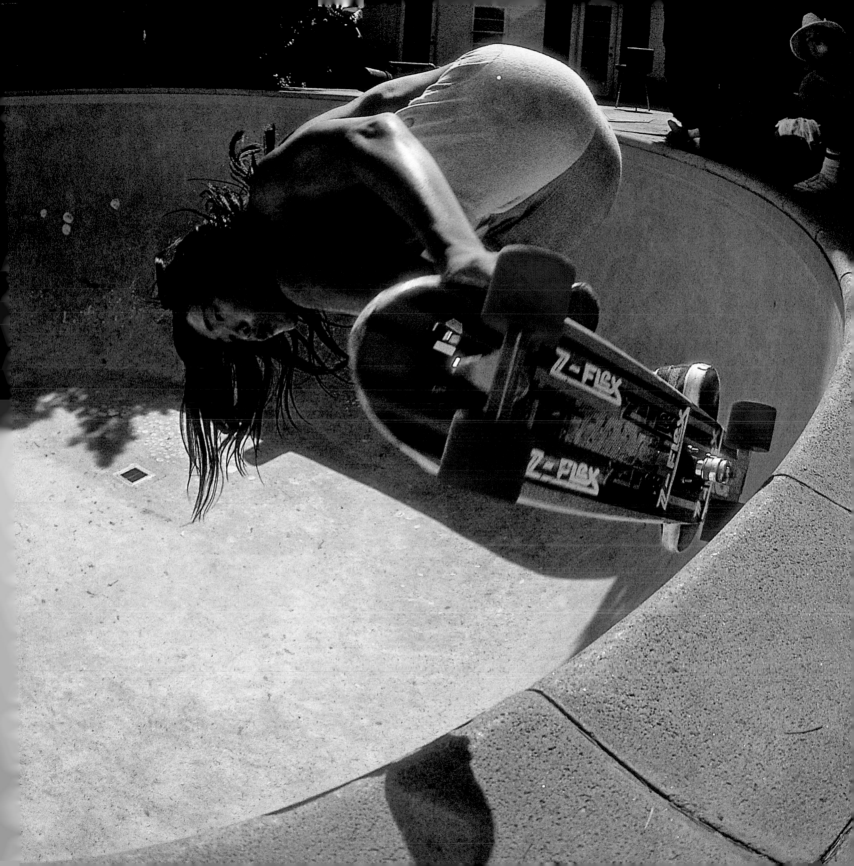

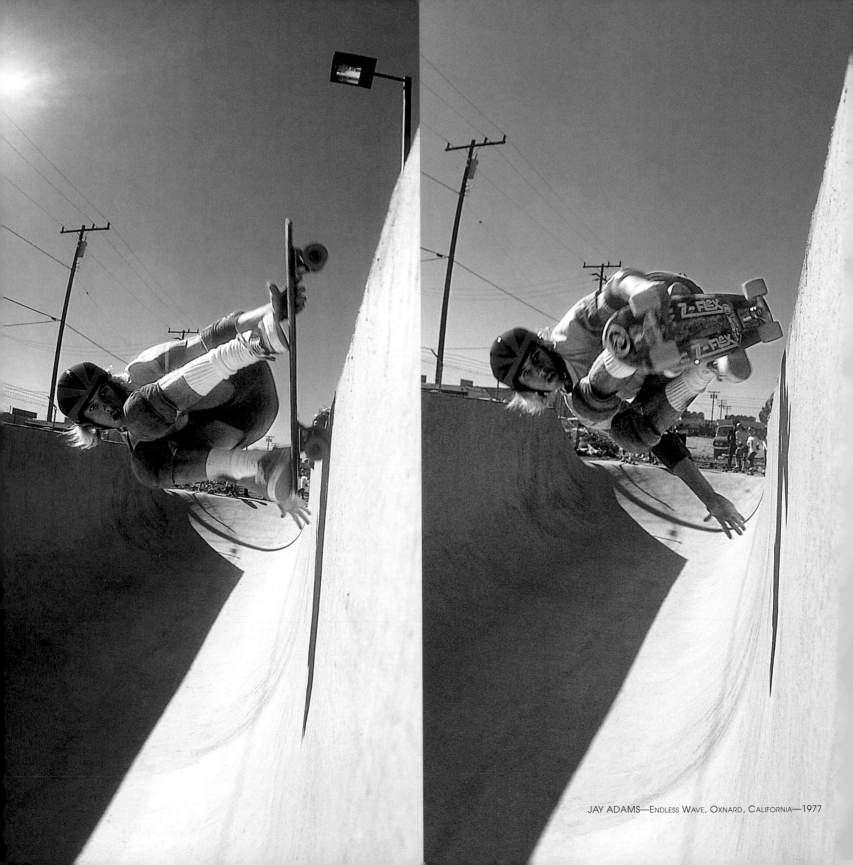

JAY ADAMS—Endless Wave, Oxnard, California—1977

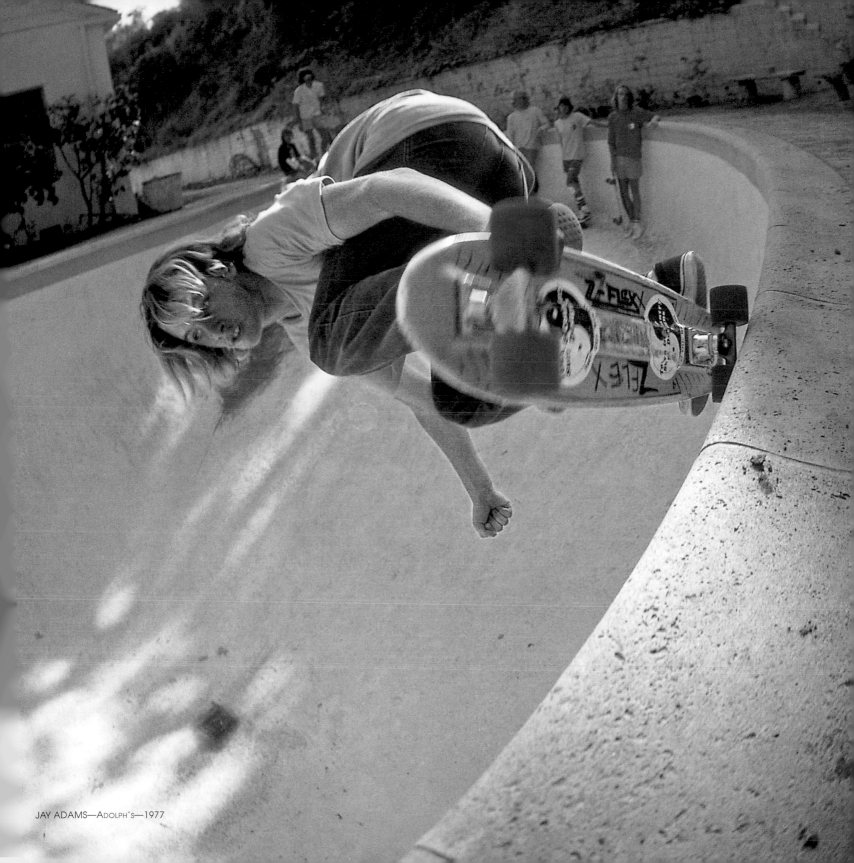

JAY ADAMS—Adolph's—1977

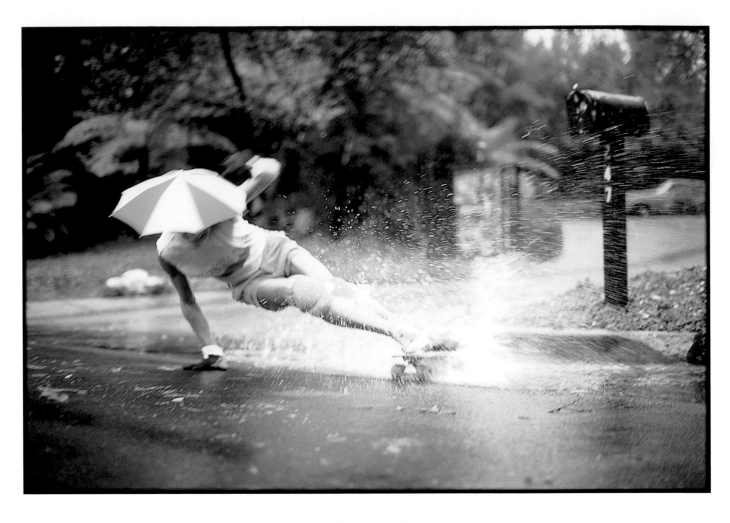

WENTZLE RUML
Rockingham—1977

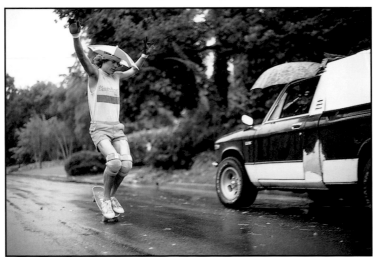

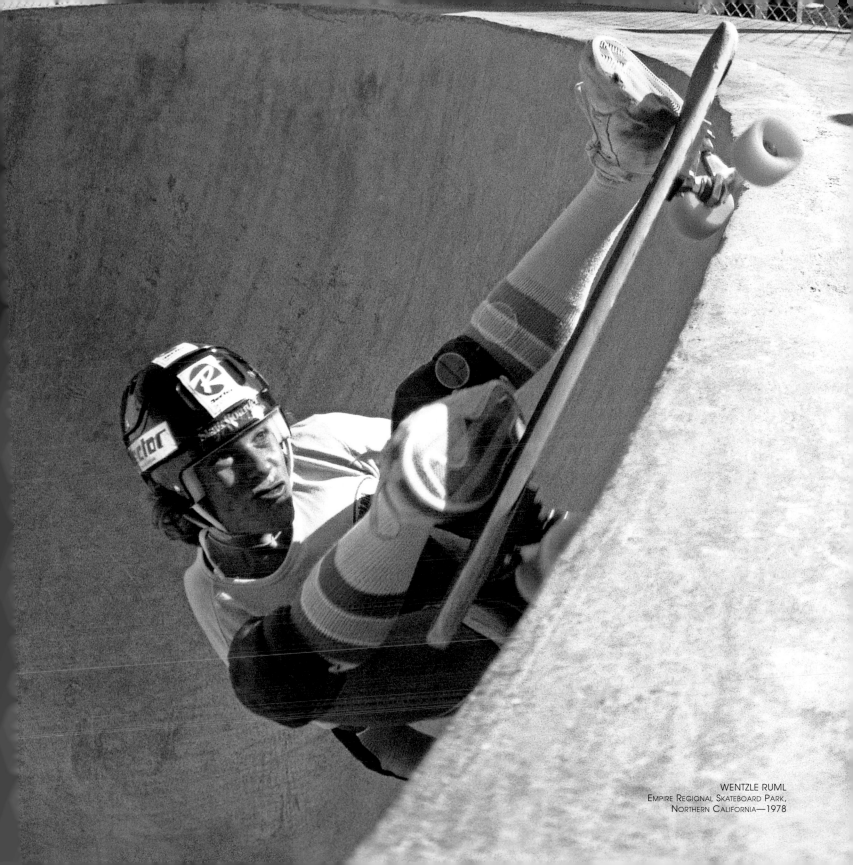

WENTZLE RUML
EMPIRE REGIONAL SKATEBOARD PARK,
NORTHERN CALIFORNIA—1978

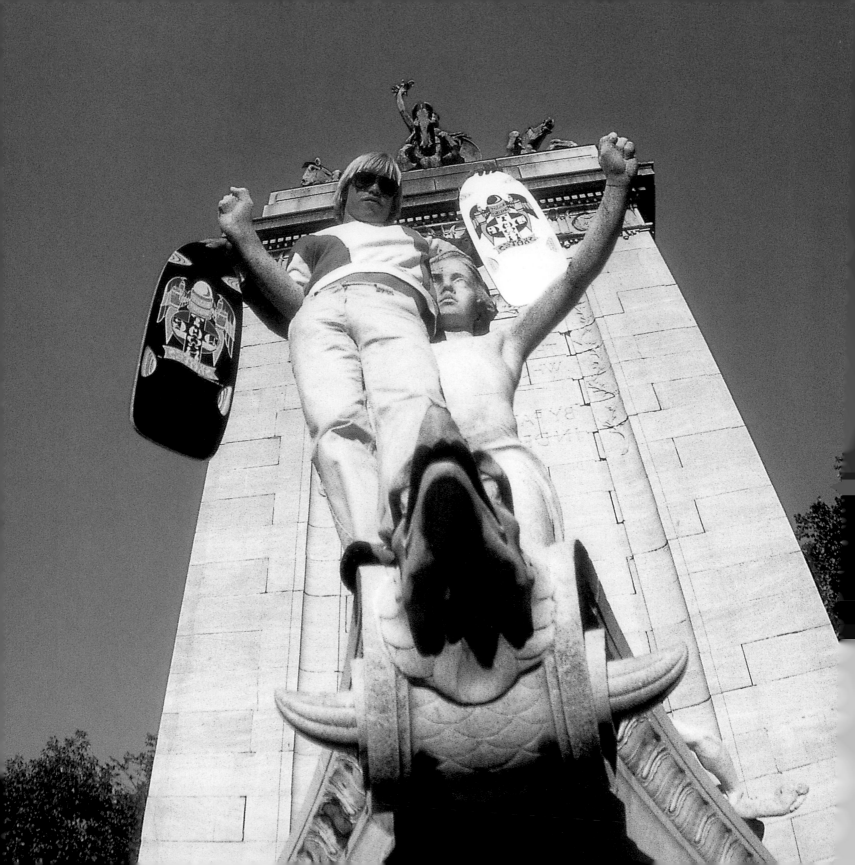

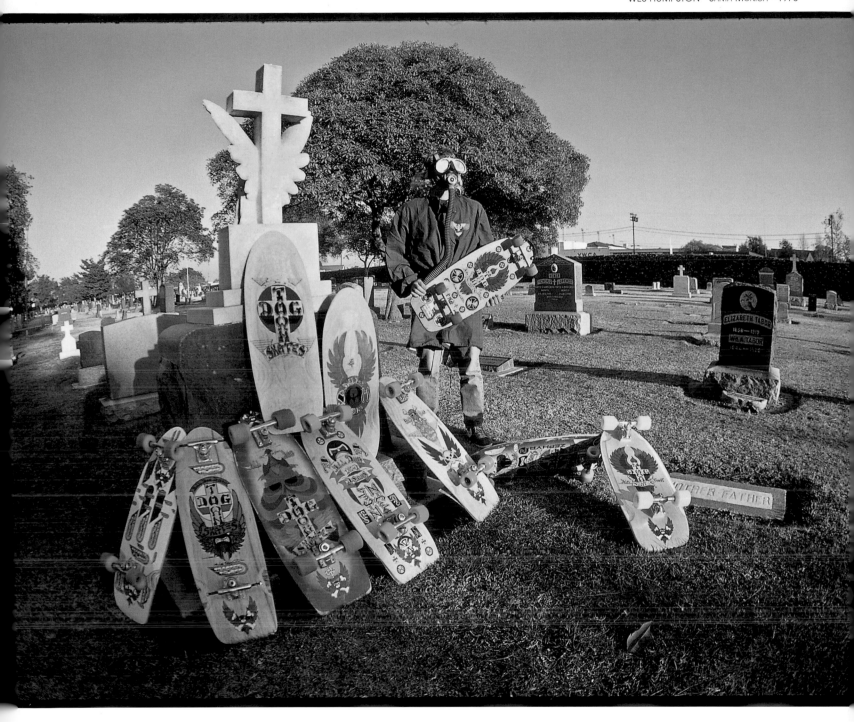

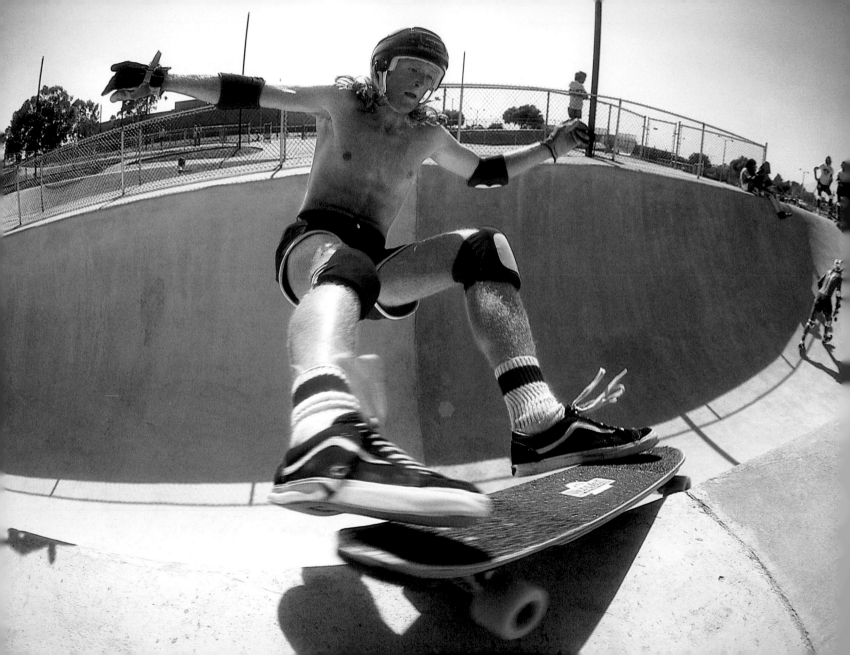

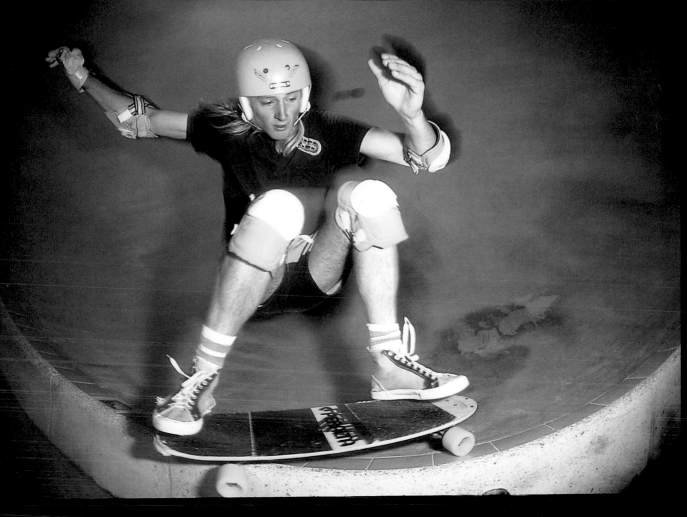

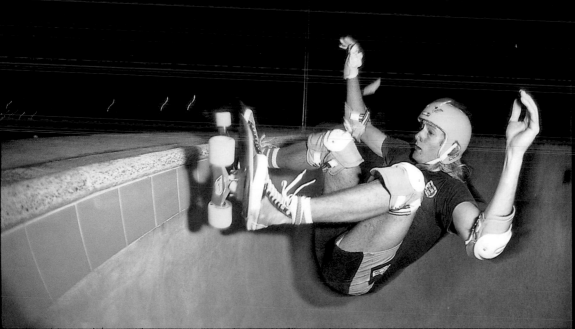

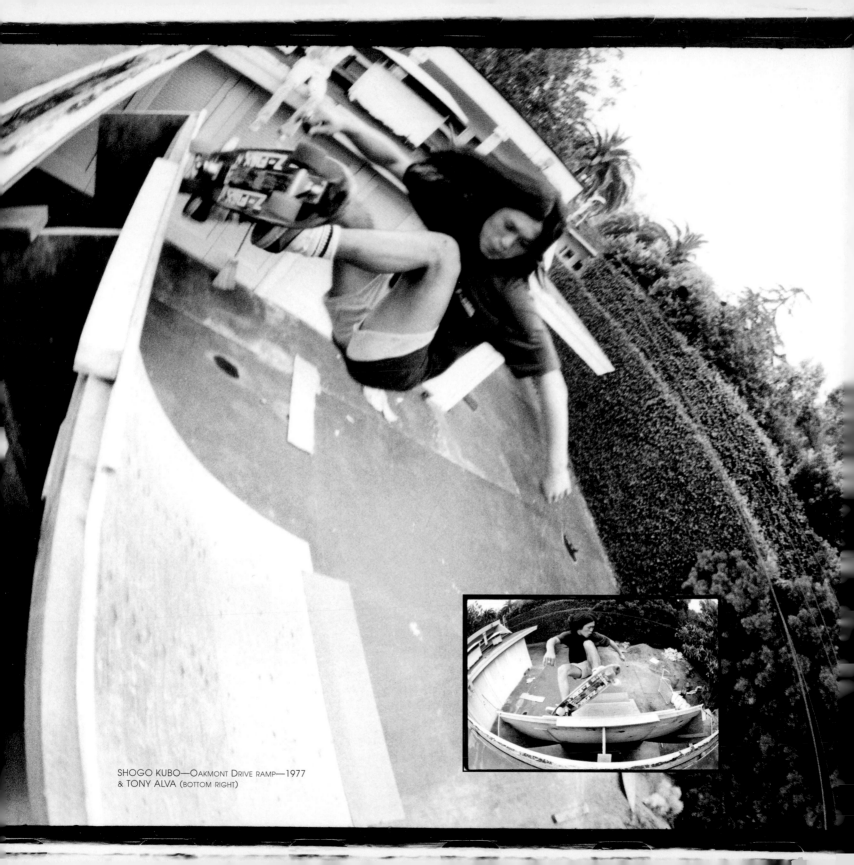

SHOGO KUBO—OAKMONT DRIVE RAMP—1977
& TONY ALVA (BOTTOM RIGHT)

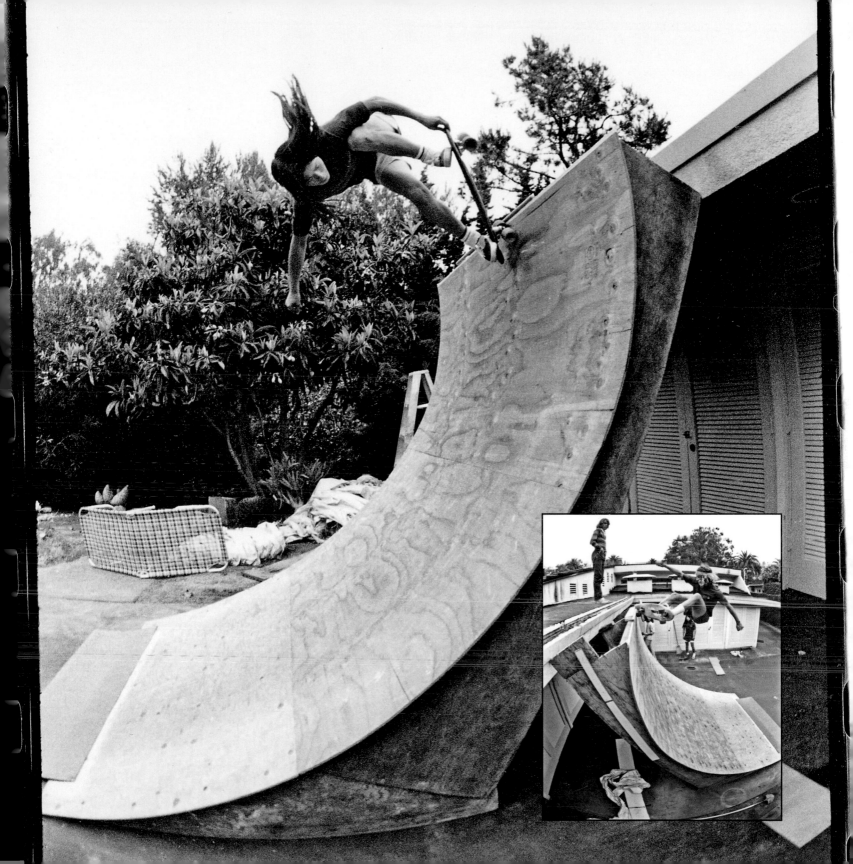

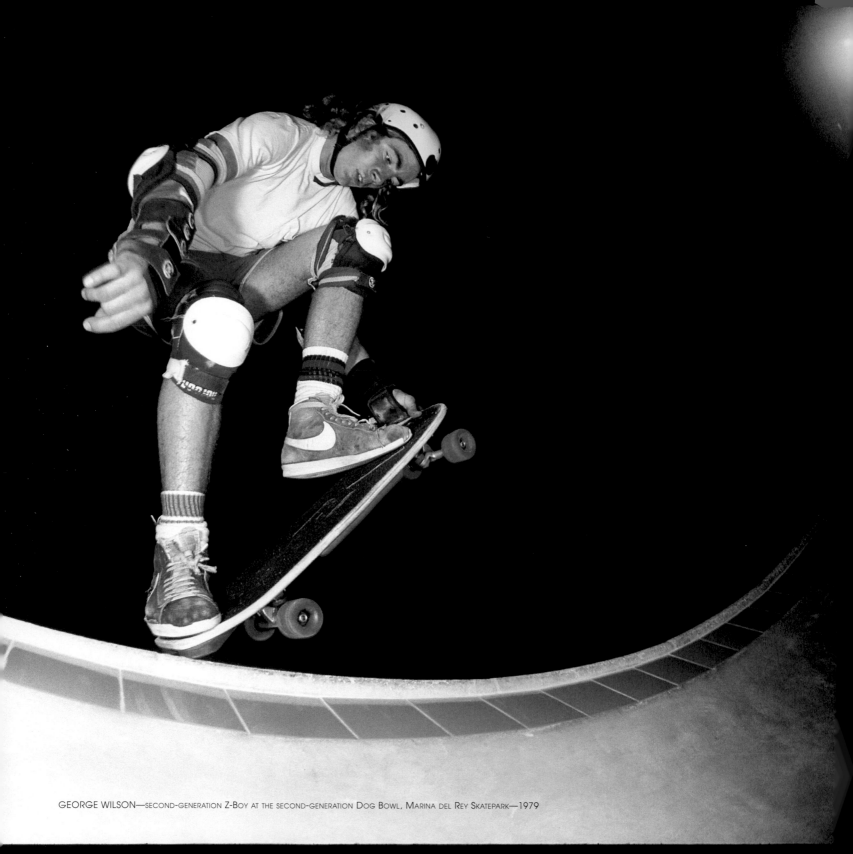

GEORGE WILSON—SECOND-GENERATION Z-BOY AT THE SECOND-GENERATION DOG BOWL, MARINA DEL REY SKATEPARK—1979

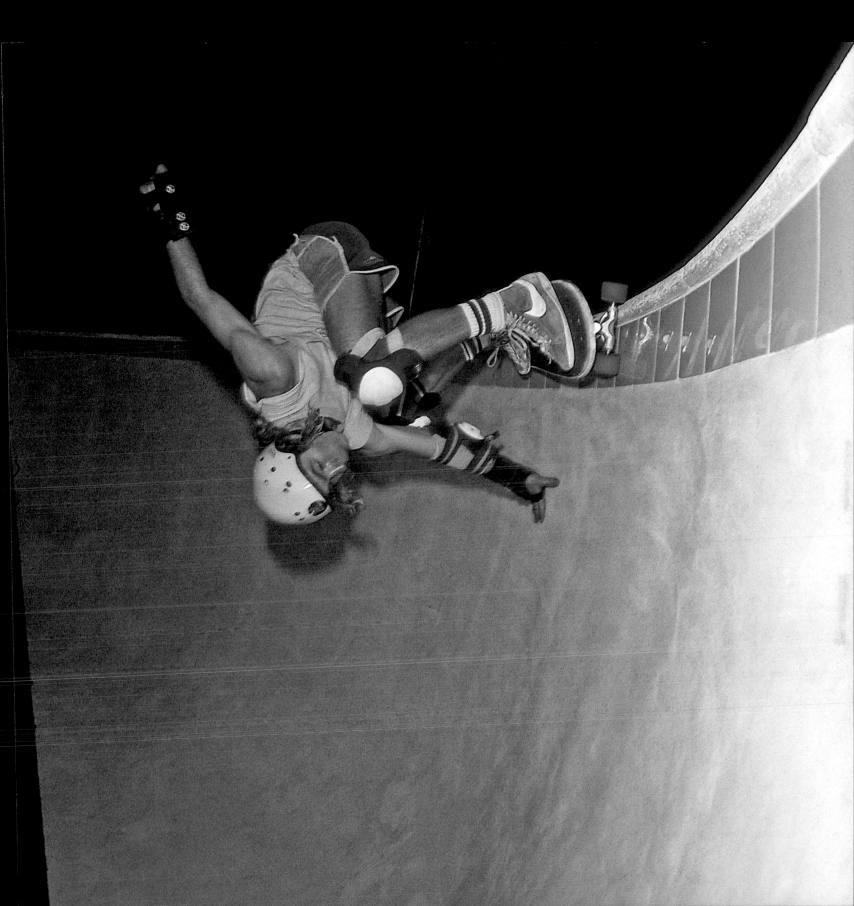

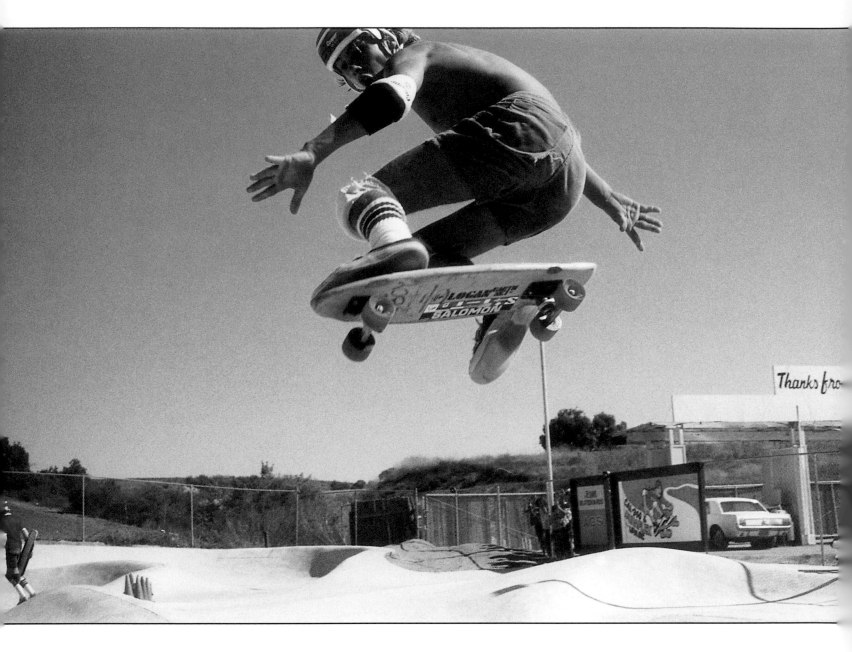

JAY ADAMS—FIRST SKATEBOARD PARK EVER BUILT. CARLSBAD, CALIFORNIA—1976

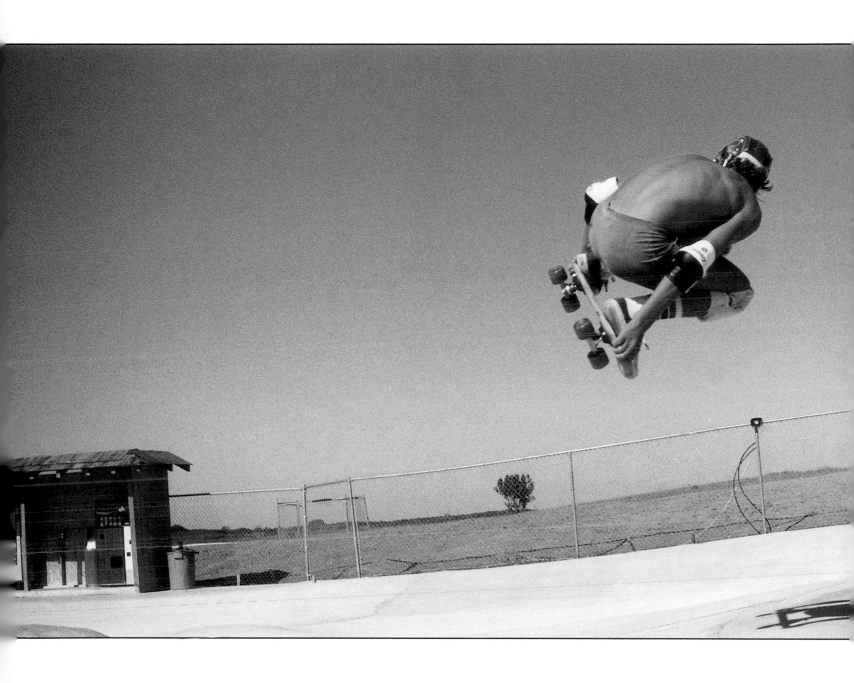

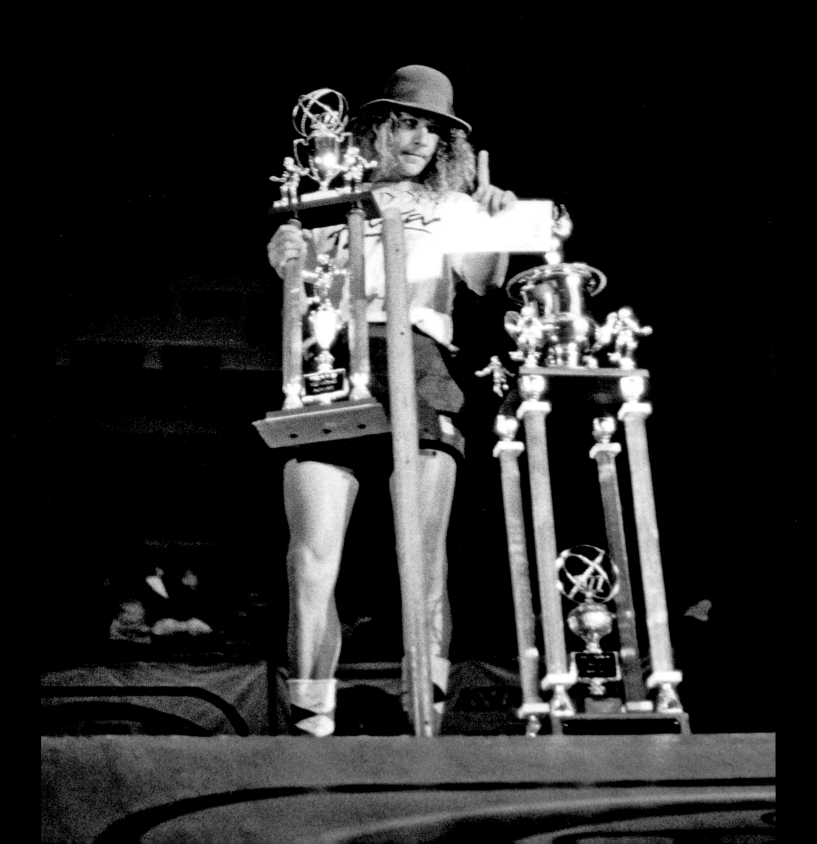

TONY ALVA
WORLD PROFESSIONAL
SKATEBOARD
CHAMPIONSHIPS,
LONG BEACH ARENA,
1977

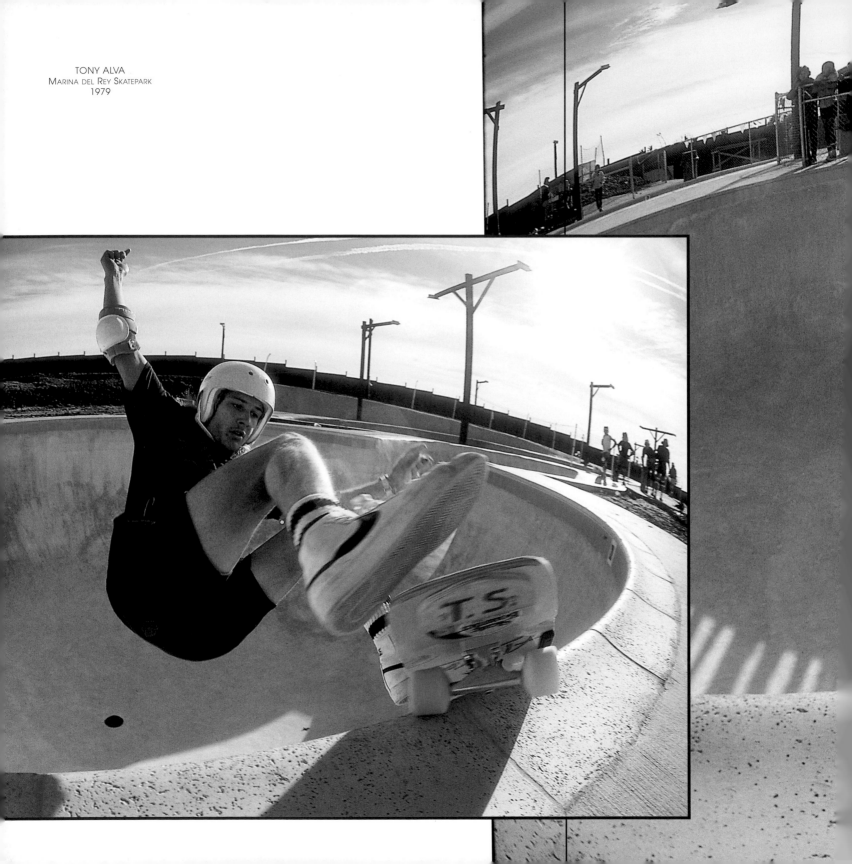

TONY ALVA
MARINA DEL REY SKATEPARK
1979

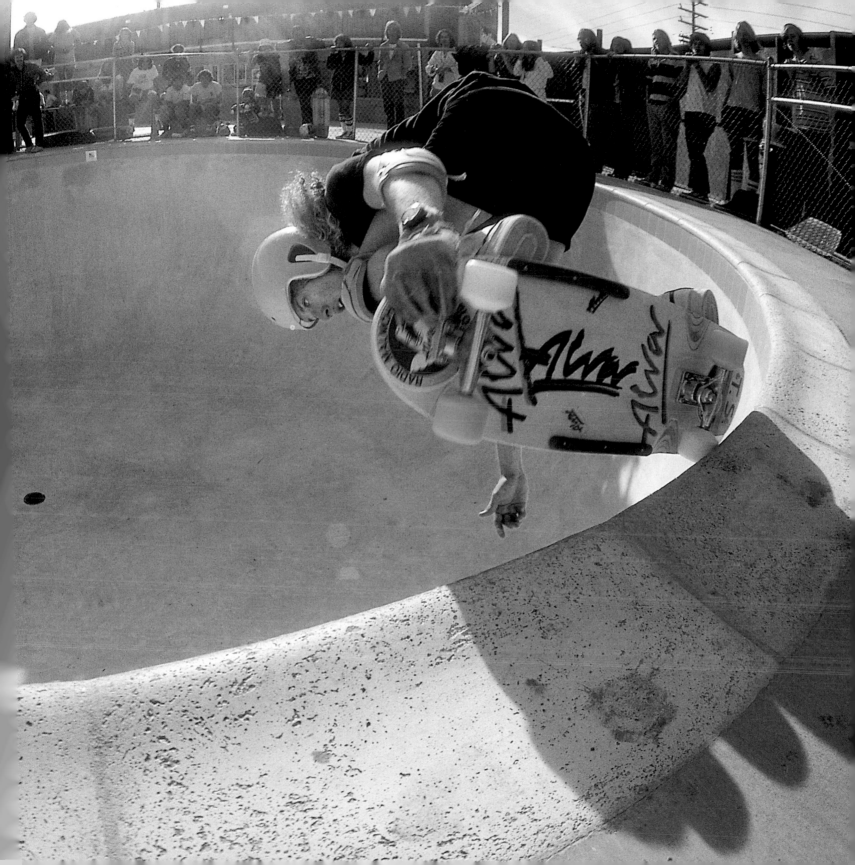

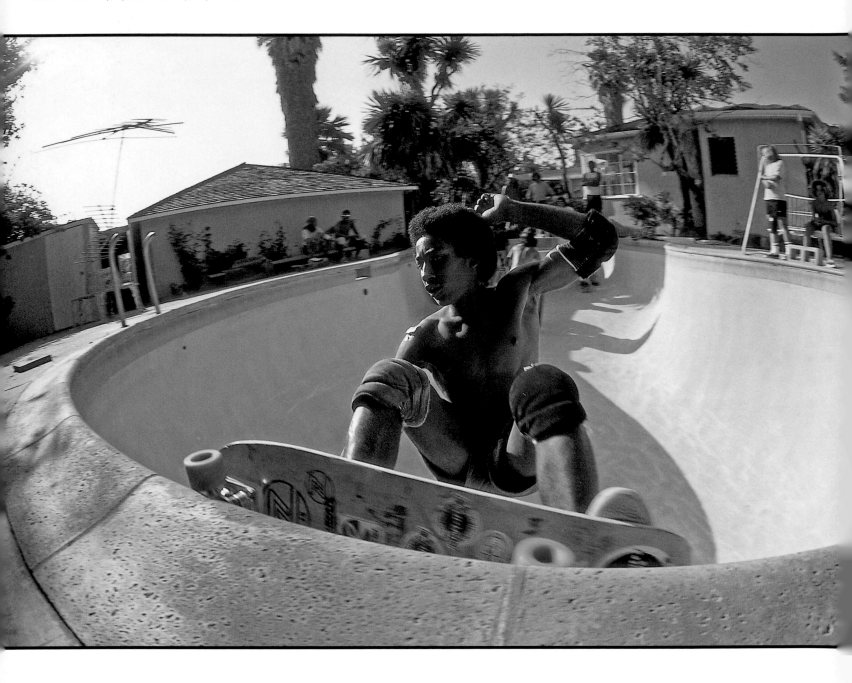

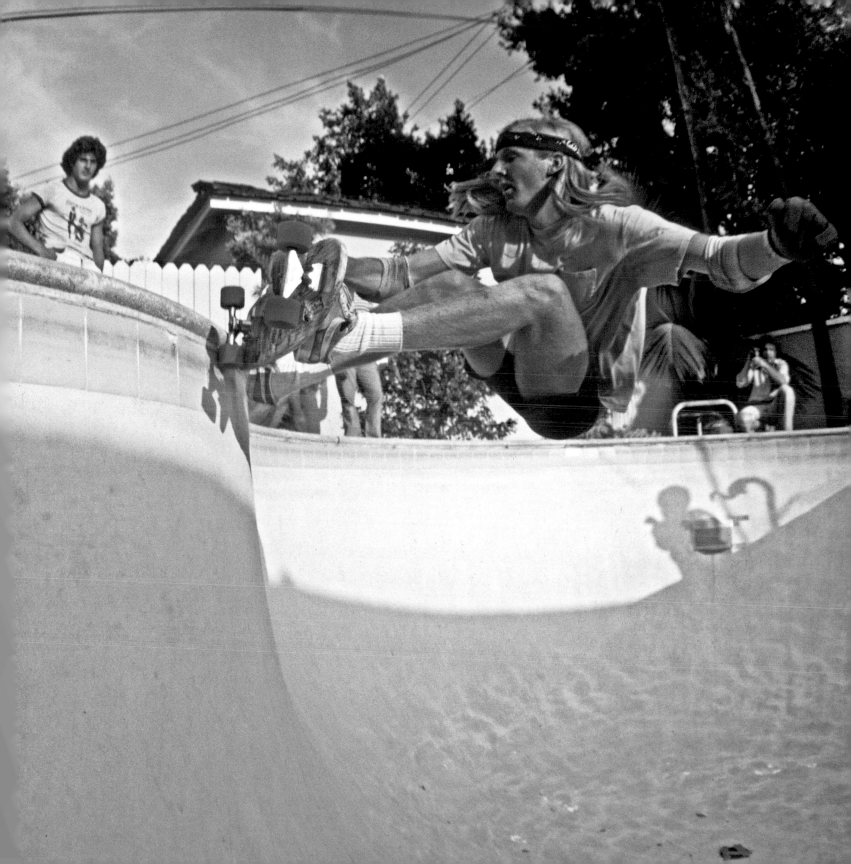

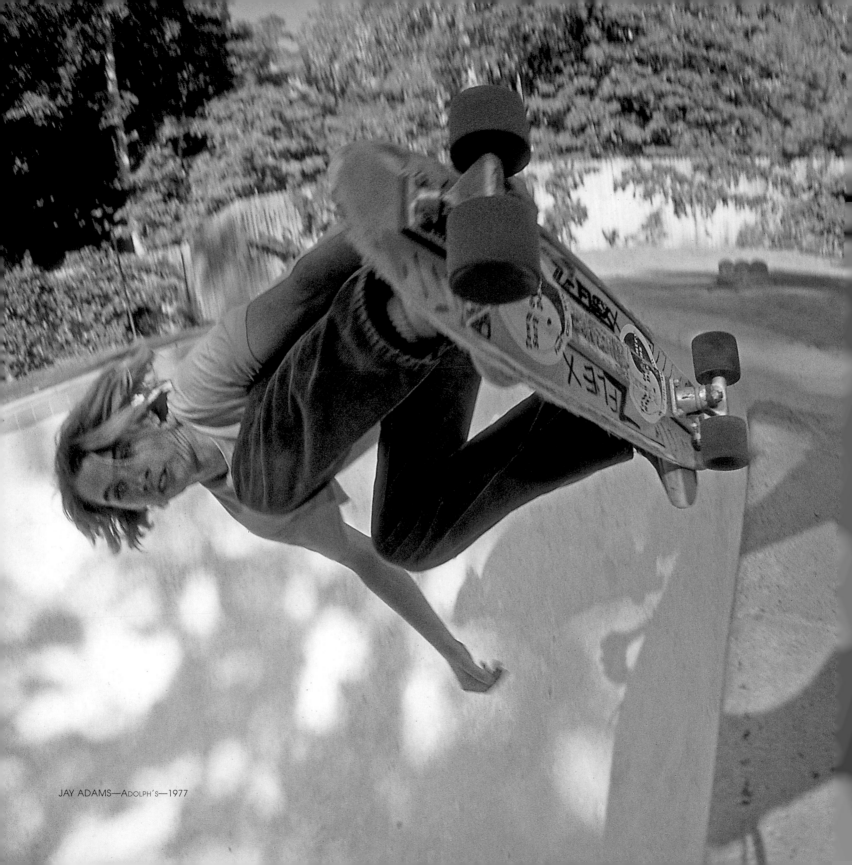

JAY ADAMS—ADOLPH'S—1977

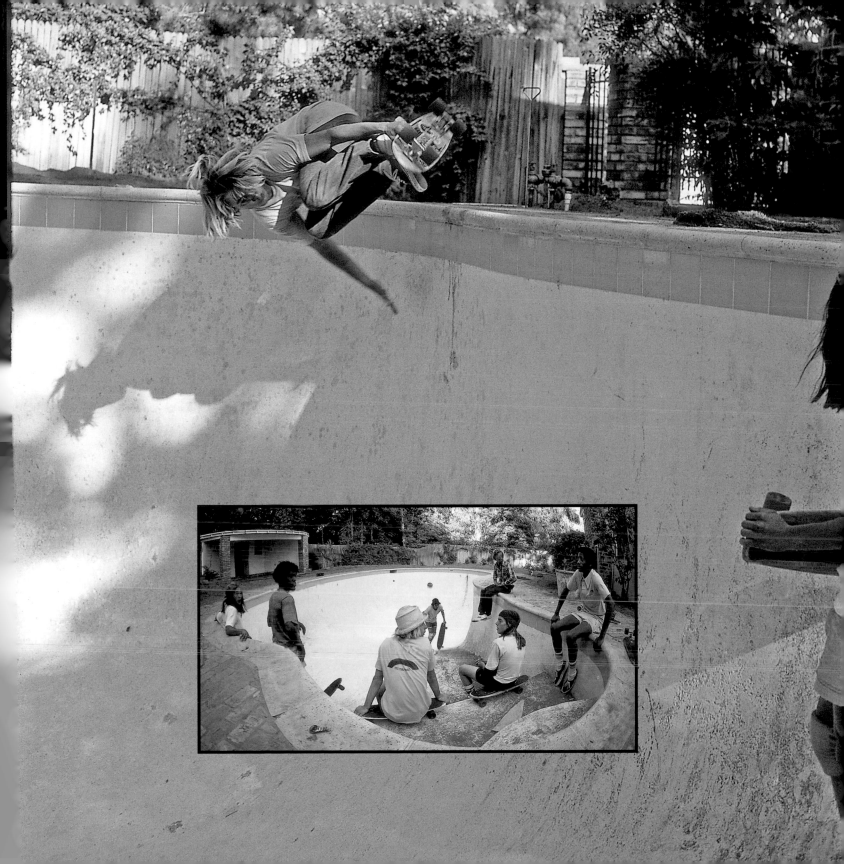

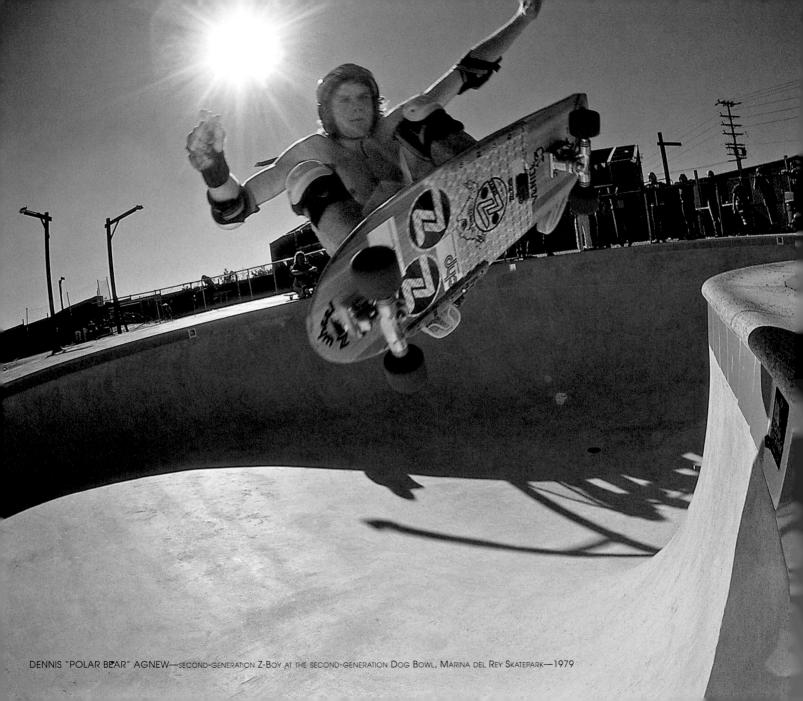

DENNIS "POLAR BEAR" AGNEW—SECOND-GENERATION Z-BOY AT THE SECOND-GENERATION DOG BOWL, MARINA DEL REY SKATEPARK—1979

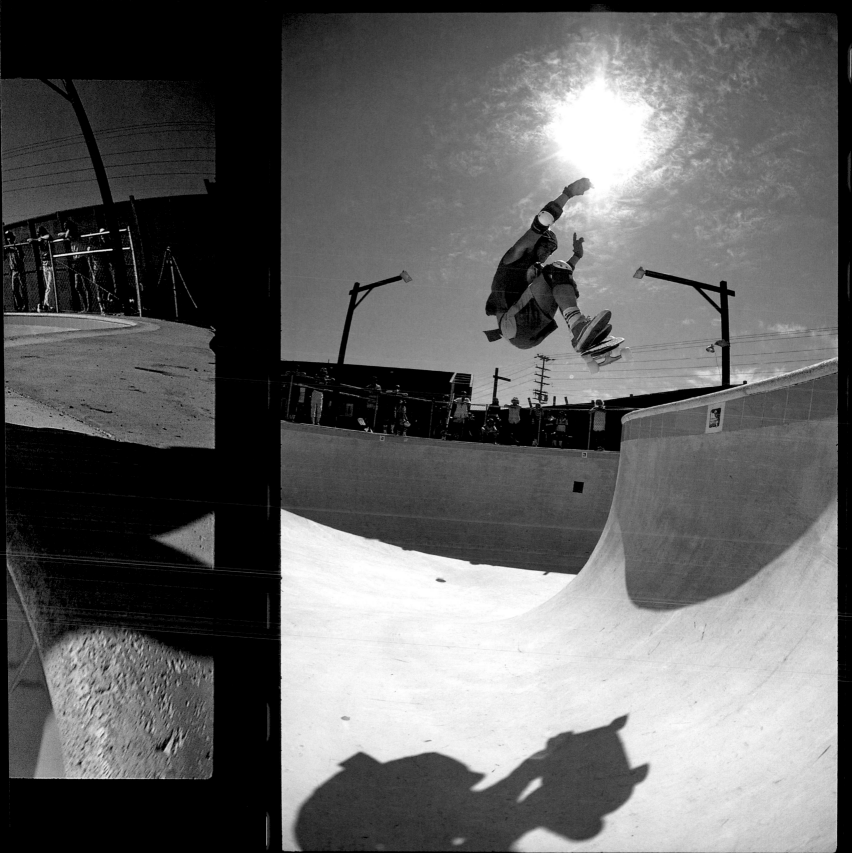

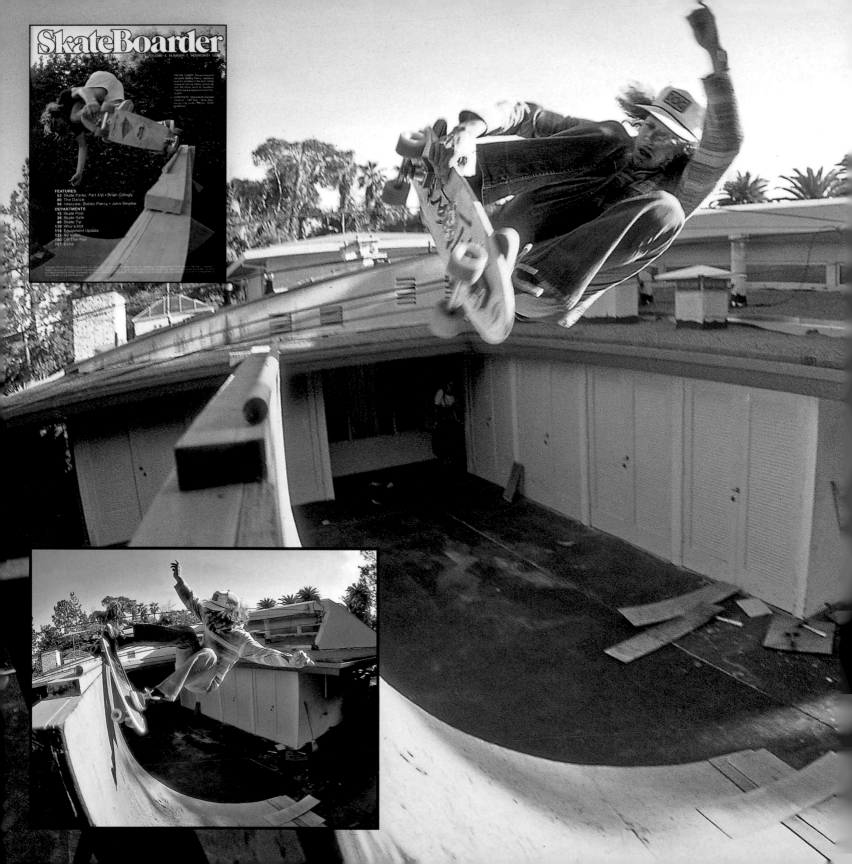

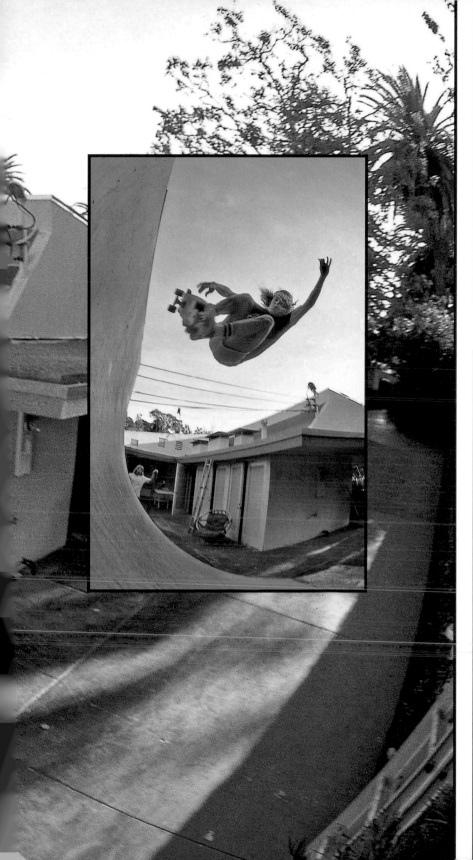

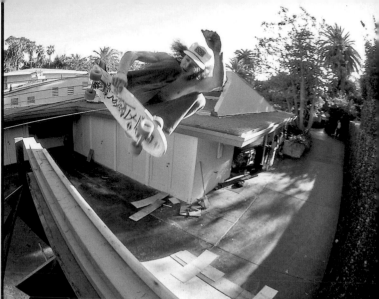

TONY ALVA—ORIGINAL *SkateBoarder Magazine* CONTENTS PAGE INSET, AND OTHERS FROM THE OAKMONT DRIVE RAMP—1977

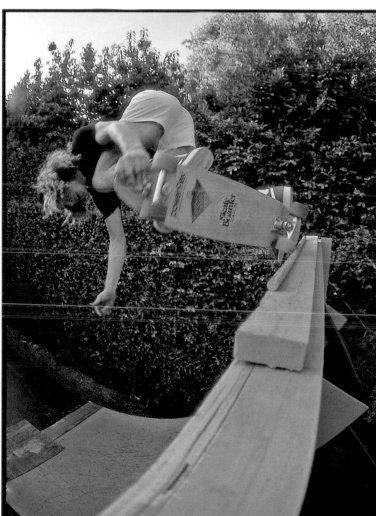

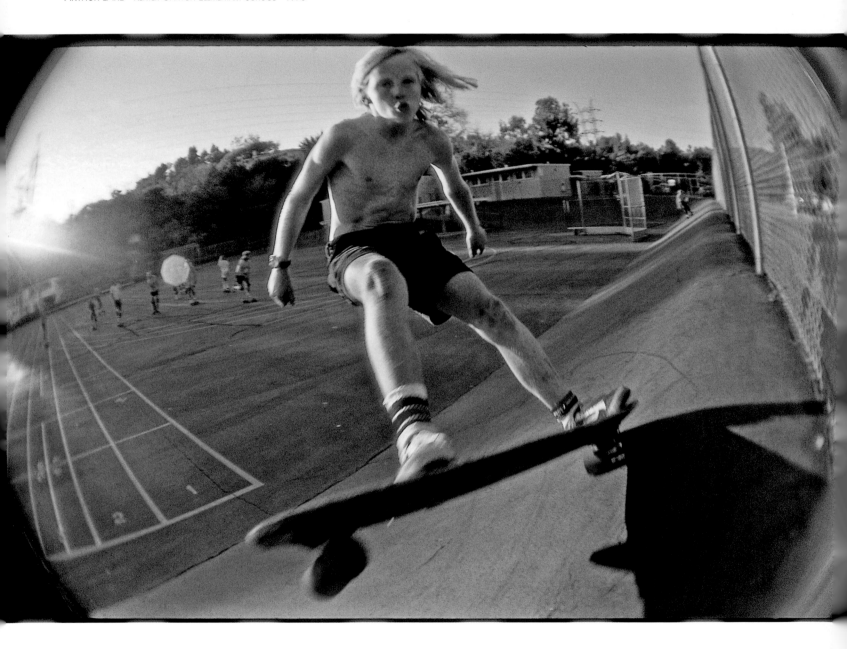

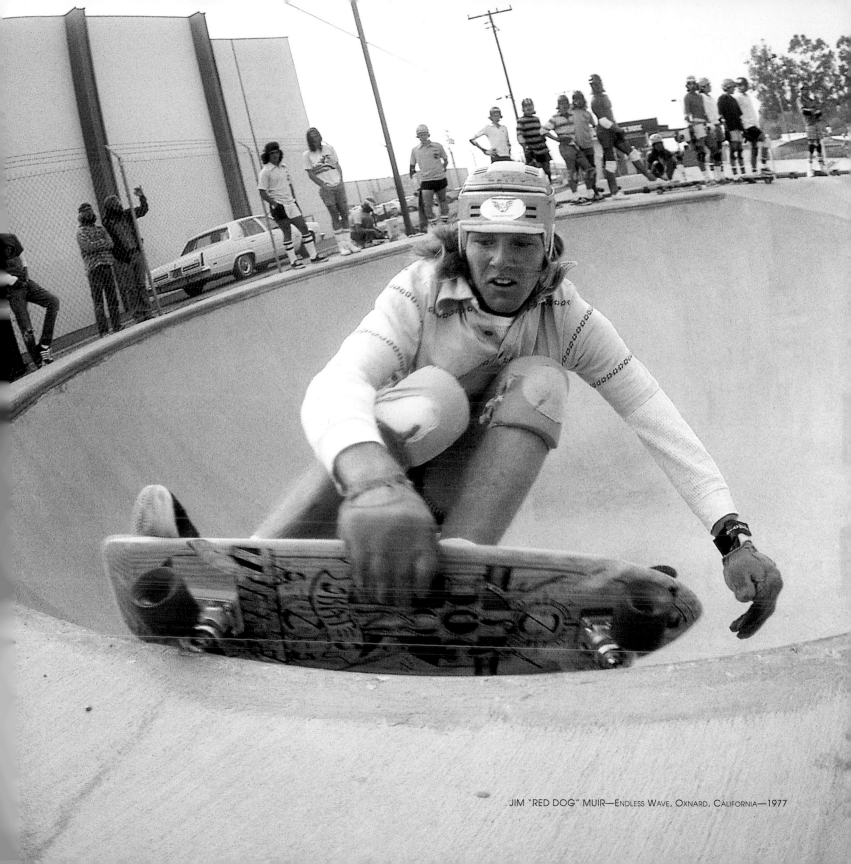

JIM "RED DOG" MUIR—ENDLESS WAVE, OXNARD, CALIFORNIA—1977

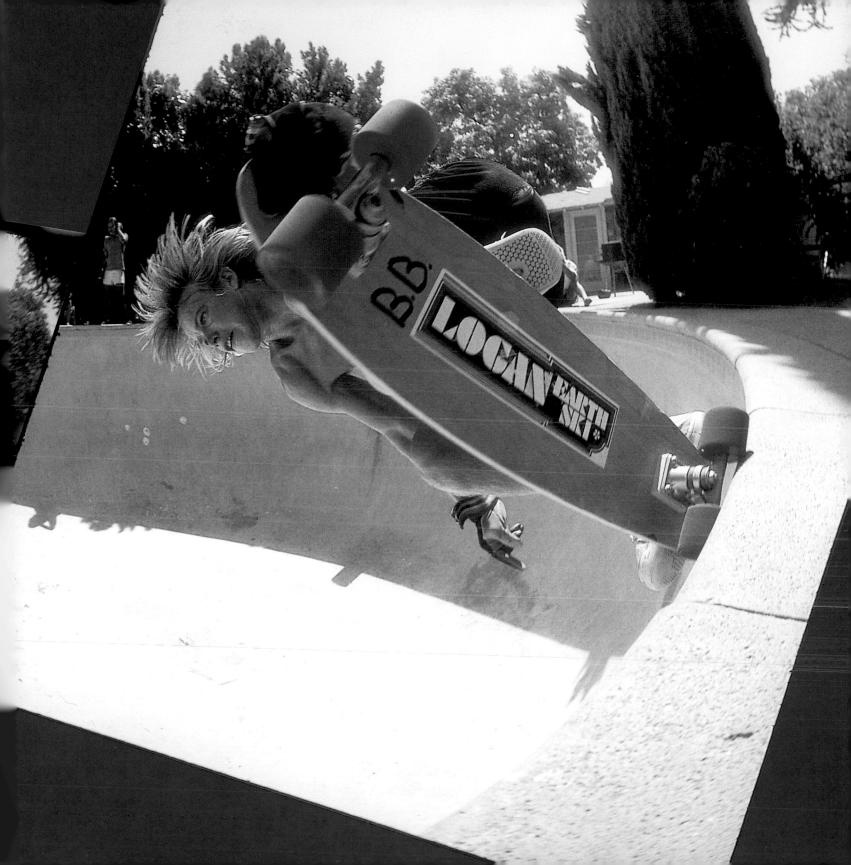

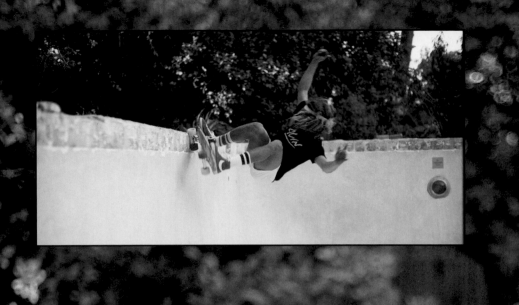

the
DANCE

Hard rock beat,
Confident feet,
Feeling is real,
A magic unique.

Tony Alva

TONY ALVA—BARNEY MILLER'S POOL—1977
AND AS IT APPEARED IN THE ORIGINAL *SKATEBOARDER MAGAZINE* (MISCREDITED)

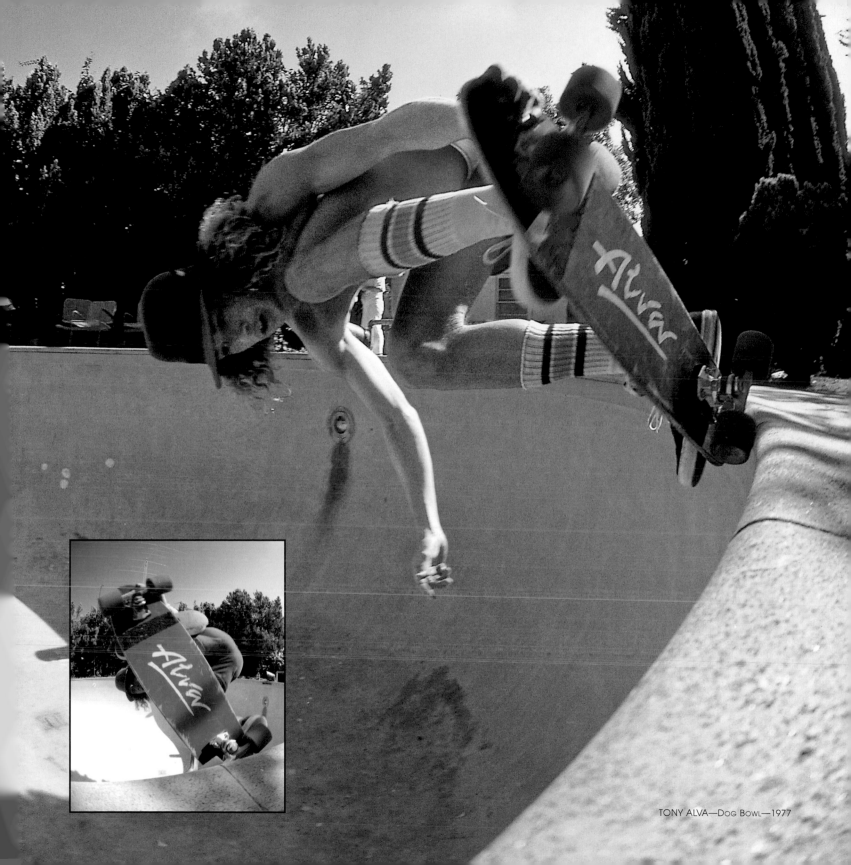

TONY ALVA—DOG BOWL—1977

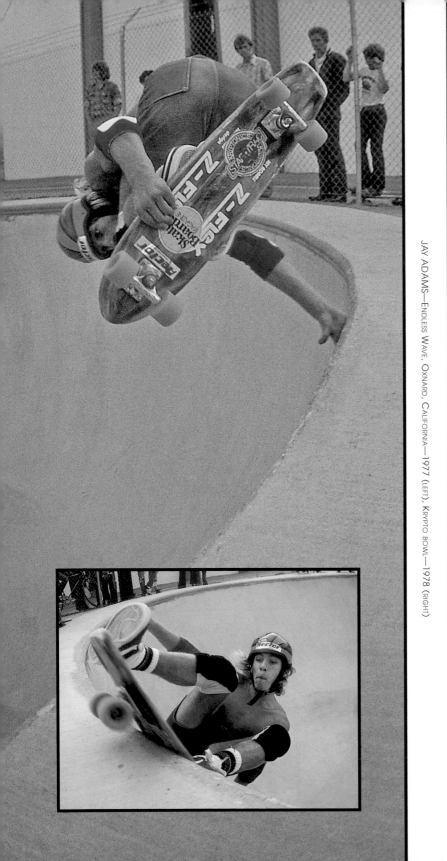

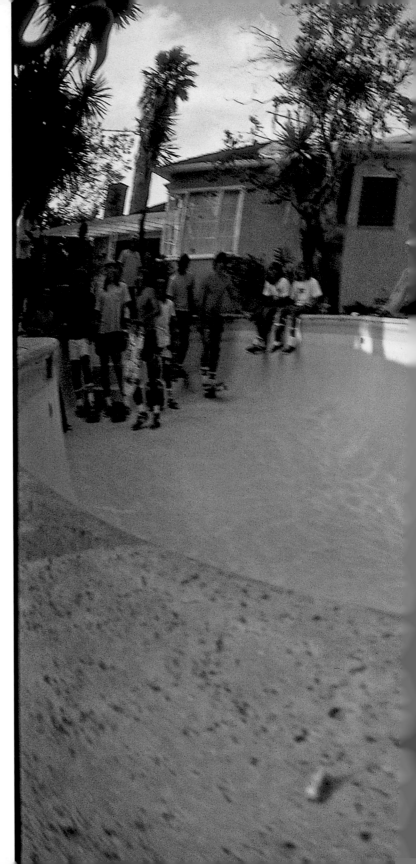

JAY ADAMS—Endless Wave, Oxnard, California—1977 (left), Krypto bowl—1978 (right)

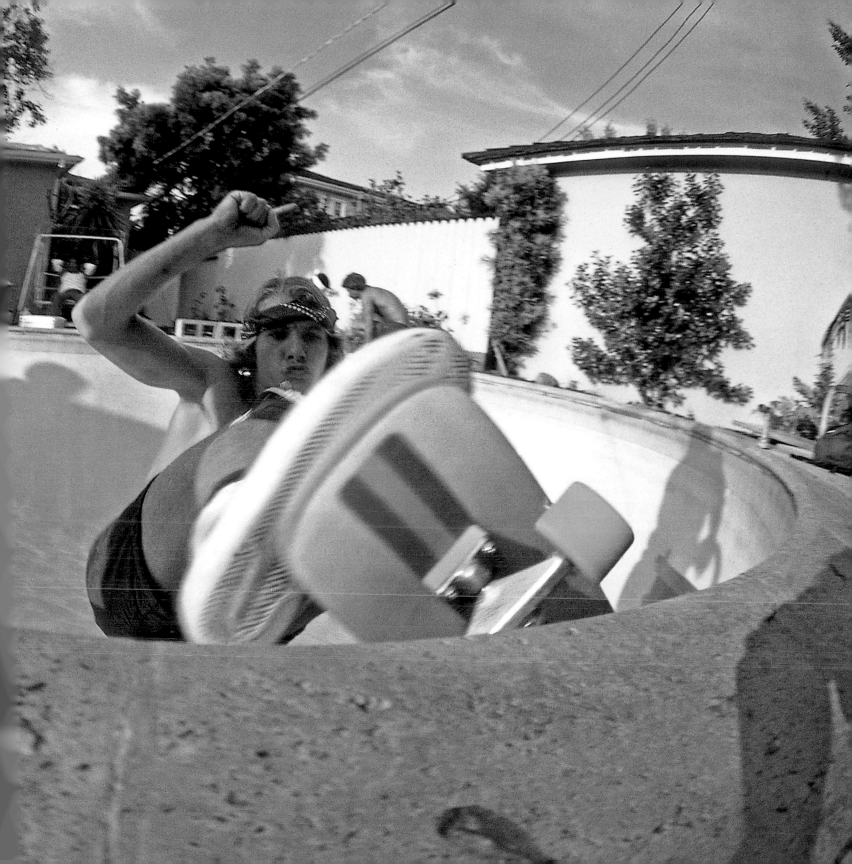

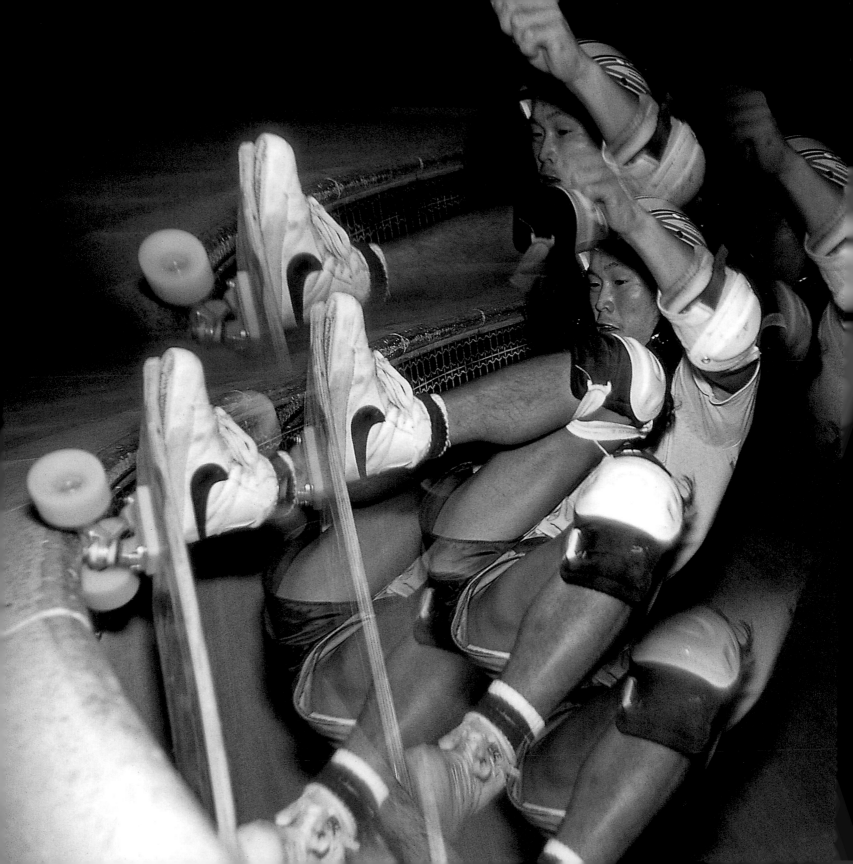

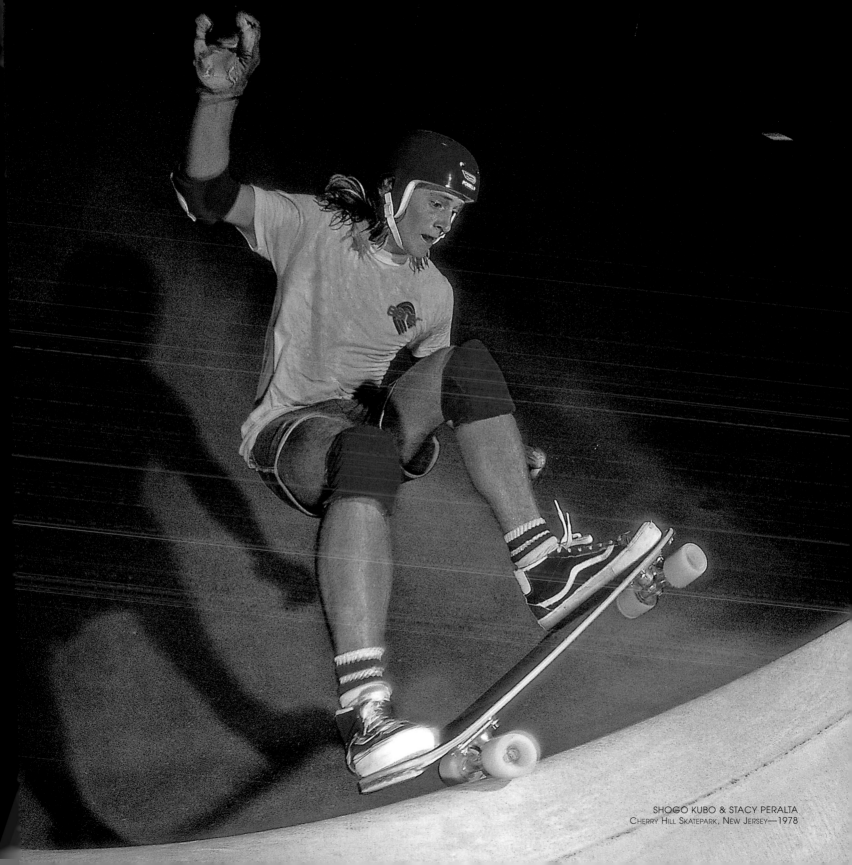

SHOGO KUBO & STACY PERALTA
Cherry Hill Skatepark, New Jersey—1978

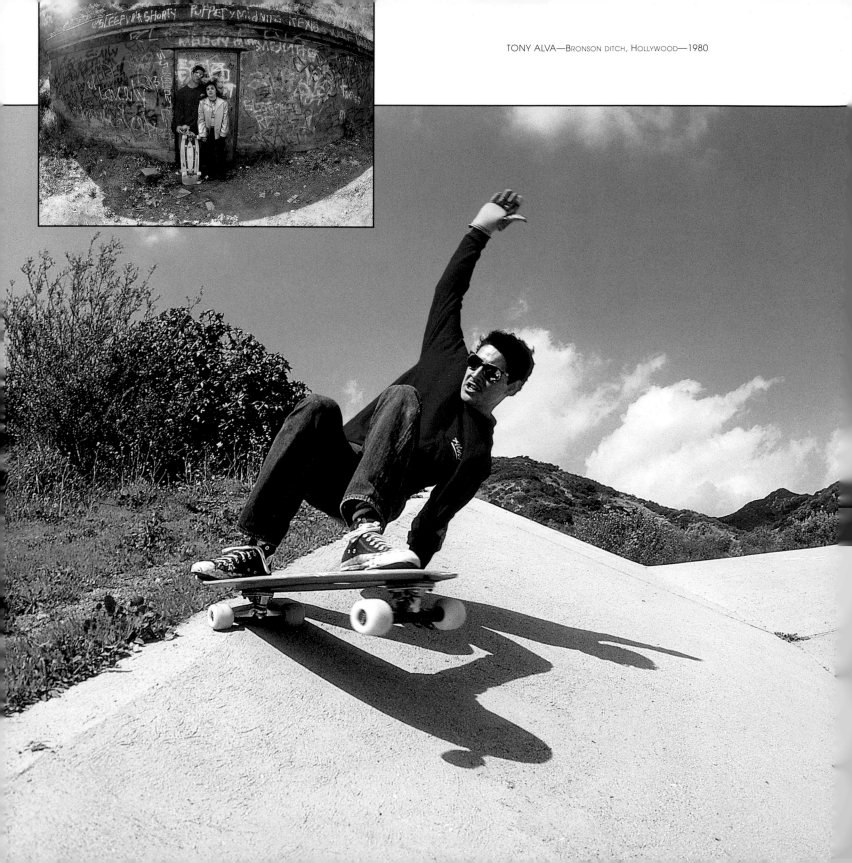

TONY ALVA—Bronson ditch, Hollywood—1980

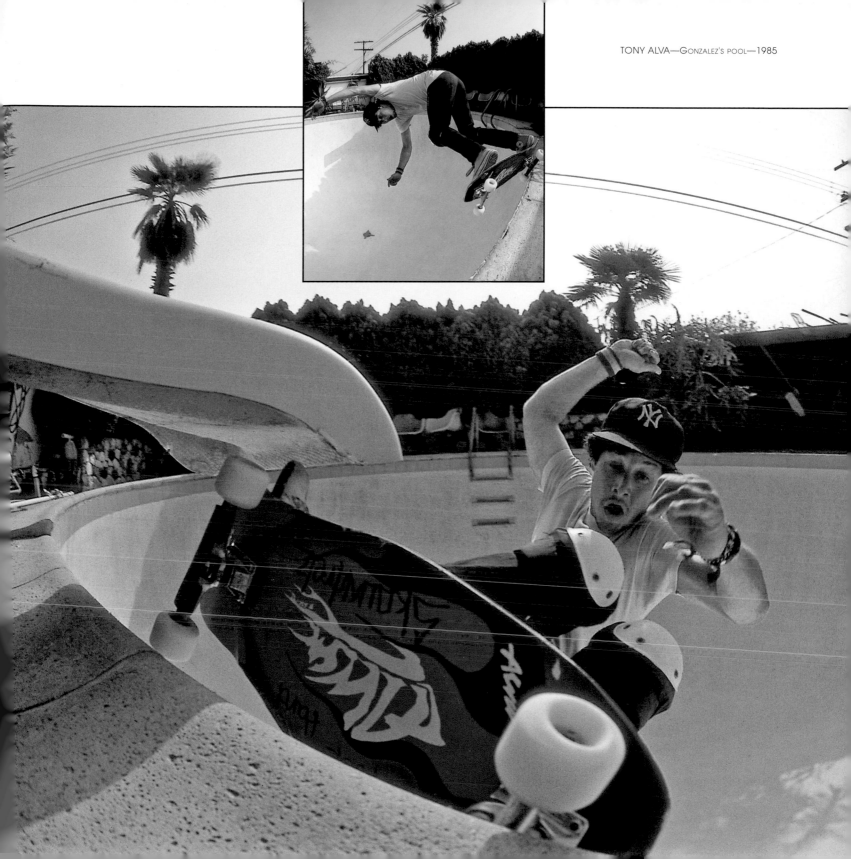

TONY ALVA—Gonzalez's pool—1985

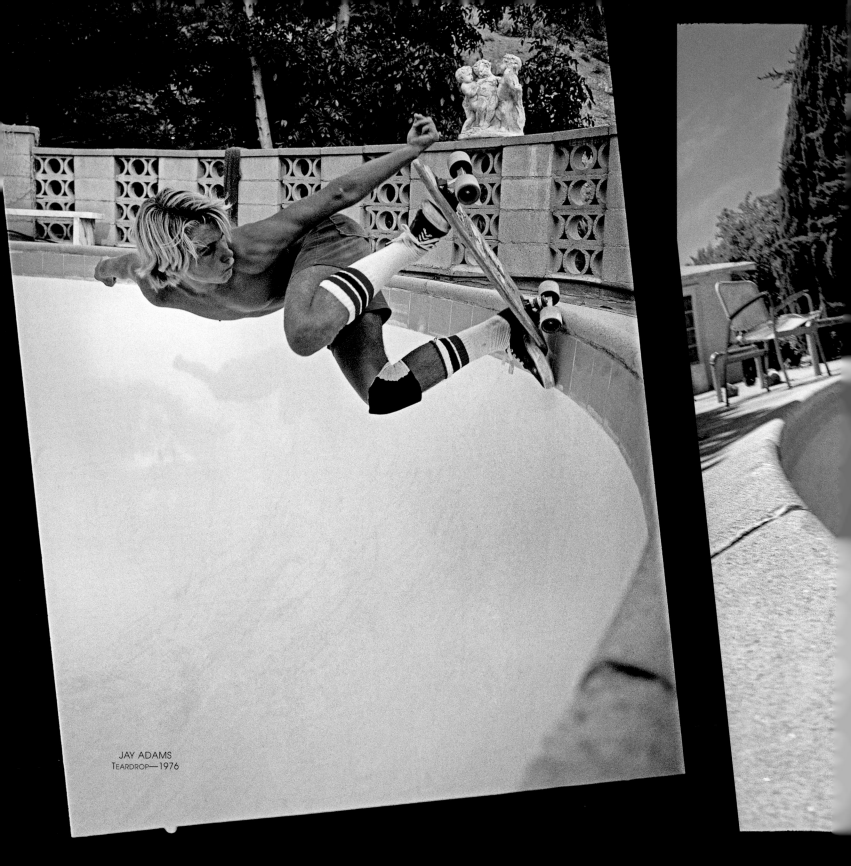

JAY ADAMS
Teardrop—1976

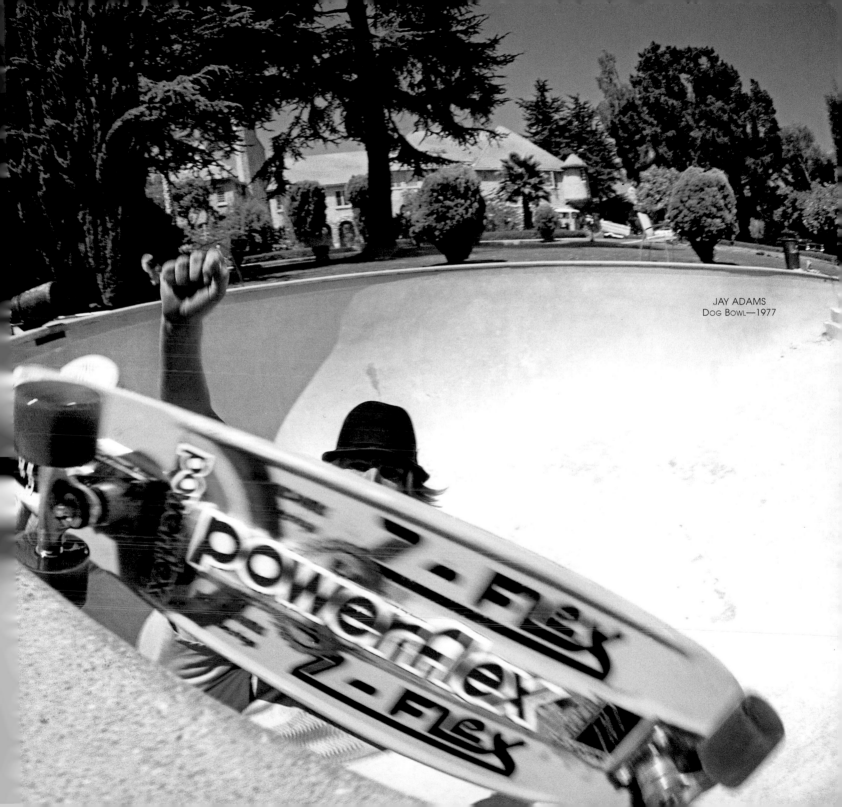

JAY ADAMS
Dog Bowl—1977

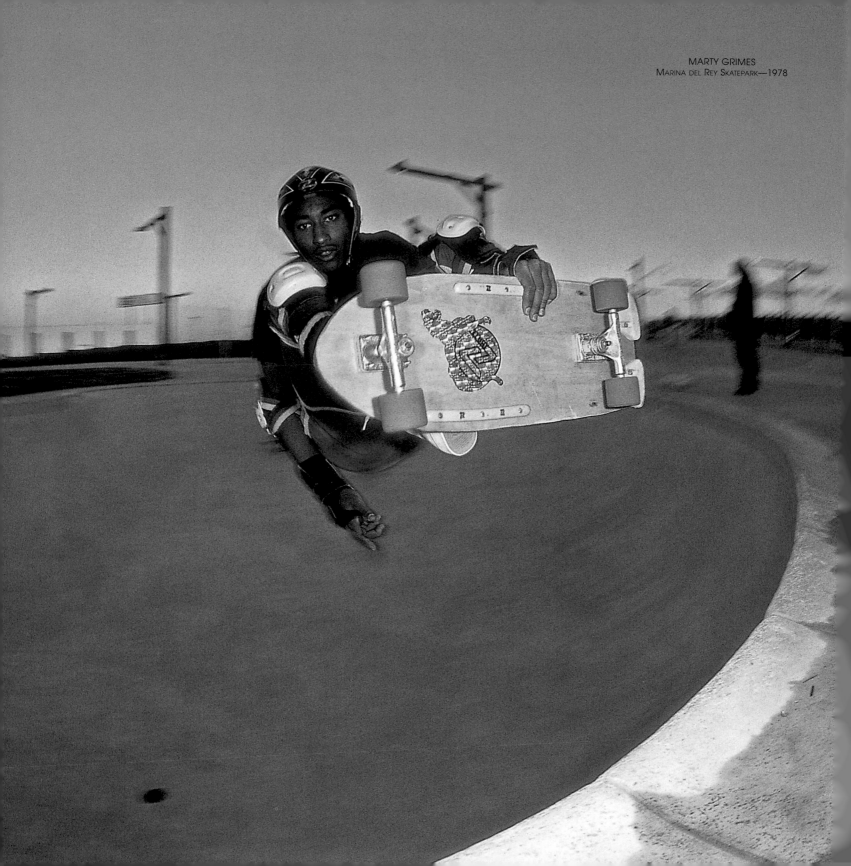

MARTY GRIMES
Marina del Rey Skatepark—1978

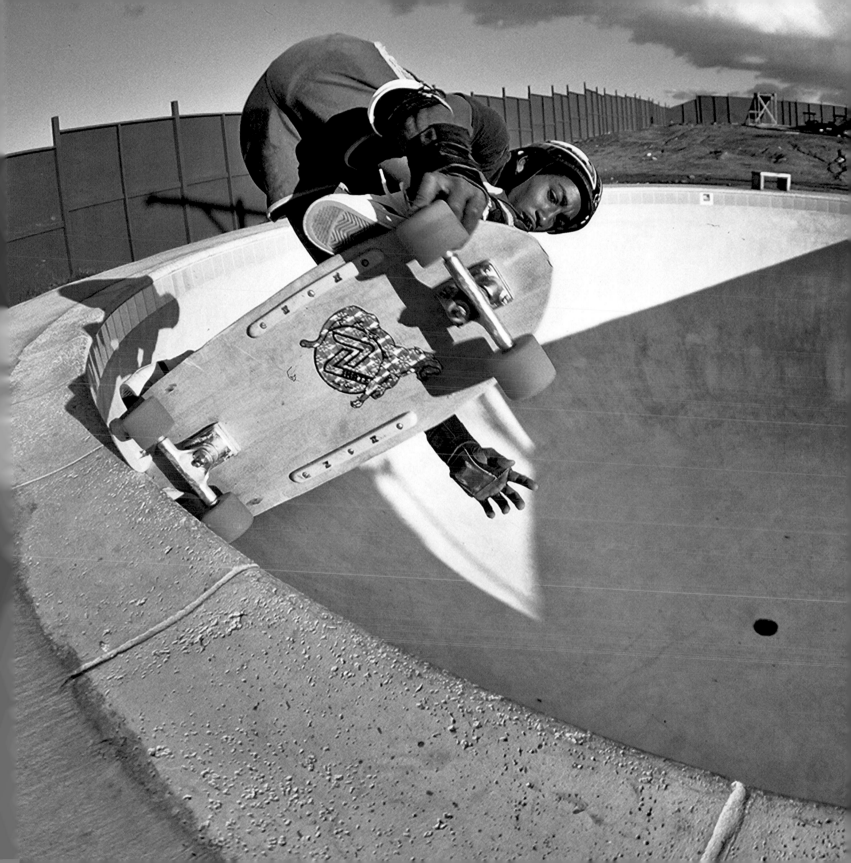

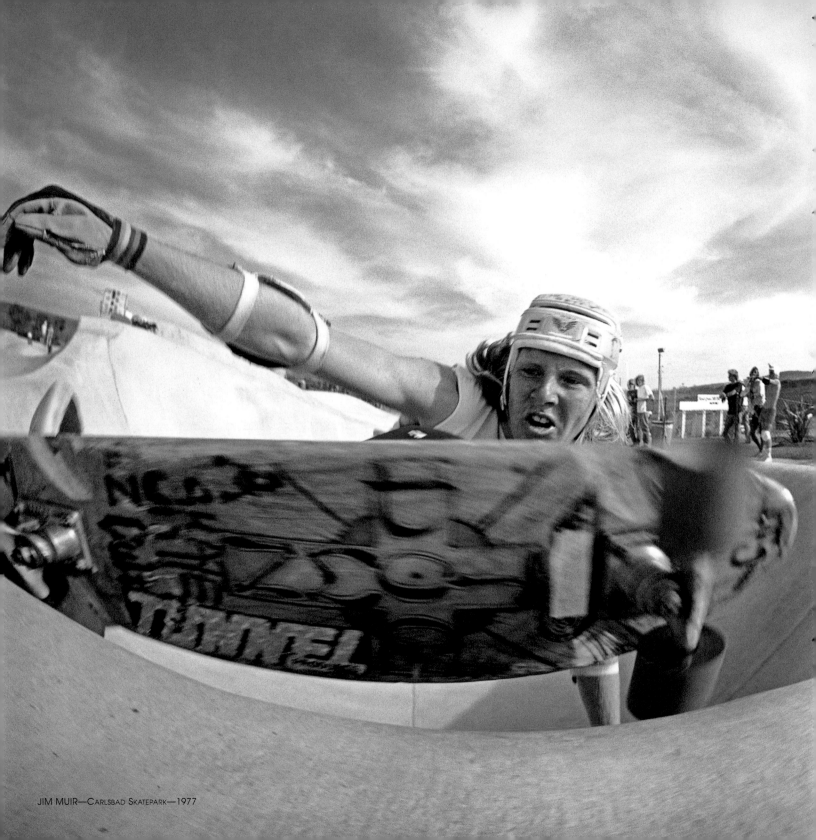

JIM MUIR—Carlsbad Skatepark—1977

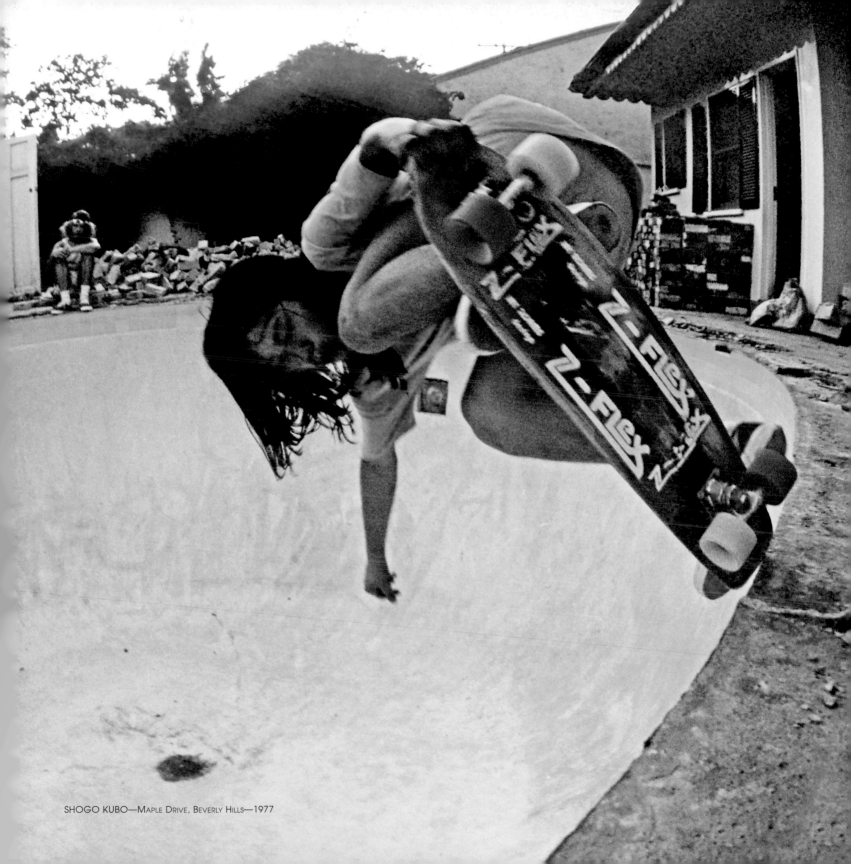

SHOGO KUBO—MAPLE DRIVE, BEVERLY HILLS—1977

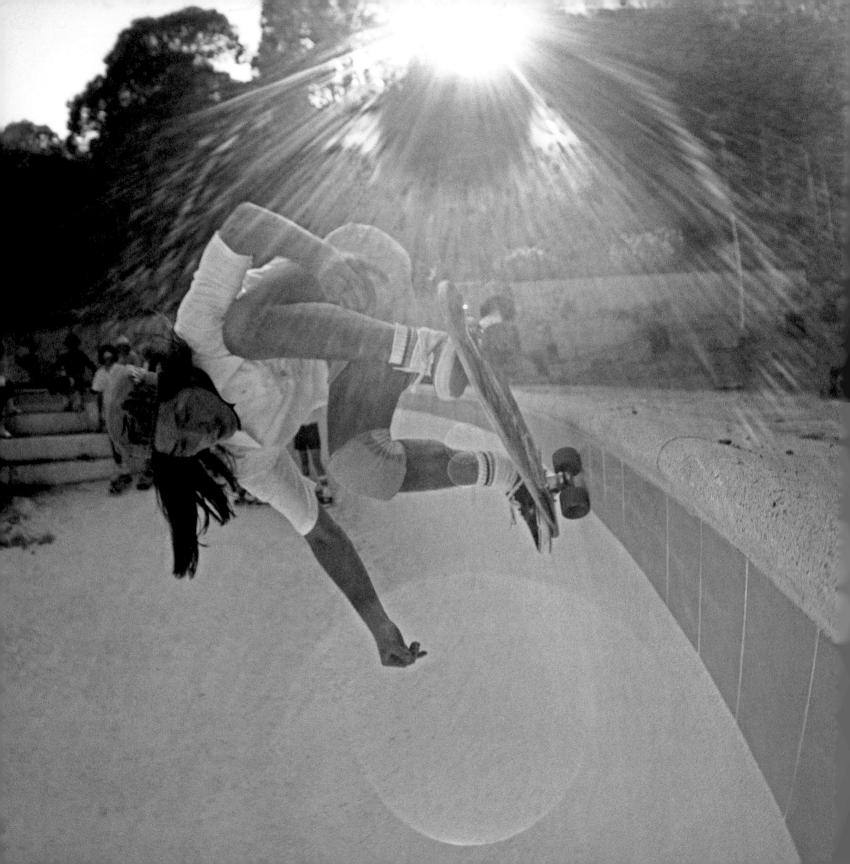

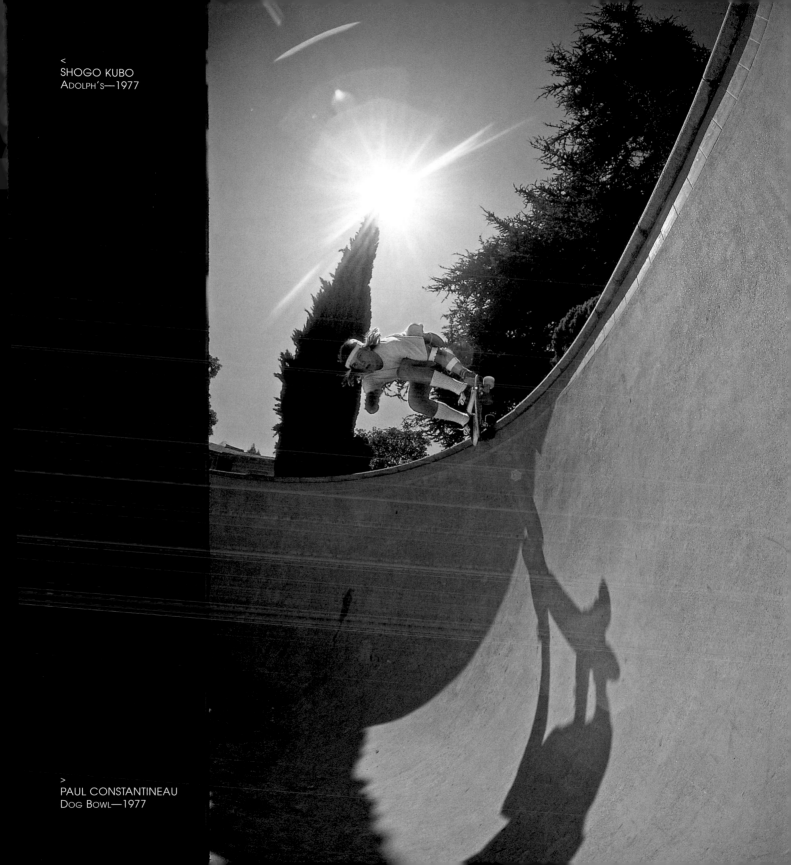

<
SHOGO KUBO
ADOLPH'S—1977

>
PAUL CONSTANTINEAU
DOG BOWL—1977

PEGGY OKI—KENTER CANYON ELEMENTARY SCHOOL—1976

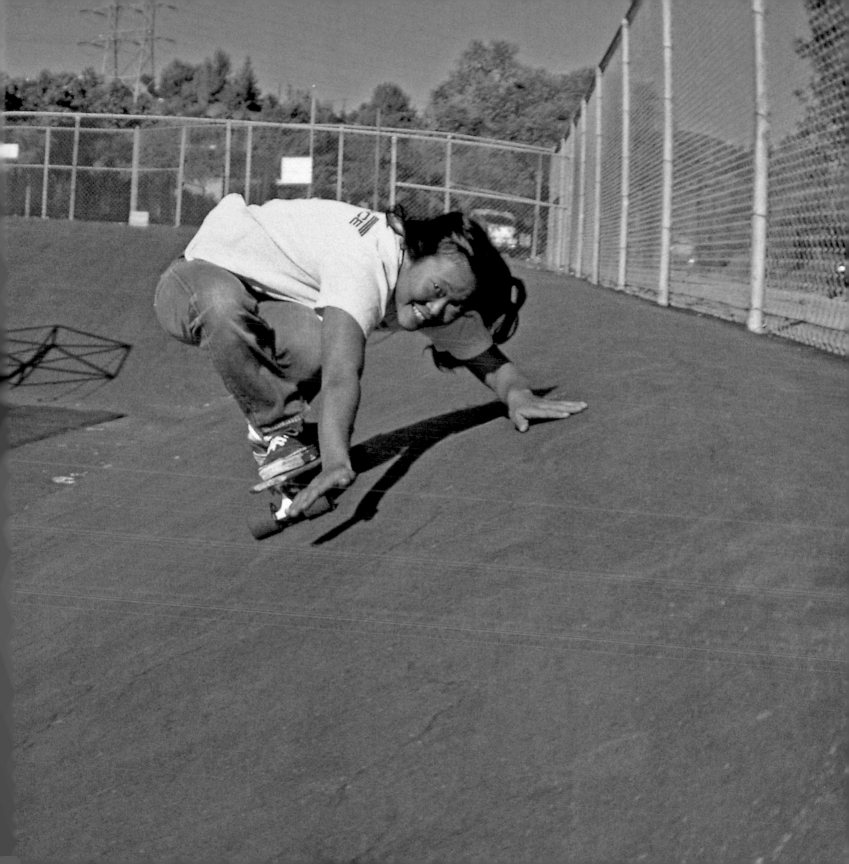

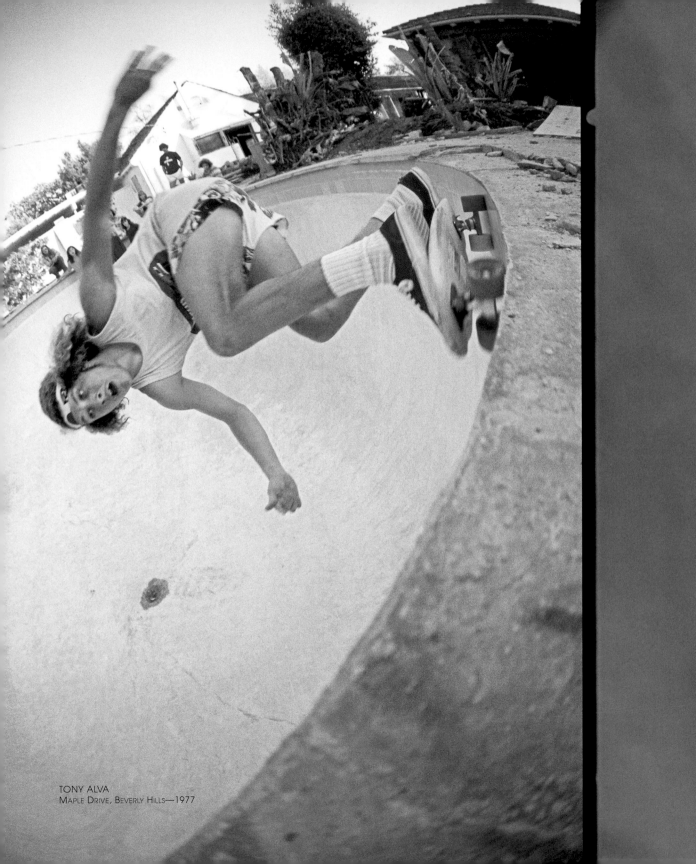

TONY ALVA
Maple Drive, Beverly Hills—1977

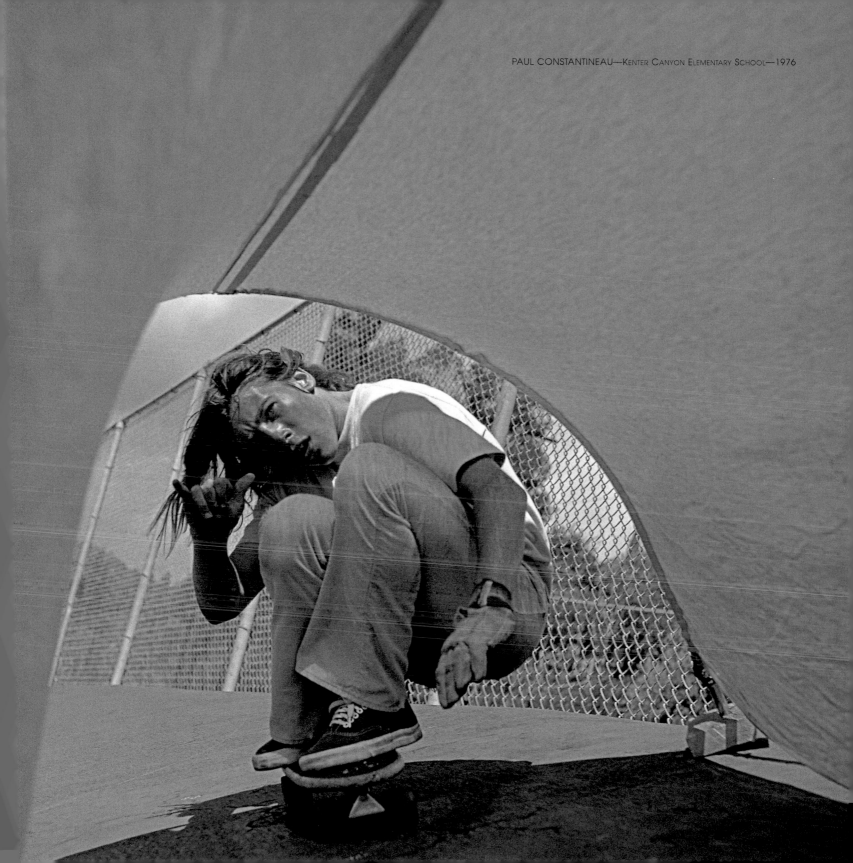

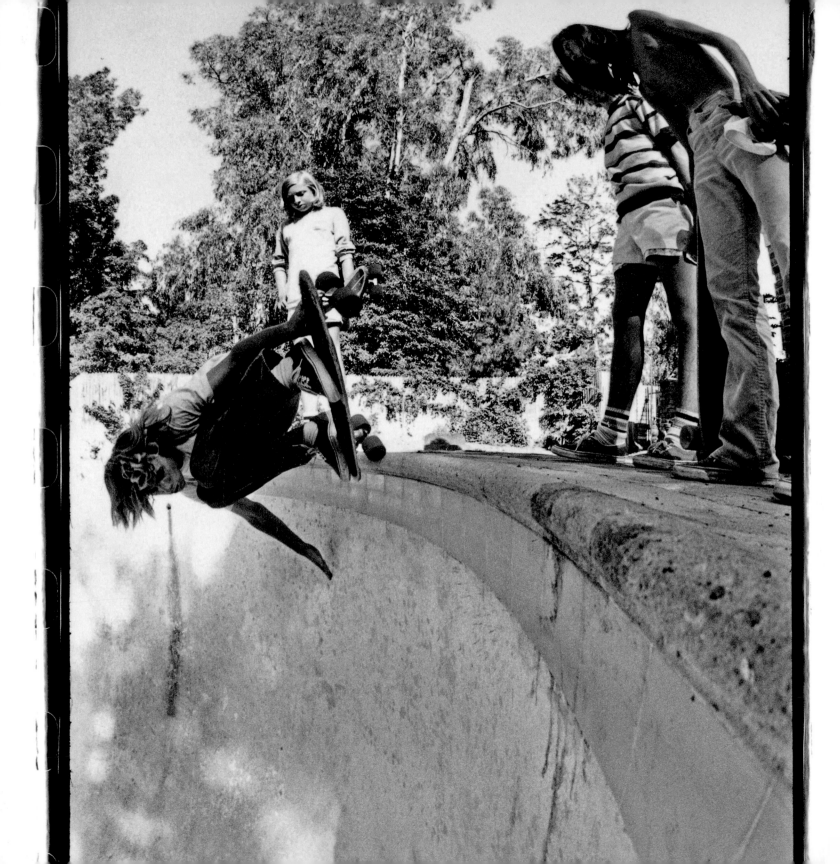

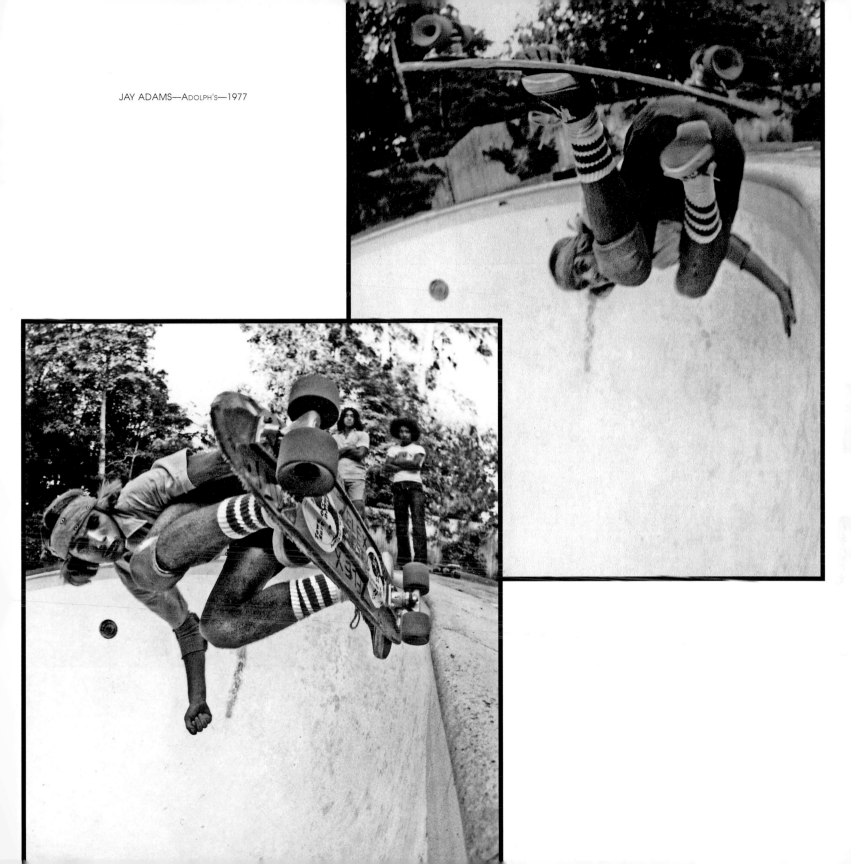

JAY ADAMS—Adolph's—1977

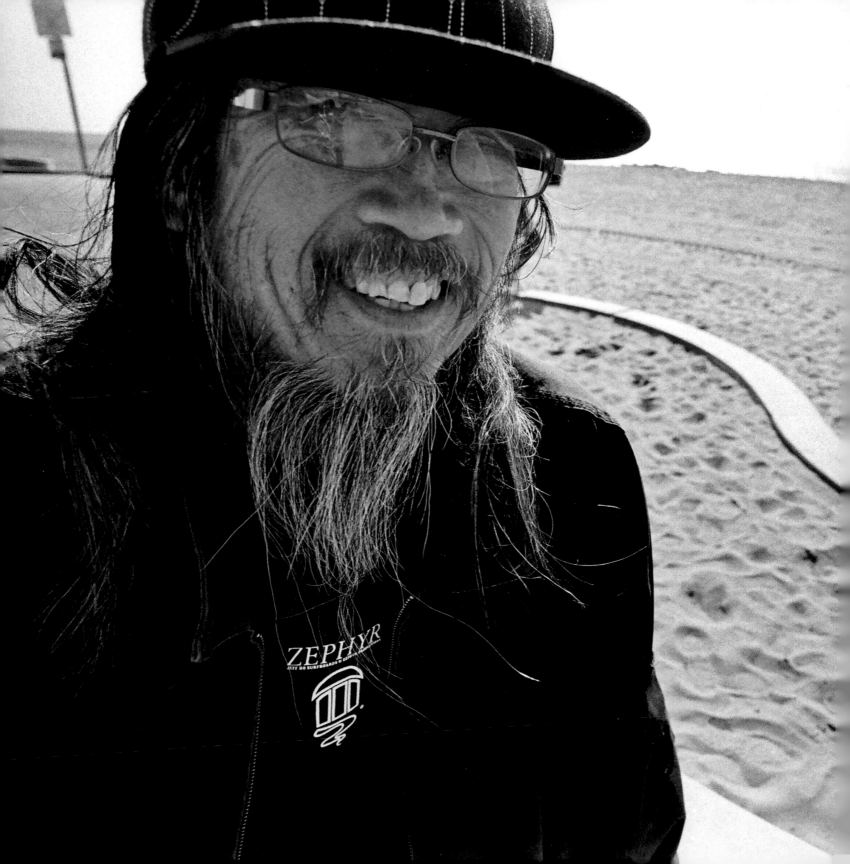

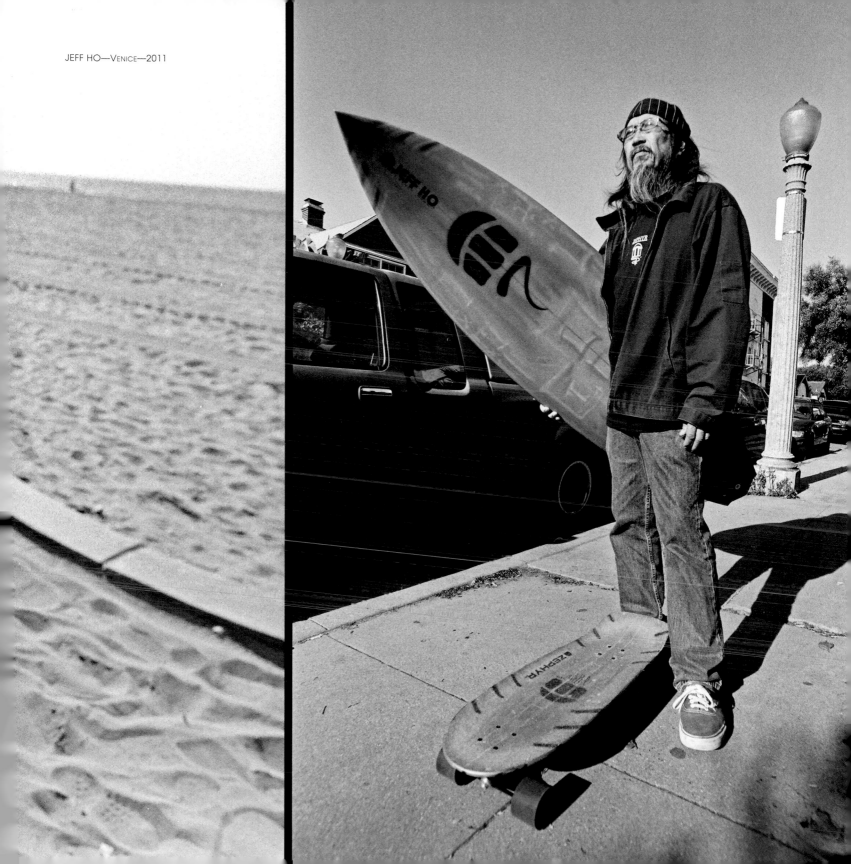

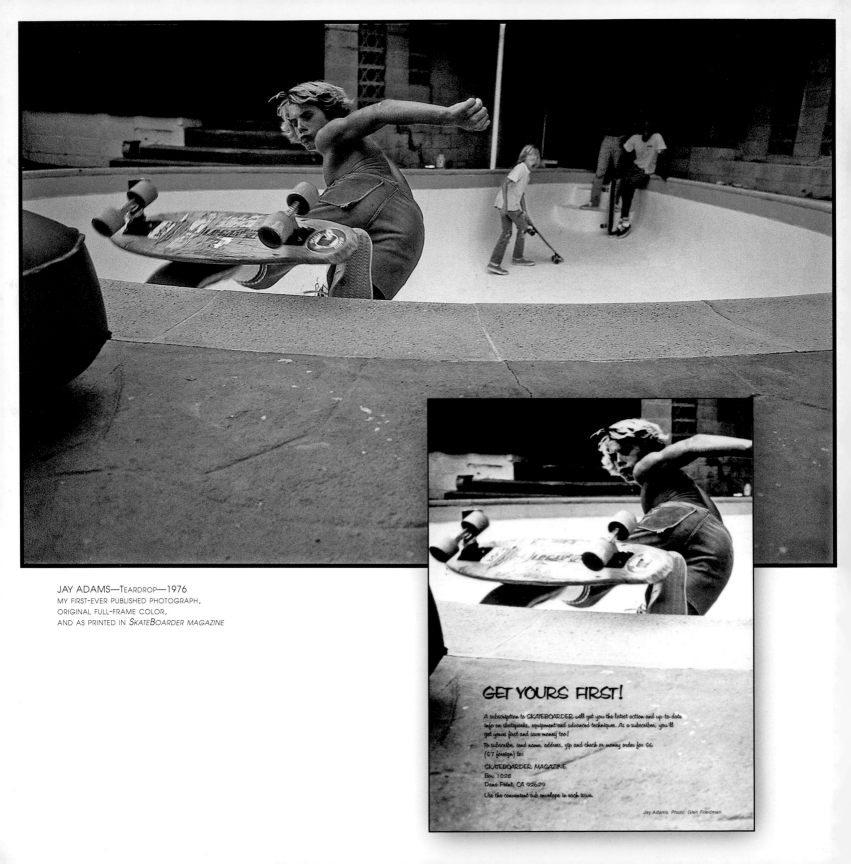

JAY ADAMS—Teardrop—1976
MY FIRST-EVER PUBLISHED PHOTOGRAPH,
ORIGINAL FULL-FRAME COLOR,
AND AS PRINTED IN *SkateBoarder magazine*

GET YOURS FIRST!

A subscription to SKATEBOARDER will get you the latest action and up-to-date info on skateparks, equipment and advanced techniques. As a subscriber, you'll get yours first and save money too!

To subscribe, send name, address, zip and check or money order for $6 ($7 foreign) to:

SKATEBOARDER MAGAZINE
Box 1028
Dana Point, CA 92629
Use the convenient sub envelope in each issue.

Jay Adams. Photo: Glen Friedman

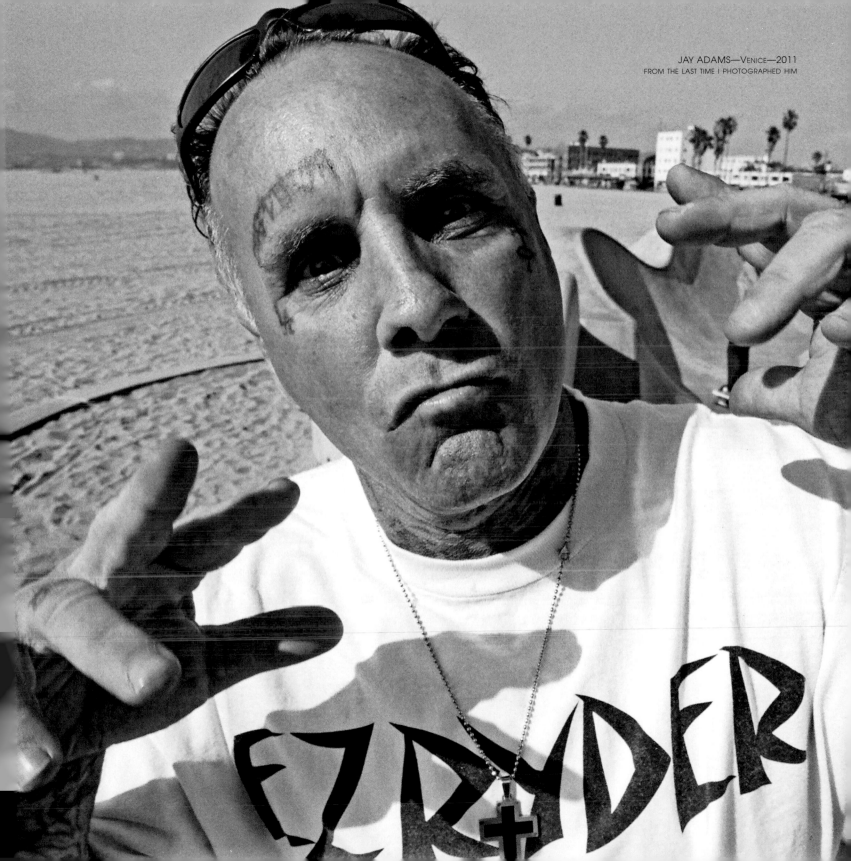

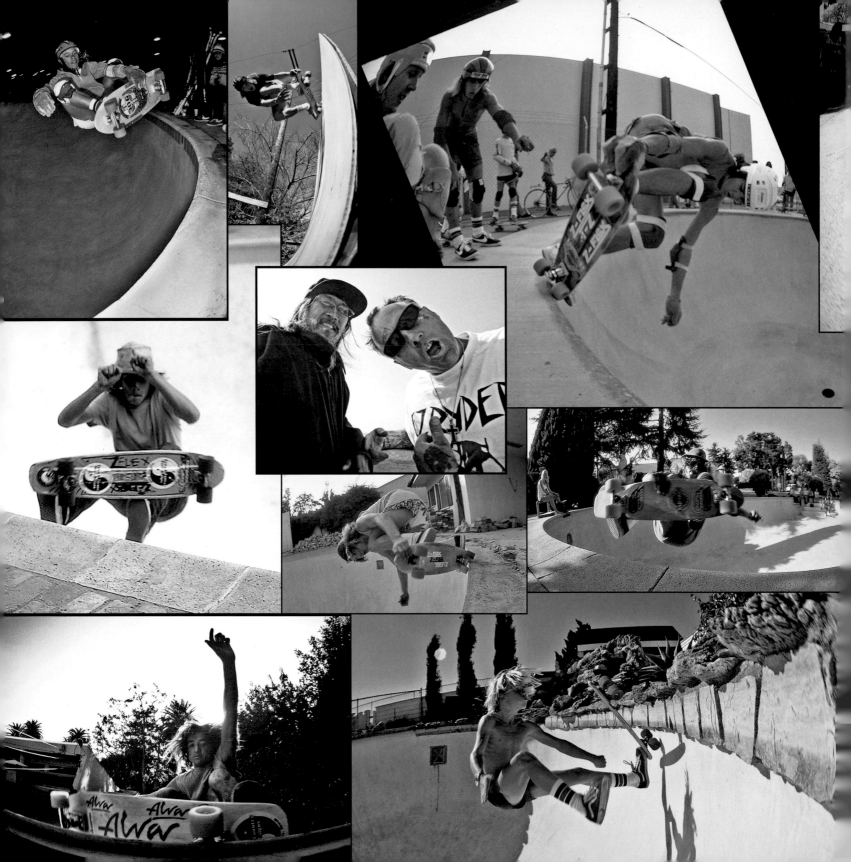

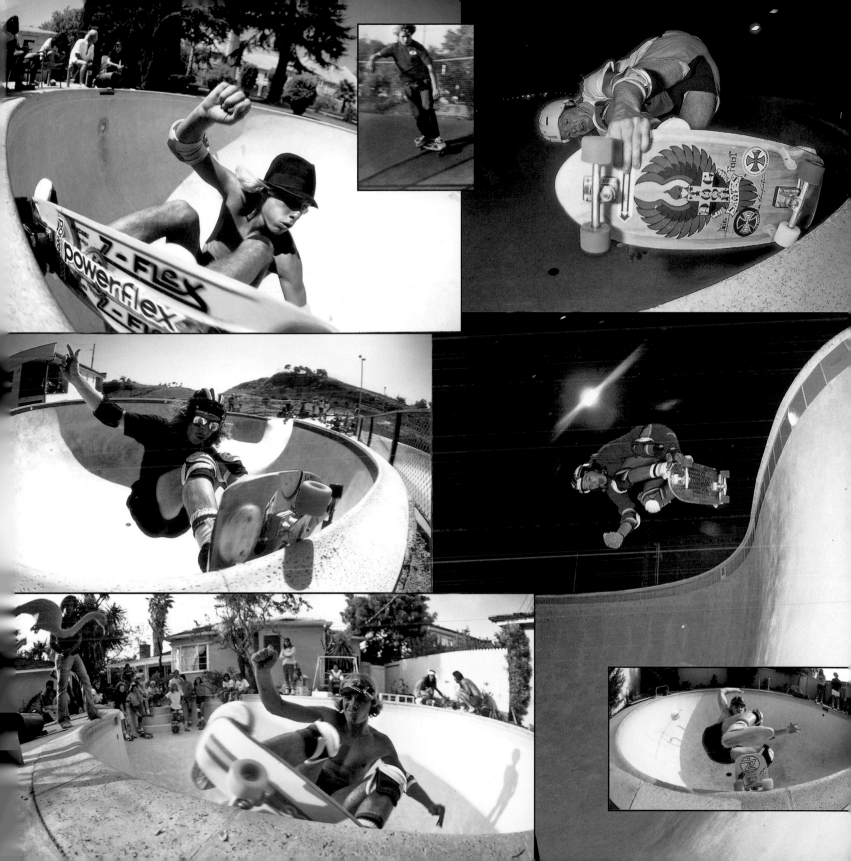

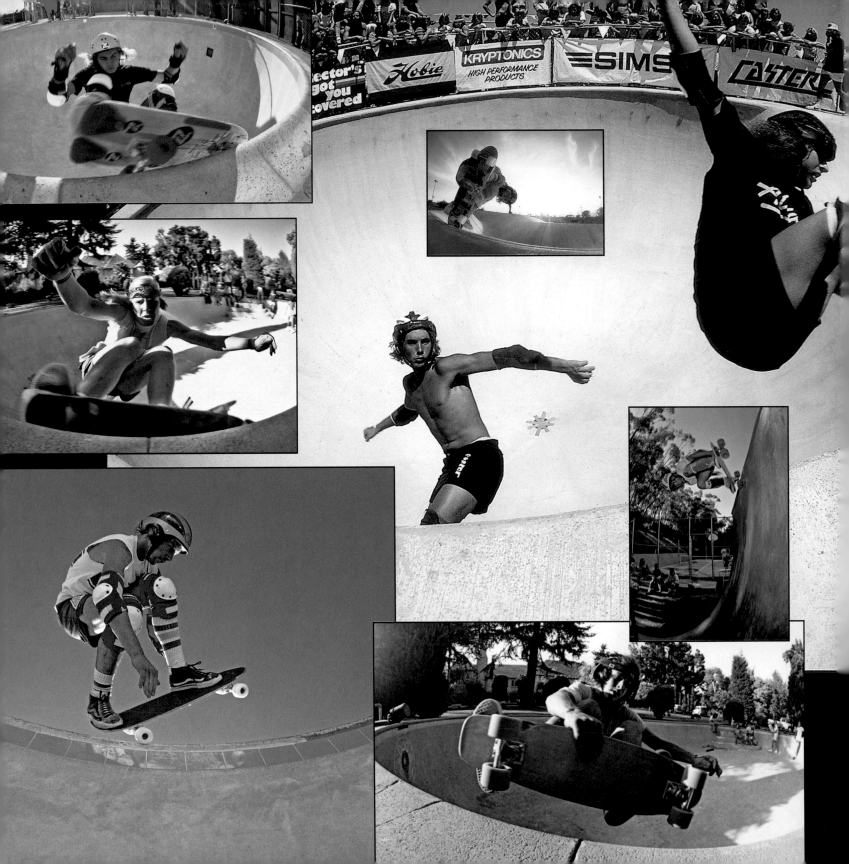

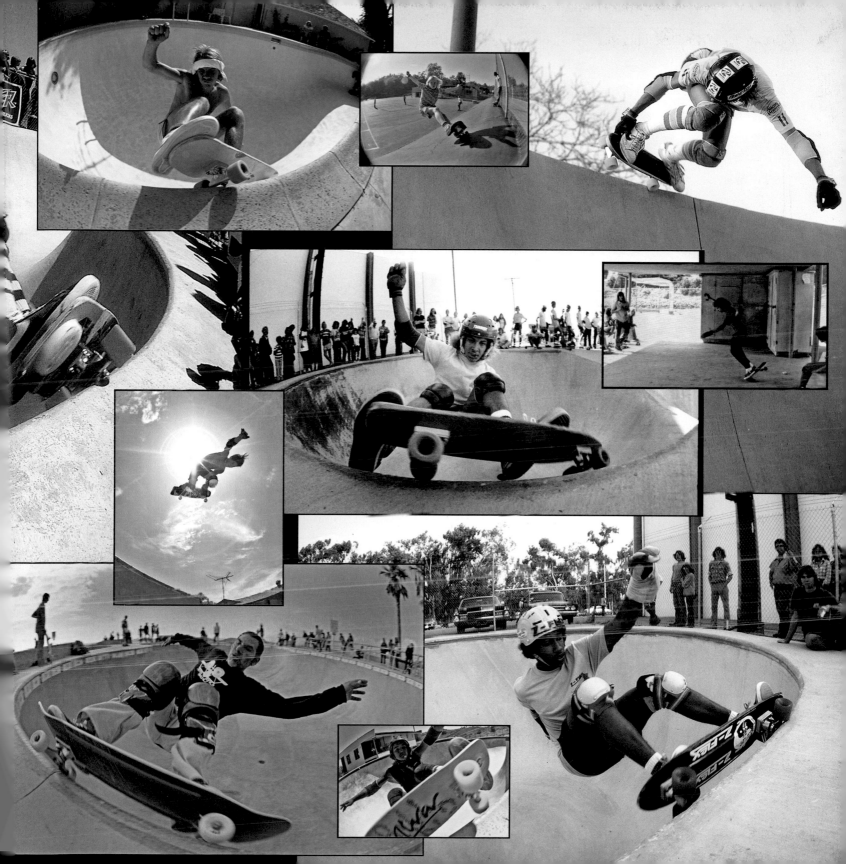

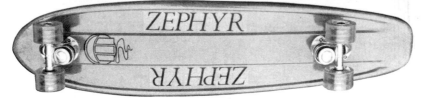

ZEPHYR

The Zephyr Skateboard

The most functional, fast, stable skateboard available. Designed specifically for professional slalom and freestyle skateboarding.

100% uni-directional, heat and pressure molded fiberglass chassis. 27" long and 6½" wide.

Natural rocker for lower center of gravity and more leverage in tail.

No-skid deep textured deck.

Center beam for controlled flex, added strength and extra wheel clearance.

Recessed wheel wells to accept wider, larger wheels.

Reinforced nose, tail and rails.

Wide blunt shape, no dangerous sharp edges or points.

All Zephyr Skateboards are equipped with X-Caliber trucks and Roller Sports wheels. To order your Zephyr Skateboard by mail, send your name, address, zip and $36.95 (Calif. residents add 6% tax) in check or money order, plus $2.00 for postage and handling.

For Getting RADICAL!

Photos: C. R. Stecyk III

Jay Adams
1st Free Form (Kate Sessions), 1st Boys' Slalom (Santa Barbara Contest), 2nd Boys' Free Form (Santa Barbara Contest), 3rd Jr. Men's Freestyle (Del Mar-Ocean Festival Contest), 3rd Boys' Freestyle (Huntington Beach Contest)

Nathan Pratt
4th Jr. Men's Slalom (Del Mar-Ocean Festival Contest)

Peggy Oki
1st Girls' Freestyle (Del Mar-Ocean Festival Contest), 1st Girls' Slalom (Santa Barbara Contest), 4th Girls' Free Form (Santa Barbara Contest)

Tony Alva
2nd Jr. Free Form (Santa Barbara Contest), 4th Jr. Men's Freestyle (Del Mar-Ocean Festival Contest)

Dennis Harvey
2nd Jr. Men's Slalom (Del Mar-Ocean Festival Contest)

Stacy Peralta
2nd Jr. Men's Slalom (Santa Barbara Contest), 3rd Jr. Men's Freestyle (Huntington Beach Contest)

Wentzle Ruml
3rd Jr. Free Form (Huntington Beach Contest), 3rd Super Heat Slalom (Huntington Beach Contest)

Bob Biniack
3rd Jr. Men's Slalom (Santa Barbara Contest)

Paul Constantineau
1st Boys' Slalom (Huntington Beach Contest), 2nd Boys' Freestyle (Huntington Beach Contest), 4th Boys' Slalom (Santa Barbara Contest)

Jim Muir
1st Jr. Men's Slalom (Huntington Beach Contest), 3rd Super Heat Slalom (Huntington Beach Contest)

Remember the last time you skated that special place? The one you know you could rip, except it ripped you, because that old skate had so much flex it bottomed out and you had road rash for two weeks? Well, cheer up, bud, now you too can ride the skateboard of the pros, proven in flat-out everyday hard skating by the Zephyr Skateboard Team, the hottest young skaters in California. Young dudes who go for it at some of the heaviest spots around demand the best, and get it. Get yours.

P. S.: Watch for the Zephyr Team to come to your town, or drop us a line for bookings. Dealer Inquiries Requested

Available at finer surf shops everywhere.
Watch for the Zephyr Skateboard wheel. Coming Soon!

13428 Maxella Ave. suite 203
Marina Del Rey, CA 90292

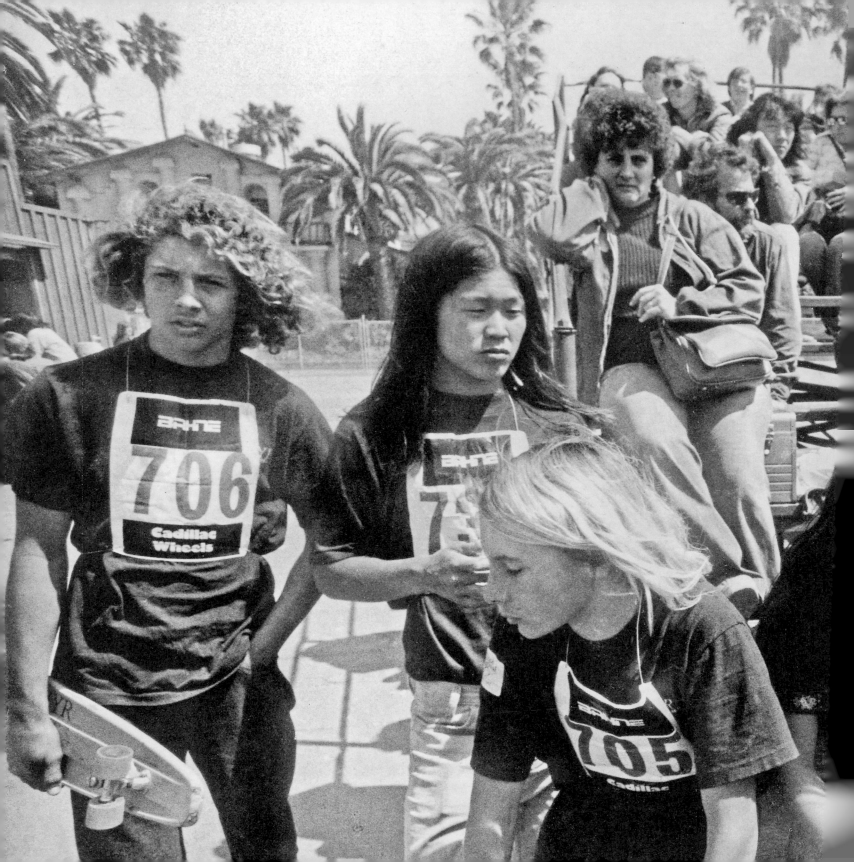